MW00813617

MICHAEL MANN

A Contemporary Retrospective

Jean-Baptiste Thoret

MICHAEL MANN
A Contemporary Retrospective

WHITE LION PUBLISHING

Table of Contents

5 Introduction

7 Chapter 1
 Sharpening

61 Chapter 2
 Television(s)

107 Chapter 3
 The history factory

143 Chapter 4
 The professionals

205 Chapter 5
 Technological defeat (*Public Enemies*)

249 Chapter 6
 Forms of late capitalism

342 Afterword: *Ferrari*

Mann, epistemologist

His world is an almost abstract interlacing of highway overpasses and skylines, bare lofts and airports, post-industrial landscapes and urban labyrinths where man is endlessly in transit, spatial, professional and intimate, somewhere between a lost origin and uncertain tomorrows. It is James Caan, the hero of *Thief*, his first film, whose fate seems limited between the obsessive search for fatherhood and the desire to make real the crumpled photographic collage he carries with him like a talisman. For almost 30 years, Michael Mann has occupied the summit of American cinema, and his aesthetic influencing on films and contemporary images is remarkable. Mann's body of work has a coherence and artistic audacity which, in eleven films, has been able to trace within a Hollywood industry always threatened by formatting, a singular and innovative line. *Heat, The Insider, Ali, Collateral, Miami Vice* and *Public Enemies* constitute so many great aesthetic and technological leaps which have transformed American cinema. How many filmmakers have tried to imitate the style and vigour of *Heat*, the *cathedral-film* he directed in 1995 with Robert De Niro and Al Pacino? *Heat* belongs, in fact, to that very narrow circle of American films which, in their time, have been able to fix the iconic truth of a period and a genre which the bulk of crime films, in Hollywood and in Europe, has not abandoned. Hardly more than a few shots are needed to recognize that *maniera* of Mann: a predilection for urban and crystalline universes, and in particular Los Angeles, a city whose cinema image he has been able to renew; a taste for solitary and concentrated men who search for their right place in a dehumanized environment; an ethereal and contemplative way of filming which favours detail and worried looks; finally, a vision of the contemporary world and its consumerist obsession where fascination and melancholy mix. Mann stands like a tightrope-walker, always on the limit between popular cinema – genre cinema or *formula* (the biopic with *Ali*, for example) – and formal experimentation, as shown by *Miami Vice* (2006), an admirable blockbuster, a masterpiece of precision and audacity manufactured within heart of the studios machine. How do you hold together in a single movement the imperative of entertainment, of readability – even pedagogy – and the rather radical gesture of an author, renewed from film to film?

Michael Mann appeared on the cinema scene in 1981 with *Thief*, a crime film in which James Caan plays a work-a-day, highline burglar who wants to hang up his drills and is building towards his bourgeois dream of a nuclear family replete with a two-car garage. But it was in 1984,

with the TV series *Miami Vice*, which he executive produced, inspired and supervised, that Mann came out of the woods. With its cops dressed in Armani suits and Hawaiian shirts, its new wave ultrasophisticated ambiences and radical music, *Miami Vice* invented the dominant aesthetic of the 1980s. A sort of glitzy and kitsch vision of the America that had just re-elected Ronald Reagan to the White House, and at the same time one that was very dark, not far from that which, at same time seduced Tony Montana in Brian De Palma's *Scarface*. Throughout his career, Michael Mann continued returning to television, his true laboratory, up until *Luck* (2011), a series which placed Dustin Hoffman in the world of horse-racing, and the recent *Tokyo Vice* (2022), for which he directed the pilot.

There is with Mann a pleasure of cinema, in the sense of the sensual pleasure of the text described by Roland Barthes, but also a belief in the ability of the form to reveal the world. Brecht said that a work could only be politically right if it was aesthetically right. Often misunderstood, Michael Mann's cinema, which is resolutely formalist, no doubt explains its delay in attracting the attention of French institutional criticism which, unlike American film criticism, has been late to notice its powerful adherence to our times.

Michael Mann enjoyed his first big public success with *The Last of the Mohicans* in 1992. Since then, he has always gone against the grain of what was expected of him, sufficiently close to keep commercial and artistic control of his projects, sufficiently distant to invent new forms and unprecedented ways of storytelling that we will try to shed light on and elucidate. How did a filmmaker of the New Hollywood generation manage to find his feet in a decade, the 1980s, which was in a certain way its negation? What is the meaning of his obsession with the crime world and these professionals living on the edge, ready to sacrifice themselves when going about their work? Why do his films give such a vivid impression of documenting our times, its relationship to others, to space, to information, to the law and to that 'late capitalism' so dear to the philosopher Fredric Jameson? Each film by Michael Mann concentrates on these turning points where our world *has become what it is*, moments of economic, political and technical mutation of which its characters become, despite themselves, the agents. And often the victims. In many regards, Mann was the man at the outpost: the first great *show runner* of American television at a time when the term did not yet exist, an early promoter of high definition (from *Ali* to *Blackhat*), whose aesthetic resources he has used for more than 15 years. Basically, what are these mirages of the contemporary that his cinema makes so real?

1.
SHARPEN-ING

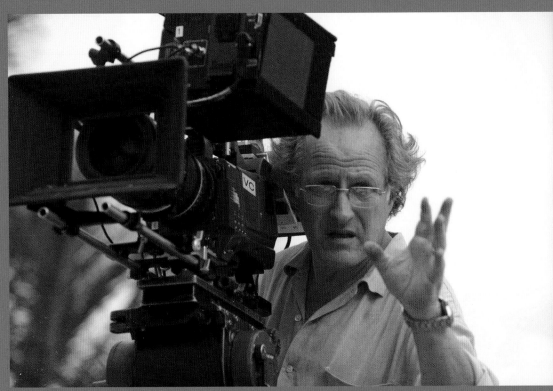

Michael Mann on the set of *Miami Vice*, 2006

First steps

Born on 5 February 1943 in Chicago, to an American mother and a father of Ukrainian descent, Michael Mann grew up a stone's throw away from the Patch, the working class district of the city which in 1871 was the scene of a massive fire. The capital of manufacturing and jazz, a symbol of urbanism at the start of the twentieth century, Chicago possesses an opaque side, that of underground business of course, but also corruption: Al Capone to name but one. On the one hand, he was the absolute emblem of organized crime, who became a national figure and source of countless fictions; on the other, he was the boss of the powerful truckers' union, the Teamsters, involved in laundering Mafia money via Sam Giancana, the strong arm of the organization and hypothetical mastermind of the assassination of the Kennedy brothers.

The violent political and trade union history of Chicago, its involvement in the struggle for civil rights through the 1960s, its mythology too, constitute a backdrop that is indispensable for understanding Mann's work, his penchant for individualism, his fascination with the crime world, his chronic scepticism about institutions, identifiable in all his films, even including *The Last of the Mohicans*, a sort of archaeology of that completely American reticence before the law, when it is applied in the name of private interests that do not speak their name. The first occurrence of the law in Mann's work takes place in *Thief*, immediately indissociable from its opposite, when the lawyer of the thief Frank, by means of coded gestures, negotiates under the nose of a corrupt city judge (named Warren in reference to the author of the farcical report made in 1964 on the JFK affair) a rapid pardon for Okla (Willie Nelson), his client's dying mentor. The scene unfolds under a famous daguerreotype of Lincoln and in the middle of a courtroom that is in the dark.

At the end of the 1950s, Mann entered the University of Wisconsin in Madison and obtained a degree in literature. In the meantime, he filmed in 16mm one of the first civil rights demonstrations against unfair segregation housing in Cicero, Illinois, the first peace demonstrations which set alight the American student world in the streets of Chicago, archive images that he would partly reuse, in *Ali* in 2001. 'I only made the decision to become a director at the age of 21. Until then, I wanted to teach English literature […]. Everything changed for me the night I saw Murnau's *Faust* and Pabst's

The Joyless Street. Two very different films. The first is expressionist and very formal, the second is more realist. Murnau made me understand to what extent this medium could be powerfully expressionistic, how much its impact could affect the spectator's point of view.'[1] In 1965, Mann knew he wanted to become a filmmaker. He decided to leave the United States for England and attend the London International Film School: 'Because of the Vietnam War. And also because, at the time, there were very few film schools in the United States. Moreover, their syllabus seemed technical. Whereas the classes in London taught cinema as an art and not just as a way of making advertising or commercial films.'[2]

During the course of his formative years, Mann discovered the artistic movements shaking Swinging London and frequented the

Thief, 1981

future cream of a new school of British filmmakers – Tony and Ridley Scott, Adrian Lyne, Alan Parker – who would impose on Hollywood in the early 1980s a graphic, pop and advertising aesthetic which undoubtedly left its mark on his first films, *Thief* in 1981 and *Manhunter* in 1986. He also made two experimental, today unavailable, shorts (*Dead Birds* and, in 1970, *Janpuri*, which received several awards at the festivals of Melbourne, Barcelona and Cannes), then was hired by the British branch of 20th Century Fox, for which he worked for 12 months. At Fox, Mann learnt about the film industry, its production language, workings and rules: how to break it down, schedule it, build a budget. It was there that the future man of television and producer of his own films prepared and realized, as an admirer of Stanley Kubrick, that great filmmaker careers are built on the ability to articulate a vision that is personal, sometimes radical, and with a strictly industrial logic: 'I saw Dr. Strangelove in 1963 when I was in Madison, Wis., where I was an undergraduate, and it was a revelation. What struck

[1] Interview with Samuel Blumenfeld, *Les Inrockuptibles*, 21 February 1996.
[2] *Ibid.*

me is that it was possible to make a film as a real auteur for a mass audience.'[3] Mann therefore created his first production company and made a few adverts in order to finance more personal projects.

In May 1968, Paris became the most agitated capital in the world. Declared undesirable by the workers and student movements, the American media had difficulty covering the events. Mann, who was only a few hundred kilometres from the Quartier Latin, took a chance: he went to Paris and worked for NBC's current affairs programme, *First Tuesday*, where he filmed the riots and met leaders of the uprising. Among them were Alain Geismar and Alain Krivine. Hundreds of his images were used for *Insurrection*, the documentary NBC devoted to May 1968.

In 1972, Michael Mann returned to the United States and settled in Chicago. During the summer, he took his camera on the road for a road movie documentary entitled *17 Days Down the Line*, to reconnect with a country that had changed so much in six years, to grasp its new vibe, in the year when the genre reaches its apogee in the wake of *Easy Rider*, with *Wanda* (Barbara Loden), *Vanishing Point* (Richard Sarafian) and *Two-Lane Blacktop* (Monte Hellman). With the help of a journalist friend from *Newsweek*, Marv Kupfer, also from Chicago, and a sound man, he travelled across America, from Chicago to Los Angeles, in search of men and women, American workers whose testimonies he recorded. A beekeeper, a farmer, a Navajo, a Vietnam veteran and a former member of the Weatherman group: 'they evoke individual communities and wonder, each at their level, about the state of nation and the world.'[4] This 37-minute-long film, which we have been unable to see as it was never released, is reminiscent of a miniature version of *Route One USA* or of *Milestone* which resembles, according to F.X. Feeney, 'a dive, both empathetic and provocative, into what makes up the very essence of America […]. The beekeeper sees in the human being the simple link in a natural cycle much better ordered than one can imagine […]. The farmer tells us that the song of the lark at dawn comforts him, but that he cannot bear to listen to the news on the radio. He has no idea what city life is like and doesn't care much about it […]. The young revolutionary, tired of the violence, comments: "The politicians are agitated in all directions asking

3 www.npr.org/2015/01/17/377447142/blackhat-a-classic-detective-story-for-a-brave-new-world?t=1592663602279.
4 F.X. Feeney, *Michael Mann*, Taschen, 2006, p. 9.

where this dissatisfaction comes from and I tell myself that the answer is both political and spiritual.'"[5] Here we start to see Mann's taste for competent individuals, defined by their tasks, whatever they are, and precise know-hows, but also the conviction that the cinema he wants to make will always begin at the source of lived experiences, of individuals made of flesh and blood, of authentic words.

Down the Line is on the other side of appearances, of arbitrary lines, of categories of individuals or statistics, of images, and thus of clichés and even films, as if a good filmmaker is first a good anthropologist. To have a small chance of understanding where the world is going, to grasp its mood and/or its mirages, you must first understand how it functions. After this documentary, Mann tried, in vain, to move into fiction. While waiting for the occasion to finally arrive, he wrote, almost compulsively, series' pilots, entire episodes, TV movies, sketches for scripts, until the day he met Robert Lewin, an established scriptwriter and television veteran. During a 10 year span Mann wrote numerous episodes for the series *Rawhide*, *Mission Impossible*, *Hawaii Five-0*, *Daktari* and *Mannix*. When he was appointed story editor for a new police series, *Starsky and Hutch*, Lewin gave his protégé his first writing job. We are far from Murnau, Pabst or Kubrick, but Mann knew you have to take television for what it is, as a way of learning the trade, making a name for yourself, of testing out characters, situations and screenplay motifs. Michael Mann thus wrote the first four episodes of *Starsky and Hutch*, which became one of the flagship series for ABC.

The first one, 'Texas Longhorn', was broadcast on 17 September 1975, after the pilot. 'Lady Blue', 'Jojo' and 'The Psychic' followed on 5 January 1977. 'Texas Longhorn' 'was a riff on a guy who wants to get rid of his wife,' Mann recalls, 'and I modeled the guy on Cal Worthington, who's a famous Los Angeles used-car dealer.'[6] With its two cops using unorthodox methods to apply their idea of justice, these first episodes follow, a bit clumsily, in the anarchist footsteps of Don Siegel's *Dirty Harry*, with rather cool manners and a violence that conforms to the strict norms of the small screen. However, the approach of the writing (shaping each character on an authentic individual experience) and some of the themes developed indicate Mann's future leitmotifs, whether in the fear of home invasions,

5 *Ibid.*, pp. 9-10.
6 ew.com/article/2012/01/21/michael-mann-interview-luck-hbo.

the fragility of family structures or, of course, the male couple, two men side by side, or mirrored, soon complementary (Sonny and Rico in the series *Miami Vice* and the film of that title, Jeffrey Wigand and Lowell Bergman in *The Insider*) or antithetical (*The Keep, Manhunter, Heat, Collateral, Public Enemies*).

'The other man who taught me a lot was Liam O'Brien – the brother of the actor Edmund O'Brien [...]. He ran *Police Story,* which was an anthology series, a different cast every week. I was also lucky that I came on board that show while Joseph Wambaugh [...] was still active in producing the show.'[7] Wainbaugh, a cop turned novelist and scriptwriter (*The Choirboys, The New Centurions, The Onion Field*) asked Mann to write four episodes of *Police Story*. In 1977, Mann gained visibility: the producer Aaron Spelling then gave him an offer to create his own TV series. It would be *Vega$*, a successful crime series with Phyllis Davis and Robert Urich in the role of a private detective investigating behind the scenes of Las Vegas. Broadcast on ABC from April 1978 to June 1981, *Vega$* allowed Mann to, for once, move to directing (the episode 'The Buttercup Killer' for the series *Police Woman*, with Angie Dickinson), and above all to understand one of the ironclad laws of Hollywood and television: there can be no artistic control of a project, whatever it may be, without a grip on production. Very quickly, he chose to leave the series over artistic differences with the production company, which opposed the pessimistic and hardboiled vision of its creator.

After this disappointing experience, Mann continued to develop projects, among which *Swan Song*, a television movie on the return to competition of a professional skier (David Soul) who is afflicted by a strange illness, directed by Jerry London in 1980, and especially *Heat*, a major crime film which Mann would direct twice, first in 1989, as a television movie (*L.A. Takedown*), and secondly in 1995.

7 *Ibid.*

Straight Time

In 1978, Dustin Hoffman and producer Tim Zinnemann called on Michael Mann to work on the adaptation of the first book Edward Bunker wrote behind bars at San Quentin prison, *No Beast So Fierce* (1973), retitled *Straight Time*. With this film, Hoffman, who also plays the main role, hoped to make his debut as a director, but after three days of filming, he handed over to Ulu Grosbard, who eight years earlier had made, *Who is Harry Kellerman and Why Is He Saying Those Terrible Things About Me*? As he does in all his films, Mann returned first to the sources of the story and the professional world it explores – the prison system, the conditions of detention, the type of men, their rituals – a big preparatory work alongside Edward Bunker, which led him to investigate for three months at the prison of Folsom, in California, where he gathered a quantity of testimonies, impressions, images and information. Let us note that Bunker, and his scarred face, would serve 20 years later as the model for Jon Voight in *Heat*, made up to look like the author.

Straight Time, Ulu Grosbard, 1978

Still carrying the imprint of the disenchantment to be found in the best American cinema of the 1970s, *Straight Time* describes the impossible reintegration of Max Dembo, an ex-con who dreams only of redemption, a second chance, an ordinary life (a job, a house and a family), and who is attacked from all sides: the experience of imprisonment forever

marked on the soul and the body of those who have undergone it, the whole society that denies those it releases the slightest chance of salvation and, above all, the judicial system, in the person of a sadistic probation officer played by M. Emmet Walsh who, by using the miserable but real power the institution gives him, sends Dembo back on the path of criminality and programmed repeat offending. Although Mann does not feature in the credits, the documentation and rewriting work he did on the script, which would finally be credited to Alvin Sargent, Jeffrey Boam and Edward Bunker, is not in doubt. Above all, the material accumulated retrospectively sheds light on a large part of Mann's obsessions and items.

The influence of his research is undeniable in the case of *The Jericho Mile*, a prison film he directed in the same year for ABC. Folsom would become the recurring crossroads of Mann's most future outlaws, be it Frank in *Thief*, the fake criminal past invented for the needs of the undercover mission by the two cops in the film *Miami Vice*, or, of course, Neil McCauley and his gang, all from behind the same walls in *Heat*. There, these men acquired a same inflexible life discipline, summed up by a small story in *Thief* (Frank's violent and decisive confrontation with a sinister screw) and Neil's emblematic declaration in *Heat*: 'Don't let yourself get attached to anything you are not willing to walk out on in thirty seconds flat if you feel the heat around the corner.' The Aryan Brotherhood, to which Bunker belonged, would return in *Heat* and *Miami Vice*; Danny Trejo, ex-con and Bunker's cellmate in San Quentin, would play the role of Trejo in *Heat*. And then the films' realism (the searching of Dembo on his arrival at the Los Angeles county jail), the description of the criminal spiral rather than the heroization of the character, the friend who betrays and provokes, by a domino effect, the downfall of the group (Gary Busey here, Danny Trejo in *Heat*), or the character played by Harry Dean Stanton, a sort of proletarian and angular sketch of Michael Cerrito (Tom Sizemore) in *Heat*, for whom the peaceful and orderly life he seems to lead does not prevent risk and adventure from coursing in his veins: 'Action is the juice', the good family man will tell Neil to justify taking part in the bank heist, which will be fatal to him. There is also no doubt that the form of perverse paternalism shown by the probation officer under the cover of the law fed the character of Leo in *Thief*, a figure just as replete with power, but in its entrepreneurial and Mafia version. Finally, the exchange with Jenny (Theresa Russell), the young woman from the employment agency who Dembo meets, obviously prefigures the conversation

between Frank and Jessie in the diner in *Thief*. In both cases, it is a moment of truth and necessary clarification before envisaging travelling a little together and starting a family.

> Dembo: How far do you want to take this?
> Jenny: I don't know. I thought we were working on something here, but maybe I'm wrong.
> Dembo: No. You're not wrong. What do you think I've being doing?
> Jenny: I guess I never really thought about it.
> Dembo: Do you want to me to lie to you and tell you I'm working in a hot-dog stand? You know I can't do a regular job. I can't sit here and take your money. Well, do you have an alternative for me? I'm doing what I do. If you tell me you can't take it and if you tell me it's too heavy for you, well, then I'll just walk out the door. I'll walk but I don't want to.

In 2011, Michael Mann again worked with Dustin Hoffman, in the series *Luck*, as Chester 'Ace' Bernstein, a former inmate who draws up a complex plan to rig horse races. Does his first appearance as an old man on the point of being released not echo, like a reprise after 35 years, the role of Max Dembo?

The Jericho Mile: thus fall the walls of Jericho

Like a (finally) free man. As Michael Mann no doubt saw himself, a man who, at the very end of the 1970s, prepared to go behind the camera for good. In its weekly program, *Movie of the Week*, ABC gave him the opportunity to bring to the small screen a screenplay by Patrick J. Nolan, a literature professor who had just gone round the television channels with his *Jericho Mile*.[8] Inspired by the partly true story of a prisoner able to run a mile in a record time of four minutes, which authorizes him, theoretically, to take part in the Olympic Games, *The Jericho Mile* allowed Mann to fully exploit the research and experience acquired during the preproduction of *Straight Time*. Mann kept the initial premise but thoroughly re-wrote the script. Rain Murphy, played

8 The film was shot in 21 days, for a budget of $1 million.

by Peter Strauss, star of the TV series *Rich Man, Poor Man* and naïve soldier in *Soldier Blue*, is a man who runs. He does only that. Sentenced to life in Folsom prison for the murder of a violent father, Murphy has built for himself a watertight space organized around a single activity which he practises in a rigorous and maniacal way. Only Stiles (Richard Lawson), the prisoner occupying the adjoining cell, enjoys his friendship. Rapidly, the prison officials spot Murphy's sporting talents and decide to build, behind the walls, a proper track on which he can train for national team events.

 Mann chose to return to the prison, Folsom, that he had already explored, and from the administration got authorization to film everything on location. A question of authenticity and openness. Mann gleaned a large quantity of elements which he gradually added to his script: here the Grim Reaper, that imposing William Blake-like fresco seen at the start of the film; the distinctive way of folding a towel; a tattoo, or the so particular elocution of the prisoners who avoid all form of contraction of words in order to make themselves understood straightaway; so many realistic details which would become one of the trademarks of Mann's writing and of its documentary quality. Twenty-eight genuine prisoners played their own roles here, 653 others served as extras, and Mann integrated into his story the prison's three rival gangs: the Black Guerilla Family, the Hells Angels (ancestors of the Aryan Brotherhood) and the Mexican Mafia. For security reasons, the production hired, in addition to the 450 guards already present, 11 extra guards in order to watch over the film crew. Already faithful to the martial technique of preparation he imposes on all his actors, Mann sent Peter Strauss behind bars to immerse himself in the prison world, to mix with the prisoners, learn their codes, gestures, manias; in short, to become one of them.[9]

[9] This constant concern for accuracy, which extends from the historical field to the smallest detail of clothing, is part of a sort of mystique of authenticity – in *Public Enemies*, for example, Mann insisted on shooting Dillinger's escape from Crown Point behind the walls of the original prison, just as he used the famous lodge of Little Bohemia for the big nocturnal gunfight sequence, arguing that this would help the viewer's immersion in the action and the period. If, in the interviews he gives, Mann says little about the interpretation of his films, he turns out to be inexhaustible when it comes to exposing their documentary sources: 'It is inaccurate and irrelevant to compare my films to other films, because they do not come from the conventions of a genre and then deviate from them [...]. They come from real experiences. To know how to treat the story of *Thief*, I do not take inspiration from the excellent French filmmaker Jean-Pierre Melville. I'm looking to meet thieves. And I guarantee you that if Melville's *Le Samouraï* or Raoul Walsh's *White Heat* are so authentic, it's because these directors met thieves, too.' (F.X. Feeney, *Michael Mann, op. cit.* p. 21).

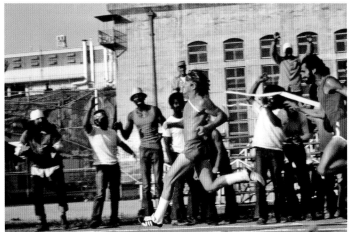

The Jericho Mile,
1979

The Jericho Mile bears the trace of Mann's London years, when he discovered the films of English Free Cinema, of Michael Anderson and Karel Reisz, with their teenagers in revolt against the institutions. His script also undeniably reminds us of one of the touchstones of this new wave, *The Loneliness of the Long Distance Runner*, directed by Tony Richardson in 1962. In this film, a freshly imprisoned young delinquent is noticed by the director of the prison, who detects in him a particular talent, long-distance running, and decides to train him for a competition that pits him against competitors of bourgeois origin. But Murphy, the protagonist in *The Jericho Mile*, is a more existential than political man who, unlike his English elders, accepts his condition and represents nobody but himself. The race functions for him as a way of concentrating himself, of focusing his existence on a single point and cutting out all the rest. A bit like the matchstick bridge built by Steve McQueen in *The Getaway* (Sam Peckinpah, 1971) and which he symbolically destroys, like a now useless totem, just before his release, or like *Cool Hand Luke* (Paul Newman in Stuart Rosenberg's eponymous film, 1967), who opposes the screws' conservatism with a disconcerting joie de vivre. Because Murphy does not respect the codes of the penitentiary game – submit or rebel – and repeats to whoever will hear him, in this case the prison psychiatrist, that he belongs to this place. 'When you run, do you pretend you're outside the walls?' the doctor asks him. To which Murphy replies: 'I'm here. I'm nowhere else. I'm here. I belong here. In this place.'[10] This resignation, or rather this self-reappropriation, constitutes the real

10 Thirty-five years later, the hacker in *Blackhat* uses almost the same words: 'I am doing the time, time isn't doing me. I am doing my own time, not the institution.'

scandal carried by Murphy, who does not nurture a feeling of injustice, nor a desire for revenge, nor hope of release. A position of withdrawal, and of symbolic independence from the penitentiary institution and the gangs he refuses to join. As a true Mannian hero, Murphy is of no gang, no network, no other category except that mental space of which he has fixed the contours (the prison walls) and the law (to run, and nothing else).

To the music of Jimmie Haskell (a cover of the Rolling Stones' *Sympathy for the Devil*), the film's opening plunges us directly behind the walls of Folsom and grabs, like a live report, fragments of prison life: a black detainee, wearing headphones, wiggles on his own to the sound of his radio, others play chess or lift weights; a group of white prisoners kill time, one of them reads a comic book, some even look to the camera, and in the middle, a man is running, followed by a partner who has trouble keeping up. The runner is Rain Murphy. But from one group to another, a same discrete action is repeated, which sheds light on the underground relationship between these diverse communities where it is a question of exchange and barter: a packet of cigarettes, a dose of powder, a handful of dollars, everything passes from hand to hand, except that of Murphy, who we see is the only one not taking part in this small illegal economy. The information seems anodyne, but it reveals an essential aspect of the character. A solitary man, obsessed with the task he has given himself, Murphy is an individualist who refuses any ties with the others, just as he has chosen to be completely ignorant of life outside. In Mann's work, discipline – regardless of whether you are a sportsman, a criminal or a cop – is as much an effective way of adapting to the world as it is of keeping it at a distance, sheltered from that reality which Bundini, in *Ali*, holed up like a wounded animal in a New York apartment, called a 'bitch'. But this desire for protection at all costs contains its opposite, since it also requires a form of insensitivity to others, and therefore yourself.

Unlike Richardson's long-distance runner who manages to push away his imprisonment through mental flashbacks that punctuate the film and let it breathe, Murphy's elsewhere remains off-camera, never appearing on the screen. *The Jericho Mile* does not yet contain that emblematic shot of Mann's cinema, almost a visual signature, that of a man lost in the contemplation of an, often marine, elsewhere. However, this utopian horizon haunts the film in the invisible form of a safe sealed forever, full of what the man has expelled from his mind: memories,

sensations, faces no doubt, impressions of life beyond the walls, an inaccessible dream.

In the first part of the film, Murphy and Stiles seem to form the sketch of the future male couples in Mann's cinema. Occupying adjoining cells, they both embody two possible attitudes to incarceration. On the walls of his cell, Stiles has stuck tens of photographs, of his wife and children, but also of various magazines, a way of visually recreating for himself a familiar and desirable environment from images that come from the outside world he endlessly dreams of.[11] 'If you are in prison from the age of 18 to the age of 30, what do you have in mind? What have you lost? What do you know about the society you return to after being cast aside? How does Frank create his ideal life? With magazines, in prison, but without the experience of life',[12] Michael Mann will say of the character played by James Caan in *Thief*. In contrast, the total emptiness of Murphy's cell walls translates not only his desire to cut himself off from the possibility of an outside world, but functions also as a comment on the artificiality of the images displayed in the cell next door. Murphy knows that the image of reality, as attractive as it may be, is not reality, while Stiles, who has not accepted his detention, chooses to believe in these images, so much so that he convinces himself that they are within his grasp. A coloured and loaded space on one side, a Spartan and blue-tinted environment on the other. And then the colour blue, soon to be associated in Mann's films with a moment of existential introspection, occasionally one of crisis: it will be the apartment haloed in turquoise light to which Neil (*Heat*) returns after spending the night with Eady, the young woman who he feels has disturbed his vital equilibrium, or that bedroom plunged into a blue night in which the profiler Will Graham (*Manhunter*) confesses to his wife that he is preparing to hunt a serial killer.

One day, Stiles receives from his wife a photo of his newborn child, which triggers in him the desire to mobilize as quickly as possible a family visit. He therefore accepts the deal proposed to him by Dr D (Brian Dennehy), leader of the Aryan Brotherhood and the first Faustian figure in Mann's cinema. But the deal is rigged, and instead of his wife, Stiles is visited by a prostitute, a 'mule' charged with supplying

11 In *Thief*, Frank's intimate utopia also boils down to a photo collage made in prison with images similarly to those accumulated by Stiles.
12 F. X. Feeney, *Michael Mann*, *op. cit.* p. 14.

Dr D with his drugs stash. Stiles, who does not understand that here the client is a slave, refuses to play the game and, by doing so, condemns himself. No one, neither the institution nor Murphy, can prevent his murder. For his part, Murphy, after having been judged a potential competitor, receives a stopwatch from the hands of Beloit (Ed Lauter), a sports trainer who has come from civilian life to improve the performances of this extraordinary prisoner. Murphy well knows that the risk is great of transforming his personal discipline into a sporting contest and letting the uncontrollable air of external life and rules penetrate his space. The child's photo, for Stiles, and the stopwatch, for Murphy, represent two forms of temptation, of a promise of improvement, and therefore of being tested. The first man chooses, via an intermediary (Dr D), to negotiate with this reality and lose. The second man also agrees to play the game, convinced that he will know how to *control it.*

Like most of Mann's screenplays, *The Jericho Mile* is structured around a pivotal scene through which the world and its stakes reveal themselves in another way, tip over, as if you were passing brutally, and sometimes thanks to a simple reply, to the other side of the mirror. A parallax effect which, following a simple change of perspective, reveals the hidden dimension of a reality, its inner workings and all, from the origins of the story, is its foundation. In *The Insider*, it is the meeting with the lawyer of CBS (Gina Gershon) who informs the journalist Lowell (Al Pacino) that the report accusing leaders of the tobacco industry cannot be broadcast in its current state, for reasons of 'tortious interference'. In *Miami Vice*, Sonny and Rico's encounter with the powerful Archangel de Jesus Montoya causes a sudden change of scale, where we pass from old school and local trafficking to a globalized network. There is the same shift of focus in *Public Enemies*, when John Dillinger, after escaping from a penitentiary in Indiana, arrives in a room filled with interconnected telephones where bookmakers multiply their earnings. Dillinger grasps how much this acceleration of technology makes him a man of the past. The first part of *The Jericho Mile* seems to be adjusted to the sporting pace of its character and tied, *a priori*, to a single question: Will Murphy manage to avoid harm from some of his prison companions (Dr D and his gang of Aryans), the death of Stiles, and remain concentrated on his performances? But the face-to-face encounter which happens in the final third of the film between him and the director of the U.S. Olympic board – a private structure we learn sponsors and reigns over the organization of the competition –

completely transforms the story. It is the last stage before the national committee gives Murphy the authorization to compete. The meeting takes place in a dark, silent room, the rituals are rigid, the language formal, and a prison atmosphere betrays, as always in Mann's work, the cold violence at work in institutional structures. Prefiguring the adoption centre in *Thief* with its small greyish and deadly boxes, the Olympic organization soon reveals its deep logic underlying competition that is supposed to be protected from any non-sporting consideration. Around a long rectangular table, a tense exchange, which Mann films like an interrogation, begins between the two men. If he had the chance today, would Murphy kill his father again? The director's question marks a turning point of the film. What is then expected of Murphy is that he brings *less to redeem himself than to offer the image of this redemption*, with the unspoken motive that his *mea culpa* will have a positive effect on the reputation of his institution, on the competition's ratings and, consequently, on the economic benefits of the global operation. For the director, it is about carefully prepared words without value before validation of Murphy's participation in the events, a simple formality to which the candidate, at the price of expected hypocrisy, could bend straight away. But the runner, steps away from a probable victory and a life changed forever, already belongs to that line of Mannian die-hards; in other words, upright men for whom authenticity is the supreme value and who prefer to lose everything (races, medals, a family or even their life) rather than their soul. The axe of a higher law, that Murphy could sense but which until now he had denied, has just fallen. The runner hesitates, grits his teeth, chooses to tell the truth and condemns himself de facto: if the opportunity arose again, Murphy would kill his father.

In Mann's work, this higher law wears several masks but one and the same face, that of American capitalism, of private financial interest, of powerful consortiums which dictate the march of the world and of history, of politics and public affairs; it transforms men into luckless gamblers who, one day, will learn that the rules of their lives are dated and fixed. By looking closely, *The Jericho Mile*, right from the get-go, brings all the narrative lines back to economic issues. Here, the actions of the characters, their motivations, the bifurcations of the story and their resolution happen in the name of a market logic which has penetrated all the interstices of their society. Behind the prison walls, like everywhere else, everything is settled by exchanges (of right processes), of markets (to defend or conquer), of profits, clients and debts. Even the picket line drawn up by the Aryan gang to prevent,

for political reasons, the construction of the training track by exploited prisoners, is denounced by a black detainee as a vulgar 'money matter'. It is therefore a trivial problem of money and of vengeance towards Murphy, who dared defy Dr D by burning, in the middle of the yard, all of his fortune. This Marxist-inspired economic determinism fills the heart of Michael Mann's films, from *Thief* to *Blackhat*. It expresses the deep conviction that the economy is the basis of all forms of relations at work in contemporary society, and we can only understand its workings and dynamics by revealing the economic structure which underpins it.

Sent back behind the walls of Folsom, deprived of official competition, Murphy decides however, on the day of the national events, to compete alone, on the brand new track built for him. The last sequence of the film and back to square one. The situation is the same (running within the walls), but in the meantime, it no longer has the same meaning. Less than four minutes later, acclaimed by his peers, Murphy beats the best Olympic time and, in the aftermath, throws over the wall the stopwatch that proves his record. Thanks to the highly symbolic gesture, he definitively expels his Olympic mirage, the illusion (which Stiles paid for), according to which one can live here and over there, free and imprisoned, faithful to oneself and in compliance with the desires of others. This awakening to the world will draw the trajectory of all Mann's protagonists who, on their way, will learn to bring down their walls of Jericho and purge themselves of the deceptive screens that prevented them from accessing what they are *deep down*. 'Don't lie to anyone,' Okla says to his spiritual son Frank in *Thief*, like a valid advice for all the films to come. Besides, Mann inscribes the metaphor in the screenplay itself: at the foot of the walls of Folsom, but on the side of free men, Beloit offers Murphy this stopwatch, on which is engraved the maxim 'To the Jericho Mile' and adds, 'maybe it's got to do with the walls come tumbling down', thus establishing a direct relationship between Murphy's adventure and the taking of the city of Jericho by Joshua in the Old Testament. Let us remember that on the seventh day of the siege, seven priests turn seven times around the city, blowing on seven horns. Up until the final blow: 'So the people shouted when the priests blew with the trumpets: and it came to pass, when the people heard the sound of the trumpet, and the people shouted with a great shout, that the wall fell down flat, so that the people went up into the city, every man straight before him, and they took the city.'[13] Thus fall the walls of Jericho. Judging by the

[13] Book of Joshua, VI, 20.

jubilation of the prisoners when they see Murphy's exploit, we can believe that he will have allowed the economic ties at the beginning to be substituted by a new collective fibre based on discipline, perseverance, abnegation and courage. But Mann, who is no Capra, keeps well away from drawing from a sole man's adventure a moral lesson for the community: if small glimmers of solidarity manifest themselves (those detainees who sacrifice part of their meal for Murphy), if some seem ready to catch fire together and beyond clannish frontiers (the building of the track, the last race), other examples prove that nothing has moved: Dr D and his gang remain withdrawn into themselves, while a white prisoner who ventures into the weights area held by the Blacks is unceremoniously driven out by their leader. Multiple and protean, the walls of Jericho here have not all fallen, which is part of this feeling of the ephemeral, of incompletion and ambiguity on which the core of Michael Mann's films end. A strange taste of victory and defeat mixed together: yes, Murphy has let slip, in the eyes of society, the chance of a lifetime, that of taking part in the Olympic events and perhaps even shining in them, but he knows that this victory, won at the price of a consented lie, would have had the bitter taste of betrayal. Murphy has lost, but he has conquered that feeling of reality after which many of Mann's characters run. Quite simply, he has won self-esteem, a moral rectitude which gives his existence of a condemned man a meaning and confers on it the priceless weight of the truth.

In the precious little book he devoted to Michael Mann, Mark Steensland noted that all the protagonists in his films possess three common qualities:[14] a total devotion to what they do – which explains the absence of psychologism, replaced by a Fitzgeraldian sense of action (action is character); the acceptance of a pact to which they think they will obtain something (or someone) which they lack; finally, the revelation that this pact, because it has reduced their freedom, can lead to their downfall. From this point of view, Rain Murphy is the first raw Mannian character, placed at the origin of a long line of men who will bear the names of Frank (*Thief*), Neil McCauley and Vincent Hanna (*Heat*), Lowell Bergman (*The Insider*), Muhammad Ali (*Ali*), John Dillinger (*Public Enemies*) or Nathaniel in *The Last of the Mohicans*.

[14] Mark Steensland, *Michael Mann*, Pocket Essentials, 2002.
[15] *The Jericho Mile* received three Emmy Awards, including those for best script and best actor for Peter Strauss.

Thief: welcome to the human world

Thanks to its success when broadcast on television,[15] *The Jericho Mile* was released in some European cinemas and in France in May 1981, just after the Cannes Festival, where it was presented in competition. Above all, it allowed Mann to direct his first film for cinema, *Thief*, *Le Solitaire* in its French version. The solitary man in question is Frank, an independent and stylish burglar from Chicago played by James Caan, just out from filming *Hide in Plain Sight*, his one and only attempt as actor and director. In this film, Caan plays a blue-collar worker from Buffalo, Wyoming, whose misadventures – his children are taken away from him because of a witness protection programme – place him in a position of struggle against a justice and State system already close to that which his character will adopt in *Thief*.

A public welfare child, Frank has just spent 11 years behind the bars of Joliet prison. Owner of a bar and second-hand car dealership in Chicago, he pursues his underground activities. At night, he cracks safes and steals diamonds. But the death of an over-greedy receiver of stolen goods leads him to Leo (Robert Prosky), a local Mafia big shot who proposes that he work for his small criminal enterprise. Wanting to put an end to his burgling career and to finally settle down, Frank sees in this offer the means to achieve his secret dream: to do one last job and start a family. In the course of one of the most beautiful sequences in the film, Jessie (Tuesday Weld), a barmaid who has seen it all, agrees to link her destiny to his.

Here, Mann takes hold of a classic figure of the genre, that of the criminal who opposes organized crime. The official source of the screenplay, John Seybold's *The Home Invaders: Confessions of a Cat Burglar*,

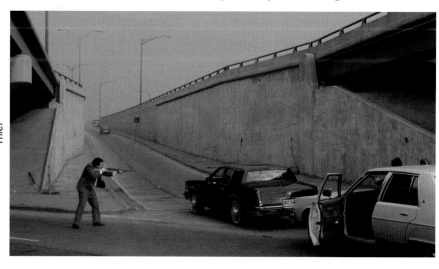

Thief

was written under a pseudonym (Frank Hohimer), in 1975, during his detention in the prison of Fort Madison, Iowa. From the sparse collection of experiences, from which no structured story emerges, Mann kept the bare bones (an environment, a trade, a few situations) and wrote the screenplay drawing on his own sources. As he did for *The Jericho Mile*, with its authentic prisoners used as actors and/or extras, Mann gave several roles in *Thief* to Chicago burglars, policemen and criminals, for what would be their first appearance in cinema. John Santucci, ex-convict and high-flying burglar, plays the role of the corrupt police inspector, Urizzi, who is always ready to 'cut corners' in exchange for a bribe. An ex-member of the Chicago police, Dennis Farina appears as an enforcer for Mafia boss Leo and would become one of the recurring actors in the 'Mann clan' (*Manhunter*, *Crime Story*, *Luck*). Thus Mann already blurred, via casting, the tenuous frontier between them, as if what really separated these men defined itself as something other than the position they occupy around that line called the law. For Sam, the old boss of a small metal factory which builds the torch bar with which Frank pierces the safe of the Los Angeles bank,[16] Mann was inspired by the grandfather of a childhood friend. The film marked the debuts of the actor Robert Prosky in the role of Leo and James Belushi as Barry, the young partner of James Caan. Finally, Mann called on the help of two renowned burglars, Milwaukee Phil and Leo Rusendorf, to serve as technical advisors and demanded from his main actor intensive preparation.

Thief shows from the outset the impeccable alliance of documentary precision and inspired stylization. The film obviously takes its place in the comet's tail of the disenchanted cinema of New Hollywood – in the same way as Sidney Lumet's *Prince of the City*, Paul Schrader's *American Gigolo* and Walter Hill's *The Driver* – at the same time as heralding certain features of the 1980s aesthetic of which Mann would be one of the precursors. *Thief* is a connection, a welding together *in active labour* of two decades of American cinema, the 1960s and the 1970s, in light of which Mann's entire cinema unfolded, and that strange era that was coming – from the 1980s to today – of which his films would endlessly track the stakes, the biases and the seduction, as well as the workings. *Thief* is thus occupied by this search for equilibrium, as much from a formal point of view, between naturalism and abstraction, between the

16 This sequence was filmed in the Zoetrope studios, at the time when Francis Ford Coppola still owned them.

hot and the cold, as from that of the story, which endlessly opposes two different political visions of work, of justice or of the relationship to others. This intermediary position, of very Fordian descent, and above all the questions it raises – How do we pass, or not, from one epoch to another? Should we remain the same when, around us, the world is changing? – will form the spine of his work. That this awareness of being part of an in-between is remarkable in itself.

The film's first shot: night and rain, a car emerges from Rat Alley, a man jumps into it, the camera accompanies the vehicle as it moves away, headlights on, into the depths of the city, towards where Frank and his partners are going to carry out their job. The realist and minimalist description of the action – a few functional replies before arriving on the site of the break-in – inserts itself within a very graphic, if not advertising, direction. The second shot of the film, which grasps the curtain of rain falling in front of dazzling projectors placed full-frame, is as reminiscent of the urban and post-industrial aesthetic of *Blade Runner* as it is, a low hypothesis, of *9 ½ Weeks*. The wet asphalt, the spots of light disseminated in the frame, the fleeting diagonals formed by the pavements compose an image that is both impressionistic and abstract, where blurred forms mix with a strong geometry of space. Frank plunges into this urban perspective as into an imprecise and seductive universe, visually marked by a confusion between things and reflections, between reality and its simulacrum. Mann cited the paintings of Camille Pissarro as a source of influence for this shot, no doubt the series of urban landscapes that the painter began in 1896, during a second journey to Rouen,[17] and more precisely *Boulevard Montmartre at Night*. We can see in this nocturnal metropolitan view, organized around a deep perspective, illuminated windows which are reflected on the damp street and the long lines of fiacres, a dual sentiment of marvel at and reticence towards what, at the end of the 19th century, was called progress. Years earlier, in 1888, Van Gogh had also, with his 'Starry Nights', and in particular *Starry Night over the Rhone*, had the prescience of these modern cities that nature, the moon and the stars would no longer light them up, a celestial vault would be covered by the artificial light of streetlights, and 'the brutal gold of gas'. This supposed disappearance of spirituality in the

[17] In a letter dated 26 February 1896 to his son Lucien, Camille Pissarro describes his painting thus: 'A motif of iron bridge in wet weather, with heavy traffic of cars, pedestrians, workers on the quays, boats, smoke, mist in the distance, very alive and animated.'

modern megacities and the quest for a substitute mysticism would become one of the central preoccupations of Mann's cinema. Filmed in 35mm, *Thief* did not yet offer technically the visual means of this search. We would have to wait for the beginning of the 2000s and the arrival of high-definition cameras – *Ali*, but above all *Collateral* (2004), *Miami Vice* (2006) and *Blackhat* (2015) – for this to find a new aesthetic.

From the very first sequence of the film, Mann shows a taste for industrial environments, for their disused factories, their monumental steel bridges covered with rust, their wastelands and smoking chimneys. The synthetic music of Tangerine Dream, a German experimental group formed in the middle of the psychedelic period and who had just created the haunting score of William Friedkin's *Sorcerer*,[18] immediately create a contrast between the very physical action of Frank (piercing a safe with a heavy machine) and the electronic pulse of the synthesizers. On the one hand, a mechanistic musical atmosphere (electronic instruments mixed with realistic noises), and on the other, compositions closer to the disco arrangements of Giorgio Moroder, like the track *The Beach* which, with its melody loops and its guitar solo inspired by Pink Floyd, accompany the Edenic moment of Frank's trajectory, just after the burglary of the Los Angeles bank.[19] A sequence less realistic than oneiric, almost a postcard, is where Frank, Jessie and his partner celebrate barefoot in the Pacific Ocean the success of the job meant to lead them to paradise. Tangerine Dream's compositions evoke a form of plenitude finally attained, but also conversely convey a more melancholic mood, as if the music could sense that this moment of happiness was just an illusion. In the following sequence, the menacing shadow of tree branches covering the ceiling of the couple's bedroom explicitly foreshadows a future placed under the sign of darkness.

This contrasting alliance between the concrete and the digital, affect and technique, between the cold and the hot, places Mann's

[18] A German group formed in 1967, Tangerine Dream had a prolific career and went through numerous musical cycles. They created around 30 original film soundtracks and around 50 albums. Formed by Edgar Froese, Conrad Schnitzler and the drummer Klaus Schulze, the group was passionately interested in technological innovations and composed exclusively with synthesizers and instruments they pioneered. Inspired by the concrete music of Karlheinz Stockhausen and Pierre Schaeffer, Tangerine Dream were at the crossroads of progressive rock and the new age.

[19] Only this track was not composed by Tangerine Dream, but by Craig Safan, whom Mann asked to write a piece in line with Pink Floyd's *Comfortably Numb*.

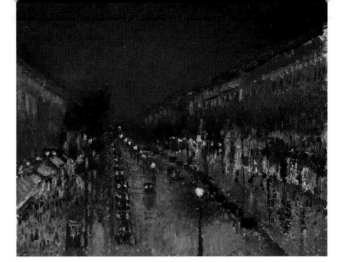

Camille Pissarro,
Boulevard Montmartre at Night, 1896

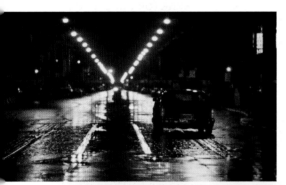

Thief

first film halfway between the cathodic coldness of the 1980s and the realism of the past decade. It expresses a latent conflict between the high-tech and the visceral (the slow-motions of the final gunfight and its sprays of blood), and draws the contours of a zone of uncertainty, typically Mannian, within which the feeling of humanity no longer goes without saying but becomes, if not a problem to resolve, then at least a cause for anxiety. The fear of the disembodiment, formatting and vampirization of individuals by technologies and modern acceleration constitutes one of the obsessions of his films to come. 'I saw Frank as a rat stuck in a 3D maze that is the city', Mann declared about this camera which plunges into Rat Alley at the start of the film, framing the city straightaway as a reticular trap. By extension, this image already speaks a truth about the character which he does not yet know or which he has chosen to ignore, which is him belonging to a global economic system on which he, the independent thief, pretends not to depend.

Happiness in fast motion

The life and fantasized future of Frank is collected in this photographic collage which he takes from his wallet at the start of the film, just after reading the alarming letter from Okla (Willie Nelson), his mentor and balance point, who asks him to come and see him in prison. Frank's collage mirrors Murphy's internal dream in *The Jericho Mile* – with the difference that it constitutes an illusion made from photos from the same magazines that deceived Stiles – at the same time as it anticipates all those postcard visions that Neil McCauley will soon hold on to in *Heat* (the Fiji Islands) or the taxi driver in *Collateral* and his postcard of the Maldives. It is the first of the Mannian mirages. What do we see in them? A photograph of Okla, a gleaming car from the 1950s, children, a happy couple in black and white, and on the right, a pile of human skulls, a *memento mori* stuck on the American way of life Frank aspires to and a coded symbol of his vanity. Through the window of a visiting room, Okla announces to Frank that he has little time left to live, an incurable angina pectoris and one request: to die outside. The possible death of Okla is an intimate earthquake, the violent reminder that time which, on the other side of the walls, is doing its work. Later, in the course of the diner sequence, one of the most beautiful in the film, Frank hands his collage to Jessie and asks her, in roundabout terms, to *enter the image*, to occupy the place he has already prepared for her, as if

the other and the world could also be mastered. Then he tells her the story of that sadistic detainee whom, one day, had succeeded in escaping. 'You don't count months and years, you don't do time that way. You've got to forget time, you've got to not give a fuck if you live or die. You've got to get where nothing means nothing [...]. I know from that day that I survived because I achieved that mental attitude.' This discipline, which comprises of *indifference to oneself (and to others) the condition for one's own survival*, foreshadows the sacrifice that the Solitary Man will be forced to make at the very end of the film, just like in *Heat*, that of Neil McCauley, also a victim of passions (love and the desire for vengeance) that weaken him, and even Vincent in *Collateral*. This moment, which is crucial, possesses in it the eyes of value of a quasi-mythical story and we understand, on hearing him state the laws of life that he has drawn from it, that up until then the man has lived in a mental world where time and fathers (Okla) seemed eternal.

To Gags, his first receiver of stolen goods, who suggests at the beginning of the film Frank meet people to invest the money earned in the street, Frank replies with a lapidary phrase, a type of manifesto: 'My money goes in my bank.' But in the meantime, the situation has changed, and Frank now forms with Jessie an embryonic family. Okla is dead, his face has disappeared from the photo, and unless he retakes hold of the natural

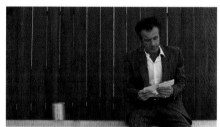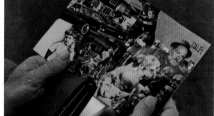

Frank's photographic collage: the first of Mann's mirages (*Thief*)

course of things and accelerates it, happiness, and its image folded in four in his pocket, threatens to unravel again. The burglar in *Thief* predates the two main characters of *Heat*, Vincent Hanna and Neil McCauley, and what Mann will say about them: 'Both are perfectly lucid. They don't bury their heads. Hanna knows exactly what he is, he recognizes his mistakes and the harm he does to his family. McCauley has a more rigid, almost Marxist approach to life, he is convinced that he has freed himself from the conditions he inherited at birth, that he can influence the course of his life. The flaw in this reasoning is that it

condemns him to not having any ties.'[20] Frank believes, wrongly, that he can keep his freedom whilst compromising his discipline. He thinks he can catch up on lost time and prepares, Mephisto-like, to sign a pact with the one (Leo) who seems to hold the keys to his mad dream. This mad dream is a dream of normality.

If Frank belongs, *a priori*, to a line of Hollywood gangsters struggling against a system which tries to bring them down – the films of Siegel, Boorman and Peckinpah for example – he differs from them radically by his desire for assimilation. Far from the classic criminal of the genre who chooses to remain outside bourgeois society, its norms, its conventions, and even cultivates his outsider status, the hero of *Thief* wants the exact opposite: do one last score before being able to integrate into this very society, to participate in its social game (the first minutes of the meeting with the female employee of the County Social Services) and to mime all its codes (boss of a small second-hand car dealership, home in a fashionable suburb, model family). But this petit-bourgeois dream comes up against an analytical error: Frank still believes in a difference in nature between the worlds of crime and legality, before understanding that we are only dealing with a *difference of degrees*. However, from the start of the film, he confesses to Okla the strangeness of the free world: 'It's fucking weirdo out there!' he explains in the visiting room; and his bar, the Green Windmill, news given by the radio (an interview with a senator who denies having ties to the underworld) again foreshadows the collusion between the two worlds. 'You could make things easy for everybody. But no, you've got to be a goof [...]', a policeman tells Frank, beaten up in the tiny room of a police station. 'They're ways to doing things that round up the corners. Make life easy for everybody! What's wrong with that? There is plenty to go around [...] What's the matter with you?' To which Frank replies 'It never occurred to you to try to work for a living? Take down your own scores?'

The sequence functions here as role reversal, the crook is joining the cops to work for real while the latter are pushing him to pay handsomely for their silence. In *Thief,* criminal activities develop at the heart of enterprises and structures that appear regular. Conversely, all the elements of the consumer society, all the institutional structures (police, justice) hide illicit practices. Thus, Leo and the police work together, like objective

20 F. X. Feeney, *Michael Mann, op. cit.* p. 16.
21 On this theme, see the chapter 3: 'The history factory'.

allies, all of them actors of the same global economy. After all, *there's enough for everyone*. Mann's films never confuse justice and the law.[21] Only the adoption centre Frank and Jessie go to in the hope of collecting a child seems to escape this corrupting spiral. The proof is given by the expensive ring that Frank, believing that things like this are done here like everywhere else, hands to an employee as a form of compensation. But this attempt at corruption fails: 'This is not a market place', she sharply replies. Nevertheless, this apparently praiseworthy rectitude hides the scandalous and deadly rigidity of institutions ('Your criteria are so far up your ass they can't see daylight', Frank exclaims) which will be pointed out in all of Mann's films: the FBI and American State taking away Muhammad Ali's sports licence in June 1967 for having refused to go and fight in Vietnam; the parole officer (Bud Cort) in *Heat* who, through humiliations and abuse of power, pushes an ex-convict returning to civilian life (Dennis Haysbert) to accept a mission which will cost him his life; the barbaric interrogation methods used by Hoover's G-Men in *Public Enemies*; or the little confidence given, in *The Insider* and *Miami Vice*, to the governmental agencies responsible for the leaks which will bring about Trudy's kidnapping. Certainly, corruption seems to stop at the doors of the adoption centre, but in reality, it encourages it, since by refusing Frank his right to the child because of a bad pedigree, it throws him into the arms of Leo who, in its place, fulfils his American dream. 'Anything you want [...]. You states your model. Black, brown, yellow or white. Boy or girl,' declares the patriarch.

First colours

Right from his first film, Mann established a colour palate from which he would not deviate. Thus, blue describes the home, stability, but also moments of introspection and freedom; it is the colour of the world to which Frank and Mannian heroes belong. In the visiting room sequence, Okla wears a blue shirt; Jessie, after accepting Frank's marriage proposal, puts on a blue pullover she will not take off; Frank's car is blue, like Sam's jacket and the fence in front of which he discovers Okla's letter. Green represents here, and in Mann's cinema, danger and death: the bar owned by Frank and which serves as a cover for his criminal activities is called the Green Windmill, its decorations (lamps, windows, neon lights...) all the colour green and the phone calls he makes there are only bad news. Barry wears a green jacket on the evening of his murder

and the gunfight at the end takes place against the backdrop of green trees, plants and a lawn. In front of the employee of the adoption centre, Frank, a public welfare child, remembers with rage this 'dead place' and the time spent shut up in the 'four green walls' of his bedroom. In *Heat*, the first appearance of Waingro, the psychopathic henchman who will end up bringing down Neil's team, takes place in front of a green mural in Los Angeles. The massacre of colonel Munro's troops in *The Last of the Mohicans* takes place in a green clearing just as Pretty Boy Floyd, at the start of *Public Enemies*, dies in the middle of a verdant landscape. In *Miami Vice*, Trudy is sequestrated in a caravan bathed in greenish light. In *Blackhat*, the first shoot-out starts on the port of Hong Kong in the midst of green containers, while the sequence preceding Chen Dawai's death is completely plunged in green (colour of the bridges, tunnels, sky, neon lights, high-rise buildings…). Finally, in *Thief*, as in all Mann's films, grey is the colour of bureaucratic organizations, of formatting and dehumanization; it is the colour of the prison, of the main room in the adoption centre, the police station, the raincoats worn by the policemen, their suits and their car. It is also the colour of Vincent's one and only suit in *Collateral*, an emblematic figure of devitalized man.

But the colours can migrate and mix with others, like the chromatic sign of a hiatus, or inviting a dual reading. Thus the sequence in which Frank and Jessie baptize the child they have just bought from a surrogate mother. He will be called David, in memory of David 'Okla' Bertineau. Here, and against all expectations, there is not the slightest trace of blue; the family that Frank and Jessie have just formed visibly does not possess the colour of a home. The discussion takes place in a Chinese restaurant, dominated by leather sofas of a bright and aggressive red which already casts on this postcard image a veil of artificiality. And of danger: in each shot (shots and reverse-shots of the couple's faces, wide shot), Mann inserts a touch of green: behind Frank's face, a greenish screen, behind that of Jessie, a veil lit up by a green light, and at the back of the restaurant, the central vanishing point of the shot leads to an emerald door which, we will very quickly learn, does not lead to the land of Oz. The maze, the cell and the box constitute motifs which, in Mann's work, characterize institutions and their oppressive power: in *Thief*, the visiting room of Joliet prison, the adoption agency, the regular row of little grey cubes, or the cramped room in which the policemen beat up Frank because of his refusal to play the game of corruption.

General commodification, the erosion of the social bond, the loss of meaning and freedom linked to the grip of bureaucratic organization count among the leitmotifs of Mann's cinema. The structural interpenetration of capitalist and Mafia economies, of consumption and corruption, of the black market and authorized commerce explains why, in *Thief*, Leo is not the negative of the legal world and to hard liberalism not its evil other, but, in Baudrillardian terms, its *ecstatic and realized version*, laid bare, accomplished. That also explains, partly, the unconventional treatment of the break-ins themselves (the one which opens the film and the robbery of the Californian bank), which usually constitute in the genre moments of climax, centres of gravity towards which most sub-plots converge and from which they spread out. Let us remember *The Asphalt Jungle*, *The Killers*, *The Killing*, *Topkapi*, *Odds Against Tomorrow*, *The Red Circle* and *Rififi*. First of all, there is the displacement of the narrative point of view. Here, the break-in to the Los Angeles bank, which opens the first third of the film, scarcely constitutes a narrative device. There is, in fact, no doubt that Frank and his partner Barry will succeed; as if by defusing the suspense of the sequence, Mann was also displacing the dramatic stakes. If there is tension, it rather resides in the way in which Frank is going to evade police surveillance with this informer moved from his car to a bus on its way to Des Moines. Then, the duration of the sequence, more than 13 minutes long, does not aim to instil a form of anxiety (are they going to succeed? Will an unforeseen obstacle disrupt the smooth running of the operation?), but to reassert the mastery of a professional burglar, to admire the spectacle of a job being done. Finally, the caper movie has always been, at least since John Huston's *The Asphalt Jungle* in 1950, caught between two impulses: on the one hand, the political metaphor of an unequal distribution of wealth which is attacked (unsuccessfully) by marginalized proletarians, poor underlings and/or no-hopers; on the other, idle gentlemen who steal for the beauty of it, Thomas Crown and his disdain for economic logic. As for Frank, he belongs to none of these families. He is not motivated by any desire for social revenge, no more than he wishes to jam the economic machinery by diverting the circulation of the money which, from the genre's point of view, is rather a confiscation.[22] It is not even an act of subversion, since the individual actions of

[22] On this subject, see the lecture by Serge Chauvin, *La Mécanique enrayée, mise en scène du film de casse* (14 February 2014), on the internet site of the Forum des images, www.forumdesimages.fr.

Blackhat, 2015

The Last of the Mohicans, 1992

Heat, 1995

Thief, 1981

Miami Vice, 2006

The Insider, 1999

Heat

Manhunter, 1986

Mannian heroes neither create a world nor modify the system. Still less are they a means to resolve money problems – Frank's vital needs are not in play, the break-in is a competence and what he takes from it ensures him a luxury, and therefore useless, life. 'Look, in what I do, there are sometimes pressures. What the hell do you think that I do? […]. I wear a $150 slacks, I wear silk shirts, I wear $800 suits, I wear a gold watch, I wear a perfect D-flawless three carats ring, I change cars like other guys changes their fucking shoes. I'm a thief. I've been in prison, alright?' he confesses to Jessie in a necessary clarification. In *Thief*, the break-in therefore overturns no order, it moves no line, it is simply an adventure, an element of risk of which the system, perfectly experienced in corruption, has anticipated the possibility and already neutralized the effects.

As for *Heat*, it opens with the robbery of an armoured van filled with bearer bonds. In the following sequence, Neil McCauley finds Nate, the mastermind and friend who brokers the possible scores, upstairs in a Los Angeles parking lot. 'A million six. Forty cents on the dollar, 640,000 to you. Here's a 150 front money […]. Know who owned these?' Nate asks, pointing to the envelope containing the bonds. 'Roger Van Zant. Owns banks in the Caymans. Runs investment portfolios for offshore drug money. Stuff like that.' Neil points out to him that the man has lost nothing since he is insured: 'That's the point,' Nate replies. He collects 100% from the insurance. He's a player. Maybe he buys his bonds back from us for 60% of their value. And make 40% on top of the 100%. Sell it back to him instead of going to the street. That's an extra 320,000 to you.' Crooks who speak like traders and who master pump-action shotguns as well as they do the complex mechanisms of an economy, the irony of the speculative economy functions at full tilt: far from burdening the assets of those they plunder, the break-in becomes one of the means by which they enrich themselves. However, between the burglar of *Thief* and his counterpart in *Heat*, and despite a common system of values, the gap is huge. One is a proletarian of crime, the other a sort of Viscontian aristocrat; one has a vision of work and exchange inherited from the industrial capitalism that was born at the end of the nineteenth century, while the other, a seasoned user of global capitalism and the virtual economy. 'My money goes into my pocket, "the yield of my labour"': many of the expressions used by Frank remind us, as an echo of Peckinpah's mavericks, of the anachronism of the character in a world whose new rules he is ignorant of. Nearly 15 years separate *Thief* from *Heat*, and Frank's dream of normality undoubtedly

still belongs to the distant layers of Neil's unconscious, like an ancestor from which he drew a lesson. 'I do what I do best, I take scores. You do what you do best, trying to stop guys like me,' Neil explains to the cop, Vincent, at the start of their face-to-face in *Heat*. 'So you never wanted a regular-type life?' Vincent then asks him, who, naturally, already knows the reply. 'What the fuck is that? Barbecues and ball games? [...]. This regular-type life like your life?' 'My life? No, my life's a disaster zone,' Vincent replies.

The cost of independence

'The Last of the Independent' is the motto sewn into the work clothes of Walter Matthau in Don Siegel's *Charley Varrick* (1974), another tale of a thief ferociously attached to his freedom who, for having robbed a deposit bank for the Mafia, gets sucked into something that is beyond him. Mann's cinema shares with Siegel's a same obsession. That with becoming everyone, at the risk of no longer being anyone, which characterizes the first half of *Thief*, when Frank, convinced of constructing for himself an honourable social identity, rapidly becomes standardized. However, Frank remains an unconventional gangster moved by an unalterable desire for independence, which is found in all Mann's men. For them, it is not about putting into question the capitalist system, nor the way of life attached to it, but about preserving, within this system, interests well understood, a form of autonomy. Hence one of the recurring questions in the cinema of Mann (and Siegel): how do you preserve your independence, and consequently your distinctiveness, within a society which aims only for formatting and the idiotic reproduction of conventions? What are these men who do not want any ties and yet end up making pacts with others? Everything is a matter of threshold, and in Mann's work this threshold indicates both a space (and its transgression, exemplified by a constant fear of home invasions) and, well before the law, keeping your word. What triggers the catastrophe and the final massacre in *Thief* is not the robbery of an employee by his mastermind – after all, Leo has reinvested Frank's money – or a last-minute dirty trick, but the betrayal of this word. By refusing the way in which Leo has chosen to place, without telling him, a large part of his earnings, Frank implicitly breaks the pact which linked him to the local underworld and unleashes its wrath. Before going to Leo's home, in the last sequence of the film, he begins by methodically destroying

all his possessions (his bar, his garage) then kicks out Jessie and his son, whom he entrusts to an old friend. By thus liquidating all that has value to him, at the same time as he discards his own affects, Frank returns to the bone of mental discipline acquired in prison ('You've got to get where nothing means nothing'), without which he will be unable to confront Leo and his people. For this chain of sacrifices, if they are part of the tragic mood which fills the film's denouement, allows him to rediscover his freedom and consequently, his ability to survive. It is then, for the story as for him, a return to square one, to before Jessie and his dreams of family, to before the collage/mirage of fantasized life which he scrunches up and then throws symbolically on the ground.

The time for settling accounts has arrived. Saved *in extremis* by a bullet-proof vest, Frank escapes the carnage. You could believe, at the end of this film, in a reactivation of a lucid nihilism inherited from Peckinpah's films, all the more so as the direction of the gunfight (*over cutting* and slow-motion on the falling bodies) borrow slightly from the aesthetic of the director of *Bring Me the Head of Alfredo Garcia*. That said, Frank does not aspire, like the outlaws of *The Wild Bunch*, for example, to a sumptuous burial of this new world to which they have chosen not to adapt, no more than it is part of that existentialist vein of a certain American cinema of the 1970s – Robert Altman, Hal Ashby, Bob Rafelson or Monte Hellman – with its heroes reduced to impotence and immobility, and who finally only act at the price of a social and intimate chaos which solves nothing. Wounded in the shoulder, Frank gets up with difficulty and moves away into the depth of the field, along a path which, as the camera gains height, reveals, on the ground, a crossing that looks like a crucifix. The figure of sacrifice comes immediately to mind and allows us to assess the enormous price that the man has just paid for his independence: a destroyed family, professional and domestic comfort reduced to nothing, and, at the end of the road, the obligation, perhaps, to start from scratch *all alone*. Therefore not to decide: between the defeatist hypothesis of a man who no longer has his place and the positive, violent and costly reaffirmation of a principle, independence, that he has just restored here.

Nevertheless, at the turn of a reply, Mann breaks very early on the classic schema of the solitary man opposed to a system that the film has pretended to reactivate. As Leo very rightly points out to him in their first conversation, all of Frank's spoils were already passing through his

hands. 'I know you already,' he tells him. And about this merchandise that Frank was selling to Gags and the others: 'Where do you think they down it? To me. I'm the bank. I handle the fence for half this city.' Illusory independence of an unaware cog in the machine, blindness to the workings of the world; Frank, like all the future Mannian characters, begins his political awakening with an apprenticeship of the economy, of its logic and traps. At the start of the sequence, which takes place at night, on a dock of the city, Frank is associated with old bridges, an industrial environment which could signify his belonging to a period that is over and about to die. Conversely, Leo appears framed in front of a modern and luminous skyline, that is to say the architectural sign of the coming times. But throughout the discussion and Leo's revealing of the mechanisms of the Mafia economy, the backgrounds blur and intertwine, a way for Mann to recalibrate these men on the scale of one and the *same* globalized economy.

The instant which seals the encounter between the two men, at the moment when Leo hands Frank an envelope containing the money he owes him, is followed by a shot that shows, 100m from there, two policemen on a stakeout: inspector Urizzi and his colleague, surprised to see a complete unknown appear in the field of the man they are watching. This same collateral effect will be used again in *Heat*, when Neil, despite himself, exposes himself to police radars by leaving a restaurant with other members of his group. Almost invisible up until then, Frank penetrates with a single gesture two concomitant networks: Leo's organization and the world of the law. Two systems of relations, of relationships and therefore of dependency from which he thought he had protected himself. Leo lays out to Frank the conditions of employment, his share of the profits, the protection and service that will be provided him in exchange for his expertise. However, the duplicity of the offer is inscribed in the very image, with Leo's face made ghastly and frightening by a *lighting in low-angle shot*, no doubt a memory of Murnau's *Faust* which reveals the symbolic nature of the proposed pact. The other pivotal sequence of the film, the one which will convince Frank to grab the offer made by Leo in this conversation, starts in a bar with the symbolic reprise of the song *Turning Point* by Mighty Joe Young. Later, in a highway restaurant, after 11 minutes of confessions, procrastinations and hesitations, Jessie lowers her guard and takes Frank's outstretched hand. Close-up on their hands which entwine above the finally unfolded photographic collage, the perfect image of an emerging

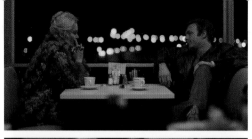

Thief

conjugal happiness, but of which Mann immediately films the dark underside and the cost. Against a background of green neon lights, Frank enters a phone box and, forgetting his natural reticence, announces to Leo that has agreed to burgle the bank in Los Angeles.[23] The very discursive construction of the story opens, from this first phone call, *the line of metaphors of economic alienation*. In the course of their encounters, Frank understands that the zone of influence and therefore power of this man extends well beyond what he imagined. He feels almost a sense of marvel at the possibility of fast-forwarding the fulfilment of his dream of normality: a child, a home, lawyers, unlimited means. It is the seductive and sunlit *recto* of an image whose *verso* he still does not know.

Power relations

After the robbery of the bank in Los Angeles, Frank goes to Leo's home to recover, as agreed, his share of the loot. The ensuing discussion deserves here to be quoted in extenso, as it constitutes one of the seminal and most enlightening exchanges on the political vision underpinning Michael Mann's cinema:

> Frank: Where's the rest?
> Leo: Don't worry about it.
> F: What is this?
> L: This is the cash part.
> F: You were light. 830,000 supposed to be here and I count what, 70, 80, 90…
> L: That's because I put you into the Jacksonville, the Fort Worth, and the Davenport shopping centers with the rest. I take care of my people. You can ask these guys. Papers are at your house. It's set up as a limited partnership. General partner's a subchapter S corporation. You're included with me in that.
> F: Count me out.
> L: I thought we had this good thing! Plus, we have a major score in Palm Beach for you in six weeks.

[23] Leo's first appearance takes place just after the visiting room sequence, as if Frank was passing from being a positive father figure (Okla) to its diabolical opposite.

F: You're talking to me? Or somebody else walked in this room?

L: What's that supposed to mean?

F: It means you are dreaming. This is payday. It is over.

L: When you have trouble with the cops, you pay them off like everybody else because that's the way things are done. But not you.

F: No, they don't run me and you don't run me.

L: I give you a house, I give you a car. You're family. What the hell is this? Where is gratitude?

F: Where is my end?

L: You can't see day for night.

F: I can see my money is still in your pocket which is from the yield of my labour. What gratitude? You're making big profits from my work, my risk, my sweat. But that is ok because I elected to make that deal but now, the deal is over. I want my end and I am out.

Thief

L: What don't you join a labour union?

F: I am wearing it! (he sketches a gesture towards the inside of his jacket where we guess the presence of a gun).

Rarely in a genre film (here the gangster movie), has the economic metaphor for power relations been so clearly expressed, except perhaps in the work of Abraham Polonsky (*Force of Evil*, 1948) or Abel Ferrara, who for a time was Mann's protégé[24] and whose vision has deep links with his own. A same practical question is at work in their respective oeuvres, a same 'polemical enterprise' about which Nicole Brenez, in her essay on the director of *The King of New York*, wrote that it consisted of 'a more and argued description of capitalism as catastrophe',[25] even if in Mann's work this critique is always coupled with a fascination that must *also* be taken account.

The last part of *Thief* begins directly after this conversation, considered by Leo as a point of no return, a breach of contract. Mann then reveals the down-side of the relationship between the two men, the mirage vanishes and reveals a hidden order, a structural *catastrophe*, of which Frank, even if he sensed its possibility, did not suspect the violence. It is the murder of Barry (James Belushi), his young accomplice, and the appearance of the Mafia boss Leo, upside down, in a mirror image, which expose to Frank the iniquitous reality of the commercial pact he has concluded, at the same time as he re-establishes the dominator/dominated relationship that his paternalism was hiding: 'I own the paper on your whole fucking life. I'll put your cunt wife on a street to be fucked in the ass by niggers and Puerto Ricans. [...]. You get paid when I say. You do what I say. I run you. There is no discussion. I want, you work until you are burned out, you're busted or you're dead. You get it?' Here, it is not the employee who decides when and how to end his work (the last score that Frank had planned), but his employer. For Frank, the illusion of material comfort and of acquired family happiness disappears in a fraction of a second. The sequence takes place in a warehouse filled with machine-tools, boiling tanks and thick smoke floating in the air. In other words, the workerist and machinic reverse-side of capitalism, which echoes the lower town of *Metropolis*, with Leo in the guise of a Molochian and vampiric machine,[26] of which the film had up until then only shown the reassuring face. Symbolically, the first encounter between Frank and Leo's empire takes place in a modest coating company, L&A Plating, a perfectly legal shop window and shell company for one of the many clandestine activities directed by his right-hand man, Attaglia. 'Whatever you need, you'd see me. I would be your father. Money, guns, cars. I'd be your father from here on out,' Leo declares on their first encounter. Certainly, Leo's working conditions are a far cry from those of the unfortunate workers in Lang's film, but the symbolic logic, Marxist inspiration, stays the same and the codes of crime fiction here allow

24 Abel Ferrara directed two episodes of the series *Miami Vice* (*The Home invaders* – season 1, episode 1 – and *The Dutch Oven* – season 2, episode 4) and, in 1986 the pilot episode for the series *Crime Story*.

25 Nicole Brenez, *Abel Ferrara, le mal mais sans fleurs*, Cahiers du Cinéma, coll. 'Auteurs', 2008, p. 12.

26 'Insofar as the production process is only a work process, the worker consumes the means of production as simple food for work; on the other hand, insofar as it is also a process of valorization, the capitalist consumes the labor power of the worker by appropriating living labor as the vital blood of capital.' Karl Marx, An Unpublished Chapter of Capital, Paris, UGE 10/18, 1971, p. 171-172.

Mann to bring to light its monstrous dimension. One word would suffice to throw Jessie out onto the street, exploited to exhaustion and liquidated like trash, a word also for David, the adopted child, to be taken from them – 'Your kid's mine 'cause I bought it. You got him on loan. He's leased. You're renting him,' says Leo – and put back on the market. Here comes to light the reality of a universe of generalized transactions in which man suffers from being only an elementary particle, the sacrificed cog in a perpetual war which is always that of the market.

Mann could make his own the remark, full of melancholy, made by Octave in Jean Renoir's *The Rules of the Game*: 'You understand, on this Earth, there is something terrifying, the fact that everyone has his reasons.' Which makes Mann a lucid realist, in the manner of Kubrick, perhaps even a moralist, for whom, with the exception of the malign entity lurking in the Carpathian castle of *The Keep* and the psychopath Waingro in *Heat*, absolute evil does not exist. Even Dolarhyde, the serial killer in *Manhunter*, has his reasons, and the cybercriminal in *Blackhat*, however trivial they may be (get rich), also possesses his own. Will Graham (William Petersen), the profiler hunting Dolarhyde on behalf of the FBI, knows that he has to connect with the killer's fantasies, his suffering, his desire to possess a wife, a family, in short, with his *humanity*.[27] The Huron Magua (*The Last of the Mohicans*) also has his reasons, since the bloody crusade he wages is anchored in his thirst for vengeance: to make the man he calls 'Grey Hair', Colonel Munro, pay for the death of his children. Only the intimate fractures, the economic logics, the social game and ideologies produce the negative and lead individuals, with their all too human weaknesses, down the slope of transgression and the forbidden. Deep down, Leo also has his reasons, which are those of the system of exploitation within which he places himself, and the protective tone he uses towards Frank ('I am your father') is unambiguous. At the very end of the film, we see him even leading the life of an ordinary, almost morose, paterfamilias in a very middle-class neighbourhood of Chicago. From his point of view, Frank's reaction is incomprehensible and consequently irreconcilable; also from his point of view, Barry's murder is a necessary evil, a violent call to order without which all in his small world would not be right.

It appeared embryonically in *The Jericho Mile*, but with *Thief*, it finds its complete form. That is to say, the model structure of Mann's future crime films: a solitary and competent man chooses to live on the

margins of society according to his own codes. But a desire for normality, often triggered by a woman (Jessie in *Thief*, Cora in *The Last of the Mohicans*, Eady in *Heat*, Isabella in *Miami Vice*), forces him to negotiate with it. And to meet his downfall. In the films not belonging to the genre – *The Insider*, *The Last of the Mohicans*, *Ali* or *The Jericho Mile*, the dilemma is the same: men confronted with a decisive choice, much more important than the screenplay seems to suggest. To continue to live in a consented illusion or to break the mirrors separating them from their deepest being, to hold on to (human or economic) chimera or to attain, whatever it costs, a form of authenticity. Mann's films are existential dramas.

At the end of the pilot episode for the series *Miami Vice* in 1984, Sonny Crockett stops in a phone box and calls his wife Caroline, from whom he is separated. 'I need to know something Caroline. The way we used to be together, I don't mean lately, but before, it was real. Wasn't it?' Connection with yourself, the search for your deep truth, and therefore the fear of living a lie, inside a seductive mirage that you perhaps desired but has shown itself to be empty of meaning, that is the Holy Grail after which Michael Mann's solitary men run. The only way of reaching it is through keeping control, mastery of self, of your actions, of your environment. Frank ends up following Oklas's advice ('Lie to nobody') and has not lied to himself. From this point of view and that alone, he has won, but he has lost everything else. In *The Jericho Mile*, Murphy's distrust of everything that symbolizes or represents the outside world already gave a glimpse, through the eye of a needle, of what was going to be one of the big preoccupations in Mann's cinema, that is to say the difficulty of grasping the images of the contemporary world. In his work, images, wherever they come from, bring fascination and alienation, and guide the individual's desire as well as leading it dangerously astray. To say that we are dealing here with a rigorous pedagogy of seeing is correct, on the condition that its stakes are situated, less in the ability of modern man – who is firstly a consumer – to decipher or pierce the meaning of the industrial images within which he is immersed than to find the right relationship between the critique they necessitate and the adherence, even the enchantment that they provoke, sometimes inexorably.

27 'He may have a history of biting – barroom fights or child abuse,' says Graham to his colleague Springfield about Dolarhyde.

Document: the other end of
(final draft, 6 March 1980)

347 FRANK

> Walks away from the sidewalk. The shredded shirt reveals
> the black vest. The heavy .45 with the hammer still back,
> hangs at the end of his arm. His face bleeds where two of
> the shots hit him.

348 TRACKING – FRANK

> Down the sidewalk towards the Eldo down the street.
> Neighbors in housecoats and robes run past to see what
> happened. Most ignore him. One or two see the blood and
> the gun and back off.

CUT TO:
349 EXT. PALISADES STREET – WIDE – DAY

> It's summer. It's sun-baked. The sidewalks are pink and
> hot. Smoked glass and steel buildings. Ocean.

350 REVERSE – YELLOW RENTAL CAR

> Approaches, searches, stops. Jessie's driving.

351 JESSIE

> Gets out. She looks different. Time's passed. She checks
> an address. Goes in.

CUT TO:
352 INT. APARTMENT – WIDE – DAY

> White walls. Light carpets. Minimal. Cell-like. A man in a
> T-shirt drinks coffee in REAR SHOT over glass and steel

table. Beyond him is a wall of light and sky: floor to ceiling window. A DOORBELL RINGS.

353 HIS HAND

Puts down the coffee mug. FOLLOW his hand to the door.

A black .45 is holstered in the small of his back.

354 DOOR

Opens. Jessie stands there. Hallway recedes behind her.

The Keep:
at the end of the granite corridors, the dream

'All that we are comes back to the surface. Who do you meet in the long granite corridors? Yourself.'
Captain Woermann

1983. After *Thief*, *The Keep* allows Michael Mann to develop outside the crime genre and erect an audacious monument to the glory of German expressionism, one of his major sources of inspiration. A fairytale for adults crossing Carl Jung's theories on dream, Bruno Bettelheim's *The Uses of Enchantment*, war films, Kubrickian influences and expressionist cinema, to which the film constantly alludes – be it the gleaming eyes of his creatures inspired by Murnau's *Faust*, the golem of the Warsaw ghetto brought to the screen in 1920 by Paul Wegener and who reappears here in the shape of the demon Molasar, the theme of sleepwalking (*The Cabinet of Dr Caligari*), the bridge separating two worlds (the village and the keep) or, of course, the keep itself, which, from an architectural point of view, is reminiscent of the fortification built by Death around a village cemetery at the very beginning of Fritz Lang's *Destiny*. And then, in Hollywood, Mann's project is in tune with the times. Indeed, since the start of the 1980s, science fiction (*E.T.*), fantasy (*Firestarter, Christine, Hunger*), heroic fantasy (*The Dark Crystal*), sword and sorcery films (*Krull, Dragonslayer, Ladyhawke* and *Conan the Barbarian*) and horror (*Poltergeist, A Werewolf in London*) sweep across the cinema screens. The

previous year, Steven Spielberg had already crossed occultism and Nazi barbarism in *Raiders of the Lost Ark*. For Paramount, *The Keep*, because it borrows from all these genres, was therefore guaranteed a success. But of this ambitious film which, originally, was to last more than three and a half hours, there remains only a truncated version of 96 minutes,[28]

Molasar's creature in *The Keep*, 1983

a work that is hindered, mutilated, accursed and occasionally fascinating and of which Mann himself hardly wants to hear about anymore.

Very freely adapted from the eponymous novel of Francis Paul Wilson, *The Keep* opens in 1941, at the foot of the Dinu pass, situated at the heart of the Romanian Carpathians. A troop of soldiers of the Wehrmacht, led by Captain Woermann (Jurgen Prochinow), turns up in a small village and takes possession of its keep, whose inverted architecture suggests that it was built not to repel external attacks, but to prevent people from escaping. Inside, the 108 nickel crosses embedded in the walls whet the appetite of two soldiers who, when evening comes, unseal one of them and unleash a force which decimates them. A garrison of SS then arrives as reinforcement and its chief, Major Kaempffer (Gabriel Byrne), after having executed some villagers, discovers in the keep an inscription which, in his view, proves the presence of partisans. He then calls upon Dr Cuza (Ian McKellen), an old Jewish professor imprisoned in the camp of Dachau with his daughter Eva, to translate it. Thousands of kilometers away, a man with strange powers, Glaeken (Scott Glenn) sets off for the Carpathians. At the same time, the demon finally appears to Cuza and, in exchange for his life and the promise that he will bring down the Third Reich, asks him to take from the depths of the keep the talisman that is keeping him prisoner. This is therefore a new version

[28] On the reference site IMDb, there is mention of an original montage of 210 minutes.

of the Faustian pacts which line Mann's work, since Dr Cuza agrees to sell his soul to the devil Molasar, who makes him believe that he is the golem of Jewish legend, but retracts *in fine* when the latter asks him to sacrifice his daughter Eva in order to prove his fidelity.

The shooting of *The Keep* was a constant ordeal, accumulating delays, various bad weather events, destruction of movie sets, the death of the visual special effects man, Wally Veevers, and the progressive exhaustion of the actors, forced to commute between the Shepperton studios for the indoors sequences, and an abandoned slate quarry in Wales in which were built the village and the stone façade of the keep. Bad luck, certainly, but also the lack of preparation before the film went into production explain, according to Mann himself, the disappointing turn of his adventure. When shooting began, on 20 September 1982, the script was not yet finished and especially, the appearance of the demon Molasar had not yet been found. Mann did not want the gothic vampire imagined by Wilson in his novel and wished for a more conceptual monster, at the limit of the figurative. Wally Veevers, just out of *Excalibur*, convinced him that he would know, at the given time, how to figure this evil creature whilst preserving its abstract and evanescent dimension; but when he died, after two weeks of postproduction, he left behind no sketch, no drawing, no visual idea of his Molasar. 'Two-thirds of the shots were no longer usable', said Scott Glenn, who plays the role of Glaeken. 'Mann had to rethink everything after the actors and technicians left. This is what called into question the whole look of the film. Veevers had to recreate the different aspects of Molasar. We couldn't really resolve the question.'[29] The film's release, planned for summer 1983, was immediately postponed by six months, right into the Christmas period, at the busiest time of the year. Mann then called on Enki Bilal to elaborate the final stage of the monster (which has three), and on Roy Field (*Krull*) in order regain control of the special effects.[30] But Paramount took a dim view of this postproduction dragging out – the fiasco of *Heaven's Gate* (1981) was still on everyone's mind – and refused Mann an increase in budget. It was then necessary to delete scenes, quickly find alternative solutions, and be content with often shoddy

[29] *Starfix*, special edition 3, April 1984, p. 62.

[30] 'Mann wanted the monster to symbolise fascism, that its skull resemble the German helmet and his body be a sort proud and noble Aryan statue, like in the paintings of the Third Reich' (Enki Bilal).

special effects, beginning with Molasar himself, who would end up resembling a muscular Aryan zombie. The effect is all the more counter-productive as the film dramatizes, beside this fictional incarnation of age-old evil, a precise historical evil (the Nazi regime, the extermination camps) in the face of which it can only pale in comparison. In terms of terror, the brutal execution of the villagers by Major Kaempffer produces a horror that is literally incomparable with that caused by the appearance of the golem Molasar and his laser red eyes.

A thousand years of solitude

'My character is someone who, over a thousand years ago, split into two personalities', explains Scott Glenn. 'A bad one: Molasar, the creature locked in the fortress. A good one: Glaeken who remained on earth. It is a sort of sentinel which only comes into action when the other creature, the Devil in fact, tries to leave his prison [...]. He is a desperate character. A thousand years without acting, watching life pass by as if on a television screen, remaining insensitive to all human feelings. All this ended up making him a sort of paltry and useless ghost. He would rather live three seconds of human life and die, than continue in this kind of purgatory.'[31]

In the released version, there remains, *from a narrative point of view*, almost nothing of Glaeken's character, of his past, his existential curse, if only an automaton which, one evening, wakes up somewhere in Greece, takes a boat for Romania, arrives in the Carpathian village, immediately becomes Eva's lover, turns out to be a vampire and ends up confronting Molasar. The dual nature of this millenarian entity (Glaeken and Molasar), however, still structures this film, but in the form of traces, of a dialogue ('When he goes, I go,' Glaeken tells Eva) and of visual clues disseminated everywhere. It is also the matrix of those couples of adversaries (Will Graham and Francis Dolarhyde in *Manhunter*, Vincent Hanna and Neil McCauley in *Heat*, Dillinger and Purvis in *Public Enemies*, Max and Vincent in *Collateral*...) who seem tied to one another by a sixth sense. Glaeken exists only to destroy his evil double, like Hanna only lives fully when he pursues McCauley.[32] At the beginning of the film, the sequence of the death of the two German

31 *Starfix*, special edition 3, *op. cit.*
32 The fate of the Nazis, the villagers and even Eva means little to Glaeken.

The Keep

Destiny (Der müde Tod), Fritz Lang, 1921

The Keep

soldiers concludes with the shot of a breach in the keep from which Molasar escapes, then symbolized by a stream of vapor made of luminous particles. In the following shot appears a close-up of the face of a man with phosphorescent eyes, Glaeken, who wakes up suddenly, while a high-angle shot reveals the presence of a whirlwind of particles – Molasar? – which falls on this bed. The montage suggests a relationship, to be elucidated, between these two actions (the unleashing of a force/the awakening of another) and establishes, between Molasar and this stranger out of nowhere, a magical link close to that which unites Halloran and Danny in *The Shining* – stretched out on a bed, Halloran also senses the tragedy ahead in the Overlook Hotel and makes the journey from Florida to Oregon. In the last sequence of the film, Glaeken, after being machine-gunned by the German soldiers, returns among the dead and penetrates Molasar's underground lair for the final confrontation. With the help of a magic sceptre, he then sucks in the vital substance of the demon at the same time as he incorporates his main physical feature (an overdeveloped musculature at the base of the neck), thus confirming a kinship that the film has endlessly suggested. Like Will Graham in *Manhunter*, Glaeken is a protector whose sole mission – and here sacrifice – consists of keeping the forces of evil at a distance from humanity. Swallowed by the keep, Glaeken rejoins his Mephistopheles-like half and, perhaps, allows the age-old entity that the film script had never evoked to reform at last.

Buried in the mists and scattered with blocks of stone in the form of monolith, Molasar's purgatory condenses the expressionist decor, at once stylized, tortuous and black, like its prisoner's psyche.[33] Aesthetically, it is completely opposed to the village, whose light tones, colours and vegetation express a feeling of life that seems to have deserted the keep. There, everything is dark, funereal, granitic, and the feeling throughout the directing aims to associate dryness and death. In Wilson's novel, the massacre of the soldiers gives rise to gory sequences, full of organic and bloody details. In Mann's film, they are just bodies immediately burnt to ashes by Molasar's deadly breath, massacres in black and white. The film ends with a freeze frame of Eva who, from the bridge, casts one last look on the keep. In an alternative ending, no doubt present in the original version, the following shot shows Glaeken,

[33] The interior of *The Keep* is the only decor that Michal Mann has ever re-created in the studio.

with a calmed face, falling through an indefinite space-time continuum, a sort of cosmic void symbolising, perhaps, the depths of the keep. While Dr Cuza and the villagers walk away, Eva returns to the ruins of the purgatory. She finds Glaecken again, stretched out on the ground, inert, his body still smoking. By placing her hands on his face, she brings him back to life. He gets up and embraces her. Mann then films the inverted reflection of the couple in an expanse of water, as there swells up the musical theme of Tangerine Dream, closer to the one which accompanies the beach sequence in *Thief*. The upside-down image takes us back to the opening sequence (the reflection of coloured mountain and a blue sky in a lake), as if, after having plunged into a parallel dimension (evil, Molasar, Nazis), the world was putting itself back in its place and returning to life (water). Unless we are dealing with a 'dream within a dream',[34] in Edgar Poe's famous words.

In *The Keep*, blue is the colour of life, the beyond of this black and destructive world – the film opens with a blue zone before plunging into the darkness of the Dinu pass; blue is the first colour Mann opposes to Molasar's awakening via the phosphorescent eyes of Glaeken the vampire; and, at the end, the latter accedes to the condition of mortal (and therefore of the living) under a halo of blue light.

Michael Mann: 'Even before the story that the book tells, the starting point was the following: I had just made an urban film, *Thief*. A very stylized and at the same time very realistic urban film. Of course, you can wet the streets, dry them, but it's still streets! And I had the desire, almost the need, to do something very close to *One Hundred Years of Solitude* by Gabriel García Márquez where I could work on an imaginary material and recreate the reality that I wanted. There is an effect in the film which shows the creature Molasar adding particles from living organisms to its body. What is the logic of this? What might this look like? How did it happen? What does this effect sound like? However, you must always make what you are going to tell and film coherent. Whatever the film, you do not restore objective reality, you create it.'[35] The reference to Garcia Marquez naturally places *The Keep* in the wake of another accursed film made five years previously, *Sorcerer*, a

34 'A Dream Within a Dream', poem written by Edgar Allan Poe and published in 1849.

35 Michael Mann, quoted by Steven Rybin, *The Cinema of Michael Mann*, Lexington Books, 2007, p. 62.

hallucinatory remake of Henri-Georges Clouzot's *The Wages of Fear*, also passed through the filter of South American magical realism. The music of Tangerine Dream, which accompanied the journey of *Sorcerer*, the presence of John Box (production designer of *Sorcerer* and *The Keep*) and the appearance of the first German trucks at the start of Mann's film remind us straightaway of William Friedkin's. The opening sequence of *The Keep* constitutes, on its own, an emblematic distillation of that place Mann also sought, halfway between fable, dream and magical realism.

Everything begins with a slow vertical panning shot which starts on a deep blue sky, descends amidst clouds and goes along the trees of a forest. There then appears a column of military trucks which progresses along a gravelly and misty road. This opening shot immediately produces a dual effect of spatial disorientation (Where is the shot's point of gravity? Where are we?) and temporal:[36] the electronic pulsations that mix with the shots of clouds and forest create a contrast between the silent nature and the acoustic impression of a mechanical force on the march. This feeling of intrusion by technology and powers which believe themselves modern (here, the Nazis, on the eve of Operation Typhoon) in the midst of natural landscapes will return throughout Mann's cinema, from *The Last of the Mohicans* – the column of French soldiers before their massacre by the Hurons – to *Public Enemies* – the gunfight at Bohemia Lodge opposing Dillinger's gang and the FBI's machine guns in an Indiana forest. Finally, we cannot help comparing this first shot with those famous ones opening *Aguirre* (1972), with that column of Spanish soldiers and Indian slaves who move down the sheer crest of a mountain in the Andes, while on the right of the image, a mass of fog threatens to swallow them up. The synthetic sounds of Tangerine Dream remind you of the atmospheric score of Popul Vuh; the conquistadors of *The Keep* will, themselves, be defeated by history and their 'psychotic fantasy' (Woermann). Mann, like Herzog, opens his hallucinogenic trip at the frontier between limbo and earthly life, playing on a floating effect between two levels of conscience that he will endlessly interweave. If Mann's desire has been able to meet and learn from Herzog's, it is doubtlessly around a same question: How do you film a waking dream? After this panoramic shot, the close-up of a struck match comes and interrupts the vehicles' advance, immediately followed by the shot of a

36 It is to maintain as long as possible this space-time indeterminacy that Mann delays precise mention of the place and date of the story.

The Keep, opening sequence

strange round shape which, after the camera focus, turns out to be a sort of small lamp fixed on the front of a truck. Back to the match, then the camera goes back up to a blue eye, wide open, framed by a big close-up. The visual rhyme which forms between the two objects motivates, on its own, their conjunction and proves one of the keys for reading *The Keep*. From the start, Mann superimposes on the narrative montage – the story the film recounts from a literary point of view – a montage by association which multiplies the effects of correspondence, analogy and visual attraction between disjointed elements, fragments gathered from everywhere (here an eye, a lamp, a wheel…), as if the film progressed simultaneously according to two different logics: a classical narrative logic and an oneiric logic that the following shots immediately make explicit. Seated in the head truck, Captain Woermann, whose face we then discover, closes his eyes and then reopens them. This introductory sequence fits completely with the drowsiness of Woermann and other soldiers asleep at the back of a truck, a hypnotic state which makes undecidable the nature of the shots which then follow: those shots of the sky, accompanied by frightening voices which seem to whisper in the clouds, do they belong to an objective or an oneiric register? Does this slow movement of the camera along a red and gold mountain and ending with the sky's reflection in a lake correspond to an internal vision? At the start of a dream? The inverted image produced here, which will be echoed by the first shot of the sequence of the alternative ending, theorizes this montage that fits the magical realism which structures all of *The Keep*, since it is always a question of situating your gaze at the frontier between the front and reverse sides, between waking and being asleep, between contemporary reality and ancient myths. It is of course this dialogue between all these antinomies which interests Mann, right to its thematic heart: a destructive force inscribed in a precise history (the Nazis, 1941), faced with evil that comes from time immemorial (Molasar). 'Where do you come from?' Kaempffer finally asks his ahistorical double, who replies: 'I come from you.'

The entry into the village, which comes just after Woermann has reopened his eyes, happens in slow motion, behind a curtain of mist, while a new musical theme emphasizes the passage towards an elsewhere that we discover. The convoy seems to advance towards death, under the bewildered eyes of the native inhabitants, like a piece of the present projected into a medieval, immobile period, outside history. Finally, just before the trucks arrive at the entrance to the keep, a majestic white horse, pulled by a man in black, appears at the back of the shot. Is this

the white horse ridden by Pestilence, one of the four horsemen of the Apocalypse? Or is it the one which, in Racine's *Phèdre*, embodies the irrational soul that gives the charioteer his power?

When Mann accepted Paramount's proposal to adapt Wilson's novel, the horror as a genre did not interest him, no more than the book, a pulp novel he judged weak, at times ridiculous (Molasar is described as an umpteenth caped avatar of Dracula) and stuck in dated conventions. Only the initial idea aroused his curiosity. He therefore began by expurgating the text of all its folkloric and gothic aspects and, especially, got rid of its Cartesian explanations of the origins of the story, the characters and of evil (Where does Molasar come from? Why has he been imprisoned in the keep?...). In line with the rules of fable and dream, what takes place is and must be accepted by the characters themselves (allegories) as by the viewers. Michael Mann, writes Steven Rybin, 'can be placed in a lineage of filmmakers (including the aforementioned Kubrick) who intentionally disregard their own source material in order to elevate, on a purely rhetorical level, their "personal vision" to grander heights'.[37] This is why, well before the brutal re-editing of the film by the producers, *The Keep*, as Mann conceives it, already carries its own radicality, as much from a narrative point of view as from a symbolic one. Certainly, entire sections of the original version have disappeared, and in the course of the last half hour, certain scenes follow one another at double quick time and *without apparent lines of causality*, But it is difficult, if not hazardous, to distinguish between what comes from the very spirit of Mann's initial project and the effects of the a posteriori re-editing.[38] Hence the following hypothesis: What if the numerous cuts made by the producers had reinforced the oneirism of the film and given it an even more enigmatic and cryptic dimension? There would therefore exist two types of oneirism in *The Keep*: a written oneirism, planned from the screenplay stage and filmed by the author – the opening sequence, for example – and an accidental oneirism which comes from the numerous mutilations the film suffered and which, by an aesthetic windfall, accomplished, in an even more extreme way, the

[37] Steven Rybin, *The Cinema of Michael Mann, op. cit.* p. 63.

[38] Many ideas are thus touched upon, like that of Molasar feeding off the fascist drives of the Nazis and who, once released, corrupts the minds of the villagers. Only the furtive vision of father Fonescu (Robert Prosky), tearing a dog apart on the altar of his chapel, still attests to this propagation of the plague.

project Mann had in mind – for example, the Jungian theories on dream which so fascinated him and in particular that of synchronicity.[39]

Already present in an inchoate manner in *Thief*, stylization becomes, in *The Keep*, extreme, to the point of sometimes getting in the way of the other aspects of the film. A film of its time as well, since at the start of the 1980s, a new wave of British filmmakers coming out of advertising (Alan Parker, Ridley Scott, Adrian Lyne and Hugh Hudson) imposed on Hollywood an anti-realist aesthetic norm, largely inspired by videos, with which Mann's film is not mismatched. But this stylization also proves how much Mann, two years before *Miami Vice*, was already looking for a form susceptible to take account of the oneiric power of the real and reveal its invisible side. 'Facts and objects are nothing in themselves', wrote Lotte Eisner in the preface to *The Haunted Screen*. 'We must deepen their essence, discern what there is beyond their accidental form.'[40] According to the theoretician Bela Balazs, stylization is the condition *sine qua non* which allows a film to attain the rank of work of art and reveal what, in *The Visible Man*, he calls the 'latent physiognomy' of things. After all, expressionism is absolute subjectivism, a way of enchanting the real, and stylization is the way to give it *form*.

In its current form, *The Keep* thus appears as a flawed and magical object, the enchanting ghost of another film which will, perhaps, never see the light of day. However, the aesthetic research done by Mann on this occasion bears its fruit, as if at the end of his descent into the heart of the expressionist volcano he had found a secret that would irradiate his entire work. Right from his next film, *Manhunter* in 1986, the attraction towards the obscure and indeterminate, those 'atrocious thoughts' which guide the profiler Will Graham and show him the path to evil, the importance of dream or a sixth sense as a way to penetrate the real, are so many themes which belong to the register of German expressionism.

[39] Following his intuition of a collective unconscious, Carl Gustav Jung developed the idea of the psyche as belonging to a universe filled with archetypes and symbols shared by all peoples, everywhere and across the ages. The theory of synchronicity describes the simultaneous occurrence of two events which, without them being linked by objective cause and effect, makes sense for the person perceiving it: 'The principle of causality tells us that the link between cause and effect is a necessary one. The principle of synchronicity affirms that the terms of a meaningful coincidence or of the order of meaning are linked by simultaneity and meaning' (Carl Gustav Jung, *Synchronicité*, Albin Michel, 1988, p. 271.)

[40] Lotte Eisner, *L'Ecran démoniaque*, Ramsay Poche Cinéma, 1996, p. 15.

2.
TELE-
VISION(S)

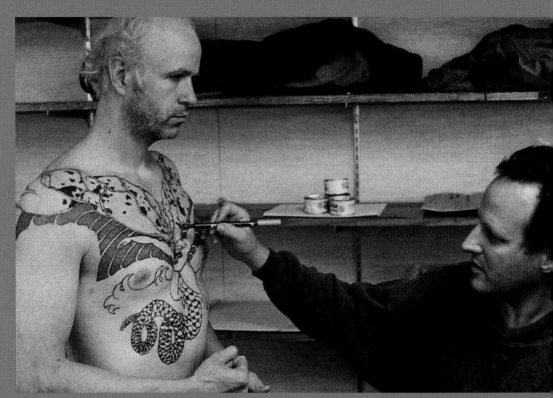

Michael Mann on the set of *Manhunter*, 1986

The laboratory

Maybe it is a legend: at the beginning of the 1980s, Brandon Tartikoff, the head of NBC's TV Entertainment branch, contacted Anthony Yerkovich, a young television producer and scriptwriter, to ask him to think up a series on the basis of two words he had scribbled on a napkin, 'MTV Cops'. Apparently the idea had been given to him by a young executive of the channel, Michelle Brusin, who was then convinced of the success of a programme that would have the spirit and look of MTV, the music channel created in 1981. The story is beautiful but, in reality, Yerkovich, producer of *Hill Street Blues*, was already working on a police series concept quite close to what would become *Miami Vice*. At the time, the city of Miami, in which De Palma had just filmed *Scarface*, captured the imagination of Hollywood and American screenwriters: 'I thought of it as a sort of a modern-day American *Casablanca*,' explained Yerkovich. 'It seemed to be an interesting socio-economic tide pool: the incredible number of refugees from Central America and Cuba, the already extensive Cuban-American community, and on top of all that the drug trade. There is a fascinating amount of service industries that revolve around the drug trade – money laundering, bail bondsmen, attorneys who service drug smugglers.'[41] Since the late 1970s, Miami had been a city undergoing a metamorphosis. Once a resort for the middle classes, it had become the prized refuge for the criminal upper class. Because it is situated on the south coast of Florida, the 'Magic City' attracted drug and arms traffickers, Cuban exiles, veterans of the Bay of Pigs and all kinds of mercenaries. Nick Nolte and Eddie Murphy, who had just been crowned by the success of *48 hours* (Walter Hill, 1982), served as models for the characters of Sonny Crockett and Ricardo Tubbs – who would finally be played by Don Johnson and Philip Michael Thomas – while *American Gigolo* inspired the pop and glamour aesthetic of the series. There remained, however, a big screenwriting problem to solve: how could two Miami cops, with their modest salary, wear Armani suits and drive a Ferrari? Yerkovich then decided to rely on a federal law that authorizes police to seize (and therefore use) any property found on the crime scene in order to justify the lifestyle of Crockett and Tubbs.

[41] en.wikipedia.org/wiki/Miami_Vice.

Tartikoff proposed to Michael Mann, whose film career was at a standstill after the critical and artistic failure of *The Keep*, that he supervised this series whose working title was *Dade County Fastlane*. Mann accepted, but, after his unhappy experience with *Vega$*, he asked for, and obtained, creative control of the series. He became its executive producer and immediately called upon his faithful collaborators, the film editor Dov Hoenig and the production designer Mel Bourne. During the first two seasons at least – from the summer of 1985 onwards, he was absorbed in the preproduction and filming of *Manhunter* – Mann was thus the all-powerful show runner of *Miami Vice*, the one the crew called its 'stylistic guru'. Filmed in 35mm, with budgets higher than the standards of the time ($1.3 million per episode), the series showed, in its smallest details, Mann's total control.[42] Be it the sophistication of the direction, the attention paid to design, interiors, costumes and musical ambiences, the architecture of the places as well (and in particular the Art Deco style of the city and of Ocean Drive, its famous avenue), or the themes addressed in the scripts, everything bears the meticulous imprint of the future director of *Heat*. 'He leaves no room for improvisation. He controls everything: the environment, the extras, the passing cars, the buildings, the light', declared Jodie Tillen, the series' head costume designer. 'He's very aware of the whole frame and not just what's happening in the foreground.'

Mann established rules, fixed limits and enacted visual laws to be respected: no earthy colour but pastel tones: he demanded a colour code per episode and did not hesitate to have certain facades of South Beach repainted if they clashed with the actors' jackets. Finally, it was he who imposed the title, *Miami Vice*, on the municipal authorities who nevertheless took a dim view of the programme exploiting the dark side of the city.

In the first versions of the script, the voiceover of a narrator, inspired by the series *Magnum*, comments on the story in the manner of a film noir. Unconvinced by this procedure which he considered dated, Mann decided to use the music of Jan Hammer and pop songs of the time to suggest the thoughts and moods of the characters. Thus, at the end of the pilot episode, a nocturnal sequence of four minutes is built completely around Phil Collins's song *In the Air Tonight*. The plot rushes towards its denouement: Sonny and Rico are on their way to arrest Calderone, a drugs trafficker who, at the start of

[42] However, Michael Mann directed none of the 111 episodes of the five seasons of the series.

The opening credits of
Miami Vice (TV show)

In the Air Tonight: moment of suspension at the end of the
pilot, *Brother's Keeper*, aired on 16 September 1984

Miami Vice, 1984

Collateral, 2004

Miami Vice, 2006

the episode, has killed Rico's brother. What happens? In reality not much from the point of view of the progression of the story and the action, which is at a standstill. Shots of Sonny and Rico silently loading their weapons, shots of their car speeding along deserted avenues, shots of the concentrated faces of the two cops, shots of the wheels and gleaming bonnet on which are reflected the city lights. Not the slightest dialogue, except a short pause Sonny makes to phone his wife. The sequence stretches out and sets a different tempo to the episode which, suddenly, seems to get lost in the mental meanderings of the characters. Here, Mann makes us feel the other side, the depth of the superficial existence these infiltrated cops must adopt, and the existential anxiety that, occasionally, seizes them. More than a sequence disconnected from the whole, it is a moment of melancholy stasis which revolutionized television writing at the same time as it anticipated one the most singular features of Michael Mann's cinema: his search for a point of equilibrium between action and contemplation. The paradox is found here in the use of what Serge Daney called the 'visual' (that is the image as a sign that now only refers to itself) – the form of the video which stands at the surface of the things – as a possible means of access to the invisible truth of beings and situations.

It is through the surf that Mann accesses our abysses.

The genesis of Miami Vice has been widely documented and the series has been the object of a comprehensive book published in 2005, *Miami Vice. A One-Man Show?*, written by John-Paul Trutnau and subtitled *The Construction and Deconstruction of a Patriarchal Image in the Reagan Era: Reading the Audio-Visual Poetics of Miami Vice.*

Miami Vice is one of the most emblematic series of the 1980s, of its values, its postmodern aesthetic, its ideology and soundtrack – all the FM pop of the time (Phil Collins, Pat Benatar, Rod Stewart, Cyndi Lauper, Bryan Ferry and other electro funk tunes) accompany the adventures of the two best dressed cops in the history of television. Right from the opening credits, which string together clichés of the city to the electronic theme of Jan Hammer, the tone is set: a slow-motion flight of pink flamingos, tracking shots of shiny limousines, arrays of young women in bikinis, yachts, glasses of champagne and turquoise water. In other words, the glitzy distillation of a series whose ambition is to paint the portrait of an America made dizzy by the cult of individualism and money, of arrogant successes and fakeness. Miami on the one hand, vice on the other: behind the gangsters' yachts and

their pastel-coloured palaces emerges a world riddled with corruption and artifice, a carnivorous and swamp-like world in which Elvis, Sonny Crockett's alligator present in the first episodes of the series, could be a humorous comment. One of the strengths of the series is undoubtedly making superficiality and coolness its commercial standard, so well did Mann and Yerkovich plug into a decade obsessed with looks, eccentricity and partying in all its forms. But in reality, the visual, musical and sartorial universe of *Miami Vice* also constituted the robe of a seductive Trojan horse which, at the time, carried in it a constructed polemical project. When you look closely, the blinding sun of Miami appears very dark and the charge against the unabashed capitalism supported by the triumphant re-election of Ronald Reagan in 1984 is particularly virulent. Retrospectively, this gap between easy on the eye, almost advertising, form and a critical content which put into pieces its conditions of possibility appeared vividly if one keeps in mind how much Michael Mann's work inscribed itself from the outset in the disenchanted backlash of the 1960s and 1970s. At the end of *The Great McCarthy* (season 1, episode 8), Sonny and Rico take part in a private speedboat race, organized by a businessman who owes his fortune to transporting cocaine. The sequence opens with the reprise of *Born to Be Wild*, by the group Steppenwolf, emblematic tune of *Easy Rider* which serves here as an ironic counterpoint to this frivolous and de-politicized jet-set which has traded revolutionary spirit for the spirit of enterprise.

If drug trafficking constitutes the narrative base line of *Miami Vice*, the majority of the episodes plunge also, through the prism of various criminal affairs that Crockett and Tubbs must resolve, into the blind spots of what Francois Cosset has called 'the great nightmare of the 1980s': the effects of financial liberalization and deregulation of the economy, the deepening of inequalities which throw the most precarious on the path to homelessness and/or illegality (how many episodes dramatize policemen giving into corruption in order to decently satisfy the needs of their family?[43]), the collapse of ideologies, the over-valuing of the private sector at the expense of the general interest, or the abandonment of Vietnam veterans, who then embody a spirit of defeat that the new administration wants to repress. Some episodes even exploit recent current affairs, like *Stone's War* (season 3, episode 2), which

[43] In *Glades* (season 1, episode 10), Sonny and Rico leave for the Everglades in search of a man likely to testify against a trafficker. The episode describes as small fishing community which, crushed by the competition and its Mafia methods, is forced to reconvert to growing marijuana.

directly refers to American interference in Central America and more precisely the Iran-Contra scandal of 1986.[44] In this episode, Sonny tries to come to the aid of a former companion in Vietnam, who holds video documents proving the American intervention in Nicaragua against the Sandinista government of Daniel Ortega. But he fails and everything ends in lies through an official version broadcast on television which is nothing but State propaganda. Let us note here that the head of military operations is played by Gordon Liddy, a former member of the committee for the re-election of Richard Nixon and ex-chief of the famous 'plumbers' who burgled the Democrat Party headquarters in June 1972.

Past the glitzy Styx of the Florida sun, most of the episodes of *Miami Vice* composed a litany of dysfunctions, lies and scandals which count among the strongest critical gestures of this period in America which then wanted to accomplish in double-quick time its president's slogan ('Let's make America great again') and celebrate, without limits, the cult of the body, money and a cool and depoliticized superficiality. It was the time of triumphant globalization, of the arrival of mindless aesthetic specific to cultural capitalism, what Jean Baudrillard, in *Simulacra and Simulation* (1981), synthesized in a brilliant phrase: 'the deceptive resurrection of the American primitive scene'. In the episode *Leap of Faith* (season 5, episode 19), a university professor (Keith Gordon) seeks to develop a powerful hallucinogenic that he has created in order to enlighten its consumers on the reality around them: 'There are no families out there anymore. The government is just a bunch of vegematics salesmen and God is gone on permanent vacation. America is turned into a big stadium with a bunch of morons identical and blue raincoats watching an endless football game. But I can change all that with my little pill. I can do what a thousand hours of reading books or discussing the great ideas can never accomplish. I can make people see.' We are in 1989 and John Carpenter has just directed *They Live*, a ferocious pamphlet which uses another slogan ('They live, we sleep') but says exactly the same thing.

While at the time, some were dead set against the small screen and chose to ignore images they judged impure, Mann seized the medium as fertile ground for experiment. Like an automobile

[44] Let us remember that it involved the sale of arms to Iran by the United States and the financing of the Contras in Nicaragua in order to destabilize the Sandinista government of Daniel Ortega, whose regime was considered to be communist by the Reagan administration.

manufacturer, he developed prototypes which he tested and has drove round the circuit of television, his laboratory, before manufacturing them for the big screen. *Miami Vice* – but it is also true for *Drug Wars, The Camarena Story, Crime Story* and *Robbery Homicide Division* – was thus for Mann an immense reservoir of motifs and narrative situations which would notably infuse his crime films. Already sketched in *Thief*, the obsessions of Mann's future cinema thus permeated the series like an auteur's leitmotifs: the tenuous limit separating the cops from the crooks, the cost of professionalism, the saturnine mood of its characters or the incestuous links between the law and economic forces. Right from the first episode (*Brother's Keeper*), the stormy relations between Sonny Crockett and his wife Caroline mirror, for example, those which undermine the couple formed by Vincent Hanna and Justine in *Heat*. Caroline makes reproaches to her husband which we will find again, almost word for word, in the mouth of Justine: 'In a lot of ways, you and your vice cops buddies are just the flip side of the same coin from these dealers you're always masquerading around with. You're all players Sonny. You get high on the action.'

Written by Michael Mann 20 years later, the screenplay of the film *Miami Vice*, is essentially made up of borrowings from various scripts of the series. For example, the sequence of the kidnapping of Trudy and her release are directly inspired by two similar sequences in *Glades* (season 1, episode 11) and *Smuggler's Blues* (season 1, episode 15),[45] while the romance between Sonny and Isabella echoes that which forms between Sonny and Calderone's daughter in *Calderon's Return. Part 2* (season 1, episode 5).

Manhunter: shadows in the dark

Released on 15 August 1986 in the United States, *Manhunter* is the title of Michael Mann's third film, but it could also be a manifesto, with the motifs of the criminal hunt and/or the obsessive pursuit of an ideal being structured in his cinema. Its French title, *Le sixième sens* (The Sixth

[45] In *Glades*, the granddaughter of a witness is held captive in a derelict house in the heart of the marshes and is freed by Sonny. Before killing the gangster, the latter replies, 'Maybe you won't even twitch', which will be used again almost word for word in the film ('Your finger won't even twitch'). The new situation of hostage-taking in *Smuggler's Blues* is almost identical. This time, it is Trudy who finds herself tied to a chair, linked to a bomb also set off by a telephone signal.

Sense), also points to a mental and psychological quality shared by most of Mann's characters, from the man of nature (Nathaniel in *The Last of the Mohicans*) to that of the modern mega-cities. 'He's here. Neil is still here. I can feel it,' Vincent Hanna reassures his colleagues who are convinced that after the robbery of the Los Angeles bank and the shoot-out that followed, McCauley has disappeared for good. In the last sequence of *Heat*, Vincent rushes to the Marquee Hotel near Los Angeles airport, inside which Neil has just been spotted. Setting off the fire alarm provokes an indescribable panic and Vincent, like an animal on the lookout, searches among the fleeing crowd for a clue that will put him on the tracks of his prey. In the distance, he catches sight of the silhouette of a single woman standing next to a car. Her appearance lasts a fraction of a second, but at this stage of the film and of the two men's mutual understanding – *what one thinks, the other also thinks* – what, for Vincent, is a signal resides in the immobility of this women in the midst of a mass movement of individuals in flight, that is a visual (Hitchcockian?) anomaly which he instinctively links to an anodyne piece of information revealed by Neil during their conversation (the existence of a female partner) and which suddenly becomes of capital importance. The sixth

Francis Dolarhyde's lair in *Manhunter*, 1986

sense translates a form of animal relationship to the other which has survived the industrial and technological transformation of the world, a sort of exceptional flair and ability, for the hunter, to plug into the mind of his prey, to decipher the slightest sign it emits. Pushed to the extreme, the competence of Mannian professionals thus produces an irrational, almost magical, aptitude, of which Nick Hathaway (*Blackhat*) and before him Will Graham, the profiler in *Manhunter*, are the best examples. When Michael Mann began shooting *Manhunter*, in September 1985, NBC was broadcasting the second season of *Miami Vice* – the

first episode, *The Prodigal Son*, was broadcast on 27 September. Two years had passed since the commercial failure of *The Keep* and Mann had fallen back to the small screen, while still working for a filmmaking career that had not really yet begun. The success of *Miami Vice* allowed him to set *Manhunter* in motion, produced by Dino De Laurentis on the heels of Michael Cimino's *The Year of the Dragon*.[46] Mann worked on a possible adaptation of Thomas Harris's novel *Red Dragon* straight after its publication in 1981, concentrating on the character of Will Graham, a former FBI investigator withdrawn with his family to Florida who returns to work to hunt a psychopath, Francis Dolarhyde, nicknamed 'The Tooth Fairy' because of the tooth marks he leaves on the bodies of his victims. Dolarhyde only acts when there is a full moon and connects his crimes to a watercolour by the English painter and poet William Blake, which obsesses him, *The Great Red Dragon and the Woman Clothed with the Sun*, painted at the beginning of the nineteenth century. The screenplay's structure faithfully follows the novel's plot, but Mann drew the plot more tightly around the couple Graham/Dolarhyde (the character of Molly, Graham's wife, is less developed), emptied the text of its psychological terminology (Dolarhyde's childhood is reduced in the film to a brief mention) and kept off camera the killer's crimes. His son asks him how Dr Lecter killed his victims. Will Graham replies with a terse explanation that covers all the murders mentioned in the film: 'In bad ways.' *Manhunter* is an internal horror movie which, against the grain of productions at the time (*A Nightmare on Elm Street*, *The Fly*, *Hellraiser*, *Prince of Darkness*…), visually *withholds* its horrors.

Manhunter marks the first cinematographic appearance of Hannibal Lecter (renamed here 'Lecktor'), which would go on to the success we all know from Jonathan Demme's *The Silence of the Lambs* (1991) and Anthony Hopkins in the role of the cannibal doctor.[47] But in 1986, neither the term serial killer nor profiler[48] had penetrated the field of popular culture, and Mann's film slightly preceded those of John McNaughton (*Henry, Portrait of a Serial Killer*, 1986), of William Friedkin

[46] Because of the modest success of *The Year of the Dragon* (1985) and in the name of a strange superstition, Dino De Laurentis did not want to reuse the title of the original novel, because of the presence of the word 'dragon'.

[47] In Mann's film, it is the Scottish actor Brian Cox who is the face of Dr Lecktor. Brian Dennehy was, for a time, planned to take the role, as well as William Friedkin.

[48] The term 'profiler' only appears once in the film, on the front page of the *National Tatler* ('FBI Manhunter Graham Consults Hannibal Lecktor').

(*Rampage*, 1988), and all of those post-*Silence of the Lambs* productions which, from *Seven* to *Scream*, made the serial killer one of the more recurring figures in Hollywood cinema. Faithful to his research technique, Mann was inspired by the profiler Robert Ressler (1937–2013) and a long correspondence with Dennis Wayne Wallace, a Californian schizophrenic killer obsessed with a woman he only met once but whom he imagined he met again with each of his victims. At the end of the film, Mann makes reference to Wallace by using the song by the psychedelic rock band Iron Butterfly, *In-A Gadda-Da-Vida* (1968), which was for the killer the soundtrack of his fantasy romance.

In the cinematic trajectory of Michael Mann, *Manhunter* represents a decisive stage and would shape his formal universe, at least until *Heat*, crystallized. The use of synthetic music and ultra stylized lights, the systematic search for an abstract and high-tech expressionism which *derealizes* each shot in the film or the obsessive care taken with the Art Deco design and ambiences showed the capital influence that *The Keep* and the *Miami Vice* series had on the visual evolution of his cinema in the course of the 1980s.

Manhunter appears as a film immediately emblematic of Mann's style, *a film of its time* as well, widely infused with the artistic scene of Los Angeles but also by the glossy aesthetic of the period: a strange synthesis of artifices borrowed from video and advertising, a form of European, and more precisely Antonionian, modernity, notably evident in the problematic relationship of the character with an environment that is less functional (or narrative) than mental, and borrowings from Californian contemporary art, be they Dolarhyde's lair, worthy of a LACMA installation,[49] or the discussion in a supermarket aisle between Will Graham and his son Kevin against the pop art background of tin cans and packets of cereal. Even the choice of movie locations contrasted with those of *Thief*, whose action took place in anonymous settings where, to use the terminology of Gilles Deleuze about the American New Realism of the 1970s, in 'unqualified'[50] humdrum and almost undifferentiated spaces of Chicago. On the contrary, in *Manhunter*, each decor appears overqualified and *dramatized* the film's sequence, so much

[49] Unlike *The Silence of the Lambs*, in which Jonathan Demme returned to a more classical (dark) representation of Dolarhyde's lair: dark and decaying interiors, dripping walls, well straight out of the Gothic imaginary…

[50] On this subject, read Gilles Deleuze, *L'Image-mouvement. Cinéma 1*, Les Editions de Minuit, 1983.

so as to match, visually, the characters – Mann achieves here the synthesis between the urban realism of *Thief* and the hyper stylization of *The Keep*: the Fish House of the artist Robert Rauschenberg, situated on Captiva island in Florida, that is filmed in the midnight blue sequence involving Will Graham and his wife, was shot at the very beginning of the film; the High Museum of Art of Atlanta, designed by Richard Meier in 1983, which serves as decor for the psychiatric hospital in Baltimore in which Dr Lecter is shut up; the atrium of the Marriott Marquis Hotel (1985), where Graham goes upon his arrival in Atlanta, a marvel of modern and dystopian architecture, swollen in its centre like a huge glass cocoon climbing 42 storeys; or the Freedom Plaza in Washington, dominated by the imposing façade of the National Theatre, on which Graham and his FBI team intercept an inoffensive jogger, thinking he is their killer.

There exists, in the artistic constellation gravitating around Michael Mann since the end of the 1970s, a behind-the-scenes man whom Mann met during the filming of *The Jericho Mile*, and who, in *Manhunter*, has the job of second unit director and appears furtively in the role of a photographer working for *The National Tatler*. It is the Italian photographer Gusmano Cesaretti, often credited with different assistant jobs[51] and whose contribution is undeniable. Revealed by his works in street art in Los Angeles at the end of the 1980s, Cesaretti collaborated on all Mann's films as location manager, consultant or associate producer. He has been and continues to be, the one who, script in hand, travels the world in search of distinctive places and settings likely to match Mann's vision. It is notably he who, with Janice Polley, spotted in Los Angeles the 95 locations for *Heat*,[52] the Art Deco style, the American modernism à la Richard Neutra or Pierre Koenig of the 1940s and 1950s, and 1980s postmodernism.

Two programs

Sitting either side of a tree trunk placed on the sand, Will Graham (William Petersen) and Jack Crawford (Dennis Farina) exchange a few

51 He appears on the credits of *Heat* as associate producer.
52 Mann and Cesaretti spent several months with a team of LAPD, at night, discovering, thanks to the police missions, a lesser known Los Angeles.
53 Vincent M. Gaine, *Existentialism and Social Engagement in the Films of Michael Mann*, Palgrave Macmillan, 2011.

words about a criminal affair which is poisoning the FBI. A serial killer has just murdered two ordinary families, the Jacobs, in Birmingham, and the Leeds, in Atlanta. If the *modus operandi* is the same, nothing objectively links these two crimes and the investigation is at a standstill. One lead: the killer seems to act when there is a full moon. In this sequence, which follows the credits of *Manhunter*, agent Crawford tries to convince his friend Will Graham, ex-profiler withdrawn to Florida, to temporarily resume service. Even if Graham claims he is leading the life he dreamt of, the mise en scène, without asserting the contrary, rather distils clues of discomfort and introduces to this splendid setting a form of visual and acoustic discordance. Visual: the ocean horizon, a place for a valorized Mannian utopia, is here barred by a massive tree trunk, and Graham, looking saturnine, symbolically turns his back to it. Acoustic: the synthetic music accompanying the first sequences of the film translates, from Graham's point of view, a silent malaise preventing him from reaching the oceanic dream within his grasp, but which in reality is distant.

 This sequence undoubtedly constitutes one of the most chemically pure representations of the dilemma that torments most Mannian heroes, between what Vincent M. Gaine has called the 'vital program' and the 'existential program', *between what they know how to do and what they desire*.[53] Mann films here the diffuse feeling of a lack, of a palpable tension between the deep aspirations of Graham and the appearance of a fulfilled life. The man occupies the space but is absent, as if paralyzed by a feeling of impediment which contaminates even his relationship with those he is closest to – the following discussion, between Molly and Crawford, both filmed from behind in front of a bay window in back light, emphasizes the presence of vertical bars crossing the shot. For Graham, this postcard is also a prison. Unlike Thomas Harris's novel, in which this tension was inscribed at the very heart of the family story (Kevin turns out to be the child from Molly's first marriage and the couple lived in a modest house), the Grahams possess, in *Manhunter*, all the outward signs of an ideal and well-off family, which allows Mann to concentrate on Will all the existential dissatisfaction explored by the directing. His impediment, even his waiting game, as in the characters in Edward Hopper's paintings, are not without object. They are the consequence of a professional activity put on standby following the physical and psychological traumas suffered with the arrest of Dr Lecter a few years previously. Crawford's proposal thus comes at just the right time as an opportunity, for Graham to

reactivate his vital program, indispensable for his psychological equilibrium. Crawford chooses not to show his friend images of the crime scenes – those sordid photos we furtively see in the plane carrying Graham from Baltimore to Atlanta – but simple photos of the Leeds and Jacobs families when they were happy, thus hoping to provoke in him a form of identification by resemblance. Because for Graham, life is a sacred thing that must be preserved at all costs. He situates himself, in the spectrum of Mannian characters, at the opposite end from Vincent in *Collateral*. 'This killing, it's gonna stop,' he says one evening to Molly, who is worried about his increasing involvement in the investigation. He will even go as far, in a sequence absent from the released version, as wanting to see with his own eyes, his face tumefied, the Sherman family that Dolarhyde, before his death, was planning to murder. At first terrified, the husband and his wife recognize Graham and invite him in. But he refuses. 'I just stopped by to see you,' he says before leaving. Graham possesses the competence of a profiler and the soul of a protector, which is attested to by the enclosure he builds, under the admiring eyes of his son, to protect turtle nests from outside intrusions. The passage from the close-up of the photos to the arrival, in the distance, of Molly and Kevin, establishes, in Graham's eyes, a link between these massacred anonymous families and his own, which elucidates through a short-cut the deep reason for his agreement. As always in Mann's work, the family, or the couple, is both what humanizes and what makes us vulnerable. Graham finds at this instant the point of convergence, and thus of equilibrium, between his trade and his life project: it is by helping to preserve the life of other families that the profiler will also save his own.

The initial reticence with which Graham agrees to take part in the FBI investigation is similar to that of Jeffrey Wigand who, in *The Insider*, is reluctant at first to say what he knows about the tobacco industry. Both, however, accept a mission which takes them away from their homes – momentarily for Graham, definitively for Wigand. They both know the sacrifices entailed but, like Muhammed Ali, they belong to that species of individuals for whom the existential program always comes out reinforced by the fulfilment of the vital program. At the end of *The Insider*, Wigand has lost heavily from a social and material point of view, but he has managed to bring to everyone's knowledge a public health scandal. Above all, he has won the esteem of his two young daughters who understand, in front of the television broadcasting the entire CBS report, how much their father, by caring for others, has never stopped caring about them.

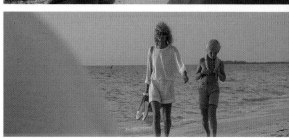

Blocked horizon:
the opening sequence of *Manhunter*

Clear horizon: the final shot

The rhyming effect between the opening sequence of *Manhunter* and that which closes it – Will, Molly and their son reunited on the beach – thus invites us to envisage the film's story as one vast operation of correction of the initial shot and of the tensions that undermine it. The final sequence opens with a close-up of Kevin who, near the enclosure built by his father at the start of the film, notes that the protection programme has worked, since most of the turtles have survived the attacks by animals from outside. By rejoicing at the success of the construction, the child also validates, from a metaphorical point of view, his father's initial choice to go away from his family, even risk his life, in order to preserve that of other families and by consequence *also his own*. Kevin intuitively understands, after Molly, how much the detour via the vital program of the father, whose face still carries the traces, has managed to strengthen family ties and chase away the existential shadows that threatened them all. Mann can thus return to the opening shot, but get rid of what disturbed it, as if, in Graham's mind, the conditions for the possibility of finally turning towards the ocean were now met. The film thus ends on that long shot of a serenity found, a sort of solar reverse shot of the initial one, almost a photo of domestic happiness that echoes a similar sequence in *Thief* when, after the successful robbery of the Los Angeles bank, Frank, Jessie and their child relax beside the Pacific Ocean.

'In *Manhunter*, Graham's social identity is in large part stabilized by his role as husband and father in his own family, an institution that the film's serial killers (Dolarhyde and Lecktor) directly target',[54] writes Steven Rybin. *Manhunter* – and later *The Insider* – touch as closely as possible one of the terrors that run through all of Mann's filmography, that is to say the destruction of the home, the home invasion, as a nightmarish downside of that domestic utopia which so many Mannian men chase. Francis Dolarhyde works in a film development laboratory in St. Louis and finds himself in contact with thousands of home movies from all over the country. At the end of his investigation, Graham understands that it is by viewing these short amateur films, sorts of time capsules of a family happiness that he is foreign to, that the killer chooses his future victims, analyses the topographies of the places and rehearses his crimes. Chronologically, *Manhunter* situates itself halfway between two episodes of the series *Miami Vice* written by Chuck Adamson – one broadcast on 15 March 1985 (*The Home Invaders*, directed by Abel Ferrara), and the

54 Steven Rybin, *The Cinema of Michael Mann, op. cit.* p. 79.

other on 31 October 1986 (*Shadow in the Dark*, directed by Christopher Crowe) – which anticipates or extends its themes. In the first one, Sonny Crockett and Lieutenant Castillo pursue a team of violent burglars who break into the houses of wealthy families in Miami, terrorize and loot them. The *modus operandi* of the aggressors, who select their victims in a place of intimacy (in this case a hairdresser's salon), the prologue sequence which describes, like the home movies viewed by Dolarhyde then Graham, the daily life of an ordinary family and some shots of intrusion at night showing the shocked faces of the victims woken up by the beam of flashlights are so many motifs that Mann will use again in his film. The second is a barely concealed remake of *Manhunter*, but remodelled to the standards of television. Sonny hunts a crazy and elusive prowler who, at night, enters homes in the north-east of Miami in order to perform strange rituals. Like Will Graham, Sonny improvises, in the course of the investigation, as a profiler capable of connecting with the intruder's mind and anticipating his acts. 'Thinking undercover, sometimes you can't stop when you need to,' Castillo tells Sonny in a direct echo of Will Graham's psychological adventure. Finally, at the same time, on 26 September 1986, NBC broadcasted the third episode of the first season of *Crime Story*, *Shadow Dance*, also written by Chuck Adamson and in which it was again a question of a home invasion that turned bad.

A necessary haunting

'The ugliest things in the world.' Thus Will Graham describes to Kevin, who worries about his troubled father, the atrocious thoughts which were occupying his mind after the hunt for and arrest of Dr Lecktor. Several months of being unable to talk, a sojourn in a psychiatric hospital and psychological scars forever inscribed in the mind of a man who knows the price to pay for being in psychic proximity of evil. By accepting Crawford's mission, Will Graham believes he can keep at a good distance from these atrocities and promises his wife that he will not enter into direct contact with the killer. But he understands very quickly how much this is wishful thinking, because his work supposes a form of identification with, even empathy for, the man he is hunting. 'I am what I pursue,' Vincent will say in *Heat*. *Manhunter* opens on a nocturnal pre-credits sequence, completely filmed by subjective camera. An individual breaks into a house and makes for the bedrooms of its occupants. At the moment when he passes in front of that of sleeping children, a strident

sound manifests itself in the score right until the appearance of the couple. The woman awakens, sits up in her bed, petrified by the torch pointed at her. Cut. Nothing yet allows us to know if this prologue is taking place in the present (the point of view of a camera) or if it is a video already recorded (the massacre of the Leeds family) watched by an invisible spectator. Throughout the film, Mann uses this music as an acoustic signal of a negative effect, even the criminal drive of Dolarhyde. Scarcely after arriving in Atlanta, Graham goes to the Leeds home, enters the house and climbs the stairs to the crime scene. Mann chooses to use the same subjective procedure, as if the profiler already wanted to follow in the killer's footsteps and see things through his eyes. When Graham enters the parents' bedroom which, with its blood-spattered surfaces, resembles a sordid dripping, Mann abandons the subjective point of view and returns to a series of classical shots and reverse-shots. Holding the police report, Graham registers on a small tape recorder his first impressions, confronts the facts with what he discovers, but keeps his clinical tone – the murderer is referred to in the third person. In the bathroom, Mann then chooses to frame the fragmented body of Graham, taken between himself (in the foreground) and his reflection diffracted by the mirrors on the walls. This specular effect, whose direction will be used intensively from now on (windows, reflecting surfaces, mirrors, etc), symbolizes of course the psychic splitting/doubling that any profiler seeks in order to enter into symbiosis with the man he is hunting. It constitutes not only the reappropriation of an emblematic motif of the double in cinema, but returns to the very fantasy of Francis Dolarhyde, who places on the eyes of his victims fragments of mirror in order to be looked at and desired by them. 'For you, it's in the eyes, isn't it?', says Graham one evening to the double lurking inside him, understanding that the path which will lead him to the killer passes exclusively through images and various kinds of representation. 'The report didn't mention eyes,' he reproaches the Atlanta policemen responsible for the investigation. 'It's in his dreams. His acts feed his fantasies. We must know his illusions, his dreams.'

How can you connect with a psyche filled with atrocious thoughts without giving in to a form of morbid, even fatal, attraction? What difference is there between identification and possession? If Graham's dark side tries to internalize the mind of the 'Tooth Fairy', the other side must keep the spectre of his victims and cherish it.[55] Graham's

[55] In *Heat*, Vincent Hanna explains to his partner Justine that contact with the horrors of the world allows him to remain 'on the edge'.

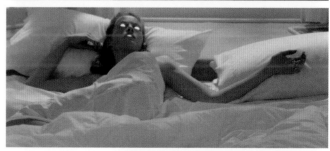

Manhunter

whole psychological adventure thus revolves around his ability to maintain a fragile equilibrium between *two necessary hauntings*. Suddenly, the phone rings. The answering machine switches on and in the void sounds the voice of Valerie Leeds. Almost a ghost. Close-up of Graham's face framed in the mirror: 'Hi, this is Valerie Leeds. Sorry, I can't come to the phone right now but if you'd like to leave a message please just wait to the beep and I'll call you back as soon as I can.' From the dead, the young woman reactivates in him the sacred feeling of life. A call to order, in short. Graham then lifts his head and looks at his specular double, as if this precise symbolic instant sealed, in the image and his mind, the interweaving of two gazes, that of the profiler *and* the protector, destined to journey together.

Recover the mindset

In the following sequence, we find Graham again, in his bedroom at the Marriott Marquis Hotel, watching a VHS tape of the Leeds family's film. Fragments of ordinary life to which he will return throughout the film, convinced that hidden there is a clue likely to put him on the trail of the 'Tooth Fairy'. To the left of the frame, the black mass of the television set, to the right, the concentrated face of Graham. We understand, from his discouraged expression, that in spite of several successive viewings, these images remain mute. Purely tautological: they only say what they show. Nothing else. Graham then decides to take a break and phones Molly. The camera moves slowly from the right to the left of the frame. It is late. Molly was sleeping. We discover her lying in the bed of the family home, in Captiva, bathed in the same blue light as at the start of the film. She mumbles a few words. But Graham has nothing in particular to say, except that he is thinking of her. 'I'll call back tomorrow. Go back to sleep'; he hangs up. The camera slowly approaches the young woman's face. At the same moment, the strident note heard in the prologue breaks into the soundtrack and produces, around Molly, the feeling of a diffuse threat. Back to Atlanta. The camera returns to its original position. Graham immediately gets back in front of the television, but his expression has changed. You would think he was now under a spell. He returns to the images and, for the first time, addresses the killer directly, in a familiar way, hurls abuse at him even, as if the killer's mind and his own had finally met.

'What are you dreaming? It's something you can't afford for me to know about, isn't it? God, she's lovely, isn't she?' Suddenly, something appears to him, he rushes to the telephone and asks Crawford for a new analysis of the corpses' corneas. The intuition will pay off: the bits of mirror the murderer places on the eyes of his victims after having killed them indicate a narcissistic penchant (to be looked at) and allow Graham to concentrate his investigation on the question of the eyes and vision. This pivotal sequence sheds light on the functioning of Graham's psyche and especially the way in which he organizes the discourse between the two facets of his mind. Mann repeats the same manner of filming (television on the left, Graham on the right) to emphasize what, from one moment to the other, has changed. In the first part of the sequence, Graham looks closely at the images, but in vain. It is the eye of the protector, who sees nothing but a banal everyday life with which he can identify. In the second part, the images are the same, but the way of seeing them has been transformed. Graham is visibly no longer the same viewer and sees in the Leeds film clues that were invisible up till then. What has happened? When he calls Molly in the middle of the night, it is less about Graham checking in with her than to simulate the mind of the profiler and his mental proximity with the killer. Is the strident note accompanying the close-up shot of his wife not the sign of a negative drive that Graham has just activated in himself? If Graham has nothing to say to Molly, it is because he is speaking above all *to himself*. When he returns to the Leeds film, the protector has given way to the profiler, hence the ambivalence, or rather the double meaning, of the following monologue: 'She's lovely, isn't she?' Who is the woman Graham is referring to here, Valerie Leeds or Molly? Both? Are the shots of Molly asleep like a blonde angel in dreamlike attire not a possible figuration of a killer's dream ('What are you dreaming?')?

If Graham knows that the parts of him, as autonomous as they are, must remain welded together at the risk of sinking into a zone of abjection which he has already frequented (the consequences of the Lecktor affair), he also knows that he can only advance by playing on their reciprocal aversion. Profiling is a method of mastered possession, of *play* between two virtualities. Graham the protector sees Molly as the intimate embodiment of all those families he must save; Graham the predator sees her as an object of macabre desire.

The next day, Graham announces to Crawford that he must fly to Baltimore to visit Dr Lecktor. 'Why?' asks his colleague. 'To

recover the mindset,' replies Graham. *Recover the mindset.* Put yourself back in the necessary psychological conditions, return to the vortex of evil, see and sniff again the man who caused, three years previously, his depression and resignation from the FBI. A trauma, certainly, but

Manhunter

also a success since, at the time, Graham's method, however perilous it might have been, had enabled Lecktor's capture. The hotel bedroom episode has just proved to him again that by approaching as closely as possible the thoughts of the man he is hunting, he gets results.

The meeting with Dr Lecktor, which takes place within the ultra-secure walls of a prison in Baltimore, marks the acme of Graham's identification work. Prefiguring the face-to-face between Vincent Hanna and Neil McCauley in *Heat*, Mann opts for minimalist cutting that favours shots and reverse-shots. The mirror effect naturally produced by the passage from one face shot to another sheds light each time on the type of relations between the two men. Stories of reflections, and therefore of doubles, but of a different nature – in *Heat*, Neil is Vincent's *alter ego*, and vice versa; in *Manhunter*, Dr Lecktor (and by extension Francis Dolarhyde) is Graham's *doppelganger*. The epicentre of evil has no colour: it is the Spartan cell where Dr Lecktor stands, a cell of clinical whiteness which seems the possible zero point of dehumanization, reinforced by an aesthetic (and a soundtrack) close to science fiction – *THX1138* is the film that immediately comes to mind. Sitting on opposite sides of the cell's bars, Graham and Lecktor sniff and weigh each other up like two wild animals that know each other intimately. In the course of the exchange, shots focused more and more closely on the faces indicate that between them there is a rapprochement that Graham seeks without desiring it. To penetrate the other's mind *at*

the risk of reciprocity. It is the meaning of the three wide-angle shots which punctuate the sequence. The first of them intervenes just after a question from Lecktor which shakes Graham ('You dream often, Will?'), translating the need, from the profiler's point of view, to stretch to the maximum the space then separating him from his interlocutor and to thus increase again a physical, and therefore mental, distance that the close-ups tend to erase. 'The reason you caught me Will, it's we are just alike!' Lecktor's reply at the very end of the conversation rings true since it hits precisely Graham's raw nerve and provokes in him a sort of vertigo which is echoed by the spiral staircase of the building that he descends after leaving the cell. The entire visual and moral stakes of *Manhunter* are found on this fragile crest line where Graham's two potentialities hold together. How to maintain an active frontier by dint of transgressing it? *How to become the other without ceasing to be yourself?* A question which, reformulated on the terrain of crime fiction, will also run through *Miami Vice*. By recovering the state of mind he had come to seek in contact with Lecktor, Graham penetrates a zone of confusion which Mann expresses right from the following shot: outside the building, Graham, out of breath, leans on a railing and stares at a piece of lawn. But the lawn, which is completely blurred, resembles an abstract green flatness. Graham undoes his tie, regains control of himself, at the same time as the counter-shot regains its sharpness. Will he always have the capacity to thus *take stock of his identity*? Identification with the killer supposes thinking, even dreaming like him and, consequently, letting yourself be *contaminated* by ideas which repel at the same time as possessing a morbid power of seduction.

In the plane taking him to Birmingham, Graham lays out in front of him two photos of the murdered families, the Leeds and the Jacobs, before falling asleep. The following dream opens on the solar shot of an engine towed on a yacht and then, at the end of a pontoon, the slow-motion appearance of the blurred silhouette of Molly. Graham is busy on the boat; Molly, in close-up, looks at her husband. The blue sky, the soaring music, the loving expression of the young woman, all contribute to making this sequence a picture postcard, the dreamlike vision of a conjugal happiness which contrasts with the sense of caging that Graham feels since leaving his Florida home.[56] But the reverse angle on

56 Note that the staging multiplies motifs of imprisonment everywhere around Will Graham (bars of windows and doors, windows that isolate…), right up to the last telephone conversation between Graham and Lecktor. This takes place in a hotel bedroom which Mann frames as if it was a prison, while in the shot of Lecktor, the bars have disappeared, thus suggesting that Graham is also captive of a (mental) prison.

Manhunter

the face of Graham staring strangely at Molly introduces a hiatus, almost a malaise, as if this shot did not belong to the same psychological order of images as the previous ones. From a visual point of view, the much darker shot indicates that Graham shares, in his dream, a space that is different from his wife's. Are we dealing with a man in love or a predator who contemplates a possible prey, or both? By dint of getting mentally closer to Dolarhyde, Graham gradually isolates himself from the rest of the world and only has an autistic relationship with his negative double: 'It's just you and me now, Sport,' he tells his reflection in a diner window, while the telephone voice of Valerie Leeds comes back to haunt him.

When he returns to Atlanta, in the Leeds' home, the identification with Dolarhyde seems complete: the cutting of the sequence is identical to that of the first visit – he climbs the staircase, goes into children's bedroom then that of the parents – but Graham plays the scene again through the eyes of the 'Tooth Fairy' as far as seeing on Valerie's eyes the fragments of mirror placed by the killer. The direction of *Manhunter* is essentially organized around these phenomena of psychic contagion sought by the profiler and captures the signs of confusion it produces. Contagion of one mind by another, of its reality and therefore of its space. Hence the expressionist dimension of the film's aesthetics, which externalizes everywhere the affects and the split subjectivity of Graham.

After having intercepted a note from Lecktor addressed to the 'Tooth Fairy' and applied several decoding techniques, Graham, Crawford and his team decide to publish a message in the *National Tatler* to set a trap for the killer. The sequence, at night, takes place in front of the Washington station, on Freedom Plaza. From an architectural point of view, this immense esplanade surrounded by imposing buildings (the seat of the government of the District of Columbia, the National Theatre and the massive facades of three hotels) contrasts with the modernist style of the other settings in the film. But it is above all the treatment of the photography, full of shadows and geometric lights, which tips the sequence towards an aesthetic reminiscent of German expressionism – one of the visual matrices of Mann's cinema – as if the very film found itself contaminated by the dark forces stirring in Graham's mind. The symmetrical composition of the first shot, the presence of two old lampposts on each side of the

[57] Who, let us remember, plays the role of Count Orlak in Mornau's film.

frame and the tiny silhouette of Graham who advances under a crushing
vault towards a fatal encounter constitute so many motifs borrowed from
expressionist cinema, be it, in *The Nibelungen*, the arrival of the valiant
knight Siegfried in front of the castle of Gunther, king of the Burgundians,
or, exemplarily, that of Thomas Hutter in the castle of count Orlok in
Nosferatu. Fixed at the centre of the shot, dominated by the vault, Graham
occupies the position of target in the space of a trap. Godard said of Fritz
Lang that he made his films as if he had as a camera a telescopic gun.
Here, Graham resembles a tiny being lost in the middle of a hostile
environment, ready to confront an enemy, or rather its abstraction, that
Mann symbolizes in the foreground in the form of a maleficent projection
which unfolds before him and seems to challenge him. The shadow of
an enigmatic demon, which spreads its wings on the wet stone, looks like
a figuration sketched on the ground of the dragon becoming of Dolarhyde
– unless it is another Molasar to slay (the failure of his previous film, the
expressionist *The Keep*), with which Mann would like to finally settle
accounts. Finally, the motif of the vault, since its emblematic use in
Nosferatu, adds to *Manhunter* a vampiric imaginary firstly embodied by the
'Tooth Fairy' in the role of a contemporary Prince of Darkness. With his
dentures, with which he mutilates his victims, his diaphanous complexion
and his lanky silhouette, Francis Dolarhyde could be a modern epigone
of the actor Max Schreck[57] who, far from the gloomy forests of the
Carpathians, now plagues the postmodern and cathodic universe of the
1980s. But is profiling not also a technique of mental vampirization of
the other? And does the killer's
psyche not act on Graham like
those occult powers which try
to take possession of innocents
in the films of the Weimar
Republic?

From one vault to the other:
Nosferatu (F.W. Murnau, 1922) and *Manhunter*

Videoscopy: critical space and the shining

'Everything with you is seeing, isn't it?'
Will Graham, *Manhunter*

Manhunter opens on an enigmatic shot of what looks like the anthracite hood of a vehicle mounted with an imposing fin. The image seems frozen, but suddenly the camera approaches and slips along a bar of headlights. Cut. Through a point-of-view shot guided by a torch-lamp, the camera then progresses along a staircase up to the bedrooms of the occupants. The importance of the texture, the thickness of the frame, the low definition of the image and the bluish atmosphere all indicate that this is a video image recorded with a Camcorder. Then appears the film title which shines, like a neon light, in green letters against the night background. Michael Mann thus chooses to place *Manhunter* under the sign of the electronic image and immediately associate it with an act of death – this journey seen through first person perspective, made by Dolarhyde inside the Leeds' home before their massacre, will become one of the recurring figures of the film.[58] Retracing the killer's steps, Graham guesses that the former took off his gloves in order to have physical contact with the bodies of his victims. Later, he understands that he reconfigures his crime scenes by placing on the eyes of the corpses fragments of mirror in which he looks at himself. It is finally by watching compulsively home movies transferred to videocassettes, in other words by putting himself in the position of the television viewer, that Graham connects intimately with the killer's mind and ends up elucidating the nature of his fantasy.

Manhunter, and all Mann's subsequent films from *The Insider* to *Blackhat*, show how much technology produces a derealization which always brings a form of dehumanization. By reducing his victims to mere surfaces meant to reflect his own image – in reality, the fake gaze of a dead person – Dolarhyde constitutes a deadly version of the voyeurism encouraged by videoscopic societies. For these societies, as for him, individuals are just images that can be enjoyed at a distance, electronic

[58] This analogy between videoscopic image and death will be literally placed in an episode of the series *Crime Story, Born to Die*. Here, the killer, who has carried out a massacre in a hair salon, is convinced that his mother is hidden in the television.

ghosts without substance. Dolarhyde chooses his future victims according to their image (photographs and films) and, in order to feed his narcissistic fantasy, transforms them into viewers of himself: fundamentally, Dolarhyde is the pathological expression of a televised relationship to others and to the world.

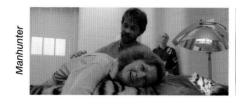

Manhunter

Midway through the film, the story shifts to Dolarhyde and, after having haunted the whole first part and Graham's mind, he finally materializes. His first appearance takes place in his home, just after the kidnapping of the journalist from the *National Tatler*, Freddy Lounds, whom we discover tied to a chair in the middle of a Spartan living room. What do we see? Old lamps, vintage armchairs, walls covered with photographs of the Earth and of the red surface of Mars, and a small television that is switched on. So a small workshop with piled retro objects, emblematic of the aesthetic of the 1980s and of his fascination with disappeared objects reduced to being hollow and useless signs. From below then appears Dolarhyde's face, part of which is covered by a nylon stocking, surmounted by a kind of branch with lamps turning around, like a satellite antenna to which his brain is connected. Mann films the serial killer of *Manhunter* as an individual disconnected from reality, desynchronized from existing channels, just like the television screen which sweeps the void in search of an elusive frequency. He inhabits the world as if it was a foreign planet and only has with his fellow men a *morbid and virtual* relationship. For him, the real, others, individuals in flesh and blood must be stripped of their substance, devitalized and transformed into images available for his chimeras. Dolarhyde lives solely inside a videoscopic hyperreality that he is the only one to occupy and for which the world only exists and becomes true, and inhabitable, on condition that it is transformed into images. A real that is totally mediatized, televised, vampirizied and here annihilated, which in the name of the fantasy of being *watched*, transforms the other into a *television viewer of oneself*. Dolarhyde is a circuit closed upon himself, autistic, at once emitter (of his fantasies) and voyeur of his own simulacra: the victims, this virtual people of television viewers that he must manufacture for his little macabre television. 'I see my desire in you. Accepted. And

loved. In the silver mirrors of your eyes,' declares Graham in place of Dolarhyde. Is that not a possible definition of television, in other words, living dead who watch madmen or idiots? From this point of view, does Blake's fresco not function also as a contemporary metaphor for our videoscopic societies stretching their menacing wings (the dragon) around a physical and social reality (the sun, the young woman) up until the final embrace? Tied to a (medical?) chair in front of a screen, Lounds is forced to watch a series of slides projected by Dolarhyde. 'Do you see?' asks the latter after each photograph of his victims until there appears his own, printed on the front cover of the *National Tatler* beside Graham. Lounds realizes that by discovering himself on the screen, he is contemplating his own death. In the videoscopic world of Dolarhyde, the image is a gorgon.

Becoming Francis again

Suffering loneliness in social life and love, Dolarhyde tries to create around him a universe which would make him integrally attractive, firstly for the women who, in real life, are closed to his desire. This is why his ephemeral love affair with Reba (Joan Allen), a young blind woman who works in the same film laboratory as him in St. Louis, Missouri, provokes an intimate earthquake and opens up for him the possibility of a relationship with another which escapes the laws of videoscopy. This human parenthesis which the film lingers on allows Mann to counterbalance the evil fabricated abstraction of the first part of the film and to humanize him. The first meeting between Dolarhyde and Reba takes place symbolically in a dark room, as if the passage through this camera obscura indicated a return to the origins of cinema before it was led astray by television. There is undoubtedly a paradox in making a blind woman the possessor of an art based on seeing, but it is the art of the off-screen and the power of the imaginary which Mann is summoning here since, in cinema, 'the whole game consists of including yourself in the image',[59] unlike television which works on the exclusion of the viewer and of all that could put him in relation with what he sees. Because of her blindness, Reba embodies a form of purity, a sensitive state, and this purity is a bath into which Dolarhyde will dive. Reba needs

59 Brigitte Le Grignou, 'Interview with Serge Daney', *Libération*, December 1988.

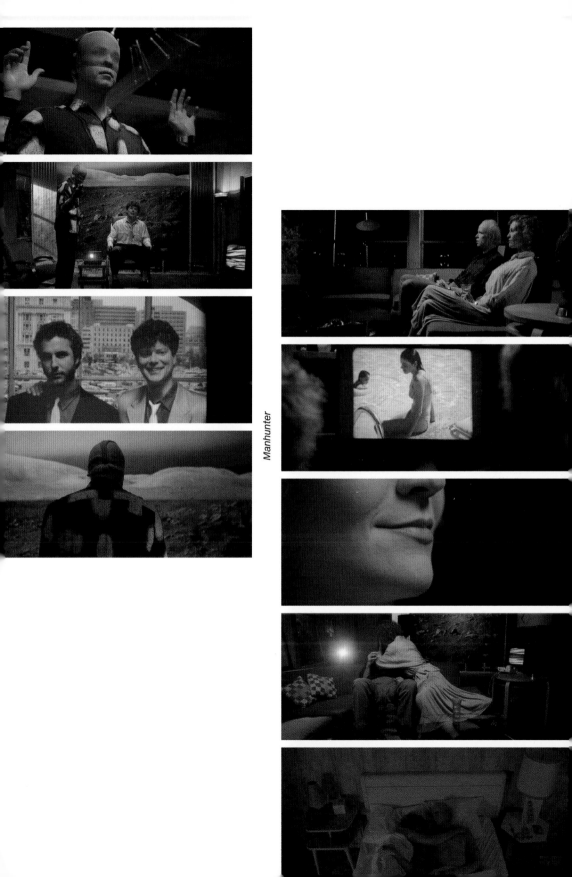

Manhunter

only to hear this man's voice, to feel its intimate vibrations, to accept his invitation. Dolarhyde leads her into the clinic of a veterinary friend and offers her the possibility of touching a sleeping Bengal tiger. It is both a gift and a way, for him, of verifying the strength of this sensibility without preconceived image – is this wild animal a cruel beast, a big cat, or both? – with which he identifies. When he sees her fearlessly plunge her hand into the animal's fur and find a form of tactile and auditory synchronicity with it, Dolarhyde realizes that is possible to establish with the other a sensitive and intense relationship, *outside the scope of technology*. A few minutes later, we find him again sitting on his sofa, watching, for the umpteenth time no doubt, the home movie of the Leeds family. Reba comes into the living room and sits down next to him. 'What are you watching?' 'Just a little homework.' The camera slowly approaches the face of Dolarhyde, whose eyes move several times from Valerie Leeds's Super 8 image to Reba's body, as if disturbed by the physical presence, at arm's reach, of a woman who is not just an image. He closes his eyes, spreads his hand on the leather of the sofa and prepares for a small session of mental onanism. But next to him, the other image is not inert, passive, nor the living simulacrum of a woman he has murdered; she reacts: Reba turns to Dolarhyde and kisses him. In doing this, she breaks his videoscopic circuit and offers him the possibility of inhabiting a space of feeling and exchange – in other words, the opposite of a relationship mediated by technology which only creates illusion. The parenthesis which opens between him and Reba, in the course of which the real suddenly dominates the virtual, is translated, just after their first night together, into an allusion to Blake's painting, from which Mann draws the composition while inverting the terms: this time, it is the woman with blonde hair, Reba, custodian of a sensitive reality, who envelops the body of the dragon, thus expressing Dolarhyde's deep desire to extricate himself from his videoscopic mirage. It is Dolarhyde's chrysalis moment. *He becomes Francis again*. In the following scene, we see him, far away, in silhouette, rushing towards Reba near a lake against the backdrop of a rising sun. It is the first and only time in the film when we see Francis Dolarhyde move outside his van or his technological fishbowl. As Mark E. Wildermuth writes: 'He wants to follow her into the world of direct light and real space, leaving the videoscopic world of indirect light behind him.'[60] But what could be a lasting epiphany is immediately

[60] Mark E. Wildermuth, *Blood in the Moonlight: Michael Mann and Information Age Cinema*, McFarland & Company, 2005, p. 107.

followed and crushed by a return to darkness: Francis desires Reba and finally embraces the real world that she embodies, but videoscopy is a robust poison, an irrepressible urge, a way of envisaging his relationship to the other which he is powerless to resist. 'See me as I really am,' says the Prime Movers song that accompanies the scene. The following day, Francis thinks of giving Reba a surprise by turning up at her home unannounced. He waits for her, parked in front of her house, when she finally appears, on the arm of a work colleague. On the doorstep, the man puts out his hand to the young woman's face to take out a fleck of dust in her eye then goes away. But Francis has a completely different reading of the scene: what he sees, or hallucinates, is not what takes place. For him, Reba lets herself be seduced and kissed by another man, while a powerful white light, the visual sign of the return of his videoscopic pathology, irradiates the couple, spreads through the shot to the point of entirely reversing its meaning. Dolarhyde's imagination here transforms the real, this image of cinema, into a video hyperreality which, visually, is situated halfway between advertising and soap opera. Convinced of having witnessed cheating and letting himself be duped by a kingdom of the truth which does not exist, Dolarhyde rushes out of his van, rediscovers his robotic gait and, with an impassive face, shoots the man from point blank range. He then goes into Reba's house, slams her against the door and starts to reintegrate her, like all the others, into his videoscopic fantasy. 'Francis is gone,' he tells her.

Video *vs* cinema

In his article 'Do you see?: Michael Mann's reflections, doubles, and doppelgängers',[61] Matt Zoller Seitz notes that when, at the very end of the film, Graham leaps through the bay window of Dolarhyde's living room and breaks it, he shares for the first time the physical space as the killer, and very quickly the same shot – Dolarhyde punches him, lacerates his face then throws him on the floor. There follows a frenetic cutting that breaks brutally with the rhythm and pace of the rest of the film: two minutes of shooting during which Mann combines short shots, slow- and fast-motion effects, multiplies intentional continuity oddities and jump cuts right until the definitive fall of Dolarhyde on the kitchen floor. Collapsed in a pool of blood whose form reminds us of the wings

[61] www.movingimagesource.us/articles/zen-pulp-pt-4-20090715.

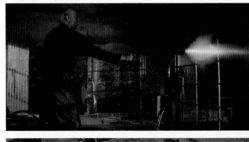

Manhunter

of a dragon, Francis Dolarhyde partially accomplishes Blake's work, a man-painting but in its trivial and insignificant form. 'The disruptive cuts make it seem as though the film is disintegrating before our eyes, shredding in the projector. This movie is having a nervous breakdown.'[62] This technical 'nervous breakdown' described by Seitz constitutes, in reality, the catastrophic resolution of a tension which structures all the film between two aesthetic regimes, or orders, which, in this middle of the 1980s, confront one another: On the one hand cinema and on the other, a new imagery, come from television and advertising, of which Dolarhyde is the radical embodiment. This tension is firstly expressed, in the film, by the predominance of blue, the colour of technology, of the radiance of the screens and of that electronic ether which haunts numerous shots, starting with the laboratory where Dolarhyde works. But it is also the *Other* of flesh, the return of the repressed, the colour of hygiene and its lustre, of evacuation and immateriality, echoing Dolarhyde's inability to comprehend his fellow human being in its organic and physical dimension. The killer finds himself torn between two worlds when his relationship with Reba emerges in him a facet of his personality – Francis – and a taste for experience which he believed inaccessible. From this point of view, *Manhunter* also constitutes a rather sombre reflection on the flip side of the medium – the television of the 1980s, as a factory producing a certain type of industrial images and especially of zombie viewers, drugged by the meaningless and dehumanized images of which Dolarhyde is the pathological version. Undoubtedly at this time, Michael Mann had an ambivalent relationship with television, and his film carries implicitly, but everywhere, the trace of this, since television was for him the refuge from the forced withdrawal after the failure of *The Keep*, but also the place where he was able to bounce back professionally.

This tension is also expressed in the story, from the first scene in the film with Will Graham and Jack Crawford, whose exchange is skewed by the photographs of the victims which Jack puts on the tree trunk, objects from the videoscopic world which come to disturb the real space and change its course (Graham agrees to come out of retirement), just as the electric blue enveloping the Grahams' house immediately expresses a conflict between the physical world and the video world. Later, following the threats made by Dolarhyde and Dr Lecktor, Graham shelters his wife and Kevin in an FBI safe house. He

[62] *Ibid.*

immediately notices in his son a change of attitude towards him and expresses his concern to Molly. 'He's afraid to leave you alone with me now?' 'I wanted to talk with him but he said he wanted to bring it up to you. Face to face,' she replies. Kevin has discovered the article in the *National Tatler* which relates the psychological past of his father and now fears for his mother. We catch up again with Graham and Kevin in a supermarket aisle. A dialogue begins in which Graham recounts his story and reassures his son about his mental health. The scene is built around a regular alternation between Graham's face and Kevin's, standing in front of the shelves full of food stuffs. At the end of the scene, Kevin asks his father if the ideas at work in Lecktor's mind, and consequently in his own, were 'that bad?' A return to Graham's face: 'they are the ugliest thoughts in the world'. But in this reverse shot, which should be identical to the previous shot of Graham, since neither he nor Kevin have moved, something has changed. It concerns the arrangement of the products situated behind Graham's face. Tin cans have replaced the boxes of cereal in the previous shot. Unless this is an unnoticed scripting error, this apparent continuity error intervenes just after Kevin has reactivated, despite himself, the mind of the profiler in that of his father. What is it about? About the manifestation, in the form of a visual hiatus, of the ability of videoscopic space – that of Dolarhyde, which Graham must also identify – to disturb, even dislocate the real space that Graham shares with his son. These friction effects between two competing regimes of images, in which *Manhunter* abounds, echo (voluntarily?) a similar mismatch used by Stanley Kubrick in *The Shining* in order to show the way in which the shining also modifies the space of the story. Now what is profiling but a gift of second sight which allows you to penetrate the mind of the other? Situated at the start of the film, the scene in *The Shining* already takes place in the midst of shelves stacked with various products. Halloran, the cook, shows Wendy and Danny around the storage space of the Overlook Hotel, then stops for a moment in front of a shelf. A strident note, sign of Danny's shining (and of Dolarhyde's criminal urge), progressively invades the soundtrack, while a zoom-in isolates Halloran's face from Danny's point of view. The cook turns round to the child and, without moving his lips, asks him this: 'Do you like ice cream, Doc?', which reveals that he possesses the same gift. Now, at this precise moment of the reactivation of the shining, a same anomaly happens in the shot (a Calumet tin, absent from the previous shots, suddenly appears on the shelf behind Halloran) which also translates a disruption of space when two different configurations of images confront each other.[63]

Deep blue

Manhunter finally marks, for Michael Mann, the beginning of an important collaboration with the director of photography Dante Spinotti,[64] with whom he will be reunited four times for *The Last of the Mohicans, Heat, The Insider* and *Public Enemies*. Spinotti's taste for atmospheric ambiences, electric lights and frames composed sometimes to the point of abstraction around geometrical lines of force, enables Mann to find a new balance between the style of *Thief,* still very marked by the realist aesthetic of the 1970s, and the sometimes advertising expressionism of *The Keep*. Maybe influenced by the minimalist and graphic approach of Gianni Di Venanzo (1920–66), the famous Italian cinematographer who lit all of Antonioni's first films (from *Le Amiche* to *L'Éclisse (The Eclipse)*), of Francesco Rosi and *Juliet of the Spirits*, Spinotti provides Mann with the founding tools of a visual and even architectural style which will reach its pinnacle with *Heat* in 1995. The meticulous use of colour shows, in *Manhunter*, a notable development since, beyond its ability to codify emotionally and thematically framing elements in particular (objects, clothes or fragments of decor), it is from now on part of what the American artist James Turrell calls a 'perceptual environment', via a holistic approach to light which embraces body and space in its totality: 'What interests me about light', explains Turrell, 'is the quality of thought that emanates from it. It is about thinking without words, a thinking that is different from our usual ways of thinking.'

The first characteristic sequence, in Mann's work, of this new relationship between light and space takes place at night, at the very beginning of the film, in the bedroom of Will and Molly Graham. Will knows that deep down he has accepted the mission that his ex-colleague Jack Crawford has just proposed, and is visibly hesitating to confess this to his wife. But the discussion is cut short because Molly immediately senses that he has already made up his mind. Rather than oppose his decision, she assures him of her support, understanding intuitively, as a perfect Mannian heroine, that the best way to safeguard their common existential program is to let Will accomplish *on his own* his vital program.

[63] The links between *The Shining* and *Manhunter* are numerous. Kevin's fears about his father – and his fear that he will attack his mother – recalls, for example, Jack Torrance's relationship with Danny and Wendy – which is itself a reworking of the relationship between James Mason and his own in Nicholas Ray's *Bigger Than Life*.

[64] Hired by Dino De Laurentis, Dante Spinotti makes, with *Manhunter*, his Hollywood debut.

Case Study House no. 22 (Stahl House),
Pierre Koenig, Los Angeles, 1960

'The moon irradiates the surf'
(*Manhunter*, 1986)

James Turrell, *Rondo Blue*, 1969

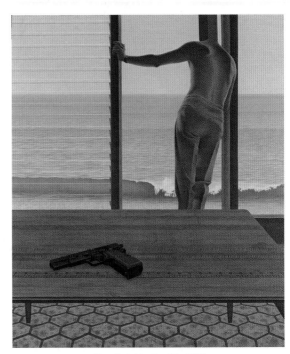

Alex Colville, *Pacific*, 1967

Heat, 1995

Dirty Harry, Don Siegel, 1971

And to be by his side, whatever happens.[65] What do we see? In the foreground, the couple lying on a bed covered with white sheets, an environment stripped down to the extreme, and, in the background, as far as you can see, the electrified surface of the Atlantic Ocean which confers on the scene a manner of weightlessness and dull sadness emphasized by the ethereal sounds by Japanese progressive rock musician Kitaro. 'The moon irradiates the surf', points out the script as a visual description of the scene. Above all, the whole of the shot bathes in an artificial blue which envelops both the bedroom and the couple, as if the colour, freed from its realist reason for being (for emitting) – what moon can shine light like this and to this point? – made palpable, beyond the objective and physical environment occupied by the characters, another space, evanescent and almost hypnotic, which invites introspection. But is this mental space, for Will and Molly, a common space? 'What do you think?' 'Stay here with me. Me and Kevin. But it's selfish and I know it,' she replies, thus revealing her off-camera thoughts, in other words two irreconcilable impulses (to desire one thing and its opposite) that she will have to make cohabit throughout the investigation. In reality, Mann firstly films this scene from the couple's point of view (the two are framed together) and the blue emphasizes an apparently united household – 'We have it good, don't we?' says Will at the start of their conversation. But on getting closer to them, with more tight shots, Mann progressively abandons Will's body to concentrate on Molly's, as if we were entering the space of the unspoken. The scene ends on a close-up of her anxious face. Eyes wide open, Molly stares at an indeterminate point, while her husband, his head turned away, has already nodded off. The two bodies may well be joined together, lying side by side, but he, or she, which comes to the same thing, is already elsewhere, leaving to the other all the mental space. A hiatus has been introduced between them which bothers the overall shot, a disturbing element *already* threatens their household with implosion, as is suggested by the entrance of a scary electronic pulsation on the soundtrack: something (the criminal urge of the 'Tooth Fairy'?, the mind of the profiler Graham?) has begun its work.

It is Dante Spirotti who, in order to enrich the spectrum of his colours, gives Mann the idea of a romantic blue associated with

[65] In *Heat*, Justine tries, in vain, to save her marriage by asking Vincent to share with her his professional experiences. In *Manhunter*, the relationship between Graham and his son is mended when the former reveals to the latter his wounds, what he has done, and draws the portrait of the man he is hunting.

the household of which this scene marks the first spectacular occurrence, 10 years before the now iconic one in *Heat*. In the twenty-first minute of the film, after letting Waingro escape in a diner's car park, Neil returns home. We discover, for the first time, its interior, a modern apartment reminiscent of Pierre Koenig's 'Case Studies', empty, deserted, completely open on to the Pacific Ocean. Neil starts by putting his weapon and keys on a glass table then goes towards the big bay window in the living room. At the beginning of the shot, Neil is just a headless body, a professional reduced to a simple gesture, before the camera, which accompanies his movement away, frames him entirely from head to foot. By thus putting down the emblematic attribute of his vital program (the gangster's revolver), Neil symbolically unburdens himself and plunges into his existential program. After action (the weapon goes off-screen), introspection. *Neil then enters the space of his thoughts*, a movement which Mann actualizes right from the following shot in the form of an oceanic reverse-shot. A form of fatigue and melancholy infuses the entire shot, which contrasts with the vivacity that Neil has shown up until then. Immersed in a bath of blue light, the man stands with his back turned, motionless, facing the deep blue, both actor and spectator of the shot: *he also looks at what we are looking at*. This shot, which has become a hallmark of the Mannian aesthetic, is inspired by a painting by Alex Colville (*Pacific*, 1967) passed through the electro-cosmic filter of the luminous experiments by Turrell such as *Raemar, Blue* (1969) or *Ocra Blue* (1968). It makes you feel what Kandinsky called 'the vibration of the soul'.[66] That is to say the perfect meeting point of the character's aspirations and the depopulated reality of his intimate space, of his desire to be elsewhere (the sea horizon, the sound of the waves, *the call of the depths*) and a feeling of impediment figured by the ambivalent architecture of his apartment: on the one hand, the frames of the windows and the balcony which vertically striate the shot create the sensation of an encaged space which echoes Will and Molly's bedroom; on the other hand, the window separating the interior from the exterior gives the illusion of a place amenable to daydreams, an inconsistent frontier that a simple change of focus (the transition from blur to sharp on the ocean) could conceal. 'Depth is as it were of all dimensions the most existential because […] it does not mark itself on the object itself and it obviously belongs to perspective and not to things… It announces

[66] Wassily Kandinsky, *Du spirituel dans l'art, et dans la peinture en particulier*, Gallimard, coll. 'Folio Essais', 1989, p. 107.

a certain indissoluble link between things and me', writes Merleau-Ponty in *Phenomenology of Perception*.[67] Here, the colour blue, maybe inherited from Yves Klein's monochromes, is not a colour of painting or an element of decor in particular (which was still the case in *The Jericho Mile*, *Thief* and even in the work of Colville, which distinguishes the oceanic blue from the wood colour of the space where the character is standing), but rather a surface of pure sensitivity freed from the theory of the chromatic circle, where are imprinted Neil's existential interrogations as it serves as a sensory backdrop for the conjugal uncertainty that seizes the Graham couple at the start of *Manhunter*. By articulating thus, the bluing and darkening of the shot with its architecture *full of emptiness*, Mann makes us feel Neil's haunting. It gives it a colour and links the entire space to the object that his existential ideal lacks.

Blue symbolizes here, and in all Mann's films (from *Thief* to *Miami Vice*), the intimate utopia of these men who, too busy to become accomplished professionals, dream of forming a couple and a peaceful home sweet home. 'The deepening power of blue is such that it becomes more intense precisely in the deepest tones, and that, internally, its effect becomes more characteristic. The deeper the blue, the more it attracts man to the infinite and awakens his nostalgia for the Pure and the ultimate suprasensible.'[68] If Neil now feels a form of nostalgia, it is in memory of a time he has probably never known and he hopes to be able to recapture a household fantasy whose purity he idealizes. Now this purity is a mirage that the following sequence, devoted to the Shiherlis couple (Val Kilmer and Ashley Judd), accomplishes, but in order to shatter it. These two sequences function, *a priori*, in an autonomous fashion, as fragments of private life put end to end (Neil/ Chris and Charlene), but in reality, they have a dialectical relationship that the link from one to the other immediately emphasizes. The first one concludes with a wide shot of Neil's apartment, which goes away from the window and leaves the frame. The second opens on the Shiherlis's house: in the foreground, the electric blue swimming pool of the couple echoes the ocean that Neil was contemplating and allows Mann to visually link the two shots. *As if one had something to say about the other.* Pointed at the house of Chris and Charlene, the camera literally turns its back on the horizon of Neil's daydreams. This 180 degree change of axis installs this scene in the same spatial field, but in the

[67] Maurice Merleau-Ponty, *Phénoménologie de la perception*, Gallimard, 1945, p. 296.
[68] Kandinsky, *op. cit.* p. 159.

reverse shot as the previous one. Do we pass here from a thought to its prosaic actualisation? In the middle of the garden, Charlene, sitting on a chair, waits for her husband. The latter appears from the back of the shot, rushes straight to her and kisses her. They have to go to a dinner party, but a question from Charlene (what does Chris do with all the money he earns from his scores?) poisons the conversation and breaks the apparent harmony of the couple. The young woman insists, the colour blue progressively disappears from the image,[69] the tone rises, Chris gets angry, violently grabs his keys and leaves the house. From one sequence to the other, everything functions by rhymes (the bay window and the architecture of the two apartments; the keys put down by Neil and taken back by Chris; his inverted trajectory in space...), effects of symmetries and ironic reversals, beginning with the transition between the ocean (and the infinity of its possibilities) and the Shiherlis's pool, symbol of a normal domestic dream. Fundamentally, by juxtaposing these two scenes, Mann gives substance to Neil's ethereal vision; he reveals the realist downside of his mental postcard and draws the curtain on its eventual triviality.[70]

At the end of *Heat*, the immense night sky of Los Angeles which serves as a backdrop to the death of Neil McCauley shifts from blue to black: 'Slipping towards black, [blue] takes on the consistency of an inhuman sadness. It becomes an infinite deepening in grave states which have no end and cannot have one.'[71] In Mann's work, dark blue is the colour of the tragic.

69 Chris even puts on a black jacket.
70 That is a reality which Neil does not want to see. He tries to keep the Chris-Charlene couple afloat as a possession that is all the more precious to him as he is deprived of it.
71 Kandinsky, *op. cit.* p. 159.

3.
THE HISTORY FACTORY

Michael Mann on the set of *Ali*, 2001

The Last of the Mohicans:
and night falls on our future

> 'The only government that I recognize – and it matters
> not how few are at the head of it, or how small its army
> – is that power that establishes justice in the land, never
> that which establishes injustice.'
>
> <div align="center">Henry David Thoreau,
A Plea for Captain John Brown, 1859</div>

'1757. The American colonies. It is the 3rd year of the war between
England and France for the possession of the continent.
Three men, the last vanishing people, are on the frontier west of the
Hudson river.'

It is with these inserts that *The Last of the Mohicans* opens, directed in 1992
and placed in Mann's filmography between the two versions of a same
story, *L.A. Takedown*, a television movie produced by NBC in 1989, and
Heat, in 1995. Michael Mann was then a filmmaker respected by the
American critics, creator of two noir films (*Thief* and *Manhunter*) of which
they praised the writing and aesthetic qualities. But he still lacked a popular
success, a film which would enable him to propose, to the studios, more
ambitious projects. Shot with a budget of $40 million, the film would
bring in more than $65 million and be, for Michael Mann, the second
biggest box-office success, behind *Collateral* in 2004. With *The Last of the
Mohicans*, Mann decided to make a stylistic sidestep, as if the radicality
reached in *Manhunter* had to be put on standby, while he returned to a
more accessible form of classicism. From this point of view, *Heat*
constitutes a sort of synthesis between the visual experimentations of
Manhunter and the classicism of *The Last of the Mohicans*.

The film belongs to what has been called the 'prewestern',
a sub-genre rarely explored by Hollywood and of which John Ford's
Drums of the Mohawk, King Vidor's *Northwest Passage* and Cecil B. De
Mille's *The Woman God Forgot* are the most emblematic jewels. At the
beginning of the 1990s, the western and adventure films situated at
the time of the Frontier rediscover their vigour, as shown by the
box-office successes of *Unforgiven* (1992), *Geronimo* (1993), *Dances With
Wolves* (1990), *Dead Man* (1993) and *Wyatt Earp* (1994). Filmed in North
Carolina – in the Blue Ridge Mountains, Chimney Rock Park and the
Pisgah National Forest – *The Last of the Mohicans* opens with a hunting

sequence in the midst of grandiose and open landscapes which, we will realize at the very end of the film, was undoubtedly the last hunting. Nathaniel/Hawkeye (Daniel Day-Lewis), Chingachgook (Russell Means) and Uncus (Eric Schweig), last representatives of an Indian tribe on the verge of extinction, are heading towards Kan-Tuckee. On their way, they offer help to a detachment of British soldiers led by the officer Duncan Hayward (Steven Waddington) whose mission consists of escorting Cora (Madeleine Stowe) and Alice Munro (Jodhi May) to their father (Maurice Roeves), commander of Fort William Henry, which is in a difficult position faced with powerful and devastating attacks by a French army led by the Marquis de Montcalm (Patrice Chereau). Magua (Wes Studi), the instigator of the ambush, is a Huron who has passed himself off as a Mohawk scout and ally of the English. The latter vanishes while the Mohicans, Duncan and the Munro sisters start off again for the fort.

Obviously, it was less the story of Hawkeye as told in 1826 by James Fenimore Cooper in his coming-of-age novel which interested Mann than the transitional period from this War of Independence, a pivotal moment at which at stake was the birth of a nation and the end of a native people, the impossible interlocution between the natives and the settlers, the inexorable domestication of a wild and verdant space by the forces of what was not yet called industrial capitalism, and the ultimate celebration of nature by those, the native Indians, who would soon be dispossessed of it. John Quincy Adams, Henry's grandfather, who became president of the United States in 1824, placed the end of this world in 1844, with the opening of the railroad linking Boston to the town of Albany, which marked New England's entry into the industrial age of the nineteenth century. Mann and Christopher Crowe,

The Last of the Mohicans, 1992

his co-scriptwriter, drew inspiration from several sources: the *Handbook of North American Indians* (a collection of 30 volumes published by the Smithsonian Institution), the journal of Bougainville, Montcalm's aide-de-camp, Simon Schama's text 'The Many Deaths of General Wolfe', published in 1991 in *Dead Certainties*, and especially the screenplay written by Philip Dunne for the version of *The Last of the Mohicans* directed by George B. Seitz in 1936, with Randolph Scott in the role of Nathaniel/Hawkeye.[72] Finally, the paintings of Albert Bierstadt, Thomas Cole and Benjamin West (*The Death of General Wolfe*, 1771) gave aesthetic direction to the film. In West's painting, the Huron kneeling before the dying general served as a model for Magua's character.

Men of law

The Last of the Mohicans is structured around three groups of individuals, three contradictory interests in the face of a War of Independence which will determine the *legalistic* foundations of the future America. The troops of the British Crown and of Nouvelle-France who fight for the annexation of the New World; the Indian tribes, whose way of life is nearing an end and who are looking for their just place in a completely changing environment; finally, the first settlers from Europe, embodied here by the Cameron family. Like Henry Fonda and Claudette Colbert in *Drums Along the Mohawk*, to which Mann discretely pays homage in the film's second sequence, the Camerons live at the frontier of the wilderness, in a wood cabin, on the fringe of those forests 'where live wild beasts, forests of the night where, in opposition to the open savanna

[72] This is the third film adaptation of Cooper's novel, after the versions of Theodore Marston (1911) and Clarence Brown and Maurice Tourneur (1920). In 1932, the novel was also adapted in the form of a serial of 12 episodes produced by Mascot Pictures and directed by Ford Beebe and B. Reeves Eason, with Harry Carey in the role of Hawkeye. Michael Mann's film follows quite faithfully Philip Dunne's script – besides, he is mentioned in the opening credits – sometimes with exactly the same dialogue (the sequence between Alice and her father around the desertion for example). But in Seitz's version, Cora is not yet this character in search of new life experience; she confesses very quickly to Duncan that she does not love him and falls in love with Hawkeye afterwards. As for Magua, he embodies the pure baddie in the story, while the Marquis de Montcalm comes across as a worthy army officer respectful of the laws. Magua and his troops directly attack Fort Henry in spite of the sedition agreement between Munro and Montcalm. The end and resolution of Mann's film completely diverges from that of Seitz, in which Nathaniel returns to Albany, escapes hanging and agrees to become a scout in the services of the English. Finally, let us note that in Cooper's novel Cora does not fall in love with Nathaniel (the white child adopted by the Indians), but with Uncas. They end up dying together, like tragic lovers.

or the reclaimed space of the clearing, you feel the archaic terror of the great woods'.[73] A place which functions both as a haven of peace and an ephemeral mirage of a New World of which the future founder of the *New York Tribune*, Horace Greeley, is soon going to boast the merits via one famous phrase: 'Go west, young man!' Caught in the pincer movement of two enemy countries, England and Nouvelle-France, who are trying to conquer this new territory, and their respective allies (the Mohawks and the Hurons), these settlers are the collateral victims of a conflict that is less warlike than legislative, since the winner will gain the privilege of imposing on all the inhabitants of the New World a body of laws to which they must submit. *The Last of the Mohicans* focuses on this moment when the law of the powerful has produced not equality but an illusion of democracy, and Mann hunts out here the early stages of this modernity of which all his urban and contemporary films make a rigorous critique.

What the English and the French bring with them is a form of perversion, not of the law, but of the equality of everyone before it, this legalism which will soon be inscribed at the heart of American political philosophy. In Mann's films, the examples are legion, which emphasize the inability of collective action partly because of the

Ali, 2001

development of judicial procedures, which primarily serve those who are at the summit of the economic, and therefore political, hierarchy: it is the case of countless episodes of the series *Miami Vice* which, right in the middle of the Reagan era, tirelessly probe the dark side of this new American economic dream; it is also what shows that aberrant legal argument, 'tortious interference', which allows the CBI consortium to stop the broadcast of the report by *60 minutes* that reveals a shameful truth about the tobacco industry (*The Insider*). It is also the case of Frank (*Thief*), whom the law forbids from adopting a child and has no other *just* solution but to make a pact with the local Mafia. But these legalistic parentheses through which a form of justice seems reestablished against the law, always close very quickly. Mann's films are thus filled with broken contracts, unkept words, toxic pacts which, once revealed, constitute the pivotal points of the script: the deal between Stiles and Dr D in *The Jericho Mile*, the decision by Van Zant, in *Heat*, who refuses to pay Neil McCauley for the stolen bonds and thus triggers the dramatic turning-point in the story; the leaders of Brown and Williamson (*The Insider*) who impose on Jeffrey Wigand a renegotiation of the confidentiality contract following his sacking; the allies of Dillinger who turn on him as soon as economic power changes side, or Max, the taxi driver of *Collateral*, who accepts the offer made to him by the hit man Vincent then gets cold feet when he realizes that a part of the terms of the deal (the business visits are murders) has been hidden from him. Every time, apparently egalitarian contracts function as alibis, smoke screens, covers with which economic power and its nebulae rule the real world. In *Public Enemies*, Anna Sage, the Romanian prostitute nicknamed the 'Lady in Red', finds herself forced to help the FBI in its hunt for Dillinger – she is the one who will alert the Bureau to the public enemy number one coming out of the Biograph Theater on 22 July 1934 – in exchange for the cancellation of her extradition. But after Dillinger's death, she receives only half the sum asked for and will be expelled from the United States in January 1936.

At no moment does Mann film justice and its exercise as an independent and respectable entity, guarantor of moral and democratic principles. It is not even desirable: in *Collateral*, the prosecutor played by Jada Pinkett Smith confesses to Max that she feels sick during the night before she speaks in court. In *Public Enemies*, the hearing, before the Senate, of J. Edgar Hoover, turns into a settling of accounts with a judge

[73] Pierre-Yves Pétillon, *L'Europe aux anciens parapets*, Seuil, Fiction et Cie, coll. 'Essais', 1986, p. 21.

that the head of the FBI accuses of corruption, the G-Men use torture when they feel like it, while John Dillinger's lawyer gets his client to stay in his prison in Indiana, following a ranting, even parodic, indictment which caricatures the grand principles of the institution and turn them against it. 'You my opposer when I want freedom. You my opposer when I want justice. You my opposer when I want equality. You want me to go somewhere for you, but you won't even stand up for me in America, for my rights and my religious beliefs, you won't even stand up for me here at home,' says Ali to his detractors when, on 19 June 1967, he refuses to withdraw his 'antipathic declarations' before a jury entirely composed of Whites.

At first judged ineligible for conscription, Ali is, for strictly

The Last of the Mohicans

ideological reasons, declared fit a few months after and summoned by the army's recruitment service. In front of the civil servant who calls him by his slave name, 'Cassius Marcellus Clay', Ali chooses to stay silent, before an FBI agent appears and handcuffs him for refusing induction. 'They're coming after you. Because they're scared of black militancy in the inner cities,' his friend and journalist Howard Cosell had warned him, thus formulating the hidden political agenda of a justice system *under control*. In this immense hall as cold as a tombstone, with its individuals crushed by an imposing architecture, Mann then chooses to briefly isolate a detail, a royal eagle in marble overlooking this small democratic theatre like the symbol of implacable oppression. Filmed from below, this monumental raptor is a Janus, both symbol of the United States (the famous white-headed eagle) and Cerberus hawk of the interests of the economic and political powers. Finally, at the beginning of *The Insider*, Lowell Bergmann and his team ask themselves about the legal status of explosive information held by Jeffrey Wigand, former director of research at Brown and Williamson, and especially the confidentiality clause which was contractually imposed on him by his ex-employers. Mike Wallace, the programme presenter, argues that it is an issue of public health and that for this reason, Wigand has the right to say what he knows. 'They don't need the right. They've got the money. The unlimited chequebook. That's how Big Tobacco wins every time. On everything. They spend you to death,' a lawyer retorts.

The Last of the Mohicans returns to the origins of this process of subjection of justice and describes the progressive covering of a civilization founded on the respect of one's word, the honoured contract and the search for conciliation (the Mohawks and the Great Sachem of the Hurons) by a legalistic superstructure beholden to interests which advance masked. 'The white man came,' says the Great Sachem before opening his tribal council, 'and night entered our future with him' ('L'homme blanc est venu et la nuit tombe sur notre avenir'). The unilateral law that the British Crown tried to impose on all those it considered as its new subjects placed, de facto, the Indians, and even the first settlers, in a position of illegality, since the principles and values which regulated their life before were, in the middle of the eighteenth century, no longer recognized by the believers in European modernity. 'I thought British policy is, "Make the world England", sir,' Major Duncan Heyward curtly reminds General Webb, whom he accuses implicitly of wanting to negotiate with the settlers their participation in the war. But to the word kept by some (the Mohawks) as opposed to the lies of others: the Marquis de Montcalm betrays Magua, who is driven by a sole obsession, that of avenging the murder of his children by the French army; General Webb betrays Munro by dispatching no help to his fort; Colonel Munro betrays the militia men by forbidding them from leaving the fort to protect their family and even ends up sentencing Hawkeye to be hanged for sedition. From then on, the degree of betrayal becomes proportional to the power one obtains, a way of pointing out twice the misdeeds of modern civilization: firstly by the emergence of an arbitrary and unjust law backed by those who possess power, then, via a hiatus which will not stop growing between human values and the environment fabricated by modernity. '*The Last of the Mohicans*', writes Mark Wildermuth, 'reveals the hypocritical application of the British post-Lockean concept of the social contract and underscores how this application poisoned the ability to make any contract on an equal basis, which, in turn, poisoned modern post-eighteenth-century law'.[74] From this point of view, the future heroes of Mann, from Ali to the hacker in *Blackhat*, appear as the direct descendants of the Mohawks, of men still resistant to any form of subjection or belonging – which also explains why Mann is not a filmmaker of the community, even less so of the people, but of solitary individuals for whom independence and integrity, whatever

[74] Mark Wildermuth, 'The Commodification of justice', in *The Philosophy of Michael Mann*, Steven M. Sanders, Accor J. Skoble and R. Barron Palmer (ed.) University Press of Kentucky, 2014, p. 186

the cost, constitute the supreme values. Even the couple does not resist this iron law which produces, de facto, an existential solitude which Neil McCauley in *Heat* summarizes limpidly: 'You wanna be making moves on the street? Have no attachments. Allow nothing to be in your life that you can't not walk out on in the 30 seconds flat if you spot the heat around the corner.' That is to say the myth of the American hero who, from Nathaniel (*The Last of the Mohicans*) to Gatsby via Ethan Edwards (*The Searchers*), is born, lives and dies alone. To the Crown envoy who, at the beginning of *The Last of the Mohicans*, asks him to join the militia, Nathaniel makes a riposte that is also programmatic, almost a Mannian manifesto: 'I do not call myself subject to much at all.' On the other hand, the British Empire prefigures all the despotic systems which are encountered throughout Mann's cinema, from the big financial corporations to the Mafia and/or criminal networks, from the FBI to the Nazi regime in *The Keep*.

Everything starts in the vicinity of the Cameron's house, when there appears a Crown envoy who has come to recruit settlers to swell the ranks of the British army. 'For King and country!' he says from his saddle. Present, Hawkeye and Uncas watch from a distance, rather perplexed, at this attempt at enrolment. And for good reason: they remember a contract already broken between them and the French, who had provided Mohawk lands for the Abenaki Indians. But Jack Winthrop, the settlers' spokesman, ends up accepting the English proposal, on condition that he can obtain, from General Webb, the real terms of the contract and above all, the possibility of leaving the army's ranks if their homes are attacked. The meeting takes place at the headquarters in Albany, in a dark room, amidst stiff and rigid-looking officers, a way of emphasizing, already, the inflexibility of this new English law. Winthrop signs but finds himself, like his fellow men, immediately threatened with prison if he refuses to fight with the army. For there exists a blind spot, an unsaid in the exchange that the place, all stiffness and zones left in the dark, translates visually and validates: here, the contracting party is written off in the name of a global geopolitical interest, the contracts signed by the English have no value in themselves, just like the anteriority of the native Indians on the land. They can be rewritten, revised, even cancelled to suit higher interests. Deep down, Webb, an emblematic figure of the Crown, has contempt for all that is not English, starting with General Munro, whom he disdainfully calls 'the Scotsman'. It is an England that considers itself dominant ('make the world England') and which wages this War of Independence as a

political evangelization mission. As always in Mann's work, narrative corresponds, as well, to a discursive logic which develops and makes precise this inaugural bias, this implicit idea of a cultural and racial superiority in the light of which is fashioned the legal system that the Crown wants to impose. In spite of the testimonies of the soldiers, Mohicans and of Cora, which all attest to the massacre the Camerons have been victims of, Munro refuses to let the militia leave the fort to bring help to the settlers' families exposed to attacks by the Indians and thus breaks the contract previously made. In front of them, he argues there is a lack of proof, but in private he confesses to Duncan the true reason for his refusal: 'Who empowered these colonials to pass judgment on England's policies in her own possessions, and to come and go without so much as a by-you-leave?' 'Do the rules of English law no longer govern ? Has it been replaced by absolutism ?' protests Winthrop who, faced with this betrayal, decides to evade English authority and rejoin his own. Accused of having assisted the settlers, Hawkeye finds himself, in the name of this variable law, sentenced to death. 'Under a government which imprisons any unjustly', writes Thoreau, 'the true place for a just man is also a prison'.[75] 'They do not live their lives by your leave! They hack it out of the wilderness with their own two hands burying their children along the way,' Cora declares to her father. 'If it's sedition then I am guilty of sedition too.'

Reaffirmed throughout the film, Hawkeye and all parties of the conflict's independence (the settlers, the French, the English and even the other Indian tribes) constitutes the real scandal of the story and its point of gravity. Above all, it retrospectively sheds light on all the central characters of Mann's films, be it Frank (*Thief*), Neil McCauley (*Heat*), Ali, John Dillinger (*Public Enemies*) or Lowell Bergman (*The Insider*). In the audio commentary of the DVD, Mann speaks of Hawkeye as the first American hero, a way of defining insubordination, the primacy of justice over the law and the necessity, sometimes, of civil disobedience as cardinal points of a compass which, in his films, always points in the same direction. On the one hand, a desire for justice which marginalizes those who hold on to it and goes against the law of some men (Hawkeye, Ali, Lowell, Bergman); on the other hand, a tendency to reveal the criminal processes of institutions whatever they may be, described as so many radical and logical extensions of a society founded on late capitalism.

[75] Henry David Thoreau, *Resistance to Civil Government*, 1849.

Men of justice

In counterpoint to these false egalitarian contracts, Mann devotes, at the end of *The Last of the Mohicans*, an entire scene to the way in which the justice of the native Indians is discussed and dispensed. The contrast is striking, and what happens under our eyes functions *already*, in the year 1757, as a *memento mori*. Accompanied by his family and his three trophy-hostages (Cora, Alice and Duncan), Magua goes to his tribe and asks for an audience with the Great Sachem, in the hope of being knighted by the Huron elder. But the sudden arrival of Hawkeye who, by sacrificing himself, thus hopes to save the Munro sisters, shakes up the council and forces the old wise man to dispense justice. It is very quickly understood that this justice does not aim to condemn one of the parties and privilege another, Hawkeye or Magua, sacrifice or vengeance. It is rather for the Great Sachem a justice of conciliation and balanced consensus, which knows only *particular cases* and which will know how to reduce, even calm down, conflicts between different parties. That also supposes being able to reverse a decision, to amend it, according to the objections formulated by each party. Thus, the Great Sachem hears the joint request by Hawkeye and Duncan who ask him to spare Cora, who has been sentenced to death as a form of consolation for Magua. Duncan takes her place and perishes by fire, while Hawkeye leaves with the young woman. But this way of dispensing justice, at once direct, simple and devoid of ulterior motives, will not resist the establishment of a new legalistic system. The final scene buries in blood the Great Sachem's verdict and with him, a form of justice still disconnected from the interests of an imperialist hierarchy.

If Hawkeye embodies the utopian side of the film, it is Magua who possesses the finest (most cynical?) political vision of the situation. He understands that this new legalistic system will soon overcome the ancestral rituals of his people and tries to adapt to it. Furious at the decision taken by the Great Sachem not to apply this law of retaliation that he was waiting for, Magua, on the grounds that he has proven his qualities as an uncontested war leader, now wants to draw advantage, on the terrain of the law, from his dominant position, as if, by dint of dealings with the Europeans, pacts and various alliances, the English legalistic poison had ended up spreading in his veins.

Magua: 'Now, the French, also, fear Huron. That is good. When the Huron is stronger from their fear, we will make the new terms of trade with the French. We will become traders as the whites. Take

land from the Abenaki, furs from the Osage, Sauk and Fox. Trade for gold. No less that the whites, as strong as the whites.'

 Nathaniel: 'Would Magua use the ways of *Les Français* and the Yengeese? Would the Huron make his Algonquin brothers foolish with brandy and steal his lands to sell them for gold to the white man? Would Huron have greed for more land than a man can use? Would Huron fool Seneca into taking all the furs of all the animals of the forest for beads and strong whiskey? Would the Huron kill every man, woman and child of their enemy? Those are the ways of the Yengeese and the *Français* traders and their masters in Europe infected with the sickness of greed!'

'I am interested in West Coast criminals who come out of West Coast prisons', Mann explained at the time of *Heat*'s theatrical release in 1995. 'They're nothing like their counterparts in New York or Chicago. They stand out from the latter in a strange way; they have still principles and gestures dating back to the ancient West. Most West Coast thieves or burglars are independent, there is still a Jesse James side to them. If you practice the same profession in New York or Chicago, you cannot afford this luxury, you must have close links with organized crime which forces you to resell the proceeds of your burglaries to approved fences.'[76] Frank (*Thief*), Dillinger (*Public Enemies*), Neil McCauley (*Heat*), Lowell Berman (*The Insider*) and even Nick Hathaway (*Blackhat*) all share a system of values which attaches them fully to those men of the old West for whom the word given, trust, moral rectitude and being true to yourself sometimes oblige to oppose the constitutive forces of modernity and transgress the laws that flow from them. Mann revives here, by transposing it to the contemporary period, a strong preoccupation of certain westerns of the 1960s and 1970s, and in particular those of Sam Peckinpah, for whom modern law, because of its natural subordination to an emerging American capitalism, instinctively provokes, if not distrust, then in any case scepticism. In Peckinpah's work, as in that of Jean-Pierre Melville, the march of history often turns against former companions, be they William Holden and Robert Ryan, separated by new economic forces in *The Wild Bunch* (the Pinkerton agency that uses the law to establish its monopoly), or Pat Garrett and Billy the Kid in the film of the same name, whose friendship shatters against the wall of a law which creates between them a sad and fatal antagonism. This nostalgia for a time when a few principles

[76] Interview with Samuel Blumenfeld, *Les Inrockuptibles*.

sufficed to produce justice is found throughout Mann's films, starting with *Heat*, which could be envisaged as a late and corrected rereading of *The Wild Bunch*.

If the thought of Henry David Thoreau infuses all of Mann's cinema, the inspiration, indeed the intellectual proximity of his films with the author of *Walden*, comes out clearly in *The Last of the Mohicans* and, 10 years later, in *Ali*. There is, of course, in Hawkeye and Walden that same anxiety, almost a melancholy at the origin of an environmentalist consciousness, in the face of the metamorphosis of the world provoked by the transformation of space and industrialization. Hawkeye's first appearance, as a sort of noble savage moving in osmosis within surrounding nature, is both reconstruction (as if we were there) and memory (there was a time when). But it is above all *Resistance to Civil Government*, the founding text written by Thoreau in 1849, which constitutes not only the essential source of Mann's relationship to the question of justice, the law and individual freedom, but also one of the matrices of the pacifist imaginary and the anti-establishment activism of the 1960s of which, let us not forget, Mann was a contemporary. The notion of civil disobedience, which gradually enters the minds of the Mohicans and the settlers, follows the necessity of opposing to arbitrary authority a form of revolt. For Thoreau, it was born in 1840 when, as a protest against the slavery policy of the American government, he decided to no longer pay his taxes, thus displaying the 'sovereign expression of the perfectionist desire to be in accord with the best of oneself'.[77] It acts as a reminder of humanity, of its essence, to a country which little by little was ceding terrain to the commercial and legalistic logic of the coming industrial revolution. 'I would remind my countrymen that they are to be men first, and Americans only at a late and convenient hour. No matter how valuable law may be to protect your property, even to keep soul and body together, if it do not keep you and humanity together', Thoreau wrote in 1854.[78] Better, civil disobedience is necessary in the name of democracy and a literal reading of the American Constitution. Revolt against a system which turns out to be tyrannical (the British Crown in *The Last of the Mohicans*, the American government in *Ali*, a criminal contract in *Collateral*, a Mafia network in *Thief* or a

[77] Sandra Laugier and Albert Ogien, *Pourquoi désobéir en démocratie?*, La Découverte, 2011, p.12.
[78] Henry David Thoreau, 'Slavery in Massachusetts', 1854.

media-economic power in *The Insider*) thus constitutes, in Mann's work, a systematic moment of revelation, even epiphany: it is the violent opening of the emerald curtain behind which appear finally, and *truthfully*, all the Wizards of Oz of our world of mirages and hidden agendas. 'Can there not exist a government in which it is not the majorities which actually determine what is good and what is bad, but rather conscience?', and then that famous sentence which Mann places, almost word for word, in Hawkeye's mouth at the start of the film: 'I think that we should be men first, and subjects afterward.'[79]

Finally: strictly individual, civil disobedience does not aim to initiate a collective movement nor to be converted into political action. It is an apolitical way of thinking, almost a sixth sense which runs throughout Mann's filmography, often quietly, as in the series *Miami Vice*, for example, and which sometimes bursts out magnificently, as in *Ali*. 'I always know when *I know*,' confesses the boxer from Louisville to the one who will become his first wife, Sonji.

Abrams for the Defense

In 1986, after the two successful seasons of *Miami Vice*, Michael Mann thought up for NBC, with the help of former policeman Chuck Adamson, a new series, *Crime Story*, about the hunt for the gangster Ray Luca (Anthony John Denison) by Lieutenant Mike Torello (Dennis Farina) in 1963. After a pilot written by Abel Ferrara and a salvo of episodes devoted to the classic opposition between the world of the mobsters and that of the police, the series made a sidestep, a sort of widening of focus which, in the sixth episode ('Abrams for the Defense', broadcast on 14 October 1986), decenters the crime story and concentrates on an ordinary news item: in a poor neighbourhood of Chicago, a black tenant (Hector Lincoln, played by the young Ving Rhames), whose young son has just been bitten by a rat, hits his landlord, an American of Polish origin (Sturkowski) who has made a fortune in real estate by renting out run-down apartments. Accused of grievous bodily harm, Hector is defended by David Abrams (Stephen Lang), a lawyer who, in his own words, has chosen to place himself on the side of those who 'have the wrong skin colour and speak the wrong language'.

[79] Henry David Thoreau, *Resistance to Civil Government*, 1849.

Written by Michael Mann, the story of *Abrams for the Defense* follows in the footsteps of a less naïve than idealistic lawyer who still believes in the power of justice. This grandson of Atticus Finch (*To Kill a Mockingbird*, by Harper Lee) has seen his father, a lawyer for the Mafia, rise up the social ladder thanks to dirty money and intends to prove that in America, when Mr Smith goes to the Senate, he can still win. To a journalist played by Pam Grier who asks him if he is going to quote Marx or Engels in front of the court, Abrams replies that the honesty of the American justice system should suffice. Of course, he is mistaken. By taking the side of the disadvantaged, and therefore those without power, Abrams experiences, in the course of the story, his own disillusionment and discovers the perverse logic underpinning the institution. Behind the reassuring mask of an egalitarian justice lurks that modern law implanted in America two centuries earlier and integrally linked to the economic interests of a few. That is to say, a formidable tool for alienation and exploitation of the weakest that an exchange between the journalist and Sturkowski illuminates in exemplary fashion: after having expounded his conception of liberty, which boils down to an absolute freedom of enterprise and minimal State intervention, he confesses that the only right he gives his tenants is 'to pay or to move out'. Sturkowski embodies here the late, but no less brutal, version of the future General Webb and Colonel Munro in *The Last of the Mohicans*. During the trial, Abrams acknowledges the wrongs of his client and decides to move the debate onto an ethical terrain in the hope that the jury will be sensitive to arguments of a moral order which will counterbalance the inflexibility of the law. Up until what point has a man the right to stand up, in the name of his family, to economic and social violence? 'All men are created equal in the eyes of God,' Abrams continues, 'and no one, individually or electively has any rights to abridge that guarantee. That is simple and clear, and if it is a value to you, your verdict is just as self-evident: not guilty!' The argument has an instant effect and Hector walks free.

'Abrams for the Defense', *Crime Story*, 1986

The episode could have ended on this happy conclusion, a kind of Capraesque victory of the clay pot over the iron pot. A neighbourhood party is thus organized on the ground floor of the building to celebrate Hector's acquittal. A moment of euphoria and dancing, an American mirage of a community protected by the force of an egalitarian justice. They are all there, Torello and his police colleagues, the lawyer, the journalist, the black tenants, reunited like in a fairy tale. But Sturkowski bursts in, hands Hector his eviction notice and says to Abrams: 'It's the law, you tell them!' There is another altercation, where the landlord molests Hector's wife, Hector hits back, Sturkowski falls to the ground and his head hits a breeze block. Disappointed, Torello is obliged to handcuff Hector and arrest him for murder. The camera slowly rises in the air, the crowd breaks aways, everyone goes their own way, while Abrams, alone in the midst of this disaster, like a vanquished righteous man, understands that his realized dream of justice has been only an enchanted parenthesis.

The three-part structure of the script of *Abrams for the Defense* (the economic affront, the illusion of a reestablishment of justice, the tyrannical application of the law) is found in very many episodes of *Miami Vice*, like a leitmotif via which Mann endlessly describes the modern law as a legal means of oppression used by the capitalist Moloch. Right from the pilot (*Brother's Keeper*, September 1984), a small-time dealer, at the wheel of a gleaming car, rejoices at the way his country functions: 'free enterprise Dude, is the basis of western democracy', he says to the undercover cop Sonny Crockett, that is to say a motto for the series, beyond its pastel and sparkling veneer, will tirelessly describe the true cost, the dark side and the ravages. Later we discover that a colleague of Sonny Crockett has let himself be corrupted in order to meet the needs of a handicapped son ('36 grand in Scott's union medical expenses last year alone, I make there a lousy 38 a year to get shot by guys who blow that much in a restaurant in a month,' he tells Sonny before his arrest). In *No Exit* (episode 8, season 1), Bruce Willis plays an ordinary gangster, misogynistic and arrogant, who finds himself in court for beating his wife. But his status as a rich man mixing with the authorities allows him to escape a sentence and it is the victim, forced to take the law into her own hands, who kills him and is sent to prison. *Rites of Passage* (episode 17, season 1) follows the downward spiral of a female student from Brooklyn, Diane, caught up in a network of high-class call girls in Miami. When her older sister Valerie (Pam Grier) tries to help her, Diane, under the blinding charm of this easy life, argues

that no regular or legal work could earn her as much money as the occasional sexual encounters with rich diplomats. The young woman will be murdered and then avenged by her sister, who will thus choose the bars of a cell over injustice. In the well-named *Bought and Paid For* (episode 10, season 2), Nico Arroyo, the son of a Bolivian ex-general turned banker (Tomas Milian), rapes and bullies with impunity a young Haitian woman whose father has bought silence, up until the day when Gina, a policewoman from the Miami-Dade Police Department, decides to shoot him dead in cold blood. Once again, the powerlessness of justice dependent on a law held by a few privileged people forces the most disadvantaged to bow down and some of its representatives to break it.

Ali unbowed, the making of a historic myth

> 'Men make their own history, but they do not make it just as they please; they do not make it under circumstances chosen by themselves, but under circumstances directly encountered, given and transmitted from the past.'
> Karl Marx,
> *Le 18 Brumaire de Louis Bonaparte*, 1852.

With *Ali*, in 2001, Mann tackles an icon of American popular culture, one of the most emblematic figures of the 1960s and 1970s, to whom countless novels, fictions, documentaries (including the exemplary film by William Klein in 1974 and that of Leon Gast in 1996), articles and other writings have been devoted; even Muhammad Ali himself, twice, printed his legend: in his autobiography *The Greatest: My Own Story* in 1976 (co-written with Richard Durham) and, a year later, at the cinema, when he played himself in front of the modest camera of Tom Gries (*The Greatest*). It is also, to this day, the only time when Mann dealt straight on with that decisive decade of American history (1964–74) which secretly haunts his entire oeuvre.

Ali

A first script of *Ali*, written by Stephen Rivele and Christopher Wilkinson (scriptwriters of *Nixon*), with Will Smith in the role of the boxer, dragged out for several years in Hollywood, and Spike Lee was long tapped to direct it. Constructed as a flashback from the 1978 fight 'Thrilla in Manila', the film recounted, in Mann's own words, a 'spiritual evaluation through suffering' in which he did not believe. When he got down to the project with his scriptwriter Eric Roth (*The Insider*), Mann followed in the footsteps of the book *Redemption Song: Muhammed Ali and the Spirit of the Sixties* (1999) by Mike Marqusee, a London journalist, writer and activist who described Ali as a figure of resistance and the avant-garde. 'For me, the end of the movie was the "Rumble in the Jungle" in 1974', Mann said. 'I think that the formation of this universal identity, as we know it today, occurred in the months preceding this fight. He [Ali] has become a model for people all over the world. He began to personify, illustrate and represent certain aspirations and the fact that it was possible to disobey. Ali stood up to the most powerful government in the world. He showed a kind of intransigence and had the courage and fortitude to say that it was possible. That's Ali's story: keeping your principles and not giving them up.'[80] In the United States, *Ali* was released on 25 December 2001, but Mann, unhappy with the first version, twice re-edited it, first for its televised broadcast in 2002 and secondly for the DVD release in 2016 – it is to this day the version most faithful to the original project. 'It needed to be reorganized, or re-authored, in a way. If all drama is conflict – and I believe it is – then I needed to make more it more tangible that lots of adversarial elements had arraigned against Ali, and that they were all connected [...]. You get the pressure impacts on his family, so that Belinda (played by Nona Gaye) believing that George Foreman is going to kill him reads as more a lack of faith. And basically, it connects those elements more to FBI/COINTELPRO operation, the CIA surveillance, and how they all link.'[81]

The film begins on 24 February 1964, the eve of the fight facing the man who does not yet call himself Muhammad Ali but Cassius Clay against Sonny Liston, for the world heavyweight champion. The opening scene constitutes one of the summits of Mannian art, a virtuoso interweaving of fragments and visions of the past life of Ali by which Mann introduces his character, not as a spectator among others of a matric moment in American history, but as one of its incarnations. First image,

[80] Words from the French press dossier of *Ali*.
[81] *Rolling Stone*, 26 January 2017.

in the early hours: Cassius Clay is running alone on a big, deserted avenue in the black neighbourhoods of Miami, deframed, like a fugitive that a police car, *as a matter of principle*, is going to stop. The sequence ends with his triumphant entrance in the stadium of the Miami Beach Convention Center where his adversary awaits him. Between these two shots, which already tell, in miniature, the story of an *appropriation* by a single man of a sporting and political frame, Mann chooses to immediately place the figure of Ali at the centre of an array of images and events which borrow as much from the life of the young boxer as from the recent history of America, establishing between the two a relationship that the film, two hours and 45 minutes, is going to unfold and shed light on. It is grasped from the start: here, unlike the huge majority of biopics produced by Hollywood, there is no family trauma or circumstantial Rosebud which might explain in psychological detail the brilliant trajectory of an individual gifted with a talent, but a clear line immediately broken by an impressionistic, fragmented, reticular structure based on the relationships between sometimes enigmatic shots which borrow first from the political thriller and drive the point home, to that of the institutional racism with which Ali has been confronted since his earliest years, this 'de facto apartheid' evoked by Mann in the audio commentary of the film. This long opening sequence – nearly 10 minutes – sets out a programme: basically, the sporting talent of Ali, already widely described and analysed when Mann launches into the project, interests him less than the way in which this man and the history of which he is a contemporary made each other.

Mann's ability to say without dwelling, his art of ellipsis and the *intense attention to detail* find in *Ali* a particularly fertile testing ground, given the mass of biographical and historical information to mine, the infinitely open field of narrative possibilities and above all the complexity of a character to recreate far from any hagiographical approach – in other words, an invitation to envisage Ali in all his facets and those of his time, the symbol, the showman, the idol, but also the weaknesses, bad husband, absent father, someone little educated but powerfully intuitive, impressionable (his fluctuating, indeed imprecise, relationships with The Nation of Islam), and as a formidable sponge capable of grasping, like nobody else, the spirit of his time.[82] A short scene (the young Cassius

[82] Ali is a blotting pad. At the start of the film, we see him watching, on television, Karl Freund's *The Mummy* (1932) in the company of his daughters. He will replay the famous walk of Boris Karloff during the press conference in Kinshasa, while imitating Foreman, whom he then compares to a mummy.

advancing through the 'Coloured only' section of a bus in Louisville right up to the horrifying newspaper cover devoted to the lynching of Emmett Till in 1955) is thus enough to remind us of the segregationist nightmare and the racial context in which Cassius had been brought up. Another poses the problem of identification to which his generation has been confronted (Cassius dubious in front of the white Christs his father paints to earn a living); it announces his desire to resurrect this dead and humiliated Black, to give back its place and pride to this people whom white power has taught to hate itself. By proclaiming himself 'The Greatest' at the moment when he became heavyweight champion of the world, Ali paved, with others, the way for a 'Black' movement which, at the end of the 1960s, claimed its African origins and became 'beautiful'. In 1967, Aretha Franklin demanded 'respect' and on 7 August of the following year, James Brown recorded his *Say It Loud: I'm Black and I'm Proud*. The film never seeks to circumscribe Ali as the sole sporting or media figure, but envisages him, on the contrary, as a symbolic and encompassing prism, always *connected* to the world around him. The sequence of the assassination of Malcolm X, carried out on the stage of the Audubon Ballroom in Harlem on 21 February 1965, is exemplary of the way in which Mann seeks, whenever he can, to place Ali at the heart of big history. Edited in parallel with shots of the boxer at the wheel of his car, Malcolm's death is revealed to him by a passer-by who rushes towards him ('They killed Malcolm!'). Stunned, Ali then pulls down on the roadside, switches on the radio, then his eyes well up with tears, to the rhythm of a song written by Sam Cooke in 1963, *A Change Is Gonna Come*, which functions here in the way of a choir: 'Then I go to my brother, yes sir/And tell 'em, I say brother can you help me please/But he winds up knockin' me/He knocks me back down on my knees/Oh there's been times that I fall/Somebody say yeah/ Life could pass me on, no no/I know I'm able, I'm able, I'm able/I'm able to carry on.' Around him, time seems to have stopped still, bystanders gather on the sidewalks. Mann begins to isolate Ali in the image, out of modesty but especially with a concern to attune the sadness of one man to a collective sorrow, toggles the focus of the boxer to the background. 'I'm able to carry on,' repeats the song like an interior voice, but retrospectively, it points to the symbolic responsibility which falls at this instant upon Ali, that of perpetuating, by his own means, the vision and the fight of the man with whom he has just broken a few months previously. For his biographers, his estrangement from Malcolm X was perhaps the only regret of Ali's life.

The world on his shoulders

We understand this from the first minutes of the film: Ali carries, to use Sartre's words, the world on his shoulders. And his entire epoch: the ghosts of segregation and the emergence of the Civil Rights Movement, the Vietnam war and the uprising of the black ghettos, the government pressures and the fear of radical activists, the role of The Nation of Islam and the secret actions of the FBI, the lynching of Emmet Till and the separatist preaching of Malcolm X. Here, everything converges and seems to aggregate in an extreme way on the speedbag he punches with determination. The boxer from Louisville is then only 22, but he and this America simmering with injustices and dreams of change are on the point of exploding together, as shown by the concentrated look of Ali, the visual leitmotif of the sequence, which stares at the same time at his ball and, in the distance, at an undefined point, the short term (his match the following day) and that existential horizon whose content he does not yet know. The parallel editing between scenes of humiliation and/or of racial oppression and Ali's training allows Mann to establish a link of cause and effect between social commitment and the sporting arena. Ali will respond to that he and his people have suffered, he will oppose it, but in and from the ring. He is just waiting for the right moment, and his thunderous entrance in the weighing room before the match indicates that this moment has come: 'Sonny Liston, you ain't no champion, you're a chump! Float like a butterfly! Sting like a bee! Rumble, young man, rumble!'

'The young man you've all been waiting for,' announces a voiceover on the first black screen of the film. But Mann defers the appearance of the man in question – Sam Cooke,[83] the young soul singer, whose five songs punctuate the sequence – and opens the film with images of Ali filmed by digital camera, grainy images, as if taken on the spot, which, in Mann's career, announce a new aesthetic direction that all his subsequent films (from *Collateral* to *Blackhat*) will explore further. 'It was something that happened quite by accident', Mann recalls. 'I shot a couple of pieces, and we were able to light them by taking a tiny flashlight and bouncing it off a card. We were shooting a human being, working out on the roof, and he sees these fires in the distance. I was stunned by this one quality it had, which was not like moviemaking: There was a truth-telling

[83] Even if, on a symbolic level, the sequence rings true since Ali is indeed the man that all Black America is waiting for.

Opening sequence, *Ali*

Opening sequence, *Ali*

style to the visuals, and the emotions were more powerful because it didn't feel theatrical.'[84] On the one hand, the iconic image of Cooke, framed in profile, a silhouette cut out by the club's projectors in front of a floor full of enamoured female spectators; on the other, its raw, deglamorized, hyperrealist flip-side; a technique which Mann used again several times: to film the Chicago riots which, in April 1968, set alight the western neighbourhoods of the city in the aftermath of the assassination of Martin Luther King and which Ali, *always at the centre* of present history, contemplates from the roof of a building,[85] to transport us into the heart of the boxing fights in the head of the adversaries; or in the long night sequence which precedes and follows the meeting with the lawyer Chauncey Eskridge when the champion, at rock bottom, ruined, banned from fighting, boycotted by The Nation of Islam and cornered by a political power which symbolically wants his skin, is forced to agree to a chain of restaurants to exploit his name in order to sell hamburgers. This is the winter moment of a trajectory violently interrupted by his condemnation on 20 June 1967 for refusing induction – loss of his license and title, a $10,000 fine and a five-year term of imprisonment. The alternated *montage* between these two sets of images – Ali in the streets and Cooke on the stage of a club – shows right from the start one of the aesthetic, and therefore political, stakes of the challenge awaiting Ali: How to reconcile these two images? How to feed one with the other? How to reduce the gap between them?

On the evening of this first victory over Liston, the entire nation, via television which is then on a spectacular rise, has its eyes fixed on the ring, but the viewers do not all have the same reading of the event. For some, they are witnessing the birth of a new hero, a model to follow. For others (the successive administrations, from Kennedy to Nixon, The Nation of Islam, the FBI), here is a possible counter-power emerging, an icon of the black community whose influence will have to be watched and tamed at a time when racial revolt is brewing everywhere. The abrupt transition, at the end of the sequence, from the popular energy that seizes the ring to a silent shot framing, face on, the sombre face of the leader of The Nation of Islam, Elijah Muhammad, thus emphasizes the two dynamics at work in the film, the two genres it weaves to the point of vertigo, the biopic and the political thriller: on the one hand, a human and sporting storm that nothing seems able to contain, on the other, often

[84] www.vulture.com/2015/01/michael-mann-profile-career-blackhat.html.
[85] Some of the shots used in this sequence – such as that of the man throwing a Molotov cocktail in the street – are taken from footages of *17 Days Down the Line*, which was filmed in the streets of Albuquerque.

opaque forces of control which will do anything to master it, in the shadow or in the light of a biased justice. From then on, all the acts and words of Ali thus have immediate public repercussions, which the montage, which systematically interweaves small and big history, constantly emphasizes. His status as world champion has exploded his private sphere and Ali lives from now on *wiretapped*. The chance encounter between him and Malcolm X in Liberia immediately takes on a political significance to decode, from the very instant when their conversation is observed by two agents of the FBI posted in a hotel bedroom. Well before his political pronouncements on the Vietnam war, Ali bursts onto the radars of power, just as Frank, in *Thief*, entered the sights of the police and Mafia networks at the precise moment of his meeting with Leo. After he has announced to Herbert Muhammed (Barry Shabaka Henley) that he is going to marry Sonji, an *a priori* anodyne sequence shows Ali in this training gym, in the foreground, surrounded by his inner circle, Howard Bingham, Bundini and Angelo Dundee. But very quickly, a change of focus from the foreground to the background moves the object of our attention from Ali to a small television which, to general indifference, broadcasts the famous and unique encounter between Martin Luther King and Malcolm X, on 20 March 1964, when the two men had just attended the Senate hearings on civil rights. Is this an image anticipating what Muhammad Ali will represent according to Michael Mann, that is to say a man mid-way between leader of the ghettos of the North and that of the South and the Christians, the embodied combination of a necessity for integration and a response 'by all means necessary' (but not violent) after more than a century of segregation? A few minutes later, two members of the FBI worry about this handshake, discuss the new strategy to adopt in the face of what they analyse as a worrying development in the black protest movement, and one of them points at a photo of Ali published on the front page of a newspaper: 'We gonna talk about this guy too.'

On the day after his victory over Sonny Liston, Ali, a freshly designated popular hero, walks down the streets of Harlem, in the midst of a crowd of admirers and journalists in a hurry to record his first words. To one of them he declares: 'I definitively gonna be the people's champion. But I just think I won't be the champ the way you want me to be the champ. I'm gonna be the champ the way I want to be.' But the way in which Mann films the sequence amends this slightly thunderous declaration of principle, as if it contained a knowledge to which Ali does not yet have access. Does he then know what champion he will be? Does he know

only the nature of this people he brandishes like a flag? The young boxer, then full of arrogance and naivety, believes at this instant in the euphoria that follows victory, a sort of popular plebiscite without consequences, an easy connection between self and world. However, headwinds are blowing up all around him, agents of influence are already pinning him down, like friendly guardians (Malcolm X, who accompanies him but refuses to speak about his conflict with Elijah Muhammed) or interested ones – that FBI agent infiltrated into The Nation of Islam and whom Mann ostensibly frames as soon as Ali replies to a journalist that he will not be a champion 'like Joe Louis'.[86] For The Nation of Islam, the new world heavyweight champion is not just a star recruit, a new charismatic envoy that the prophet and Malcolm X fight over, but also, and perhaps above all, an important source of income, a particularly profitable investment who must be pampered. Contrary to the customs of The Nation, Cassius even received his new name scarcely a few days after his victory: he became Muhammad Ali on 6 March 1964. This complex balance between fidelity to a sincere religious commitment and the awareness, passed on by those closest to him, of exploitation by a profit-making organization whose support varied according to his market value, constitutes one of the enigmas that Mann leaves in suspense. 'I love the Nation, Herbert. I love Elijah Muhammad. But it don't own me,' says Ali to Herbert after his victory against Jerry Quarry in Atlanta in October 1970. But at the same time, to the consternation of his second wife Belinda (Nona Gaye), he entrusts him with organizing his next fight against Joe Frazier.

Vietnam

Just after his refusal of enlistment in 1966, Ali replies on the telephone, from his hotel bedroom, to a journalist who asks him to explain his decision. 'I know where Vietnam is. It's on TV. Southeast Asia? Well it's there too? What do I think about who? Vietcong? Man, I ain't got no quarrel with them Vietcong. Ain't no Vietcong ever called me nigger.' At the forefront of the protests against the Vietnam war, at a moment when American opinion was still largely in support of its army's intervention in Southeast Asia, the majority of American institutions turned on Ali and made him to pay dearly for his 'antipatriotic declarations'. The indomitable

86 World heavyweight champion for 11 consecutive years (1937–1949), Joe Louis was the first black sporting hero hailed by the Whites. Some have accused him of being their Uncle Tom.

Ali made an act of *civil disobedience* in reaction to a system which promoted a war he considered unjust and tyrannical: 'I'm fighting the entire US government', he declares to Howard Cosell (John Voight) on ABC. In *Sports Illustrated*, the journalist Jack Olsen wrote: 'The noise changed into a din, into the drums of a holy war. Radio and television commentators, old ladies, bookmakers, priests, Pentagon strategists from their armchairs and politicians of all stripes united their voices in a crescendo demanding "the head of Cassius".'[87] Ali refused all opportunities to retract and apologize, or even make amends, thus welding together the two major lines of protest in American society which, previously, advanced separately: on the one hand, the black revolution, on the other, the refusal of the draft and opposition to the Vietnam war. In 1967, the pastor King showed for the first time his rejection of the war: 'As Mohamed Ali says, we, the blacks, the Viets, the poor, are all victims of the same system of oppression.' 'The FBI considered him more dangerous than me or Rap Brown', wrote Stokely Carmichael, president of SNCC and then the Black Panthers. 'Mohamed Ali had a much broader popular base than ours. The government knew its attitude would cause more of a stir than all of us combined. I knew they would hit him the hardest. They would take his title back from him, there was no doubt about it, they would definitely indict him, they would do everything possible to bring him to his knees. Many people refused to go, some ended up in jail, but of all those who opposed the Vietnam War, Ali risked the most.'[88]

Ali is neither an ideologue nor a militant, even less so an activist wishing to convert his popularity into political action, but a deeply intuitive man armed with a unique compass, that of his own desires and of his independence at any price, which firstly pushed him to refuse his name, Cassius Clay, and be baptized by Elijah Muhammad, as if it was making *tabula rasa* of his past. 'Nobody made me. I made me. No one's in that ring but me!' he retorts to his father who accuses him of denying his own genealogy. He is especially seduced by the independent mind of the woman who will become his first wife, Sonji, by her professionalism, her way of mocking dress codes, Afro haircuts and even religious bans, but he gradually understands that this ostentatious display of freedom is just a disguised alienation, another oath of allegiance to the cultural imperialism fashioned by white America.

[87] www.contretemps.eu/mohamed-ali-combats-en-heritage.
[88] Quoted by Frédéric Roux, *Alias Ali*, Fayard, 2013, p. 355.

The 'winter' moment of Ali

Howard Bingham, his official photographer, worries about his statements on Vietnam: 'You know what you're doing, Ali? You know what you just said?' and Lipsyte adds: 'Everyone, Europe to China, every home in America, everyone's gonna know what the heavyweight champion of the world said about the U.S. war.' 'So what? I ain't gotta be what somebody else want me to be and I ain't afraid to be what I want to be, think how I wanna think,' he replies. But, although he does not formulate it yet, what Ali thinks, despite his idiosyncrasy, does not emerge in him *ex nihilo*. If Ali thinks about the world, *the world also thinks in him*. This is why, from the opening sequence of an unusual length, Mann takes care to link Ali's provocations and pronouncements on society to this desire for emancipation and revolution which had been brewing in the black community for decades, as if one dictated the conditions of possibility of the others. This sixth sense guiding him belongs as much to history as to himself, to the spirit of the times as to an individual inclination, and

Ali and Malcolm X

it is one of the originalities of the film to have been able to encompass in this two-headed biopic Ali and his era, an Afro-American and America. Ali in fact reveals himself incapable of repressing a thought, whatever it might be: the brief conversation he has with Malcolm X in front of a hotel in Liberia is suddenly interrupted by a thought which comes to his mind. Firstly, as a voiceover – 'You shouldn't have quarrelled with the Honourable Elijah Muhammad' – this thought gradually separates him from the discussion. His eyes leave those of Malcolm, whose words become scarcely audible, and floats for a short instant in a mental void, a zone of *internal deliberation*. Everything is at stake here: when Ali looks at him again, straight in the eyes, the break between the two men is complete: 'You shouldn't have quarrelled with the Honourable Elijah Muhammad,' he then tells him before turning back. According to Marc Marqusee, 'what explains his decision to follow Elijah Muhammad is that Ali suspected that Malcolm would ask him for a deeper political commitment which would put him in danger.'[89] From the very beginning, this separation is inscribed in the staging which reserves for Ali and Malcolm X two different visual treatments: a calmer way of filming

Malcolm, often fixed and clear shots echoing clear and framed thinking. Conversely, for Ali the unbowed, Mann prefers the shoulder camera, shots in movement, sometimes hesitant, blurred, behind or ahead of the movements of a man difficult to identify. More than a contrast between two distinct styles, it is a political opposition that Mann makes us perceive here, between the precise and affirmed identity of the ideologue and the shifting one of the free man who is still searching for himself.

A few days after the victory against Liston, Malcolm X visits Ali, who is marvelling at a television programme about the ravages caused by termites. The amused astonishment of the boxer at an insect documentary – 'You can have six millions termites in your house and you don't even know it until you go to get something to eat and you busted the floor' – of course symbolizes his naivety in the face of the power of a mass phenomenon that was not seen coming and his weak political consciousness, the opposite of Malcolm X who came to invite the champion to accompany him in Africa. He confesses the extreme difficulty he felt in repressing the rage aroused by the death of four girls in a bomb attack perpetrated by the Ku Klux Klan in a church in Birmingham, on 15 September 1963. At the start of the film, the young Ali attends, from the back of the Masjid Al-Ansar mosque, a speech by the most charismatic ministers of The Nation of Islam who, against the non-violence and integration propounded by Martin Luther King, preaches the law of retaliation: 'To those of you who think you came here today to hear us tell you, like these Negro leaders do, that your times will just get better, that we shall overcome, someday, I say to you: you came to the wrong place.' Ali listens, soaks in these words, but already stands at a distance from Malcolm X, without being part of this audience committed to the cause. The film does not rule on the deep causes which, in May 1964, led Ali to distance himself from Malcolm X, but it demonstrates the preacher's considerable influence on him. On the content: his opposition to the war and to white power, or the positive affirmation of his skin colour. On the form: his ability to transform his sporting exploits and noisy declarations into outlets for disadvantaged black youth, that oratorical talent which he developed in contact with him, learning from Malcolm X the way with words, the rhetoric and the verve, finally his storytelling qualities, illustrated by that imaginary match against Joe Frazier which he invents live on ABC. 'Ali gives the impression of a man trying to convince himself that he made the right choice in choosing the Messenger over Malcolm', Howard

[89] Quoted by Frédéric Roux, *Alias Ali, op. cit.* p. 233.

Bingham said. 'Years later, he would feel shame for having turned his back on the man who had guided his thoughts and been like a parent to him.'[90]

The visceral attachment of the Mannian hero to his independence explains not only his strongly individualist dimension, but also his reluctance to produce, by his cause or his actions, the collective, to make of himself the perimeter of a vaster group. Even if his words find an important echo among the majority of American Blacks, Ali does not aim to build beyond the ring some community of interests or situations – the ability of an attitude and of an idea to propagate to the point of making a people, emblematic of classic Hollywood cinema, is always debunked in the work of Mann who, as an heir to the American critical cinema of the 1970s, always distrusts those who speak in the name of others.

Like Nathaniel in *The Last of the Mohicans*, Murphy (*The Jericho Mile*), Neil McCauley (*Heat*), Lowell Bergman (*The Insider*) or John Dillinger (*Public Enemies*), Ali must find, even invent, the modalities and the meaning of his independence, which is measured by his ability to stand up to the forces who try to control him – his opposition to the Vietnam war, his refusal to be drafted and its consequences take up more than a third of the film. This independence is not a quality that goes without saying. It is conquered, and as always in Mann's work, possesses a downside and a cost. Following his refusal to be drafted, Ali is thus kept away from the rings for three and a half years. But unlike most of the other Mannian heroes, whose existential quest is not in tune with a popular cause or a political commitment,[91] Muhammad Ali ends up accomplishing this and finds, in Africa, the people of which he wanted to become the champion.

Kinshasa, the epiphany

From a young age, Ali endlessly stocks up images, but it will take him years of successes and failures, of paradoxes and stubbornness to finally understand and make correct use of them. The emergence of his identity takes place in October 1974, when he arrives in Kinshasa, Zaire,[92] for the famous 'Rumble in the Jungle' which will pit him against George Foreman

90 *Ali, le film et l'homme,* Editions 84, 2001, p. 61.
91 Even if John Dillinger, right in the middle of the Depression, becomes despite himself a sort of heroic figure for the poorest. In *The Insider*, Jeffrey Wigand exposes a public health scandal.

and towards which the whole film converges. Ali is 32 years old. The story does not mask the economic and political interests that surround this sporting Barnum nor the scarcely concealed motivations of its two principal Geppettos: promoter Don King, who here plays the sporting and social card to realize a juicy financial operation, and the president of Zaire, Mobutu, a corrupt and grotesque leader, who sees in this fight the opportunity to put his country at the centre of international attention. Very quickly, a tense discussion faces Ali and his second wife Belinda, revolted by the way in which the two men manipulate her husband regardless of the physical risks. She points out to him what Ali, in reality, knows already: King, this 'dashiki-wearing rip-off',[93] is worth no more than Herbert. He 'talks black, lives white and thinks green'. To which Ali replies: 'Clean cut Muslims parading on the South Side of Chicago don't get this done!' The boxer is not fooled by this manipulation and chooses, like a strategist familiar with the functioning of power relations, to see the glass as half full. After all, King has succeeded in organizing the first Black championship in Africa, thus offering the opportunity to show to disadvantaged Blacks of both continents an event which takes place in a place where their ancestors were reduced to slavery, a fight directed at those that the promoter, during the press conference, calls the 'Black proletariat', an expression which is, however, just a commercial slogan for him. More precisely, Don King uses Ali, but Ali uses him in turn, like a Trojan horse, the end justifying the means here since in the United States, the sport constitutes one powerful armed wings of soft power. A few minutes after Ali's victory against Foreman, King rushes over to the champion to congratulate him, but the latter symbolically spurns him and reasserts at the same time his independence. Powerful and systematic as it is, the critique of capitalism in Mann's work never goes as far as its rejection, since it is with its own weapons that you fight it, mitigate it and can even benefit from it.

Filming from the air, with a high-angle vertical shot, the camera firstly follows in Ali's footsteps, who runs on the dirt roads of Kinshasa, before going back down to his height. Thus begins one of the key sequences of the film, as if a responsibility had just fallen, literally, on the champion's shoulders. In his wake there soon gathers a disparate crowd of supporters

[92] The fight in Kinshasa is in reality filmed in Mozambique, in the Machava Stadium in Moputo and not in Zaire, which in the meantime became the Democratic Republic of Congo.

[93] Let us note that Don King played his own role in the double episode *Down for the Count* in season 3 of *Miami Vice* in 1987. There is a question of match-fixing and the episode ends on the death of Zito.

acclaiming him. Dispossessed of himself, filmed in slow motion like a chrysalis in symbolic full transformation, Ali is grabbed by children who lead him in front of a series of frescoes painted in his glory on the walls of the city. Faced with these drawings representing him as a mythological figure defeating tanks, malaria and Foreman, Ali finally understands the meaning of his fights and the nature of the people he wanted, 10 years earlier, to become the champion of. These drawings constitute the opposite, at 20 years distance, of those white Christs that his father painted to make a living, like a reappropriation through the image, *icon for icon*. His opposition to the American government, his personality (summed up by his catchphrase 'Stings like a bee!') and his sporting career now form just a single motif by which the three 'Ali's harmonize and reconcile. At 7,000 miles from home, to the rhythm of the 'Ali, boma ye!' ('Ali, kill him!') chanted by the crowd and of *Tomorrow* by Salif Keita, the boxer from Louisville reaps the rewards of his independence of mind and of his tenacious fight against injustice. The making of the Ali myth, which constitutes one of the key questions of the film, here reaches its culminating point.[94] It is at this precise moment, and at the beginning of the bout which will pit him against Foreman, when thousands of spectators applaud him as he enters the arena of the 20 May Stadium, that Ali no doubt identifies that undefined point he was staring in the beginning of the film: that point where, having finally *become what he is*, he attains a form of universality which goes beyond him and obliges him, as champion and hero of this international of oppressed peoples which Malcolm X had wished for. Ali's story obviously possesses a messianic dimension that Mann does not eliminate. That is to say the story of a man who becomes boxing world champion, is stripped of his title and goes on to fight with extraordinary determination to reconquer it to the cheers of an entire continent for which he has become a messiah. When Foreman, after an injury, threatens to return to the United States, King asks Ali to help him and uses a biblical metaphor which echoes the status freshly acquired by the boxer in Africa: 'Be Moses, in reverse. Do not let my people go. Stay the fuck right here, in Egypt, if you'll pardon my Swahili.'

Few people have faith that Ali will beat George Foreman, the 25-year-old mastiff who has just knocked out Frazier and Norton. But Ali has studied

[94] It is one of the key moments in the trajectory of Ali, which prefigures the arrival of John Dillinger, acclaimed by a crowd of bystanders, at the moment when he is transferred to a prison in Indiana.

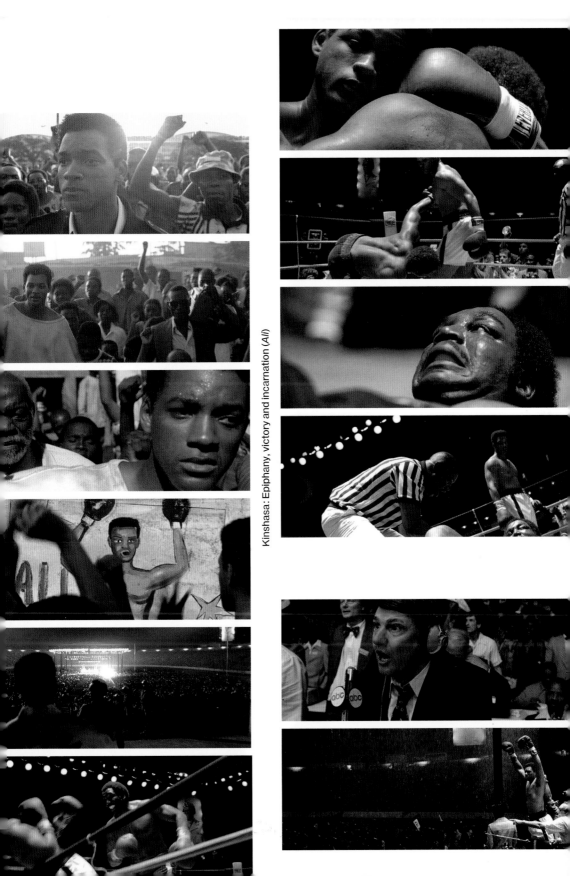

Kinshasa: Epiphany, victory and incarnation (*Ali*)

his adversary's style, his way of fighting, and understands that endurance is his weak point. After eight rounds spent taking hammer blows from Foreman, Ali, less exhausted than his adversary, senses his time has come. On the last chords of *Tomorrow*, he throws a series of fatal punches. On his last legs, Foreman wavers then collapses like 'a tree in a forest' (Howard Cosell).[95] It is the culmination of Ali's sporting career and symbolic aura which, after his victory at the Supreme Court over the American government, changes scale to be fulfilled with the people for and with which he has just won. In Zaire, Ali becomes aware that being in harmony with himself was the *sine qua non* condition for his popularity, much more than a part of his sporting career, which he has been right to sacrifice. By understanding what happens in the ring only acquires its power from what takes place outside of it, Ali finally resolves his internal tensions between the individual and the collective, self and community, social commitment and sporting practice. The people's champion celebrated here is as much the man who has just won back the title of world heavyweight champion, as the one who, against negative forces, knew how to remain faithful to his convictions and intuitions. In this respect, Ali has become an inspiration.

At the end of his victorious fight, Ali climbs on to the ropes of the ring and stands up, with outstretched arms, towards the spectators, while throughout the stadium fly American and Zairean flags. Suddenly, a torrential rain beats down on the stadium and the shot freezes on this image of a statue-like Ali, in perfect communion with his people. Are we dealing with, as it is written in the Bible, the arrival of time of rejoicing via this 'spring rain watering the earth',[96] or an ephemeral moment of grace that Mann chooses to make last as if to prolong its magic? Ali's final triumph is, like that of Murphy in *The Jericho Mile*, almost unique in the filmography of Michael Mann, who is more inclined to close his films with moments that are tragic (*Heat, Public Enemies*) or sadly uncertain (*The Insider, Blackhat, Miami Vice*). But this *frozen triumph* will not last eternally, in the same way that the landscape contemplated by Nathaniel and Cora at the very end of *The Last of the Mohicans* only becomes grandiose because it is on its way out. After all, nothing changes in Folsom prison after Murphy's victory, and the consecration of Muhammad Ali does not put an end to racial oppression.

[95] We think here of the end of *Gentleman Jim* by Raoul Walsh (1942) and the victory in extremis of Jim Corbett (Errol Flynn) against the boxing champion John I. Sullivan (Ward Bond). Even Ali's footwork is reminiscent of Flynn's.

[96] Book of Hosea, VI, 3.

4.
THE
PROFES-
SIONALS

Michael Mann with Al Pacino and Robert De Niro on the set of *Heat*, 1995

Heat, 1989/1995

Here is a film that Michael Mann shot two times. A gang of professional robbers led by Neil McCauley attack an armoured car right in the heart of Los Angeles and snatch bearer bonds. But the operation turns to carnage because of Waingro, a violent ex-con recruited at the last moment in order to temporarily reinforce the team. McCauley and his gang – Chris Shiherlis, Michael Ceritto and Trejo – decide to eliminate Waingro, but the latter manages to escape. On the advice of Nate, the man who brokers the scores, McCauley agrees to sell the bonds back to their owner, Roger Van Zant, a corrupt businessman. The operation fails. The investigation is given to Vincent Hanna, a battle-hardened lieutenant of the LAPD. Between him and Neil, a long hunt begins.

1989: *L.A. Takedown*, 10 days of preproduction, 19 days of filming, lesser known actors (Scott Plank and Alex McArthur, who had just played the role of the assassin in William Friedkin's *Rampage*), the cathodic backdrop and a filmmaker still searching for his *grand form*. In other words, a television movie of 92 minutes conceived as the pilot of a television series for NBC, which would never see the light of day.

1995: *Heat*, months of preproduction, 107 days of shooting, $60 million, two icons finally together, Robert De Niro and Al Pacino, and the same filmmaker who, with this film, would reinvent the crime movie and establish himself as one of the greatest stylists of contemporary American cinema. Profiting from the commercial success of *The Last of the Mohicans* and from an industry that opened its doors wide to him, Michael Mann launched into the production of what would become his *magnum opus*, *Heat*, or the *L.A. Takedown* he had dreamed of. In Michael Mann's career, *Heat* is a tipping point, at once centrifugal (all his cinematographic and televisual experience of the 1980s lead to it) and centripetal – *The Insider*, *Collateral*, *Miami Vice* and *Public Enemies*, an abstract re-reading of *Heat*, could not have seen the light of day without this imperious crime film directed in 1995. A way also of recapitulating a genre, the crime film and its existential blackness, which, from John Huston to

L.A. Takedown, 1989

Jean-Pierre Melville, seemed, one day, to end on that elegiac shot of a cop holding the hand of his deceased alter ego. How to survive this tragic confrontation between Pacino and De Niro which seems to summarize the genre and put an end to it? *How to come after* this sumptuous conclusion? How to re-ignite the flame after such an extinction? In the revue *Film Comment*, Richard Combs writes of *Heat* that it is '*The Killing* directed by a Kubrick which would have the ambitions and the power of *2001*.' And the author notes the discrete homage that Mann pays to Kubrick via the use of a short extract from Gyorgy Ligeti on the first encounter between Pacino and De Niro. *Heat* also opened, for Mann, an astonishing decade as, between 1995 and 2006, he successively directed *Heat, The Insider, Ali, Collateral* and *Miami Vice*. During these 10 years of intense activity, he kept away from television – after the mixed success of *Ali*, he returned to it a single time, in 2002, as executive producer of the series *Robbery Homicide Division*. At the time, Mann undoubtedly imagined that he was done with the small screen and that *Heat* was going to allow him, finally, to devote himself exclusively to cinema. A short sequence of the film functions almost as a metaphor, even a *parapraxis*, of the ambiguous relationship he always had with television: one evening, Vincent returns home and discovers his wife, Justine, in the company of a man, Ralph, comfortably seated on the living room sofa. Vincent then concentrates his anger on a switched-on small television and snatches it violently. 'You can ball my wife if she wants you to. You can lounge around here on her sofa. In her ex-husband's dead tech, post modernistic, bullshit house, if you want to, but you do not get to watch my fucking television set!' A few minutes later, in front of a bus stop, Vincent opens the door of his car and, with a kick, ejects the set, which shatters on the tarmac. What is this about? On the one hand, the reaffirmation of something which belongs to him and sums him up (the televisual oeuvre of Mann is then more imposing

'This stuff just flies through the air. They send this information out and it's beamed out all over the fucking place.' (Heat)

than his cinematographic one at the time of *Heat*), and on the other, a furious will to get rid of it.

Written at the end of the 1970s, in parallel with the script of Ulu Grosbard's *Straight Time*, the original script of *L.A. Takedown* (180 pages reduced to about a hundred for the television version) constitutes less the first draft than the dramatic matrix of a cinema to come, a reservoir of plots and motifs that Michael Mann would draw on in most of his crime films, from *Thief* (Frank's rigid doctrine, his photographic collage as form of intimate utopia, the inability to make the private and professional spheres coexist) to *Public Enemies*. After having tried, without success, to produce its big screen version,[97] Mann seized the opportunity offered to him by NBC to test his epic script in the form of a rehearsal, in the theatrical sense of the term, but on a miniature scale, as much from the aesthetic point of view as the economic. Seen in the rearview mirror of *Heat* and according to a strictly comparatist approach, *L.A. Takedown* possesses, to borrow the lapidary expression used by Mann in one of the bonuses of the DVD, a flavour comparable to that of an 'freeze-dried coffee' next to 'a grand arabica'. But the face-to-face between these two versions invites us less to look in the same way at two false twins than to adopt two distinct ways of looking at the same film, taken at two moments of its elaboration. 1989/1995: everything resembles, and everything differentiates, in an ironic echo of the couple Hanna-McCauley. Everything is similar: the characters and their relationships (a duo formed by a cop and a gangster), most of the screenplay's twists and turns and dialogues, certain shots (the face-to-face between the two men cut identically in *Heat*), musical themes (Eady's escape on the heights of Sunset Plaza) and documentary sources, starting with Chuck Adamson, a member of the Chicago police, who served as model for Mike Torello, the cop played by Dennis Farina in *Crime Story* in 1986 and for the characters of Patrick McLaren/ Neil McCauley in *L.A. Takedown/Heat*. And everything is different, starting with the story's denouement. Doubtless for budget reasons, Vincent's hunt for Neil ends, in *L.A. Takedown*, not on the tarmac of Los Angeles Airport, but inside a hotel. Neil McCauley is shot dead by Waingro, the psychopathic enforcer hastily hired for the opening

[97] In the middle of the 1980s, Mann proposed to Walter Hill to direct *Heat*, but the latter declined the offer.

The spaces of Los Angeles
in *Heat*

Los Angeles, *downtown*
in *Collateral*, 2004

heist, and it is Vincent Hanna who settles his account. To the reconciliation accomplished between Justine (played by Ely Pouget in *L.A. Takedown*) and Vincent conversely, in *Heat*, the impossibility of the couple by Hanna himself in the waiting room of a hospital. A timid and narrow sketch on the one hand, a monumental and elegiac fresco on the other, the narrowness of the cathodic aquarium against the extent of the cinemascope, everything, in fact, contributes towards the crushing of the prototype. However, the embryo of *L.A. Takedown* finds its rightful place on the formal trajectory of its author as the work plan of a great film to come, in the same way Mann prepared that of *Miami Vice* (2006), 15 years later, with the series *Miami Vice* and *Drug Wars: The Camarena Story*.[98] The director finds his bearings inside a city, Los Angeles, in which he is filming for the first time, stocks up fast on images and impressions (mural paintings, night fog, ochre lights, aerial shots, hard geometrical effects) which will reappear in *Heat* then *Collateral*. *L.A. Takedown* belongs fully to the 1980s (Billy Idol, sports cars and impeccable blow-drys), continues its flashy aesthetic, but in a minor, darkened, distant key, as if Mann already had his eyes turned towards the mineral postmodernism of *Heat* and *The Insider*. Beyond the compression imposed by the televisual format (less scenes, less characters, less digressions…) and obligatory primacy of plot twists over the psychology of the characters, the vision of *L.A. Takedown* thus enables us to envisage Mann's watershed film from its origins and the immense path covered since. And this path is a secret, a grand form of melancholic (oxymoronic?) action that Mann would have taken almost 20 years to perfect: to push to its philosophical limit the principle of the image-action specific to classical American cinema in order to explore its tragic down side – alienation and desolation as abutments of professionalism – and add it to this image of time and of doubt inherited from the 1970s of which he is still today the sole and authentic heir. Basically, *L.A. Takedown* is *Heat*, but placed in the wrong box, a box which makes images but not shots, oblivion but rarely time, which tolerates rest, even distraction, but not contemplation. *L.A. Takedown*

[98] *Drug Wars: The Camarena Story* is a miniseries (3 episodes, 4 hours 30 minutes) from 1990 of which Mann was the executive producer. It relates the affair of Enrique 'Kiki' Camarena, agent of the Drug Enforcement Administration who was kidnapped by the Medellin cartel, tortured then killed. Drawing on the investigation by Camarena's colleagues, the series returns to the ambiguous position of the Reagan administration concerning Mexico and the war on drugs, and describes the generalized corruption of Mexican institutions. We find here some of Mann's obsessions, starting with the difficulty of combining work and life in a couple.

thus reaffirms the validity of the law and the positivity of action, which allows you, *in fine*, to go beyond and resolve all the lines of opposition in the story – it is probably the limit of the televisual object, which accepts psychological conflict but not metaphysical doubt. *Heat* would go the opposite way. By digging right down these same lines, it reaches a melancholy, almost absurd, gap which leaves these same characters and the viewer on the edge of an existential abyss.

'In *Heat*', writes Mark Fisher, 'it is not families with ties to the Old Continent who plan heists, but teams without anchors, in a Los Angeles all in chrome and interchangeable designer kitchens, a city of monotonous expressways and of diners open all night […]. The specters of old Europe that haunted the streets of Scorsese and Coppola have been exorcised, buried somewhere beneath the international coffee chains, along with the old feuds, resentments and fiery vengeances.'[99] With *Heat*, Mann took up the line opened by Samuel Fuller (*Underworld USA*), Don Siegel (*The Killers*) and John Boorman (*Point Blank*) which, in the 1980s, reprocessed film noir from *overexposure*. The criminal organization that Walker – the main character played by Lee Marvin in Boorman's film – tries to trace bit by bit, no longer belongs to the shallows of the underworld, but acts in the cold and sunlight of Los Angeles. The true gangsters no longer speak an approximate language blended with a Neapolitan accent, but the language of the stock exchange, and the gambling dens of yesteryear now possess the respectable face of free enterprise. Thus, *Point Blank* is less a revenge film (getting back the stolen money) than a metaphysical quest tinted with paranoia on the new masks of power and the economic foundations of the American dream.[100] In *The Godfather*, and even *Goodfellas* (1990), Coppola and Scorsese describe, in reality, a world which has already disappeared, with colourful Mafia bosses, observing mysterious rituals and codes inherited from a family history often born in Europe, and having built their fortune at the time of an economic Fordism that became obsolete in the 1970s. In contrast, the gangsters of *Heat*, but especially of *Collateral* and *Miami Vice*, are contemporaries of what is called post-Fordism, that stage of capitalism characterized by the globalization of finance and consumption.

[99] Mark Fisher, *Capitalist Realism: Is There No Alternative?*, 2009.
[100] Let us note that in the very last shot of *Thief*, Frank, wounded, reappears through the bottom of the frame, exactly like Lee Marvin returns from the dead (the prison of Alcatraz) at the start of John Boorman's *Point Blank*.

In the middle of *Heat*, Neil McCauley visits Kelso (Tom Noonan), a sort of enigmatic intermediary supposed to provide him with all the technical details necessary for the robbery of the Los Angeles bank. The man lives at the heights of the city, in a modest house, surrounded with antennae and satellite dishes. Visibly intrigued by the extent of Kelso's knowledge, Neil asks him how he found all this information. 'Just comes to you. This stuff just flies through the air. They send this information out and it's beamed out all over the fucking place. All you have to do is know how to grab it. See, I know how to grab it.' Such a scene would have been unthinkable in the classical world of gangsters, which would have sought to motivate, through the screenplay, the link between the informer and the information, between the medium and the message (an informant, a relative, an indebted individual or a man being blackmailed, even tortured?). Here, Kelso embodies this virtual and volatile world dominated by technologies of communication and information.

McCauley and his gang are shareholders, speculators who invest in all sorts of markets, heist professionals who work together, not because of belonging to an age-old Mafia or for a personal motive but with the prime aim of making profit. This is why, with the exception of the restaurant sequence, *Heat* contains no moment of camaraderie, since the condition for the possibility of this association of robbers resides in their essentially utilitarian and ephemeral links. It is fuelled neither by friendship nor by a family history in particular, but by private interests, and only exists in the one-off articulation of an opportunity with a precise technical competence. Everything is played out, and is assessed, on a case-by-case basis, by temporary agreement. Thus, the meeting between Neil, Chris, Michael and Trejo which precedes the robbery of the downtown bank resembles more a discussion between pragmatic entrepreneurs who evaluate their respective risks as if it was a question of investments on the stock exchange than a meeting of old school mafiosi forced to act *also* in the name of loyalty to the clan. 'If I were you, I would be smart. I would cut loose on this,' Neil says to Michael, after having reminded him of the solidity of his financial situation. The stay-at-homes of the Scorsese's films, always attached to a place, a family or a neighbourhood in particular, have given way, in Mann's crime films, to nomads without attachments who move in a dehumanized, ahistorical and precarious world.

That does not mean that between certain members of the gang (Neil and Chris, for example) there cannot form a sort of friendship,

Opening sequence, *Heat*

Mirages of the Fiji islands and disappearance (*Heat*)

complicity or fidelity (Trejo) which goes beyond the strict frame of their objective interests. For in *Heat*, as in all Mann's films, nothing is ever as clear-cut. There is what these men in grey suits would like to be (technicians of crime indifferent to emotions) and what they are really, and this tension is inscribed in each of them: Chris Shiherlis squanders the family capital through his gambling addiction, Michael Ceritto seeks in crime a sort of vital intensity he lacks and Neil dreams of horizons that are incompatible with his trade. The robbery of the Los Angeles bank marks the beginning of their fall and the fateful disruption of a modern machine that they believed to be perfectly oiled. Their humanity gradually wins out, calculation gives way to the unexpected (Donald Breedan, co-inmate of Neil in the prison of Pelican Bay, is hastily recruited to replace Trejo) and old feelings again dictate behaviours. For the better (the saving of Chris) and for the worse, since it is because of an immemorial emotion (revenge) that Neil will never achieve his Fijian dream.

Incompatible trajectories
(*Heat/Collateral*)

Diagonals, straight lines, crossroads, freeways as far as you can see, and then the Pacific Ocean, *L.A. deadline*. Frontier of a desire, that of the Old World of course, of which America was once the most beautiful dream. 'The Sky Chief', says of Lake Michigan an old fisherman to Frank at the beginning of *Thief*. Los Angeles, a reticular mega-city in love with its infinite horizon, sleepwalking city-desert, crystalline hell and artificial paradise 'where everything communicates without two people's eyes ever meeting',[101] where the headlamps of the cars and the luminous signs mix with the piercing eyes of coyotes (*Collateral*). At the start of *Heat*, Neil McCauley meets Eady (Amy Brenneman), a young graphic designer who invites him for a drink at her house in the heights of Sunset Plaza. A long conversation begins between them, with the backdrop of Los Angeles at night, a sea of sparkling lights that Neil compares to the iridescent seaweed of the Fiji Islands, his intimate utopia. But Michael Mann emphasizes at the same time the artificiality of the shot, and therefore of the desires expressed there,

[101] Jean Baudrillard, *Amérique*, Le Livre de Poche, coll. 'Biblio essais', 1986, p. 60.

since the couple seems plated on a background to which it *visibly* does not belong. Rather than linking through the depth of the field the characters to the urban background and optically ratify the possible actualization of their desire, Mann and Dante Spinotti treat Los Angeles like a projection surface, an inaccessible and inconsistent mirage which says their relationship lacks perspective, in the literal sense (a blue screen on which is projected the L.A. skyline[102]) as well as in the figurative: McCauley will never reach the Fiji Islands and the hypothesis of the couple will end in the limbo of a motorway tunnel suddenly invaded by a dazzling, almost unreal light: a moment of epiphany for Neil, who realizes that he is fundamentally also a blank page which, far from expressing the promise of a story written by two hands, offers the spectral image of his inanity. In Mann's work, the possibility of the couple never goes beyond (or rarely: *Manhunter*, *The Last of the Mohicans* and *Blackhat*) the stage of virtuality. It remains suspended like a thwarted power, a horizon never reached (Vincent Hanna and Justine in *Heat*, John Dillinger and Billie Frechette in *Public Enemies*, Sonny and Isabella in *Miami Vice*) or destroyed (the Wigand couple in *The Insider*, Frank and Jessie in *Thief*, Chris and Charlene in *Heat*).

In Mann's films, we lose count of those shots where the characters, filmed in short focal length, appear stuck onto a decor, like disembodied individuals caught in the net of a cold and bluish geometry (*Heat*). A world-aquarium, in short, found everywhere: the psychiatric cell of Dr Lecktor (*Manhunter*), the editorial room of CBS (*The Insider*), or the apartment-fishbowl of Neil McCauley with its big bay windows open on to (visually) but closed to (physically) the sea. Encrypted in closed and transparent spaces, the Mannian characters are all like James Caan and Willie Nelson in *Thief*, forced to communicate in a visiting room and to pretend not to know that the window separating them, in reality, exists. Extreme visual communication is not real opening on to the world. It is also the screen that separates Will Graham and Dr Lecktor when they first meet in *Manhunter*, or the glass tomb of the taxi driver in *Collateral*. For Michael Mann, glass is not just an architectural element,

[102] Mann wanted to be able to unite in the same shot the two actors and the lit-up nocturnal panorama of Los Angeles – the sequence was filmed on the heights of Sunset Plaza – but the weak sensitivity of the 35mm film did not allow it. It was Dante Spinotti who then had the idea of installing on the balcony of the house a blue screen behind the actors and to project on it a film of the city.

the sign of a mineral and specular urbanity, but a *relationship to the world* of which Los Angeles, city of paradoxes, offers the perfect metaphor. Transparency vs opacity, flux vs real human exchanges, fantasy vs reality, closing vs closedness, depth vs surface, so many antithetical events that Los Angeles, like Mann's films, deploys but does not want to resolve. Such appears to be one of the singularities of Mann's cinema, itself located in the in-between of a history of forms which would distinguish classicism from the contemporary, to always envisage anything and its opposite. In other words, to systematically install himself and his characters at the centre of multiple ambivalences that are to be unfolded. Los Angeles enclaves embody but liberate desires; it appears as the result of an aggressive urbanistic policy, but resembles a wild space ('If water is cut off for three days, jackals will reappear with the desert sand', writes Hans Heisler, quoted by Mike Davis in *City of Quartz*); finally, it is the height of an alienating postmodernism ('the cultural logic of late capitalism', to borrow the subtitle of Fredric Jameson's famous work), a deceptive urban mirage, but its multiethnic dimension (the opening sequence of *Collateral*) and the oceanic desires it arouses are enough to give it seductive depth. It is the postcard of the Maldives that Jamie Foxx keeps in his taxi, the frozen image of a paradise *within sight but out of reach*. There exists between Los Angeles and Michael Mann's cinema a natural sympathy, as if the 'city of light' (Neil, *Heat*), 'disconnected and fragmentary' (Vincent, *Collateral*), held the secret and underlying cartography of his films. 'It's not like New York or Chicago where you always know where you are, where the neighborhoods are clearly demarcated, where the architecture largely determines the cultural bustle. Los Angeles would be more like the internet. If you have heard of a site, you can access it, but it is not given to you right away; there is a procedure to follow. You won't see it from the highway.'[103]

In *Collateral*, the red and gold taxi driven by Max crosses the city as much as the city crosses it. It matters little that the camera adopts the open point of view of the city or the closed one of the vehicle, since the direction always embeds them. Throughout the film, Mann thus multiplies the reflection shots – or what is a reflection if not the flip of one image upon another? – and strives to visually confuse the two main spaces of the story. It is the glowing bodywork of the

[103] Interview with Michael Henry, *Positif*, no 524, October 2004, p. 9.

The gunfight sequence in *Heat*, renamed "WWIII" for the shooting

vehicle on the surface of which pass night views of Los Angeles, or those rectangular skylights formed by the taxi windows (small projection windows?) which, by the over framing effect produced, remind one of the narcissistic dimension of the City of Angels, incapable of dissociating reality from its representation. Conversely, it is those aerial shots which transform Los Angeles into a glittering grid – only Bosch's *Hell* gives this impression of blaze, writes Baudrillard in *America* – and reduces those who crisscross it into tiny luminous spots; or the reflection of the taxi that we see at the beginning of the film caged in the mineral facade of a high-rise building. How can we not think here of the opening credits of *North by Northwest*, one of the possible formal matrices of Mann's urban cinema, with its Cartesian coordinates figuring right angle junctions, its interlacing of lines and its promises of encounters, both random (at what point are two lines going to cut across each other?) and strictly determined by the map of the city?[104] For the formal system of Michael Mann is designed to engender crossings, interferences and collisions. Thus, his films proceed not only with an understanding of the modern city – which can affiliate them partly with urban action cinema – but also a *concrete geometry of relationships* where the destinies of men are indissociable from a formal and topographic dynamic which reformulates them. Such are the first shots of *Heat*: two Metro lines, a train approaching and, in the centre, a station platform. Perfect symmetry of the composition in the frame. An ordinary man (Neil in close-up) gets out of a train and takes an escalator. Wide shot: Neil sinks down to the bottom of the frame at the heart of an interlacing of metal structures which efface him. First step towards a physical dissolution imposed by urban space which continues in the following shot: framed from above, Neil is already just a small silhouette progressing diagonally in the frame. But what attracts our attention here, and which visibly interests Mann, are the geometric motifs drawn on the ground: two white lines (an abstract version of the two railway tracks and the two escalators) and a curved arrow at the centre of the frame. That is to say a conceptual programme which pre-exists the fiction and will condition its emergence. The film is structured in fact around these two geometrical figures (the line and the curve) and experiences the passage from one to the other, like the criminal path imagined by the hitman Vincent and

[104] On *North by Northwest* as matrix of contemporary action cinema and modern conspiracy fictions, see the special issue of *Cahiers du cinéma* devoted to Alfred Hitchcock in 1984.

the ability, for Max, to extricate himself from it, found the formal system of *Collateral*. In *Heat*, the straight line is situated on the side of inhumanity, of programming (corridors, tunnels, escalators, highways, etc.), of disappearance (physical and therefore of identity) and *in fine* death (result of all the frontal encounters), while the curve is the sign of a humanity which tries to *make an event* in space, to deprogramme itself, *reconquer itself*. The lines placed in the preamble to the film recall of course the parallel lives of Vincent Hanna and Neil McCauley, and the curve appears as the sign of their respective deviations, of one towards the other and consequently their crossing – in front of the hospital, the statue of a *pietà* prefigures the last shot of the film and the almost liturgical nature of their meeting.

Mann's cinema and Los Angeles, his city of predilection, approach what Marc Augé has called supermodernity, 'a world where you are born in a clinic and die in hospital, where there multiply, in luxurious or inhuman modalities, transit points and provisional occupations […], where there develops a tight network of means of transport which are also inhabited spaces, where the regular visitor of department stores, of cash machines and credit cards reconnects with the gestures of "mute" commerce, a world thus promised to solitary individuality, to the passing, provisional and ephemeral'.[105] In the American city, as American cinema filmed it in the 1970s and 1980s, spaces could be ordinary (from hovels in the slums to residential areas) but embodied and reflected something of the personality of those who occupied them. The modern architecture of a Wright or a Le Corbusier still sought to stand out, inside the urban fabric in which it inscribed itself, through distinctive forms, stilts, remarkable entrances, clear delimitations, while postmodern architecture celebrates on the contrary 'their insertion into the heterogeneous fabric of the commercial strip and the motel and fast-food landscape of the post superhighway American city'.[106] In Mann's work, spaces thus tend towards undifferentiation to the point that nothing really distinguishes a hotel lobby from a private apartment, a business open space from a chic restaurant. Everywhere the same architecture which favours geometrical lines, effects of transparency and crystalline surfaces enclose the individual and expel him. It is trompe-l'oeil contemporary urbanity, this 'dead tech, post modernistic bullshit

[105] Marc Augé, *Non-lieux, introduction à une anthropologie de la surmodernité*, Seuil, 1992, pp. 100 and 136.

[106] Fredric Jameson, *Postmodernism or the Cultural Logic of Late Capitalism*, p. 115.

house' that Vincent Hanna decries on leaving Justine's loft in *Heat*. Is it a coincidence that *Heat* and *Blackhat* end in airports (Los Angeles and Jakarta), non-places par excellence of the contemporary? In this decentered world where each individual is just passing in transit (Vincent in *Collateral*, McCauley in *Heat*, Frank in *Thief*), it is not enough for two trajectories to cross for a meeting to take place.

In *Collateral*, a film which appropriates the topography of Los Angeles and reflects its fluid logic, everything begins with a play of exchanges: exchange of suitcases (prologue in the airport), exchanges of clients (a young woman prosecutor for a hitman), exchange of itineraries, exchange of cars (a postcard for a business card), and later, exchange of tasks between Max and Vincent. Then suddenly, between the taxi driver and the prosecutor we will find again at the end of the film, something is formed, where *each recognizes the lack that eats away at the other*. We then see the beginnings of a mutual attraction which, strangely, takes the form of a conversation between cartographers that Howard Hawks would not have disowned. Amorous discourse but language of experts. How to get most quickly from L.A. Airport to downtown? How to avoid the traffic jams in Santa Monica? What routes to take? In other words: could our trajectories coincide? The conceptual power of Mann's cinema, its tendency to abstraction, also lies in the way in which his films always find a way to convert what they recount into spatial or geometrical paradigms. This systematic interdependence transforms any life line into a trajectory in space and any modification of this line (rupture, curving, deviation) into a spatial bifurcation or a bump in the road. In *Heat*, Neil McCauley, a few miles from a possible escape, changes his mind (revenge before escape, friendship before the couple) and therefore direction; in *Collateral*, finally, Max's destiny develops only through collisions and brutal changes of direction: everything begins with the vertical fall of a corpse-projectile on his taxi, continues on a horizontal bridge from which he throws Vincent's briefcase and ends, and therefore frees itself, through the accident he causes in the heart of downtown Los Angeles.

By pursuing each other,
we always end up meeting (*Heat*)

In line with the formal programme set out in the opening (two parallel trajectories destined to curve towards each other), *Heat* aims finally at a single event: the final reunion of Neil McCauley and Vincent Hanna, Al Pacino and Robert De Niro, hand in hand, together in the last shot of the film. If the direction organizes the face-to-face of the two men four times, Neil and Vincent only meet physically twice. The first time, in a restaurant, fixes the rules that the second, on the approach of L.A. Airport will put into practice. *Heat* unfolds from these two sequences, two emblematic moments in the history of the crime film and of cinema, two encounters which magnetize the film and give it its perspective. For a meeting to take place and have a chance of lasting, the desire of one must connect with that of the other, or the indifference of one must be vanquished by the other's desire. Now, with the exception of the last shot (which I will return to), there are in *Heat* only missed meetings: meetings that are not desired (all the pursuits of the film) or condemned (Neil and Eady), forced meetings – the duels, confrontations and the central sequence of the gunfight – or deadly – all the shots/reverse shots in the axis end in the death of one of the protagonists (Waingro vs the armoured car's guard, McCauley vs Waingro, Hanna vs McCauley, Waingro vs the young prostitute…)

Placed in the middle of the film, the first meeting between Hanna and McCauley sheds light, by its position, on the symmetrical and dialectical structure on which *Heat* is constructed, as much from the point of view of the direction as of the story. Now, if this symmetry supposes an opposition in principle between two antithetical but perfectly complementary terms – one always defining itself in contact with the other – it appears in Mann's work for its dynamic and distributive value. Because what interests Mann is what circulates between the terms, what is exchanged, what is transmitted and what, occasionally, ends up blending together. Between Hanna and McCauley, forced to confront one another because of a dividing line, the law, which deep down they feel secondary, between their respective groups (meals, domestic rows…), but also between the fiction of the genre (crime film) and that of couples (drama) – two fictions that the film interweaves right up to their limit by envisaging the fallout of all the events from one sphere into another. It is because of the time devoted to hunting criminals that Vincent Hanna enters into conflict with his wife, who will even end up flirting

with another man, a certain Ralph, in order to put him to the test. On his side, Neil quickly understands that the marital problems of Chris and Charlene could have poisonous repercussions for his own work. At the start of the film, he makes a call from a telephone box to the businessman Roger Van Zant, but scarcely after the conversation ends, we discover that he had *at the same time* his eyes focused on a motel bedroom situated on the other side of the street. The door opens and reveals a scantily dressed Charlene in the company of an unknown man. By then imposing on her a deal (give Chris a last chance and fulfil his needs if it fails), Neil seeks as much to help his friend as to take care to secure his perimeter of work. When he gets Neil information on a tenacious cop on his heels, Nate, in the hope of convincing Neil to suspend his next score, imparts to Neil the tumultuous state of Hanna's private life ('Three marriages. What do you think that means? He likes staying home?'), as if he was bringing the ultimate, even superior truth about his dangerousness. Finally, the central conversation between Neil and Vincent gradually changes register, passing from their job to their intimate life. The two men confide to one another about their secret obsessions, the state of their social lives, their respective solitudes, then, in passing, Neil reveals that he shares his life with a woman. Vincent does not know it yet, but the revelation of this private detail will be fatal to his *alter ego*: at the end of the film, while a panicked crowd rushes outside the Marquee Hotel, Vincent scans the scene on the lookout for a sign which could put him on the trail of his prey. It is then that he spots, from afar, the presence of woman alone, immobile, who, ignoring the rush of people scattering, seems to wait for her man beside a car. Vincent does not know her name, Eady, he has not even seen her, but he knows, at this precise moment, that he has in front of him the woman Neil mentioned. In *Miami Vice*, Mann will push up a notch this logic of permutation of registers by accomplishing the alliance of the two worlds. The passionate love which is sparked between the cop, Sonny, and the partner of the criminal Mabuse, Isabella, thus mixes with the undercover story, contaminates it, weakens it to the point of putting into doubt the characters' identities. And consequently, one of structuring motifs of the crime film. In this universe of make-believe and globalized exchanges, the relationship uniting Sonny and Isabella is asymmetrical, since if he has fallen in love with a woman he knows everything about, Isabella is ignorant of his hidden side, the fictional identity of the man she is enamoured with.

Did Mann remember the way in which Richard Fleischer, in *Violent Saturday* (1955), had already mixed the fiction of a heist and the description of a small mining town, inviting, as Nicolas Saada finely analyses it, 'Fuller into Minnelli's', the crime film into the melodrama?[107] But if Fleischer rummaged around in the shameful parts of an apparently clean and morally irreproachable population, then gave the robbers some sequences of ordinary intimacy that were infrequent in the genre, Mann hunts for the same within the other.[108] From then on, it is less a question of humanizing or softening the image of those who situate themselves on the wrong side of an uncontested law than of questioning the validity of what separates them *really*. The blood of the old West, of before modern law, runs in the veins of Mann's cinema. From *Thief* to *Heat*, via *The Last of the Mohicans* and *Ali*, he has always dramatized individuals resistant to all form of authority and control – whether it is a criminal organization, a public institution or the American government, it matters little also of these contemporary Mohicans who now live in residential neighbourhoods or drive sports cars. By multiplying, from their first appearance, the echo and rhyming nature between Neil and Vincent, the film develops of course the idea of their resemblance and moves their generic confrontation (the cop against the gangster) over to the simple *fatum*. They are like the two antagonistic characters in *The Wild Bunch* or *Pat Garrett and Billy the Kid* in the film of the same name: men who, on the level of conscience, share similar values but who, from the point of view of modern law, must confront each other. By facing his *alter ego*, Vincent Hanna experiences a crisis that is both ethical and human, since if, from a professional point of view, he must pursue his prey, the man he fundamentally shares the same code of honour, the same nightmares, the same repulsions, the same sense of justice and of work. To such a point that at the end of the film, after the bloody debacle of the robbery of the Los Angeles bank, Vincent and Neil seem to momentarily share out the tasks, as if one was accomplishing what the other desire: the violence with which Vincent treats Van Zant's henchman

[107] Supplement of the DVD/Blu Ray of *Violent Saturday* published by Carlotta.
[108] In *Thief*, the long conversation between James Caan and Tuesday Weld which takes place in the middle of a diner constitutes an intimate sequence of a duration that is abnormal in the classic frame of the crime film (more than 10 minutes), which indicates, from the first film onwards, Mann's desire to interweave the fiction of the genre with that of the couples, as if was already seeking the ideal point of balance where one would be endlessly reactivated by the other (*Heat*).

Encounters (*Heat*)

who has given up Neil and his gang belongs to Neil's psyche, his disgust at cowardice and gratuitous violence (the execution of Waingro at point blank range). But in this America at the end of the twentieth century, because of a law of which Mann has shown, from *The Last of the Mohicans* onwards, the corrupted foundations, these two men cannot cohabit. They are condemned to hunt each other. More film noir than crime film, *Heat* can only plunge head first towards its tragic dead end.

When he confesses to his wife Justine: 'All I am is what I'm going after', Vincent formulates less a theorem about identity (Vincent = Neil) which would ruin the duality on which *Heat* is based and unfolds than he puts to the test the gap between him and his double, between the world of the cops and its flipside, between the modern and the classical, between action and resignation, between the 'neither do I' that the two men say to each other at their first meeting and the visual dividing line that the cutting maintains between them despite everything. For this gap no longer goes by itself. For Michael Mann, who long sought this point of equilibrium between classicism and its surpassing, it is a question of putting into crisis the concept (here, of dualism), but not to put an end to it. 'While returning to classical figures in the construction of the plot and of the characters, [Mann] does not stop putting into peril their unity, without however destroying it',[109] writes Pascal Couté. A Mannian paradox par excellence: how can classicism reinvent itself in contact with the contemporary, with its technological and aesthetic developments? And conversely: can the contemporary come without the prior mourning of classicism? A prolific paradox through which Michael Mann rejoins the great American cinema of the 1970s, that of Monte Hellman (of *The Shooting* notably, whose ending is reminiscent of that of *Heat* since, at the end of the journey, we stumble on our double: literal in Hellman's film, symbolic in Mann's) or of Alan Pakula in their will to loosen links without ever breaking them.

In *Heat*, the effects of symmetry function as so many forces of articulation (between the intimate and the professional, between private space and public space, between the law and its other side, etc) but also of reflection, in the optical sense of the term, since each character, or almost, and each situation possesses its inverted reflection *in the camp opposite*. During the burglary of the precious metals depository,

[109] In Vincent Amiel and Pascal Couté, *Formes et obsessions du cinéma américain contemporain*, Klincksieck, 2003, p. 84.

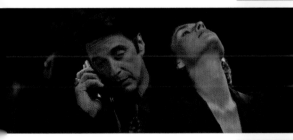
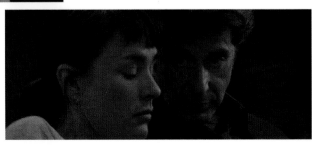

Heat

De Niro positions himself outside the building, in a dimly lit corner and thus catches the eye of Pacino. A first (fake) face-to-face between the two men, or rather their images: the frozen and marble-like face of one against that of the other, literally its negative, which appears on a video monitor. The alternation of their faces, frontal and in close-up, produces a specular effect which expresses the almost organic nature of their relationship. A few minutes later, the same optical device, but this time reversed. McCauley, who knows he is being watched, goes into an industrial zone of Long Beach and misleads the LAPD by giving his associates fake targets, a decoy that the policemen will take seriously before Vincent understands the subterfuge. This time it is McCauley who traps Hanna and turns against him the surveillance device by tangling him up in the target of a camera lens. Resources of symmetry: under-exposure of the first man (darkness, confined space, sombre face) against over-exposure of the second one (luminosity, open space, uncovered face).

After 90 minutes, Neil McCauley pulls over on the side of an L.A. highway. The pursuit between the two men is aborted and ends in a meeting. In the rear mirror, McCauley makes out Hanna's silhouette. The latter approaches and gives Neil a reply with a double meaning: 'How you doing?' This question, even if it is part of the fiction of *Heat*, undoubtedly goes beyond it. Twenty years after *Godfather 2*, in which the two actors crossed each other without meeting (one in the role of the young Vito Corleone, the other in that of his son Michael), it was expected from *Heat* that it would accomplish what Coppola's film had failed to do. Now, it is one of the strengths of Mann's film that he does not seek to erase the extra filmic nature of this encounter, but on the contrary plays *with* the desire it arouses, thus forcing the viewer to envisage all their face-to-face encounters from the dual point of view of the history of cinema and of the story itself. Let us note in passing that the film encodes right from Robert De Niro's dramatic entrance (in the station) the cinephile memory of the viewer – a combination of a light slow motion on the actor's face and a halo of vapour which discretely reminds us of the opening of *Taxi Driver*. Although Al Pacino and Robert De Niro have continued to film since 1995,[110] nobody doubts

[110] In the same year as *Heat*, in 1995, De Niro also filmed in *Casino*, his second swan song. And then *The Irishman* in 2019...

that the most brilliant part of their career ended with this film, thus making *Heat* the flamboyant swan song of the two most gifted actors of the New Hollywood generation.

This restaurant sequence, inspired by a story told to Mann by his friend Chuck Adamson, was the point of departure for the writing of *Heat*: 'He met the real Neil McCauley in 1963, before shooting him dead during an armed robbery. Shortly before, they had seen each other in a café and had talked for a while together. [...] Adamson, during his meeting with the real McCauley, told me that he was fascinated by his discussion with him even though he did not expect to find such a fascinating guy and, very quickly, their conversation had revolved around the fact that one of the two would inevitably kill the other.'[111] Then starts the central sequence of the film, which, firstly economically, allowed *Heat* to see the light of day. A face-to-face of six minutes and 24 seconds between the two most fascinating actors of American cinema of the last 30 years. Shot and shot, returned blow for blow. Rigorous, metronomic and perfectly symmetrical alternation. It is worth remembering the disappointment of many critics who regretted that Mann did not frame the two actors together, a stance which even aroused controversy over the reality of their physical co-presence during the filming. An idiotic controversy – rapidly refuted by the photos showing the two actors on the set – but understandable since no shot in the film effectively attests to their meeting.

Throughout the sequence, Mann holds, obstinately, the editing of shot/reverse shot, which generates a *paradoxical* meeting which brings together as much as it distinguishes. Robert De Niro and Al Pacino face one another, but they do not share the same shot. If there is a cut, this is firstly because Neil McCauley is resigned to this meeting more than he wishes it. From his point of view, the separation of the two men on screen appears logical, it says nothing other than the reformulation, by the direction, of a one-way desire. First reading: Al Pacino and Robert De Niro are two personalities, two irreducible actors whose mythical aura does not authorize sharing. Second reading: the rigorous symmetry of the cutting (each narrowing of the shot is immediately repeated in the following shot) creates a mirror effect between them. The metaphor appears limpid: one is the inverted replica

[111] Interview with Samuel Blumenfeld, *Les Inrockuptibles, op.cit.*

of the other, his false twin. Neil McCauley and Vincent Hanna resemble one another (modern aspect of the sequence) and are different (classical aspect). In *Heat*, as in Michael Mann's cinema, a certain modernity corrects the classicism, *rectifies* it, and vice versa. This caesura, this *cutoff*, finally plays on expectation, and finally on the retention of a wide shot which will not come, including in the final sequence.

On his way to the L.A. airport in the company of Eady, Neil receives a call from Nate (Jon Voight) informing him the place where Waingro is hiding, the human grain of sand who has jammed his group. What for Neil is simply a detour (a bullet in the traitor's head) transforms, on leaving the hotel, into a dead end, when his eyes meet Vincent's. He abandons his other half, Eady, but not his double. After Neil sounds the alarm, the sequence begins with the evacuation of the Airport Marquee Hotel and therefore of the frame, as if it was a question of emptying the space around these two men and extraordinary actors. Opening of space, the incoming closure of a life. From the human commotion that reigns outside the hotel to the no man's land of the approach at LAX, is put in place a process of figurative and visual purification of the frame. A grandiose fight is promised, less Leonian (here, there is no distance) than Melvillean. The film could have been called *Le Samouraï* ('Godson' in English) or *Un Flic* ('Dirty Money'). Gradually emerges a deadly and monumental geography which confers on the duel a metaphysical dimension. In a few seconds, we pass from a stifling and noisy urbanity (the shouts, the crowd movements, the sirens of the vehicles…) to an anonymous and informal space, at the limit of wilderness, as a preamble to the deep and essential nature of what is going to come. At the heart of this barren arena are left only a few primordial elements: cubes flanked by red and white squares – there is the grid and the geometrical requalification of space – some planes landing and others taking off – there is Neil's desire in counterpoint to his *big night* – and then the lights of the runway which, intermittently, sweep the frame – there is the ethical flickering, the moral indecision, the definition of the Neil-Vincent couple in short, condensed in a luminous problem. The light does not arbitrate the duel, it does not intervene to reassert its primacy in the middle of the shadows, it constitutes on the contrary the visual power which undermines it. By turns drowned in darkness or dissolved by dazzling overexposure, Neil McCauley and Vincent Hanna try to survive, in other words resist figuratively to their opposite force: the light (the law) for the former, shadow (his anguish) for the latter.

In the middle of the cubes, the two men move, stalk each other, and Mann still does not compromise: to never have them appear together in the frame. Thus we pass alternatively from Pacino to De Niro, but the editing, less cutting than during their first encounter, softens their differences, attenuates what separates them. Via a series of tracking panoramic shots, the camera thus endlessly links the bodies of the two men, from the face of one to the weapon of the other, from a look to a weapon, etc, producing, through montage, the illusion of one and the same body. A recomposed body which would be that of both men and offer, for the viewer, the fantasy of a reconciliation, since it is true that in *Heat*, identification suffers from having to (not) choose your side. Last instants of the hunt and final encounter: a ramp of projectors lights up. De Niro shows himself, a shadow passes to the feet of Pacino who fires on this shadow – his own *and* that of the other man of course – De Niro collapses, the lights of the runway go out. It's over. Finally, the two men share the same shot. Unlike the meeting in the cafeteria, the *cut* has finally been healed. After all, De Niro, a handful of seconds from his own end, reaches his hand out to Pacino, ratifying for the first (and last) time a desire to meet that Mann's direction immediately makes real. De Niro and Pacino in the same shot, that is to say the terminal horizon of *Heat*, the promise of a meeting deferred to the end but finally realized. Pacino seizes De Niro's hand and thus seals a fraternal *re-union* that the film has endlessly prepared. Finally, it perhaps realizes that failed meeting between William Holden and Robert Ryan at the end of *The Wild Bunch*, which Mann, an admirer of Peckinpah, had doubtless not accepted. It repairs it. At the same time, Mann does not deliver exactly the expected shot. Neil McCauley and Vincent Hanna certainly appear framed together and full-length – one collapsed on the ground, the other from behind – but a void remains. What is lacking here? The essential, in other words the copresence of their faces. Mann films alternately the two faces, that of Neil first of all, sprawled on a concrete block, and that of Vincent, turned to the horizon – but never both at the same time. One face for two bodies. A magnificent idea which alone summarizes the melding accomplished here, since the face of one is worth the body of the other, and vice versa. We then understand the meaning of this wide shot where we see Pacino, from above, advancing towards his brother in arms whom he has just shot in the heart. By placing his camera above the two men, Mann erases, in the image, Pacino's face (we only see his body and his head), while that of De Niro is visible. This idea reminds us of that famous high angle shot in the staircase of *Psycho* which allowed Hitchcock to show Anthony Perkins transporting his mother,

thus feeding the viewer's belief in her reality even if, *precisely*, we could not make out her face. For the face is what *defines* the human, summarizes it, much more than any other part of the body. It is the privileged place where appears our humanity or, conversely, our inhumanity; it is the place where it verifies itself (let us only remember *Invasion of the Body Snatchers*) and produces signs of its presence. It is for all these reasons that the faces of Al Pacino and Robert De Niro could not appear together, since at the end of *Heat*, Pacino holds the hand of his other, of himself, of his corpse. 'You live among the remains of dead people,' his wife Justine reproaches him in the middle of the film, forgetting to say or not wanting to say that with them, we can leave the remains of ourselves. Fundamentally, the tragic dimension of the final shot of *Heat*, amplified by the elegiac tune by Moby which then reaches its climax, comes from the fact that it seals, at the same time as it buries, the *only true couple* of the film.[112] Because in the course of the story there has developed between Neil and Vincent a sort of powerful *philia*, producing between them a proximity much stronger than what unites them to their respective partners, Justine and Eady. *Men without women*, to borrow the title of a collection of short stories by Hemingway. In counterpoint to all the matrimonial conflicts which have punctuated the film – right up to the exhausted exchange between Vincent and Justine, which ends on the impossibility of them living together, something which both of them recognize – the diner sequence worked towards, conversely, the reciprocal recognition of two men, the birth of an intense friendship, up to attaining a form of osmosis that is typical of male relationships in Michael Mann's cinema. Neither amorous nor even sentimental, these relationships constitute in his work the highest degree of conversation and intimacy, without which humanity would no longer really make sense.

After having received a call on his pager informing him of Neil's presence outside the airport, Vincent abandons Justine in the waiting room of the hospital and runs down a staircase with the passion of a man in a hurry to rejoin his mistress. Or his other half. Hence the feeling of solitude and desolation which bursts out in this final shot, the mournful expression of Vincent, his motionless posture, the inert body of his friend, the great night which is coming: *who better than Neil had understood Vincent?*

[112] Two ends of films come immediately to mind, which dramatize a destroyed couple holding, *in fine*, each other by the hand. It is, of course, the finale of *The Wild Bunch*, but also that of King Vidor's *Duel in the Sun*.

The ghost of McQueen

William Friedkin, who offered him the main role in *Sorcerer*, said of Steve McQueen that a close-up on his face was worth all the landscapes in the world. That his presence in the frame, even motionless and taciturn, gave density to the shot, a sort of undefinable magnetism, made of mystery, refinement and charisma. McQueen attracted the eye like a magnet and perfectly condensed the two qualities that American cinema has always valued: professionalism (whether playing he a policeman, a gambler, a burglar or a businessman, McQueen was always the best) and a systematic distrust of words; the man who acts rightly does not need to talk. No doubt if he had not died in the year of *Thief*, McQueen would have worked with Mann, so much did he embody the values close to his heroes, individualism, freedom and a natural scepticism about all forms of authority and/or power. Above all, McQueen had appeared in *Bullitt* by Peter Yates, a milestone film of the American crime genre of the 1960s whose ghost hangs over *Heat* from beginning to end. *Bullitt*, let us remember, follows the footsteps of an inspector in San Francisco (McQueen) tasked with protecting a mafioso for an opportunistic politician, who hopes to profit from his testimony against the criminal organization in order to boost his career. From the point of view of the screenplay, the dramatic structure (the spectacular sequence of the film placed at the centre of the story) and even the style (the elegant clothes of the characters, the refined treatment of the frame and of the spaces crossed, the use of strictly functional dialogues), the connections between Yates's film and Mann's are numerous, almost too obvious to only be by chance; starting with the final sequence which, in both films, takes place on the tarmac of Los Angeles Airport and, sometimes in almost the same shot, exploits the same places. Frank Bullitt, like Vincent Hanna in *Heat*, pursues his antagonist between runways and rows of dazzling floodlights, and after having shot him, returns home in the early morning, to his apartment in San Francisco. Throughout the film, McQueen has shown no zeal, no excitement or rage in the exercise of his job, and the epilogue, where we finally see him put down his holster, enter his bathroom, look at himself in the mirror, tired, and close the door of the bedroom where his partner is sleeping, offers the image of desperately routine life, a Sisyphus-like return home which makes you think of the last shot in *Miami Vice*, as if, fundamentally, nothing had happened that could really change the course of things.

Steve McQueen and Jacqueline Bisset in *Bullitt*, Peter Yates, 1968

Amy Brenneman and Robert De Niro in *Heat*

Bullitt

Heat

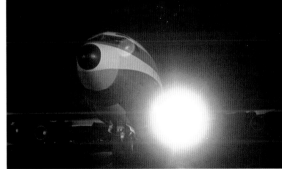

With its honest cop forced to put himself on the margins of the law in order to enforce it, *Bullitt* opened the way to the new crime film of the 1970s that was taken by Madigan, Harry Callahan (*Dirty Harry*) and Popeye Doyle (*French Connection*) as it anticipated the cold violence and corruption of State structures. But Yates's film, written by Harry Kleiner, introduced above all what the French composer Nino Ferrer would have called a feeling of 'disabusion'. That is to say a form of disenchantment with the workings of the world and the inability of the professional to really modify its course through his actions, which goes through all Michael Mann's cinema right up to *Miami Vice*. During the whole film, McQueen is essentially reduced to what he sees (spotting a suspect in the middle of a crowd, analysing the content of a suitcase, attending a surgical operation) and the camera follows in his footsteps, waits for him, shows what he sees, what he seeks. Like him, it retraces its steps, reframes the same places, tracks the same faces, scrutinizes the same images. Apart from the famous pursuit sequence in the bumpy streets of San Francisco, McQueen always stands on the edge of events, rather tight-lipped, indecipherable. In the middle of the film, his partner Cathy (Jacqueline Bisset), who works as a designer (like Eady in *Heat*), follows McQueen to a crime scene and comes face to face with the corpse of a young woman in a motel bedroom. McQueen then places his body between Cathy's eyes and this vision of horror.

We find them again a few minutes later on the edge of a highway. Filmed from afar and in long focal length, in the middle of a field of buttercups which reminds us of the hill on which Neil catches up with Eady, their discussion off camera gives the scene a quirky, derealized aspect and anticipates some of the essential questions that will occupy the Mannian heroes: the real cost of professionalism, the impossibility of forming a couple and the future of affect in the contemporary world.

'I thought I knew you,' Cathy confesses. 'But I'm not so sure anymore. Do you let anything reach you? I mean, really reach you? Or are you so used to it by now that nothing really touches you? You're living in a sewer, Frank. Day after day.' 'That's where half of it is. And you can't walk away from it,' he replies. 'I know it's there, but I don't have to be reminded of the whole thing. The ugliness around us. With you, living with violence is a way of life. Living with violence and death. How can you be part of it without becoming more and more callous? Your world is so far from the one I know. What will happen to us in time?' What Frank Bullitt does

not confess, Vincent Hanna, in a similar exchange, will say in *Heat* to his wife Justine who, unlike Cathy, reproaches her man for not sharing with her his professional experiences.

> Justine: You never told me I'd be excluded.
> Vincent: I told you when we hooked up, baby, that you were gonna have to share me with all the bad people and all the ugly events on this planet…
> Justine: And I bought into that sharing because I love you […]. But you have got to be present like a normal guy some of the time. That's sharing. This not sharing, this is leftovers.
> Vincent: Oh, I see. What I should do is, come home and say: "Hi honey, guess what? I walked into this house today where this junkie asshole just fried his baby in a microwave because he was crying too loud, so let me share that with you. Come on, let's share that and in sharing it, we'll somehow cathartically dispel all that heinous shit." Right? Wrong. You know why? Because I gotta hold on to my angst. I preserve it, because I need it. It keeps me sharp, on the edge. Where I gotta be.

Collateral: these hollow men

> Max: What are you?
> Vincent: Indifferent. Get with it. Millions of galaxies of hundreds of millions of stars and a speck on one in a blink. That's us. Lost in space. The cop, you, me, who notices?

Ten years after *Heat*, in 2004, Michael Mann returned to the crime genre and signs with *Collateral*, a rigorous character study of the figure of a professional, via the character Vincent, played by Tom Cruise, a perfectionist assassin obsessed with mastering himself and the world, who is in the lineage of *Thief* and especially the gangster of *Heat*, of which it embodies a possible future. Vincent's trajectory starts symbolically where that of Neil McCauley ended, at Los Angeles Airport, and finishes in a subway train (the same one?) from which Neil came out at the very start

of *Heat*.[113] Even the flashing lights that refereed the final duel between Neil and Vincent return at the very end of *Collateral* in the form of a providential power cut which enables Max, the taxi driver, to hit Vincent during a brief exchange of gunshots which breaks out in a subway carriage.

Collateral, 2004

The story of *Collateral* takes place during a night in Los Angeles and follows the murderous journey of a hitman, Vincent, tasked with eliminating all the witnesses at a trial in which Felix Reyes-Torrena (Javier Bardem) a local drug baron, is playing for high stakes. He sets out with a taxi driver (Jamie Foxx) who, essentially taken hostage, drives him from one target to another. 'When I started considering the project, I had just made *The Insider*, which had an epic dimension, lasted 2 hours 40 minutes and was strictly psychological. *Ali*, *Heat* and *The Last of the Mohicans* were also extremely broad stories. The initial appeal of *Collateral* for me was to go in the absolutely opposite direction. One night, no costume changes, two characters who are the opposite of each other, and each participate in the creation of the other at the end of the film. It was very attractive. At the time, I had the *Aviator* project in hand. I had developed it, I was producing it and could direct it, but I would have had the feeling of remaking *Ali*, another biopic and

113 The noise of a plane that Mann introduces in the precredit, like a suture with the sound material which infused the end of *Heat*, invites us to link the two films.

a huge production. That's why I asked Marty [Scorsese] to take over the reins and why I let myself get sucked into Collateral.'[114] If Mann abandoned *Aviator*, a project on which he had been working since the end of the 1990s, it is probable that *Collateral* kept certain aspects of it, as if Vincent had found again a bit of Howard Hughes's inordinate hubris, his obsession with control and speed, and Max, his reticence concerning the real, his Chateaubriand-like taste for shutting up 'in a narrow space his long hopes'.[115]

Collateral* is, to this day, the only film Mann has directed without having initiated (and written) it. When he received the script from Stuart Beattie,[116] he reappropriated the material, readjusted it to fit his own obsessions, filled out the two main characters and decided to symbolically move the action from New York to Los Angeles. After *The Insider* and *Ali*, Mann returned here to his favourite city, whose architecture and organization constitute for him a natural topos, a space that is both anxiety-inducing and hypnotic. The aim of professionalism, the cost of individualism and the place of affect in a contemporary world dominated by strictly economic logics and of which Los Angeles would be the realized version thus form an array of questions which immediately inscribe *Collateral* in the fold of Mannian preoccupations.

Right from the opening sequence, everything about Max and Vincent are oppositional: appearance, attitude, socio-professional milieu, skin colour. And their first exchanges confirm the gulf separating them. Even Max's natural milieu, that is to say the cultural and ethnic diversity of Los Angeles that the taxi driver experiences from the first moments of the film, is reformulated negatively by Vincent, who only perceives in this heterogeneous topography just signs of a contemporary adiaphora: 'Whenever I'm here, I can't wait to leave. Too sprawled out, disconnected. You know,' he confesses to Max on getting into the taxi. 'Seventeen million people. If this were a country, it'd be the fifth biggest economy in the world, and nobody knows each other.' With its grids that extends to infinity and its luminous points which pierce

[114] Interview with Julien Gester, *Libération*, 20 October 2017.
[115] In *Mémoires d'outre-tombe*.
[116] One line from the dialogue of the script, finally deleted, explained the title of the film. Vincent congratulated himself on being a professional killer who, in the course of his career, had only caused 'two collateral hits'.

the night like a starry galaxy, Los Angeles echoes the mental universe of Vincent, his existential anxiety. Mann films the city like an almost futuristic megalopolis, emptied of all human presence (the last part of the film), a crystalline and mineral space in the face of which he has a dual relationship of terror and fascination. Vincent is haunted by the vastness of the universe and consequently, he thinks, the insignificance of human life. From his anxious relationship to the cosmos and to the world, he has forged a discipline and a metaphysics which are entirely oriented towards the question of his own survival. A frenzied individualist, indifferent to everything except himself and the objectives he has set for himself, the hitman in *Collateral* crosses the film like a lone wolf, necessarily, and towards a tragic denouement of which he himself fixes the terms: 'I read about this guy, gets on the MTA here, dies. Six hours he's riding the subway before anybody notices his corpse doing laps around L.A., people on and off sitting next to him. Nobody notices.'

Vincent is a *professional machine*, a sort of Terminator in a grey suit, an executive of crime who has built around him a citadel of insensitivity and therefore inhumanity. Whereas Max is an automaton who, by deferring the action of his life (starting a luxury limousine company), has separated himself from the real world. One has replaced all meaning with action to the point of making it the alpha and omega of his life, while the other tirelessly defers it to and takes refuge in a same advertising dream – the Maldives postcard in the sun visor of his cab, and the glossy catalogue of cars he looks at every night. As a pure Mannian hero, Vincent is obsessed with losing time, while Max denies it. Basically, the meeting between Vincent and Max is that of someone anaesthetized by someone paralyzed.

Everything thus seems to separate the two men but, as a Mannian couple who do not know this yet, Vincent and Max also resemble one another, firstly in how they occupy space and keep it at a distance. Vincent appears first, in an airport hall, where he receives a briefcase containing his criminal route map. Mann opts here for a mental treatment of the sequence since, beyond the sunglasses he wears, an outward sign of a willed opacity, Mann's direction works to isolate Vincent in the frame, be it with the use of the long focal length which clearly detaches his face from an unreadable environment or the sound atmosphere, rather a confused and distant buzz, from which stands out the echo of his footsteps.[117] Even immersed

[117] Is this a homage to the start of *Point Blank*, with Lee Marvin pounding an empty corridor with his reverberating feet?

in the crowds, Vincent immediately appears as an individual who has with his milieu and other people only a functional and minimal relationship. The introduction of Max conveys a similar idea. In the hubbub of the taxi depot, at the time when the night teams swap with the day ones, Max waits for his vehicle. The very fragmented editing at the start of the sequence, which only grasps snatches of disconnected actions and especially the impression of sensory aggression, is interrupted as soon as Max gets into his taxi (fall of the external sound level, slower cutting), a protective bubble in which this turtle-man finds his bearings and reconstitutes his little world sheltered from the world. A space both limited (glass cabin) and totally open thanks to this exotic postcard which serves as an escape and a horizon: 'It's my own private getaway. Things get heavy for me, I take five minutes out and I just go there. And I just concentrate on absolutely nothing,' he says to Annie. If the space that they have both created must remain at hand – hence their common obsession with control – these two orders have difficulty harmonizing. For Max, Vincent's entrance translates, over the miles travelled, into a progressive destruction of his crystalline bunker: the windscreen cracked by the corpse of the first witness, Ramone, the blood on his bodywork, the food which comes and messes up his interior, right until that final accident which completes the bursting of his bubble. In return, Max also constitutes for Vincent an agent of chaos – the briefcase he throws from a bridge and which obliges the hitman to change strategy. Finally, the two men share a technical competence, which Vincent immediately identifies in Max, and an ability to grasp in the other signs which reveal him, a same *sixth sense*: a few glances suffice for Max to make the identikit picture of Annie and understand her weaknesses, while Vincent decodes any situation lightning quick – when the three crooks come to rob Max in a deserted alleyway, with the police who prepare to stop Max's taxi because of the damaged windscreen, or the inventory of forces in the nightclub in Koreatown.

At the start of the film, Mann films almost twice the same sequence: a client enters Max's taxi and starts discussing the latter's professional situation, caught between a supposedly temporary activity and a major project which occupies, in reality, all his mind.

Downtown, 312 North Spring Street is the address where this young woman in a suit is headed, Annie, a prosecutor by profession, concentrated on her business. Between her and Max, the exchange is

at first mechanical, functional, each in their own bubble, until this question asked by Annie, who then seems to care about her interlocutor: 'Take pride in being good at what you do?' The frame then widens, encompassing Max and Annie, thus showing a possible bond between them. Mann opts here for a romantic ambience in the sequence, a moment out of time supported by the aerial shots of Los Angeles and the music of Groove Armada, *Hands of Time*. At the same time, Annie's question, a benign comment, touches a raw nerve in Max ('What, this? No, this is part-time. This is a fill-in job. Pay the bills.') and reveals, without aiming to, the existential hiatus of this man who pretends to be what he visibly is not. At the end of the taxi ride, Annie opens up in turn to Max and recounts her routine, an anxious night spent rewriting a summing-up which she imagines is catastrophic. Between these two anguished souls, something has happened.[118] Max then offers his 'own private breakaway' (the postcard) to Annie who, in return, gives him her business card. The symbol is limpid: by slipping the young woman's card in his sun visor, Max substitutes one image for another and designates Annie as the new horizon of his desire. The latter rushes into a building and crosses, from afar, the route of the hitman. Is this here a furtive handover between the object of a desire (Annie) and the man who will turn out to be the agent of its fulfilment (Vincent)?

The hitman gets into the taxi but, to the same question, Max chooses not to reply. Unlike the previous sequence, Mann insists on the distance separating the two men, whom he frames separately from the exterior of the vehicle. No possible interlocution, no human affinities, up until this economic compromise which Vincent, before going to Ramone's house, proposes to him. The spatial arrangement of the taxi (the client sitting behind the driver) of course invites a more psychoanalytical analysis of the exchanges. This couch on wheels of which Mann is going to exploit all the resources also constitutes the place for a *reciprocal psychoanalysis* between the two men, even a metaphysical transaction where one participates in the existential awakening of the other. Emotional, empathetic, caring for his fellow man, Max comes up against this blank figure that is Vincent, a human enigma of which he is going to try and understand and reveal the

118 That Mann takes care to situate outside the economic field, since Max offers for free Annie the ride she has just made.

intimate workings of.[119] 'Of all the cabbies in L.A., I get Max, Sigmund Freud meets Dr Ruth,' says Vincent to Max after the Koreatown shooting. But it is Max who situates himself in front, as if it was firstly about accelerating his awareness. In the first part of the film, Max is petrified by the tyrannical voice of power and carries out his orders, so much so that he seemingly has internalized his class servitude. Until the hospital sequence, during which he is forced to visit his mother in Vincent's company before running off with his briefcase, Max protests but does not act. After each murder, he protests, asks questions, disapproves, but continues despite everything to assist the hitman in his bloody task. A collaboration, in the strict sense of the term, that the latter does not fail to emphasize when, after the murder of Ramone, he calls him 'Lady Macbeth', in reference to Shakespeare's queen who, awoken, hides her crimes, but reveals them all once asleep. 'Out damned spot!' she cries while rubbing her hands. Granted, unlike Lady Macbeth, Max did not want or commit these crimes, but his passivity is a form of complicity – after all, he too has hands stained with the blood from Ramone's corpse, which he helps to lift into the boot of his car. Vincent points out here, with a malice that strikes true, the pathological dimension of his inertia. The two coyotes who, in the middle of the night, cross the road and the eyes of Max and Vincent, thus function as animal projections of the two men. The first coyote glances quickly at the taxi, then starts off again without worrying about what surrounds it; the second, fleeting, just follows it. For Max, Vincent is neither a horizon nor a model, but the catalyst for an action that has been deferred too long. He thus becomes a force for education and emancipation, as much from a political, cultural (learning to listen to jazz), intimate (he encourages him to get back in touch with Annie) as existential point of view: to learn to look straight on at the mirages he has made for himself and dare to

[119] Of all the heroes of Mann's films, Vincent is the most enigmatic. A single piece of information, that you imagine authentic (he has done this job for six years) is provided by Vincent himself to Max before his meeting with Felix. For the rest, nothing is verifiable, and the tragic personal story he recounts about his father ends with its ironic denial. However, as he does each time, Mann gave Tom Cruise and Jamie Foxx voluminous biographical documentation on their respective characters. We learn, for example, in the audio commentary that Mann recorded for the DVD of *Collateral*, that Max is the youngest of a family of seven brothers and sisters, and that Vincent was born in Indiana, like John Dillinger. Was this here about forging a discrete genealogical link between the public enemy of 1934 and the killer of *Collateral*, as if, on the scale of crime, one constituted the possible terminal version of the other?

break them one by one, be it his mineral cage (the taxi), the glass door which prevents him from entering the Federal building where Annie is, or the glass doors of the subway which separate him from Vincent at the final gunshot.[120] Vincent gives back to Max a visibility and even offers him the means of breaking with this state of infantilization into which his mother, a sort of extension of the one in *North by Northwest*, has plunged him; a mother who harasses him (she calls the exchange 'every ten minutes'), who makes him feel guilty ('Why couldn't you call me on the telephone? I'm lying here wondering if something terrible happened to you!') who lectures him (flowers? A useless expense) and who knows nothing about the life of her son, except for the tissue of lies he has crafted for her.

The two men arrive in the heights of West Hollywood, where the second target of the cartel lives, Sylvester Clarke, a former prosecutor now an attorney for the criminal underworld. Max then receives a call from Lenny, at the taxi dispatch, who has just been warned by the police about the damaged state of his vehicle – in reality, a victim of Vincent has fallen on the roof of the car a few minutes earlier. Between Lenny and his employee, a one way discussion begins, or rather a violent injunction by the employer: whatever the explanations given, Max will have to pay for the damage. Vincent gets impatient, turns to Max and whispers to him how he should reply. *How to stand up for your rights?* Max, hesitant, obeys and repeats, like a good, submissive pupil, Vincent's words: 'It was an accident. I'm not liable.' Faced with the unexpected self-assurance of his employee and his sudden ability to speak the brutal language of capitalism, Lenny begins to back pedal. Vincent now orders Max to insult his boss. 'I can't do that. That's my boss. I need my job.' 'No, you don't,' retorts Vincent before taking the transmitter and giving the coup de grâce: 'Albert Riccardo, Assistant U.S. Attorney, a passenger in this cab, and I'm reporting you to the DMW […] How am I supposed to not get excited listening to you try to extort a working man You know goddamn well your collision policy and general-liability umbrella will cover the damages.' This sequence, during which a man on the side of power (and of crime) initiates another to legalistic technique, proves

[120] This motif of broken windows, recurrent in the film, symbolizes the real and imaginary screens that the two characters must break through in order to accede to their intimate truth.

Collateral

again how much in Mann's work the law is firstly the weapon of the powerful, the consequence of a constantly unequal balance of power. The introduction of the two characters into the film works first of all on a class divide. The clothing appearance of Vincent (a metallic grey suit, dark glasses which isolate him from the others), his way of moving with ease and assuredness in an icy space to which he has all the keys (the entrance code for the federal bunker, the pass for the gates…) and finally, the music of Bach which accompanies him getting into the taxi contrast in every respect with the presentation of Max, who appears in a working-class, popular milieu, noisy and colourful, as he waits for a work tool inside which he is going to be able to take refuge for a brief while. When Max's taxi leaves the depot, Mann's camera lingers for a long time on a mural painting representing a headless white horseman mastering a bull, a harbinger of a fiction placed under the sign of domination and exploitation. After having checked Max's competence, Vincent proposes that he offer his services and his taxi for one night. The proposal breaches the rules of his profession, but the $100 bills that Vincent ostentatiously brandishes offer the image of a predatory, even vulgar, capitalism that Mann deliberately merges with the apparently acceptable one of an assassin. There is here a subtle shift from a stereotype of the film noir which makes of Vincent the equivalent of the femme fatale, a modern *homme fatal* if you like, enigmatic, immediately seductive, manipulative, and whose irresistible charm, if not erotic, becomes purely economic.

Max is a proletarian who, in reality, does not have the means to refuse the mouthwatering offer (which will turn out to be loaded and diabolical) which he has been made. His dual inferiority comes from the fact that Vincent possesses a capital both economic and cultural which crushes him. The man handles the art of rhetoric as a formidable liberal newspeak ('You killed him?' 'No, I shot him. Bullets and the fall killed him.') and possesses sufficient eloquence to distort, in the other, the slightest moral questioning (the murder of the first witness compared with the massacres in Rwanda: 'I off one fat Angelino and you throw a hissy fit.') In the first part of the film, Max, submissive and helpless, has nothing to say in reply, if not a confession of weakness, almost a justification of his own servitude: 'I never learned to listen to jazz,' he tells Vincent in the club in Leimert Park. Max suffers from not being visible, of being absent from this place which, nevertheless, he occupies physically (the hospital sequence in which his mother addresses Vincent, as if her son was not there). This invisibility to which he has resigned

himself, to the point of only fully existing, but virtually, inside a dream (Island Limos), is also that of a social class. It is the Marxist background of all of Mann's films which emerges again. Until the hitman's entry into his life, Max has lived – for 12 years – his alienation in the state of denial, in other words in the refusal to see his real condition as an exploited man. Beyond his personal and psychological idiosyncrasies, Mann firstly politicizes Max's inaction by linking his inability to make concrete his entrepreneurial plan to a class conditioning. As if for this man, a modern blue collar, the American dream of success for everyone was just a mirage of liberalism fabricated in order to blind them, as if the social barrier separating him from this woman met at the start of the film, Annie, was for people of his kind an insurmountable obstacle. No love stories are possible in forbidden territory. The postcard of the Maldives, thanks to which Max regularly escapes, thus completes the portrait of this consenting and alienated subject described by Cornelius Castoriadis in *The Imaginary Institution of Society*, a subject 'dominated by an imaginary lived as more real than the real, although not known as such, precisely because it is not known as such. Then, the essential nature of heteronomy – or of alienation, in the general sense of the term – at the individual level, is domination by an autonomized imaginary which arrogates to itself the function of defining, for the subject, both reality and its desire.'[121]

When the body of the first witness crashes onto the windscreen of his taxi, Max does not need long to understand the hidden terms of the deadly contract made with Vincent, instead of a supposed business dealing. Destabilized, almost petrified by this revelation, Max tries, first of all, to make an ethical argument to his employer. Because for him, money possesses despite everything an odour and his work cannot be totally disconnected from its aim. Conversely, Vincent is indifferent to the finality of his activity, regardless of whether it involves carrying out a contract, driving a car or killing a man: all are interchangeable objectives which amount to the same thing. One of his possible ancestors is Joubert (Max von Sydow), the hitman in *Three Days of the Condor* (Sydney Pollack, 1975) who, at the end of the film, explains his personal ethics to the character played by Robert Redford: 'I don't interest myself in "why?". I think more often in terms of "when?"... Sometimes "where?". And

[121] Cornelius Castoriadis, *L'Institution imaginaire de la société*, Seuil, 1975, pp. 140-141.

always "how much?"' For Vincent as well, the product of his work is situated beyond good and evil. 'You were gonna drive me around and never be the wiser,' he says to Max, as if taken aback by this *concerned* man suddenly wondering about the goals and meanings of its work. That is to say a way of revealing one of the functional paradigms of the world of enterprise, of which his murderous small trade offers a radical metaphor: 'Whilst work in itself is considered in all circumstances as "moral", its end and result are considered in the very act of working – it is one of the most baleful features of our times – as fundamentally "neutral as regards morality"', already wrote Gunther Anders, in 1956, in *The Obsolescence of Man.*[122] Vincent behaves as owner of the means of production (Max's knowhow, acquired for $600) and is astonished that his employee can, because of a change of objective, put into a relationship his activity and his purpose. How to make a labour force understand that it does not belong to itself and that even if it contributes to the enterprise reaching the aims it has set itself, the finality of this enterprise does not concern it? 'If it makes you feel any better, he was a criminal involved in a continuing criminal enterprise,' he tells Max, to appease his moral conscience. 'Once people are accustomed to their masters they are no longer capable of doing without them', wrote Rousseau in Book II of *The Social Contract*; it will take Max long hours of prevarication and four murders before he finally disobeys and breaks the link of exploitation binding him to Vincent.

In the course of the film, Vincent also initiates Max to capitalist logic, its techniques of management (possessing his work tool: Island Limos), of intimidation and its language. Max soon reveals himself to be a gifted pupil, as is shown by the replies, sometimes word for word, that he borrows from Vincent during his tussle with Felix, the head of the cartel, and the discount he grants him *in fine* as reparation for the damage caused by the loss of information. At the start of the conversation, Felix thinks he is talking to Vincent, reproaches him for his negligence and explains his situation with the help of a Mexican Christmas tale which tells the story of an inseparable couple, Santa Claus and Black Peter, a small

122 Gunther Anders, *L'Obsolescence de l'homme. Sur l'âme à l'époque de la deuxième révolution industrielle* (1956), Éditions de l'Encyclopédie des Nauisances/Éditions Ivréa, 2002, p. 322.
123 The tale calls here for double reading since Vincent occupies both the position of Santa Claus (vis-à-vis Max) and that of the black donkey (vis-à-vis Felix).

donkey who, in the shadows, looks after his dirty work and thus participates in his success.[123] Max's body, which passes off for Vincent, creates an illusion, but not yet his personality. A simple change of lighting is enough for Mann to point out the tipping point of the face-to-face: suddenly, Max's face darkens, his expression hardens and there he threatens the enforcer positioned behind him. Alerted by this sudden self-assurance, Felix eases and then considers his visitor an equal. What has played out here is nothing other than a mental short-circuit, or an effect of perfect coincidence between Max's mind and Vincent's. This lightning flash of negativity which, for an instant, has crossed Max's mind, has saved him (he reacquires the information in the place of Vincent) and makes explicit, at this precise moment, a form of porosity between the two men. Mann is a filmmaker of 'and' rather than 'or', who always works in a dialectical fashion on his couples of characters, thus leaving the viewer, if he so wishes, the task, which interests him little, of passing on them and their activity a moral judgment. The irony of the script of *Collateral* does not aim just to make of Vincent the one who will liberate Max from his blockages and his illusions. It is pushed to its limit in the gunfight scene during which, in the nightclub in Koreatown, Vincent literally saves Max's life by killing one of Felix's enforcers who was preparing to shoot at him. A few seconds later, Max is spotted and exfiltrated from the club by Inspector Fanning (Mark Ruffalo). But in the doorway, Vincent shoots Fanning, as if the film's screenplay always worked out, via the intervention of the hitman, so that Max must owe his emancipation to Vincent.

From Vincent's point of view, Max's liberation has an evidently suicidal dimension, since he has created the conditions for his disobedience. However, what links the two characters in *Collateral* resembles a devious form of friendship thanks to which is played out, *in fine*, their reciprocal accomplishment: by dying seated in a subway carriage, like a passenger fallen asleep, Vincent accomplishes his own nihilistic vision which is that of a total anonymization of the world and of individuals, *he becomes what he thinks he is*, an atom lost in the indifferent multitude; as for Max, he seems to finally free himself from his big nocturnal bubble for a new, open, ochre space, taking on an uncertain reality that must now be confronted. If Vincent is a sociopath, he is a sociopath of a third type who considers himself the best in his domain, but also as a negligible being lost in the heart of a humanity he judges insignificant, unlike Dolarhyde, the serial killer in *Manhunter*, who seeks to draw his victims into his own megalomaniacal delirium. Nevertheless,

all the solitary characters in Mann's films, and Vincent in particular, find themselves victims of their own arrogance, too sure of themselves, convinced that their professionalism will overcome the reality of the obstacles: it is Frank (*Thief*) who believes he can navigate his way inside a system which considers him as a mere cog in the machine; it is the English (*The Last of the Mohicans*) who will pay with their lives for having underestimated the strategic and military capacities of the French, or Neil (*Heat*) who, with the exception of Vincent, does not sufficiently appreciate his adversaries, from Waingro to Van Zant, and runs straight to his end through an excess of self confidence (wanting both Waingro *and* Eady).

When Max finally gets out of the subway train in the company of Annie, the first rays of sunshine appear in the Los Angeles sky and an electronic sign planted on the platform indicates a date, 24 January 2004, as if it was marking this particular day as a date of rebirth which then echoes the fevered story that Daniel, the jazzman at Leimert Park, had recounted, a few hours earlier, about his meeting with Miles Davis. A memorable, founding moment which, to hear it, has marked a before and an after. His life could have changed that day, taken the direction of his dreams of becoming a professional musician, but the man did not know how to seize his chance in time. 'I was born in 1945, but that was the moment of my conception. Right here in the used-to-be crowded room.' While at the edge of the subway, Vincent's body sinks into his 'great night', the dawn closing *Collateral* signifies Max's rebirth after 12 years of burial. For him, it is perhaps the start of the Revolution. Perhaps, since *Collateral*, like most of Mann's films, ends on a moment of suspension, a sort of uncertain denouement which, rather than concluding on the state of a changed world, chooses to emphasize indecision, as if any victory was precarious, temporary and fragile.

Professionals for nothing

'Vincent [...] is in many ways an empty vessel of capitalistic success in the beginning of *Collateral*,[124] writes Steven Rybin. His Darwinian obsession with adaptability, his pathological valorization of efficiency are not in the service of any utopia or Shangri-La. This hollow

[124] Steven Rybin, *The Cinema of Michael Mann*, *op. cit.* p. 191.

professionalism which confuses the quest and its object is pushed here to its tragic limit at the same time as it reveals the depressive essence of contemporary capitalism. Basically, Vincent enters the film like a modern zombie, an 'idiotic' technician, as Clément Rosset would have said, and, thanks to an encounter that ends up escaping him, finds himself the victim of a return of affect and humanity which disrupts him.

Of professionalism in all its forms, of the man who is devoted to an activity in which he excels, Mann made his favourite figure, identifiable from the obsessive runner in *The Jericho Mile* right up to the genius hacker in *Blackhat*. Even the original title of his first film, *Thief*, points to the profession rather than the man exercising it. However, this almost liturgical relationship to the profession, expounded on from film to film, does not lead to a spiritual elevation, but to the edge of an existential void. It does not fill, it empties; it does not humanize, it mechanizes or isolates; it is not a prayer for the living but, as Justine emphasizes to Vincent in *Heat*, an offering to the dead. From this point of view, with *Collateral*, Mann does two things at once: on the one hand, he pushes to its philosophical limit this obsession with professionalism which is specific to classic American cinema, of which his previous films (*Thief, Heat* and some episodes of *Miami Vice*) has begun the critical deconstruction, and on the other, he strips bare the cult of performance in a modern capitalist world which makes the false hypothesis that a good technician does not dream. It matters little that this peerless technician is a hitman, a safe-breaker or a taxi driver, since they all suffer from a problematic relationship to their respective *existential programs*, that is to say a way of giving meaning to their life via a horizon that surpasses the strictly operational or materialist frame. To this existential program is opposed, as we have said, a *vital program*, which identifies with a professional competence which serves as a compass. Even Max, submissive and timid as he is, is sure that he will be the best. The conflict between a vital programme and an existential equilibrium, between the inflexible discipline required by the profession and the social aspiration of the one exercising it, is a constant which thus runs through the entire oeuvre of Michael Mann, at odds with American classic cinema, for which *the two merge*. A constant of his crime films of course, but also of *Ali* (the boxer's determination, which puts into peril his private life and his two marriages) or *The Insider*: when, after being sacked by Brown & Williamson, Jeffrey Wigand returns to his little suburban house and announces the news to his wife, the latter, seized by panic, throws back in his face the cost of his

professional integrity. How are they going to live now? How will they pay for the medical coverage? The car payments? And the house?

In *Heat*, the conversation that begins between Neil and Vincent about their profession and the cost they say they are ready to pay to exercise it resembles a manifesto, as if Mann was gathering in a few exchanges the central tension between those two programmes which fuel the tragic pulsation of his cinema. Tragic: that which resists reconciliation.

> Neil: I do what I do best, I take scores. You do what you do best, trying to stop guys like me.
>
> Vincent: So you never wanted a regular-type life?
>
> Neil: What the fuck is that? Barbecues and ball games? This regular-type life like your life?
>
> Vincent: My life? No, my life is a disaster zone. I got a stepdaughter so fucked up because her real father is this large-type asshole. I got a wife. We're passing each other on the down slope of a marriage. My third. Because I spend all my time chasing guys like you around the block. That's my life.
>
> Neil: Don't let yourself get attached to anything you are not willing to walk out on in 30 seconds flat if you feel the heat around the corner. Now, if you're on me, and you gotta move when I move, how do you expect to keep a marriage?
>
> Vincent: Well, that's an interesting point. What are you, a monk?
>
> Neil: I have a woman.
>
> Vincent: What do you tell her?
>
> Neil: I tell her I'm a salesman.
>
> Vincent: So then, if you spot me coming around the corner, you're just gonna walk out on this woman? Not say goodbye?
>
> Neil: That's the discipline.
>
> Vincent: That's pretty vacant, no?
>
> Neil: Yeah, it is what it is. It's that, or we both better go do something else, pal.
>
> Vincent: I don't know how to do anything else.
>
> Neil: Neither do I.
>
> Vincent: I don't much want to either.
>
> Neil: Neither do I.

Long before their meeting, the mutual esteem that Neil and Vincent have for each other is based on the acknowledgment of a respective competence. 'M.O? Is that they're good,' replies Vincent to his colleagues on the scene of the first heist. Later, when he realizes that his surveillance system has just been discovered by Neil, Vincent cracks a smile and tears into the man watching him from a silo like a distant friend whose audacity and intelligence he visibly appreciates. A relationship that Nate (Jon Voight) sums up in a phrase – 'He admires you' – before detailing the professional qualities of the one who is pursuing him. But it is in the turbulent and unstable private life of Vincent (three marriages) that Nate will seek the absolute indicator of his tenacity, as if the failure of his existential program (with which Neil identifies) proved the quality of his vital program.

'I'm alone. Not lonely,' Neil confesses to Eady on their first meeting, a way of immediately situating himself as the opposite of the classic professional who boasts of his solitude and cultivates it. Neil points out here, and makes this young woman for whom he feels an unexpected and sincere attraction, understand the false programmatic link on which his existence, which is arriving at its autumn, is built. His solitude does not come, unlike that of the professionals of Jean-Pierre Melville, from

Collateral

a desire, and ontology or a chosen relationship to the world, but from a constraint that his profession imposes upon him. Their first conversation, in front of the panorama of Los Angeles, resembles a confession between two beings who feel out of place, poorly connected to this mega-city they occupy without inhabiting it: one belongs to a family that comes from Pennsylvania and feels lost there, while the other, from the San Francisco region, is just passing through. This feeling of dephasing, at

once geographical, intimate and social, is shared by all of the characters of *Heat*, from Justine and her daughter Lauren to Donald Breedan, the prisoner freed on parole, forced to accept here a job which humiliates him. For Neil, the dissatisfaction which comes bursts out at the moment of the restaurant sequence where the members of his gang are gathered for an anniversary dinner. Chris Shiherlis, Michael Cerrito and Trejo are all accompanied by their wives, but not Neil, whose distant and melancholy point of view the sequence adopts. For Neil, the spectacle of these close-knit couples undoubtedly does not erase their difficulty in staying together (the stormy relationship between Chris and Charlene, for example), but it arouses in him a desire for adventure which translates afterwards into the call he rushes to make to Eady. After having spent the night with her, Neil, already dressed, places on the young woman's bedside table a glass of water covered by a paper napkin – a delicate gesture, a typically Mannian detail, which informs us about the elegance of the man, his education, but also his anachronism. The bluish atmosphere of the bedroom lets us glimpse the possibility of a lasting relationship, even a family which – as Neil knows well – contradicts the discipline he has imposed on himself. His contemplative look upon Eady's sleeping body, this moment of mixed tenderness and anxiety which expresses itself there, echoes the declaration of love and dependency made by Chris a few days earlier in Neil's apartment: 'For me, the sun rises and sets with her', he said of his wife. At that precise instant, Neil understands that his vital program has become insufficient; he chooses to not choose, and this (illusory?) will to reconcile the two programs will drag the story down its tragic slope. His final decision to branch off by the Marquee Hotel to settle his accounts with Waingro, in other words to complete *despite everything* his vital program, will be fatal to him. For Vincent, his *alter ego*, this program constitutes the lifebelt for a chaotic existence, the sole beacon in the midst of a private life he describes as a 'disaster zone'. His entrance into the film – in bed with his wife Justine – is made with a fragmented montage, offering the image of a broken body, in pieces, which recovers its shape once he puts on his work clothes (suit and weapon), as if this man was only *entirely* himself when exercising his profession.

In the films of Michael Mann, the effects of circulation between the private sphere and the social world, the points of contact (and of friction) between the imperatives of the professions and the demands of being a couple are always repeated in the form of a tension between these two programs, vital and existential, which *Heat* has brought to its point of

incandescence. These comings and goings which constitute one of the so recognizable features of his cinema not only move his films on a ridge-line where the genres (noir and melodrama) look at and affect each other mutually, but also interrogate, in the same movement, the ontological dissatisfaction which embraces all these professionals. What idea of happiness can produce the excellence of the technician? Does there exist a professional whose intimate life is not reduced to a 'disaster zone'? What are the conditions of possibility for an existential program when the vital program occupies all the space? Finally, what is the difference between an operational man and a machine (Vincent in *Collateral*)? So many questions which structure Mann's cinema and unravel around one or several pivotal scenes functioning, for the character, as moments of internal deliberation. It is Muhammad Ali choosing not to reply to the injunction of the investigator who calls him by his slave name (Cassius Clay) with a view to his induction; it is Jeffrey Wigand (*The Insider*) who, on the edge of the Gulf of Mexico, meditates for a few minutes in order to decide if he must testify or not in Mississippi, knowing the accomplishment of his existential program (telling the truth) will destroy his vital program (the material comfort of his family); it is Neil of course, at the very end of *Heat*, who puts his revenge before his couple, or Max, in the final part of *Collateral*, who accelerates in the streets of downtown until he causes the accident which will free him for good. To decide between two competing impulses, to change perspective or try to make there cohabit two *a priori* incompatible *habituses*, like Frank, already, traversed in *Thief* by antithetical lines: to desire absolute independence *and* the bond of love, to dream of himself as a thief *and* a petit-bourgeois, to want to be outside the system *and* at its heart, marginal *and* like the others.

Might this reflective impulse which seizes the Mannian professional at the moment when an existential program collides with and fractures his vital program be a reformulation, or an *aggiornamento*, of that demon of the fatalism specific to film noir for which the destiny of individuals seems to be written inside a capitalist and postmodern world in which they have the sole alternative of exploitation or disappearance? Although he often denies it, Michael Mann is *also* part of a long history of American cinema and of crime film in particular which, over the decades, has questioned itself about the virtues of its technicist horizon. *Thief, Heat, Miami Vice* and *Collateral* thus belong to the comet's tail of a crisis of professionalism whose beginnings can be spotted in the

gangster films of the 1930s. That is to say, to cite the most emblematic case, the pathological coming out of Cody Jarrett (James Cagney) at the end of *White Heat* by Raoul Walsh, but that the screenplay by Ivan Goff and Ben Roberts folds onto *in fine* a family trauma, explaining the pathological behaviour of Jarrett by a sort of badly resolved Oedipal conflict. A psychological motive which structures a good number of Hollywood screenplays and which, in the name of an assumed anti-psychologism, Mann will poke fun at in *Collateral*, with that murder story invented by Vincent about the death of his father. To be the best in your line of work, granted, but to do what? With what aim? At what price? In *Union Station* (Rudolph Mate, 1950), William Holden plays a young policeman posted to the central station of Chicago who, in the middle of the film, tells his superior (Barry Fitzgerald) about the questions he asks himself about the invasive place occupied by his vital program. The latter, a gnarled old cop, reassures him, but also warns him against the absence of an existential program: 'A good policeman must work full time. But a man must be careful not to be just a policeman.'

Professionalism, a cardinal value of classic Hollywood cinema, seems to lose its lustre, incapable from now on of fulfilling the promise it carried of harmony between the individual and the world, nor even of modifying it effectively. In the course of the 1950s and 1960s, this ontological doubt contaminated all the genres of American cinema and was one of the causes of this crisis of which struck most of the films of New Hollywood, of which those by Mann continued the line. 'It's pretty empty,' Vincent says to Neil, who is expounding to him his life discipline. From Richard Fleischer's *The New Centurions* (1972) to *Heat* (1995), a same figure of the disillusioned cop thus runs through American cinema,[125] caught between routine and disenchantment, a feeling of uselessness in the face of a task out of reach and a competence for nothing. From then on, what other existential way out is there for someone who is now just a function, but about which he even comes to have doubts, if not disappearance (George C. Scott's suicide in Fleischer's film) or self-sacrifice (Al Pacino in *Heat*)?

[125] It is even the archetype of the cop in most of the crime films made in the 1970s.

Capitalism and sociopathy

'Executives climb their calvary
In nickel elevators.'
 Michel Houellebecq, *The Will to Fight*

The character played by Al Pacino in *Heat* thus constitutes one of the
terminal figures of the cop in the 1970s, perhaps even its swan song.
In *Collateral*, Tom Cruise embodies another facet of this crisis of
professionalism via a new type of criminal that appeared in Hollywood
cinema from the late 1950s onwards. Criminals, often hitmen, dedicated
to destruction without having a taste for it, men who have become
machines by dint of having been instrumentalized by their function.
In 1958, Irving Lerner directs *Murder by Contract*, an independent film
shot on location in Los Angeles and which constitutes a sort of missing
link between *This Gun for Hire* (Frank Tuttle, 1942) and *Collateral*. The
originality of *Murder by Contract*, and its status as a precursor in the
history of American film noir, comes from the way in which Ben
Simone's screenplay connects criminal activity to a strictly economic
logic, and rids the killer of any psychological or sociological background.
To someone who asks him about his profession, Claude (Vince
Edwards), the film's contract killer, describes himself as a professional

Collateral

among others, thus appearing as one of the possible matrices of the character of Vincent: 'It's business. Same as any other business. You murder the competition. Instead of price cutting, throat cutting. Same thing [...]. The risk is high but so is the profit.' 'You were born like everyone else, flesh and blood, you got to feel!' points out to him one of his clients, who, like Max in *Collateral*, seeks to understand this man of a third type: 'I feel hot, I feel cold. I get sleepy and I get hungry.'

If the cops and gangsters in *Heat* originate rather from their counterparts in the films of Richard Fleischer (*Violent Saturday*, *The Last Run*, *The New Centurions*), the hitman in *Collateral* continues the line of dehumanization and programming which appeared in certain crime films of the 1950s (*Murder by Contract*, *Blast of Silence*) and was theorized by Don Siegel, who is undoubtedly the one who, in the course of the 1960s and 1970s, best radiographed this man-machine that has become an execution automaton, a professional completely reduced to a pure operational function, be they the soldier Reese (Steve McQueen) in *Hell is for Heroes* (1962) or the hitmen played by Eli Wallach (*The Lineup*, 1958) – 'You've never met someone like Dancer', they say of him. 'It's a pure object of pathological study' – and especially Lee Marvin (*The Killers*), of whom the character of Vincent in *Collateral* could be a cinematic son. Besides, the screenplay of Mann's film borrows from the two film adaptations of Hemingway's short story *The Killers* (Siodmak in 1946 and Siegel in 1964) the idea of an ordinary individual (Burt Lancaster, John Cassavetes and Jamie Foxx) forced into collaborating in a crime planned by a Mafia organization.[126] The suit and the grey hair, the dark glasses, the determined, even mechanical attitude, everything visually links the hitman of *The Killers* to the one who appears in the first shots of *Collateral*. Siegel's film also contains some of the foundations that will occupy Mann's cinema: the abstract development of the clichés of the genre (the monochrome and stylized silhouettes of the killers who appear in the credits), the vision of a new urbanity, soulless suburbs and metropolises which Siegel's direction treats as interchangeable spaces (Miami, New York, Los Angeles), the new obsession with speed (Johnny North is no longer the boxer of Siodmak's version, but a racing driver), elegant but ruthless killers who brutalize with the same indifference women and poor blind people. Finally, the figure of the apparently respectable businessman

[126] One could also cite the excellent and little-known *Drive a Crooked Road* by Richard Quine (1954), a hidden rereading of Hemingway's short story.

(played by the future President of the United States, Ronald Reagan, whose first role it is) who, far from the gambling dens of yesteryear, merges criminal and economic logics. But unlike Lee Marvin who, intrigued by the indifference of his first victim (John Cassavetes) to his fate, decides to trace the origins of his existential fatigue, Vincent does not seek to know the motivations of his employer nor what justifies the murders he must commit. He does not even feel a desire to.

With *Collateral*, Mann pushes to its limit this Siegelian art 'of a behaviour more and more detached from its justifications'[127] and from its moral implications by making of this perfectly operational professional that is Vincent a genuine sociopath. Like Charles Manson finding in the counter-culture moment of the 1960s a favourable environment for his future atrocities, the assassin in *Collateral* moves with ease in this capitalist and postmodern world with which he shares the cynicism and the totems (individualism, performance, profitability, speed). Programmed to function, Vincent *never reflects on his acts* outside the strict field of their technical execution, even if, in the course of the verbal confrontations with Max and the unforeseen events which disturb his criminal roadmap, something like the repressed returns in him (a hint of remorse after the death of the jazzman Daniel), but also of the return of a kind of *tragic*, which, through death, rehumanizes him. Fundamentally, Vincent is, in his own way, a chemically pure model of the modern slave who does not know himself, who does not even conceive – like Max at the start of the film – that one could question the system which employs him (here a criminal cartel of which he knows nothing) and, *a fortiori*, hold it to account. The echo effects, even the continuity, between *Heat* and *Collateral* also invite us to establish a form of genealogy between Vincent and Neil, as if the former constituted a possible, even fatal, extension of the latter, and dehumanization, a logical antidote to his existential crisis. Neil is certainly an individualist turned towards personal fulfilment, a burgling entrepreneur who seeks to fill his bank account, but he still carries in him the remains of a classical Hollywood humanism which supposes a possible harmony between self and world, a sort of natural empathy towards his fellow men and the concern, despite everything, to live in society (or a couple?). Whilst Vincent, by circumscribing all his being to a hypertrophied vital program, is now just a blank, indifferent, hollow figure, a pure professional who

[127] Jean-François Rauger, 'Visages sans yeux', *Cinémathèque*, 2, 1992, p. 81.

Heat

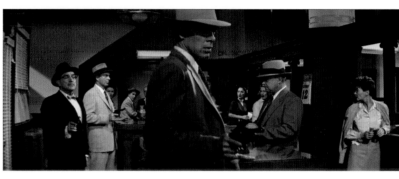

Violent Saturday, Richard Fleischer, 1955

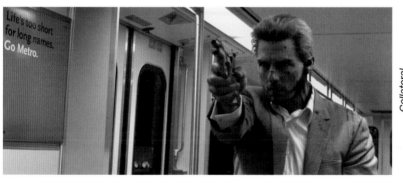

Collateral

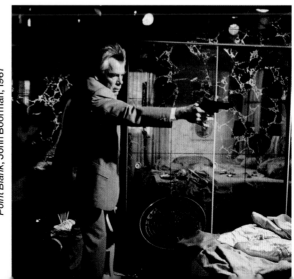

Point Blank, John Boorman, 1967

lacks that something which other men possess and which is called affect. For him, *the social field does not exist.* Individuals resemble small machine-like monads who move restlessly in a universe of generalized transactions. Consequently, one can predict, calculate, plan and therefore quantify everything. It goes like this for men as for the rest. The entire world is parametric.

'The standard parts that are supposed to be there in people in you, aren't,' Max tells him in the middle of the film, thus pointing out the spectral and deadly fate of this professionalism which one is accustomed to call 'Hawksian'. The hitman in *Collateral* embodies exactly that 'blasé man' defined by Georg Simmel in *Philosophy of Modernity*, incapable of assessing the value of differences between things, as much on the physiological level (insensitivity by dint of stimulations) as the economic one (the intense circulation of goods and individuals): 'This psychological attitude is the faithful subjective reflection of total impregnation by the monetary economy; as far as money evaluates in the same way the entire diversity of things, expresses by differences of quantity all the respective differences of quality, as far as money with its indifference and absence of colour stands as the common denominator of all values, it becomes the most formidable leveller, it irredeemably empties things of their substance, of their property, of their specific and incomparable value.'[128]

Thief, *Heat* and *Collateral* thus represent three ages of modern capitalism. Frank is an artisan who, one day, places his competence at the service of a small criminal business led by an old school clan chief. Leo expects of his employees that they not only be efficient forces of production, but also, and perhaps especially, integrate into a same 'family' until they share its way of life, friendships and trust. Their scores still resemble those that the bandits of the Old West and/or of the 1930s carried out: robbing banks and jewellery stores. It is a world of physical value on the verge of extinction. *Thief* thus describes a capitalism with a still human face, which is local (a single field of action, the United

[128] Georg Simmel, *Philosophie de la modernité*, Payot, 1989, p. 240.
[129] *Collateral* and *Terminator* both function around a same triangle of characters: Max, Vincent and Annie/Kyle Reese, the Terminator and Sarah Connor. Max/Kyle must protect Annie/Sarah from Vincent/Terminator, whose mission is to kill her. Sarah must fulfil an existential program she is ignorant of (avoid a nuclear holocaust and give birth to the one who will oppose it), just as Max must fulfil his own. In the two films, it is a negative power (Vincent and the Terminator) which, against its will, becomes the agent of this fulfilment. But if for Cameron, the posthuman produces a sort of childlike excitement, it is for Mann a source of tragedy.

States) and guided as much by the search for profit as by affects –
besides, Leo's vexation by Frank is what precipitates the film towards
drama. From *Thief* to *Heat*, 15 years have passed and the mutations of
capitalism that Mann describes are considerable. Neil McCauley is at
the head of a gang of experts in organized crime and his chic techno-
commercial outfit contrasts sharply with Frank's proletarian appearance.
As much from the point of view of his education as of his competences,
Neil navigates with ease in the world of modern enterprise and stock
exchange investments. He knows their codes and language. *Heat* is
already situated on the side of a globalized, indifferent, virtual and
cynical capitalism which Neil, as a Mannian anachronism, tries, despite
everything, to temper by trying to keep a form of humanity: an aversion
for mindless violence (Waingro) and respect for certain old-fashioned
principles (robbing banks but not people). Finally, with *Collateral*, Mann
draws the portrait of a man, Vincent, totally impregnated by the
monetary economy, who believes himself, undoubtedly, to be a
sophisticated agent of the most advanced contemporary capitalism.
This crime *trader* thus shows an absolute individualism and a total, and
therefore deadly, neutrality regarding the world and his work – after
all, murder is an economic activity like any other, with a law of supply
and demand, a stock exchange, a market and clients to conquer. For
him, the victims – a term he never uses – are just boxes to tick before
dawn. But there exists a bias in his conception of things as in that of
the globalized capitalism of which he is the avatar: by rationalizing
everything, Vincent believes himself immunized but ends up breaking
apart in contact with the indeterminacies of the real and especially
those of Max, be it his fear, his emotions or precisely his empathy. Life
is not an economic theory.

Thus, in prolonged contact with Max, his veneer of
respectability gradually cracks and the ideologue of triumphant
ultraliberalism shows his barbaric face. At the end of the film, this
suited professional turns into a savage and deregulated machine. With
a bloodstained face, a robotic attitude, armed with an axe and his flair
as only compass, he sets off in pursuit of Max and Annie in the
underground of Los Angeles. The shot showing Vincent jumping in
extremis onto the end of a subway train and the fast zoom on his
demented face could be out of a film by James Cameron, and more
precisely *Terminator*, with which *Collateral* is secretly in dialogue.[129]
Unlike Max, who finally trades in his provisional vital program (the
taxi) for an existential program to fulfil (Annie, Island Limos, quite

simply life), Vincent has no replacement program, except the blind fulfilment of a mission with which, at that moment of the film, he merges himself completely, a black hole into which he can only rush. 'The logical consequence of individualism is murder and misery.'[130] Is this misery the matter in which the eschatological atmosphere of the film is steeped?

This image of nothingness which, from the bottom of the abyss of *Collateral,* looks at the Mannian professional evokes the nightmare which haunts the nights of Vincent Hanna in *Heat,* and of which he reveals the content to Neil during the sequence in the restaurant. Vincent imagines himself seated at a banquet table, surrounded by all the victims he has seen. 'They're staring at me with these black eyeballs.' 'What do they say?' Neil then asks him. 'Nothing. They don't have anything to say. See, we just look at each other.' *Collateral* thus prolongs this feeling of desolation already perceptible in *Heat* but in the form of a nightmare expressing, perhaps, the morbid becoming of professionalism when it is pushed to its limit.

Mastery in trompe-l'oeil

There is often in Michael Mann's directing a shift towards very wide shots which, by a brutal effect of distancing (the entry of the French army in a clearing in *The Last of the Mohicans*) or of elevation (the speedboat journey of Sonny and Isabella filmed high and in a wide shot in *Miami Vice*), replace the human figure in a frame that surpasses it. Without breaking the narrative continuity nor even the general enunciation, these changes of scale do violence to it for an instant and let us glimpse the immeasurable size of the universe, its infinity, but in the form of the whole. 'That is sublime in comparison with which everything else is small', writes Kant (see the last shot of *Heat*). But next to these shots which exalt man's relationship to his natural environment, another series of shots, filmed at a high angle of cities or inhabited zones, reveals the existence of a dominant and invisible point of view on the world, in other words of a power which would have *mastery* of

[130] Interview with Jean-Yves Jouannais and Christophe Duchâtelet, *Art Press*, 199, February 1995, quoted by Bernard Maris, *Houellebecq économiste*, Flammarion, 2014, p. 40.

it. It is the long opening shot of *Blackhat*, with this camera which, from stellar space, sinks towards the Earth like a predator on its prey and prefigures the grip of virtual networks on the physical world. Or, in *Collateral*, those high-angle vertical shots of the road network of Los Angeles which express a dual feeling of imprisonment – what is this totality of which we are captives? – and of control, as if, before free men are taken in charge of by structures or characters in particular (Vincent and his will to power), there floated in the air, like a diffuse but omnipresent threat, a controlling force always quick to dominate them.

What is a great professional but someone who masters to perfection a technique and a trade? It is a man who controls, is competent, 'They're good' (Vincent Hanna), the Mannian hero par excellence: Frank, virtuoso jewellery thief, Neil McCauley, expert in heists, Muhammad Ali, world heavyweight champion, Nick Hattaway, hacker genius, or Lowell Bergman, star of American journalism. The obsessive relationship of Mann to the question of professionalism appears all the more fascinating as his oeuvre is part of the tradition of a cinema of hyper mastery, like those of Hitchcock, Welles, Antonioni, Kubrick and Melville. In Hollywood, everyone knows this and has even sometimes experienced it: from the writing stage to that of postproduction, nothing escapes the sharp eyes of Mann. The testimonies of his collaborators abundantly describe a man gifted with a remarkable technical knowledge, a tireless worker concentrated on the slightest detail, be it a costume, the place of an extra in the frame, the inflexion of an actor's voice or a tiny camera movement. From this point of view, Michael Mann is undoubtedly the most professional of the professionals of Hollywood. But also its most experimental. Mann has never hidden his admiration for Stanley Kubrick, which was that of an aspiring filmmaker for an idealized master, but undoubtedly also for a certain idea of a craft which only becomes great on condition that it is taken to its highest degree of adventure and perfection.

In his collection *Essays and Lectures* published in 1954, Heidegger analyses the fundamental ambiguity of the deployment of the individual through technique which, in his view, leads necessarily to exhaustion, nihilism and distress. A will to domination (and power) of oneself and the world, but in reality, an insidious process of dispossession. In other words, if technique constitutes a procedure for the articulation of

being and strength (the professional), pushed to its limit as metaphysical project (the complete calculability of the world and of individuals), it becomes a power for disarticulation. Transposing this anxiety to the field of cinema, Jean-François Rauger analyses the notion of mastery in the work of Otto Preminger: 'That the cinema of Otto Preminger demonstrates a great mastery has finally less importance than the fact that his oeuvre has, equally, thought about mastery, and has been able to demonstrate that to want to control the real is to take the risk of losing it forever.'[131] To lose from wanting too much to control is a possible definition of mastery *in the films* of Michael Mann. The excess of mastery, which threatens all his professionals, translates into a withdrawal into the self since the encounter – that 'undermining exteriority', to borrow Blanchot's expression – carries in it all that potentially puts it in danger: the unforeseen, affects, incoherence, the gap from oneself, quite simply the real. Hence the instinctive distrust shown by Neil when Eady speaks to him for the first time at the start of *Heat*, Vincent's refusal to enter into physical contact with Felix and, more generally, their common reluctance to leave their zone of comfort and/or mastery. Autism is the other side of independence and solitude, the curse of the lone professional. In Mann's work, mastery thus appears as a false friend, a trompe-l'oeil which firstly lets you suppose that there can only be total fulfilment within a parameterized zone. But all his films prove that excellence, as essential as it is in the exercise of a profession (robber, scientist, boxer or filmmaker), cannot be an end of itself. Consequently, if his cinema never stops celebrating its virtue, it also shows how the excess of mastery – or *mastery for itself* – leads, in reality, to an existential void (Neil) or to a totalitarian pathology (Vincent in *Collateral*, Hoover in *Public Enemies* and all those systems which fantasize about a total mastery over individuals). Thus, Mann's films organize themselves and often turn upon a moment where the real breaks in (a feeling of love, an unforeseen affect) that his characters try, and of course fail, to control. Granted, most of them end up losing this so coveted real and disappearing – hence their tragic dimensions – but by losing it, they have rehumanized themselves and have moved outside the technical field. As Jef Costello (Alain Delon) says in *Godson* (*Le Samouraï*): 'I never really lose.'

[131] Jean-François Rauger, 'Otto Preminger: la maîtrise invisible', in *Conférences du Collège d'histoire de l'art cinématographique*, 1994, p. 58

5. TECHNO- LOGICAL DEFEAT

(PUBLIC ENEMIES)

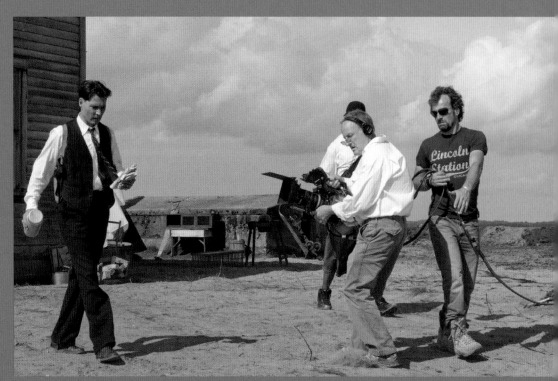
Michael Mann on the set of *Public Enemies*, 2009

With *Public Enemies*, which he directed in 2009, Michael Mann returned, for the second time in his career after *The Last of the Mohicans*, to a founding period in the history of the United States (the 1930s, the Great Depression, the bloody epics of the first gangsters in age of information and talking pictures) but also of his crime films, *Thief*, *Heat*, *Collateral* and *Miami Vice*. It was also for Mann, 30 years after *Thief*, a return to his hometown of Chicago, where the film was mostly shot. *Public Enemies* starts on 26 September 1933, with Walter Dietrich's escape from an Indiana penitentiary organized by John Dillinger, and ends on 22 July 1934 in front of the Biograph Theater in Chicago where Dillinger, denounced to the FBI by a Romanian prostitute he was frequenting, Anna Sage, is shot dead. The period Mann chose to treat in the short existence of John Dillinger constitutes, certainly, a tipping point in the life of the public enemy number one of the time, but also in the history of the struggle against crime as much from a political point of view as a technological one. As if, by focusing his story on the passage from 1933 to the summer of 1934, Mann had sought to explore the archaeology of the world in which Frank (*Thief*), Neil McCauley and Vincent Hanna (*Heat*), Ricardo and Sonny (*Miami Vice*) and Vincent (*Collateral*) would one day evolve. From this point of view, *Public Enemies* constitutes, for Mann, as much a quest for origins – when did the world of *Heat* begin? – as a vast recapitulation of his motifs and obsessions, to which the screenplay, in its desire to establish a genealogy with his previous films, endlessly echoes.[133] 'Dillinger is a bandit from the 19th century, not the 20th or the 1920s, which marked the birth of modernism', Mann said at the time of the film's release. 'Moreover, a decade later, an improved version of modernism took shape and the institutions and their organization did not change until the end of the 20th century.'[134] Mann's interest in the 1930s and its industrial and technological mutations is firstly part of an emblematic movement of the filmmakers of his generation, who, from Robert Altman to Martin Scorsese, have very often returned to the period of the Great Depression, as if it could shed light on and elucidate something of the 1970s.[135] In the middle of the 1980s, Mann was first of all interested in the figure of Alvin Karpis, an

[133] Here, Shouse is an avatar of Waingro who also shoots dead a guard for looking badly at him; the face-to-face between Purvis and Dillinger; the death of Walter Dietrich, mentor of Dillinger, which echoes that of Okla in *Thief*...

[134] Interview taken from the French press pack of the film.

[135] On the relations between the 1970s and 1930s in American cinema, I refer you to my book co-written Bernard Bénoliel, *Road Movie USA*, Hoebeke, 2011.

ex-member of the Barker gang, who became one of the four public enemies of the period before his arrest in 1936 and his incarceration in Alcatraz, where he stayed until 1969.[136] He then drew from it a screenplay he deemed unsatisfactory. At the beginning of the 2000s, Bryan Burrough, author and correspondent for *Vanity Fair*, started to write a miniseries for HBO on the main figures of the criminal underworld in the 1930s. By Burrough's own admission, the project fell through because of his inability to write a good script, but he exploited his research in an important essay, published in 2004 under the title *Public Enemies: America's Greatest Crime Wave and the Birth of the FBI, 1933–34*. Michael Mann's production company, Forward Pass, acquired the rights, as did that of Leonardo DiCaprio, who was interested in the role of John Dillinger. When, two years later, Mann began the development of a film based on Burrough's work, DiCaprio had started on *Shutter Island*. He called on Ronan Bennet, a scriptwriter with whom he had just worked on a project devoted to Che Guevara,[137] and proceeded to make the final revisions in the company of Ann Biderman, the author of several episodes of the series *NYPD Blue* and future creator of *Southland* (2009–13).

Caught in a vice

'1933. It is the fourth year of the Great Depression. For John Dillinger, Alvin Karpis and Baby Face Nelson it is the golden age of bank robbery…'. It is with this written board that begins Michael Mann's eleventh feature-length film, an announcement which carries with it a form of carefreeness that is immediately corrected by the first shots of the film. Outside an Indiana penitentiary, in Michigan City,[138] some prisoners in single file are keeping in step, their feet chained, under watchful eyes of the guards and watchtowers. Behind them, the imposing walls of an anthracite building crushes them; on the ground, a wounded prisoner bears witness to the violence of the prison system, figured here in the form of granite monolith, that is to say a new image among others

136 Alvin Karpis was undoubtedly the most intelligent and gifted of the public enemies of the period. Arrested in 1936, he was extradited to Canada in 1971. He then lived in Spain, where he died in 1979.
137 This is *Che*, the film-dyptic by Steven Soderbergh (2008).
138 This sequence was in reality filmed in the penitentiary of Stateville, Illinois.

of the brutality at work in all these governmental structures or corporations which are found throughout Mann's cinema. John Dillinger embodies first of all for Mann the prototype of the individual that the penal institution has transformed into a criminal. Scarcely has he been transferred to the prison of Crown Point, in Indiana, then Dillinger is exhibited to journalists who have come to see the most famous of the public enemies. 'Ten years ago, I was a wild boy, and, well, I was foolish. I held up a grocery store, which I never should have done 'cause Mr. Morgan was good man. And they sentenced me to 10 years in the state penitentiary for a $50 theft. When I was in prison, I met a lot of good fellows. So sure, I helped set up the break at Michigan City. Why not? I stick with my pals and my pals stick with me.' The second sequence of the film, during which Purvis pursues Pretty Boy Floyd in an orchard before shooting him, is introduced by a song by the bluesman Otis Taylor, *Ten Million Slaves*, whose words bring together the harshness of modern work and the status of the slaves who, three centuries earlier, were torn from their native Africa and crossed the ocean, in chains, to be exploited in Virginia. The refrain effects of the text – 'Don't know where, where they're going/Don't know where, where they've been' – thus feeds the feeling of a perpetual present which escapes the evolutions of history and indicate that, despite appearances, nothing has changed. Always the daily repetition of the same tasks in the service of a system which enslaves. By choosing to place this song at the moment when Purvis appears for the first time in the film, Mann certainly establishes a relationship between the first slaves and the outlaws (chained and/or hunted like Floyd), but from the outset makes of Purvis the agent of a system of slavery (the FBI) to which he himself is bound hand and foot.

Public Enemies

Two antagonistic forces oppose Dillinger, his robberies like his desire for freedom, but they have, at the beginning of the 1930s, interests which, in reality, converge – in the same way that Ali found himself stuck between the FBI and The Nation of Islam, and their shared will to contain his popularity (and therefore his political strength). On the one hand, the American State, embodied by J. Edgar Hoover and his G-Men, obsessed with the capture of these gangsters who make the headlines and enjoy, among the common people of the Depression, a worrying popularity; on the other, the Crime Syndicate, then being completely restructured, which looks unfavourably upon these indomitable mavericks whose glorious feats attract the police light. But in reality, we are dealing with two objective allies, two faces of a single oppressive system which then seek to *modernize themselves*, in other words *adapt technologically* to the coming times. For Hoover who, during a press conference declares with great fanfare 'the United States of America's first War on Crime', the time has come to pass from craftmanship to enterprise, from passion to efficiency. At the beginning of the 1920s, he created, inside the Justice Department, a special agency charged with ensuring the maintenance of law and order. From the terrorist attacks which rocked Washington in 1919 to the capture, in 1932, of Bruno Hauptmann, kidnapper of the son of Charles Lindbergh, Hoover had a sole vocation: to struggle against all the forces which, he believed, were destabilizing his country, from the gangsters of the 1930s to the Communists he fantasized were everywhere right until his death in 1972. History will prove it: Hoover lied, manipulated, did not hesitate to distort the facts and rewrite them to his advantage (Dillinger's death, for which he took exclusive credit) or to bend the laws to his will to power. During his career, he accumulated on his contemporaries many secret files,[139] as if suffering from a mania for archiving and surveillance. Blackmail, Hoover knew it well, as a master of it, of course, but also as a victim, since the mafia had constantly threatened to reveal his homosexuality – that secret love for the lawyer Clyde Olson, who, although he did not speak, appeared in the film, always at his side.

Dillinger and the outlaws of his kind are thus crushed twice, caught in a vice between two twin entities which, at the end of the film, act logically in concert. The screenplay ends up revealing their

[139] These are the infamous secret files, the vast majority of which were destroyed by Hoover's faithful secretary when he died. Scarcely elected in 1968, Nixon dreamed of retrieving them.

War through images (*Public Enemies*)

Public Enemies

alliance, since it is Martin Zarkovich, the corrupt detective from Chicago, who has become the Nitti's henchman, who organizes the fatal encounter between Melvin Purvis and Anna Sage, that infamous 'Lady in Red'[140] who will inform the FBI about Dillinger going to the cinema. If the FBI and the Crime Syndicate end up working together, it is because the law, as always in Mann's work, only constitutes a smokescreen, a circumstantial alibi for the arbitrary exercise of ideological (the FBI) and financial (the Syndicate) power.

In *The Insider*, CBS and the tobacco industry, which it is supposed to investigate, put the same pressure on Jeffrey Wigand and Lowell Bergman, and collaborate *in fine* in the name of common economic interests.

In *Public Enemies*, Mann also multiplies the effects of resonance between the two structures, be it their indifference to the law – for some, the struggle against crime must know no legal limit, for the others, the law must serve business and not constrain it – or their places of power, which follow the same Taylorist architecture. Thus the bookmakers' hall run by Phil D'Andrea, with its aligned desks, its charts of betting odds and interchangeable employees, does not clash next to the telephone listening centre of the Bureau or the administrative headquarters of Chicago that Purvis discovers just after his promotion: modern and bureaucratic spaces, populated by masses of anonymous workers transformed into robots, described thus in the film's screenplay: 'It's like the "Corporate Office of the Future" designed by Albrecht Speer. Agents are at grey metal desks dressed identically in dark suits, white shirts, dark ties. No personal effects. The individual is reduced to a component in a gleaming machine.' The reference made here by Mann and his two co-scriptwriters to the architect of the Third Reich in order to characterize the dehumanization at work in the new offices of the FBI is found in numerous allusions to the fascism then rampant in Europe, as an invitation to envisage the modern transformation of the Bureau, and more widely of American institutions, as part of a precise historical dynamic which surpasses the frame of the

[140] In reality, this 'Lady', Anna Sage, wore an orange dress, a detail which Mann rectifies. Let us note that Sage has been the object of a film adaptation, *The Lady in Red*, directed in 1979 by Lewis Teague, with Robert Conrad in the role of Dillinger and Pamela Sue Martin in that of the *Lady in Red*.

Depression. Even the massive wall of the Indiana penitentiary is reminiscent of the granite façade of another prison, that of *The Keep* and its Fascist-inspired architectural style. Hoover embodies that inflexible will to impose at all costs a modernity whose totalitarian side Mann endlessly reveals. In response to Senator McKellar's questions about his legitimacy as Bureau director, Hoover describes himself as an 'administrator', the first cog in a system which is preparing to trade in ethics for performance, the presumption of innocence for results. Furious that Dillinger has been able to escape from Crown Point prison, he gives Purvis the new line of conduct to follow, in the form of a crystal-clear understatement: 'No obsolete notions of sentimentality. We are in the modern age. We are making history. Take direct, expedient action. As they say in Italy these days, "Take off the white gloves!"', thus marking his approval of the radical methods used by the Fascist regime. Afterwards, Hoover moves over to a group of handpicked American adolescents whom he proudly describes as the future new guard of the G-Men. The image then passes from colour to black and white and takes the form of a newsreel broadcast on the imposing screen of a movie palace in Chicago where sat Dillinger, Red and other gangsters with whom he now has to work (Baby Face Nelson and Shouse). Suddenly, the programme is interrupted by an episode of *America's Most Wanted*, a series of small propaganda films (thought up by Hoover) which disseminated the portraits of the most wanted criminals of the moment. The lights of the hall come brutally back on the viewers while loudspeakers spit out in an authoritarian voice the order to check the identity of their neighbours. In a sepulchral silence, they all obey, like a petrified and submissive mass, turning their heads from right to left, with the exception of Dillinger, whose face then occupies all the screen. The programme begins again with a newsreel of the period devoted to Ethiopia. Another allusion to the Italian situation, since in this year of 1934, Mussolini's troops invaded the former Abyssinia for an occupation which, until 1941, would be marked by violence and cruelty. The combination of these three short sequences allows Mann to show several aspects of a same totalitarian *Zeitgeist*: the enrolment of youth for a populist programme ('Make America safe again'), hypervisibility and denunciation as techniques of political control, the manipulation of the masses by the media, and the despotic ambitions of the Empire. Had Mann remembered here what Herbert Marcuse, father of the American New Left and lecturer at Lowell Bergman's university in *The Insider*, wrote, in 1964, in his

critique of modern forms of capitalism and of the 'advanced industrial society' (*One-Dimensional Man*)? 'Technological rationality reveals its political character as it becomes the great vehicle of better domination, creating a truly totalitarian universe in which society and nature, mind and body are kept in a state of permanent mobilization for the defence of this universe.'[141] The penultimate sequence of *Public Enemies* also takes place in a movie palace, the Biograph Theater in Chicago, for the projection of *Manhattan Melodrama* (W. S. Van Dyke, 1934) attended by Dillinger. Everything invites us to join together these two cinema experiences, the inexpressiveness of a blinded crowd and Dillinger's emotion before this gangster film which, in his eyes, recounts *his story*: on the one hand, a propaganda tool for viewers automatized by impersonal forces, and on the other, the imaginary place of an apprenticeship, a lesson in life or philosophy for oneself. After all, the factory of Hollywood images does not know neutrality: the nature of what is projected on a cinema screen determines a certain type of viewer that Michael Mann chooses, *in fine*, to oppose, doubtless aware of the dual historical and contemporary relevance of what he is saying.[142]

[141] Mann's work is, in many regards, of Marcusian inspiration. No doubt the appearance in 1964 of *One-Dimensional Man*, the future manifesto of the American counter-cultural movements, gave him an intellectual background, an analytical focus which he enriched in contact with other thinkers (Foucault, Baudrillard, Jameson…) but to which he had remained faithful. For Marcuse, contemporary society is characterized by very strong industrialization (the 'advanced industrial society'). It aims to block any social change and any other possibility of life, with the unique aim of ensuring the perennity of its logic of productivity and domination. The one-dimensionality of society shows its tendency to neutralize any form of external critique by absorbing it. Democratic in appearance, it is fundamentally totalitarian, since it leaves nothing outside it and its limits, be they geographical spaces, behaviours that are distinctive and outside its law, human groups or institutions. Contemporary society, writes Marcuse, is 'a non-terroristic economic-technical coordination which operates through the manipulation of needs by vested interests'. These false needs suppose the standardization of society, of thought, of ways of life, and impose backbreaking work to satisfy them. The paradox resides in the fact that the individuals feel happy, but this feeling is itself the object of a manipulation. Social change, or any form of resistance or counter-model, carries in it the risk of putting into question this comfort and security. Then, political and social uniformization explains why opposites have the tendency to join one another, interests included, and fundamentally only work towards the stability of existing contemporary society.

[142] As if Mann was also describing a certain state of contemporary America cinema and its ability to produce for anaesthetized crowds a tepid and totalitarian flow.

Physiologies

The FBI and the Crime Syndicate both seek to consolidate their power by increasing their resources (their capital). The two big corporations in *Public Enemies* are even directed by two men, J. Edgar Hoover and Frank Nitti,[143] who in many ways resemble one another. Two weak bodies, suffering from a form of coldness and rigidity. 'Looks like a barber,' says of Nitti John Dillinger when he sees the new strongman of the Syndicate in a posh place in Chicago, pointing out intuitively the blandness of one of the most powerful characters in the United States. Far from the truculent figures of the first American gangsters (Al Capone), this executive of crime profits from his position and/or his fortune at no moment in the film. He is a taciturn, inexpressive being, suffering from a deficit in affect which makes him similar to Jesus Archangel Montoya, the leader of the cartel in *Miami Vice*, a lacklustre and chilling individual who, in spite of his power and opulence, seems incapable of pleasure. During the horse race in Miami, Nitti asks about the temperature ('It's hot out, right?') and confides to Phil D'Andrea, his subordinate: 'Ever since those pricks shot me, I can't get warm.' More than confiding his own physical weakness, Nitti implicitly recognizes how much his own organism, and therefore what still makes of him a human being, is an encumbrance. However much, like Hoover or Montoya, he may control vast financial networks, manipulate masses and know how to control them, mastery of his own body partially escapes him. That is to say biologically failing bodies, with reduced sensitivity, themselves vampirized and chilled by the dehumanization of a system of which they are the best zealots. If vitality is lacking in those who run these capitalist conglomerates, it constitutes, conversely, the major asset of Dillinger and the outlaws of his kind, their first quality and, by extension their pathology (Baby Face Nelson). In the first half of the film, Dillinger never misses an opportunity to celebrate his robberies, and immediately converts the money stolen from the banks into various forms of pleasure. Even the idea of saving or of anticipating the end of his activity seems foreign to him: 'What we're doin', don't last forever,' Alvin Karpis warns him at the start of the film. But Dillinger,

[143] A gangster of Italo-American origins, Frank Nitti (1886–1943) was one of the main henchmen of Al Capone and leader of the Chicago Outfit. He was essentially responsible for the management of financial flows inside the mafia business.

in the name of his prescience of a non-existent future, knows that he has only the enjoyment of a present that will not last. 'Right now,' he repeats throughout the film like a mantra which could be a manifesto. The game is worth the candle and it is Clark Gable who, in *Manhattan Melodrama*, takes the words right out of his mouth: 'Die the way you

Public Enemies

lived, all of a sudden. That's the way to go. Don't drag it out. Living like that doesn't mean a thing.' *Public Enemies* could have been called *Death of a Matador*, in reference to Hemingway's eponymous book, or *The Man in a Hurry* (Paul Morand), so much does Dillinger belong to that same family of men constantly confronted with their death and for whom expenditure becomes the only possible antidote to the tragic fatalism which haunts their existence ('I got a feeling that my time is up,' says Red just before the gunfight at Little Bohemia Lodge). The present, only, and life, but carried to its highest degree of intensity and panache. No adaptation is possible to this dull and modern world to come nor any way back down the line of his own story. It is not Dillinger who says it, but Neil to Vincent, just before dying in *Heat*: 'I told you I was never going back.' After all, 'Action is the juice,' argues Michael Ceritto to justify his participation in the bank robbery which, however, will cost him his life.

Dillinger is thus the *physiological* polar opposite of Frank Nitti, of Hoover and of this modernity which cannot come to be without a deficit in humanity. He wants to continue to *feel*. A *vitalist* drive against the death drive. Far from the histrionics and the facial contortions he used so much in the films of Tim Burton, here Johnny Depp opts, under Mann's directing, for a much more sober and subtle way of acting. His face expresses all the emotions going through him, unlike

the aphasic Dillinger played by Lawrence Tierney in Max Nosseck's 1945 version. After the episode in the Sherone residence and the murder of agent Barton by Baby Face Nelson, Melvin Purvis tries to make Hoover understand that his agents – most of them law students in good physical shape – don't have the sufficient qualities in the face of the endurance and experience of the gangsters they are hunting ('Our type cannot get the job done'). As things stand, he is leading his men to a massacre and asks his superior for the transfer of particular competences – from the ex-marshals of Texas and Oklahoma – as if a bit of human substance had to be reinjected into the body of the bureaucratic elite. This admission of weakness, that Purvis will have to repeat three times, is painful to the ears of Hoover who, on the other end of the line, cannot or *does not want to* hear about the physical and mental fragility of his young modern force. When they arrive in the central station of Chicago by getting out of an imposing locomotive, the ex-marshal Charles Winstead (Stephen Lang) and his colleagues seem to resurface from a past industrial age. Their appearance, in the midst of an environment of steam and steel, immediately introduces a feeling of power dramatized by the use of close-ups and slow motion. The alliance between Hoover's G-Men and these men wrapped in shabby dustcoats marks, in the film, the first important stage in the FBI's takeover of the struggle against the public enemies. A necessary alliance for this moment of transition between a still insubstantial modernity and a solid archaism, technology in its infancy *and* experience on the ground. The relationship between Winstead and the FBI (Purvis, but especially Hoover) resembles that between Henry Fonda and Gabriele Ferzetti in *Once Upon a Time in the West*, a veteran bounty killer and a businessman, together, at the time of the confiscation of American territory by a wild capitalism already embodied, like Nitti, by a handicapped body, suffering from an illness which eats away at it from inside.

Melvin Purvis
or the experience of dissolution

John Dillinger and Melvin Purvis have a relationship which belongs to that line of duos of men which, from *Heat* to *Blackhat*, structure most of Mann's films since both of them stand at odds with (Purvis) or apart from (Dillinger) this new system of which both sense the totalitarian ambition, the desire to cover over with its stone hand the entirety of

space and its possibilities. When he is appointed by Hoover as head of the Chicago Bureau responsible for the Dillinger case, Melvin Purvis is still only a good idealistic soldier, almost a boy scout who has just carried out a brilliant feat of arms – the death of Pretty Boy Floyd. In the screenplay, he is described as 'Clean cut and handsome. A square jaw. Chester Gould modelled Dick Tracy's profile after Purvis. He's not big, but he's tenacious. He's an incarnation of the social elite of his time: white, Southern patrician and a Christian gentleman.' His first appearance proves it: dressed as a Ranger and sure of his gestures, Purvis possesses all the outer signs of this 'modern force' that Hoover is calling for. To the journalists who ask him why he thinks he can capture Dillinger, he replies: 'We have two things Dillinger does not. The Bureau's modern techniques of fighting crime scientifically and the visionary leadership of our Director, J. Edgar Hoover.'

Purvis is not yet aware of it, but he owes his appointment as much to the media coverage obtained by Floyd's death as to the weakness of the human resources at Hoover's disposal to staff his Bureau. With a head full of his boss's ambitious discourse, surrounded by motivated young agents and a cutting-edge technical environment, Purvis is living through his time of innocence. But this time will be brief. He quickly understands that the modernization of the FBI orchestrated by his leader gives the individual no rights except that of being a cog in the State machine. This State is an end without reciprocity and therefore enjoys unlimited moral power: to torture a man until it gets information (Tommy Carroll who, to shorten his suffering, will put the FBI on the trail of Little Bohemia Lodge), to beat a handcuffed woman under the embarrassed but silent eyes of the other members of the Bureau (the beating of Billie Frechette) or to threaten an immigrant worker (Anna Sage) with deportation if she does not collaborate. The veil of impunity covering this new exercise of the law clashes with his deep convictions, disturbs his ethics and creates in him a dilemma that he will be unable to resolve. Because despite its modern look, Purvis belongs to the old world, just like Dillinger, with whom he shares certain moral values. His Puritan education, his taste for precision and respect for procedure do not prevent him from being able to make the distinction between Dillinger and Nelson, professional bank robbers and bloodthirsty psychopaths, or the punitive thirst of his leader and the complexity of the men he is hunting. Unlike Hoover, he does not confuse transgression of the law and inhumanity. For him, all criminals are not

animals. But his refusal is resistance in principle, a Jiminy Cricket who only acts inwardly, since in reality, Purvis collaborates *fully* with the brutal methods of the Bureau. He may look away when a man is tortured, show delicacy towards an exhausted woman (Billie Frechette, whom he carries in his arms after her grilling by agent Reinecke) and remain dignified at the bedside of his victims, his compassion turns out to be incompatible with his position as an executor of orders. Humanism does not constitute a necessary condition for this *forced march to modernity*. Regardless of the losses (those inexperienced agents who fall like flies), all that counts is the media, and therefore, political profit, Hoover will draw from the eradication of the public enemies. Finally, Purvis has no control, except at the extreme margins, on events, as is shown by the bogus promise made to Anna Sage, in exchange for her information on Dillinger, to make sure she remains on American territory.

The relationship between Hoover and Purvis therefore reminds us, at 25 years distance, of that which opposed Captain Woermann and Major Kaempffer in *The Keep*, and the martial words of the latter anticipate, sometimes word for word, those of the Bureau chief in *Public Enemies*. When he arrives in the Carpathians, at the foot of the col which the German army has as its mission control, Kaempffer, who defines himself as a political soldier, is annoyed at Woermann's behaviour, his laxness with the villagers, whom he suspects of hiding partisans, and his weakness towards the Romanians, who are nevertheless his allies. 'Your security doesn't work because your methods are wrong. The answer's fear.' Woermann is a loyal German soldier but who has contempt for the regime of Adolf Hitler and Nazi ideology, which he describes as a 'psychotic fantasy'. Like Purvis, a witness to the abuses of the G-Men, Woermann is present at the barbaric atrocities of the *Einsatzkommandos*, protests to his superior, but, as the latter points out to him, never puts his acts in harmony with his thoughts. From this point of view, he is living through the same affliction of the soul as Purvis, since both condemn two systems (the FBI and the Nazi regime) in which they participate despite everything. 'Were you with the German anti-fascists fighting us in Spain?' Kaempffer asks him. 'No. Did you stop the *Einsatzkommando* in Poznan? No. You have been contaminated by this German disease, Woermann. Sentimental talk. It allows you to feel sensitive, superior and yet stay safe because you take no action.'

The original screenplay of *Public Enemies* followed Purvis's career until his resignation from the FBI, on the day after Dillinger's

Melvin Purvis: progressive shifts towards inhumanity (*Public Enemies*)

death. This short sequence took place in the office of Hoover, who proudly exhibited the death mask of Dillinger. 'John Dillinger was an outlaw and he was my adversary. But he was no punk. And he was no hoodlum. I came here to say that I have no future in your Bureau. And I do not desire one. I quit.' In the film, Purvis just leaves the crime scene scarcely a few minutes after Dillinger's death, like a silhouette among others, in a wide shot and anonymously, while all the cameras are pointed at the corpse of his adversary. A symbolic disappearance which the film holds onto, but which, in reality, was completed with his suicide on 29 February 1960. What would be the point of filming Purvis's adventure to its tragic end, since when he leaves the frame, he is a man already dead, and his ethics scorched earth?

Just after his transfer to Indiana, Dillinger is shut up in an iron cage placed in the middle of a vast room, like an exotic animal that can at last be contemplated. Mann then invents an encounter which did not take place in reality, the only one, between Purvis and Dillinger who, from each side of the bars, sniff one another like wild animals. For Purvis, it is a moment of vanity in the face of this prey desired for so long. Dillinger is the first to start the conversation and, in an echo of the central sequence in *Heat*, asks Purvis about his relationship to death. 'I'm used to that. What about you?' Purvis remains silent and turns back. In a glance, Dillinger sees in his adversary's eyes that spark of humanity, and therefore of compassion which he senses is coming into conflict with what he does. An intimate hiatus which, under a marble appearance, devours him from the inside, a series of cracks that will soon form an abyss. The exchange closes with a close-up of the face of Purvis who, behind Dillinger's back, staggers under the coup de grace ('You ought to get yourself another line of work, Melvin') he has just received.

Purvis is an effective servant of the FBI, but not the ideal agent Hoover fantasizes about, as he lacks a form of insensitivity to the suffering of others and to death, an ability to put his affect aside. As for Dillinger, he is not indifferent to death, but has learned to tame it, to mourn his dear departed. Besides, the opening sequence ends with the death of Walter Dietrich, who gives out his last breath while squeezing the hand of his protégé. Mann isolates for a short instant Dillinger's face while the car races across the plains of Wisconsin. A few necessary seconds of introspection in order to come to terms with his mentor's death, but life must go on, revenge (Shouse, the violent sidekick he must get rid of), laughter and the next robbery. Mann uses with Purvis the

same effects of latency, some close-ups of his tense face which, after each confrontation with death or practices he considers intolerable, speak of his existential uncertainty: firstly the founding moment of his disillusionment, the death of agent Barton, whom he finds dying in the corridors of the Sherone residence after he posted him there alone; those two drunken men he took for gangsters and killed before the assault at the Little Bohemia Lodge; agent Carter Baum, riddled with bullets by Baby Face Nelson at the moment of his escape, or still, in the hospital of Manitowish Waters, the calvary of Tommy Carroll whom he cannot *look in the face*. The face shots which punctuate this barbaric litany could mark moments of introspection, but Purvis is not the righteous man of a Sidney Lumet film. The painful confrontation which is established, in him, between the honest man and the Bureau lackey always concludes with the victory of the latter. Everything is going too fast for him. Consideration demands a time that the rush of events does not allow him. Psychologically, Purvis has not known how to or wanted to take off his white gloves, and his powerlessness in the face of death becomes an insistent poison. The man dies slowly, his face becoming marble-like, mortified while still alive. The psychological trajectory of Purvis thus echoes that of Alice Munro, in *The Last of the Mohicans*, who, by dint of unresolved confrontations with death and the horrors of war, becomes catatonic and ends up throwing herself from a cliff under the shocked eyes of Magua, in a magnificent sequence which revives the poignant vein of certain films by Griffith and in particular *The Birth of a Nation* – Flora Cameron (Mae Marsh), the sister of a Southern colonel, was already throwing herself from a promontory in order to escape a black servant who wanted to rape her.[144]

'No man is an island...'

...says the famous poem by English preacher and poet John Donne which is said to have inspired the title of Hemingway's novel *For Whom the Bell Tolls*. 'No man is an island entire of itself; every man is a piece of the continent, a part of the main; if a clod be washed away by the sea, Europe is the less, as well as if a promontory were, as well as any

[144] Let us note that in Griffith's film, this sequence is at the origin of the foundation of the Ku Klux Klan in 1865.

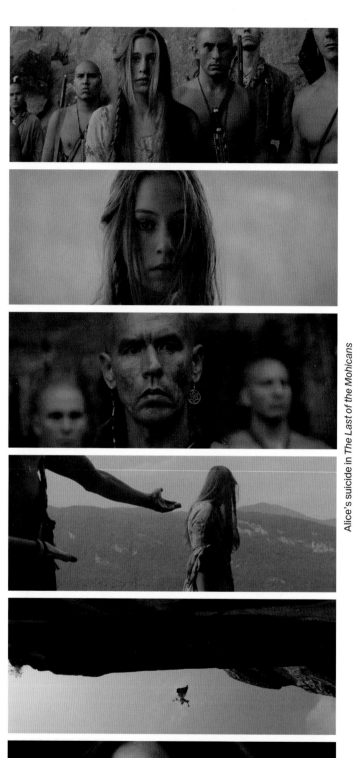

Alice's suicide in *The Last of the Mohicans*

manner of thy friends or of thine own were; any man's death dimini-shes me, because I am involved in mankind. And therefore never send to know for whom the bell tolls; it tolls for thee.'[145]

After having shot Pretty Boy Floyd in an orchard in Oklahoma, Purvis runs over to his victim and addresses him by his birth name, Charles Arthur Floyd, as a mark of respect for the man, and not only the gangster, whose life he has just taken away. The slightly affected expression of Purvis at the moment when Floyd expires translates a total absence of satisfaction which contrasts sharply with the Purvis played by Ben Johnson in the version by John Milius (*Dillinger*, 1973), an implacable lawman who celebrates each execution of a criminal by lighting a cigar.[146] The sequence, including its cutting, echoes the death of the stag at the beginning of *The Last of the Mohicans*, to which Chingachgook rushes to pay homage: 'We're sorry to kill you brother,' he says in front of the animal's corpse. 'We do honour to your courage and speed, your strength.' In *Public Enemies*, as in all Michael Mann's films, *no death is restorative* because no man, even the worst of them, is an island. This way of depriving death of its romantic, even chivalric, dimension puts Mann's films against the grain of the huge majority of contemporary Hollywood blockbusters, for which the death of certain men constitutes the precondition for a better world. In his work, it always questions a loss, an idiotic gap, a catastrophe for all mankind, as shown by the tragic mood which accompanies the end of Neil (*Heat*) or of Vincent in *Collateral*. Even Neil will pay dearly for his detour via the Marquee Hotel where Waingro has gone to ground. By killing him, he takes revenge but restores nothing; what's worse, he undoubtedly shuts the only exit remaining to him. 'The real nightmares are those that men inflict on themselves in this war,' replies Captain Woermann to the caretaker of the keep who, at the start of the film, explains to him that what terrorizes the villagers are bad dreams. In *The Last of the Mohicans*, after three days of siege of Fort Henry by the French army, the Marquis de Montcalm asks Colonel Munro to accept surrender in exchange for freedom for his troops. Now, Munro knows that after General Webb's refusal to send reinforcements, the battle is lost. A short discussion then ensues with Major Duncan Heyward who

[145] John Donne, *Devotions upon Emergent Occasions*, 1624.
[146] Purvis will also use the lighting of a cigar as a signal for intervention against Dillinger in front of the Biograph Theater. Is this a nod to John Milius's version?

The sad war (*The Last of the Mohicans*)

pleads for a chivalric death ('We'll go back and dig our graves behind those ramparts'), a collective suicide which would prove the grandeur of the Crown. This unwanted declaration is followed by a slow panoramic shot along the wall of the fort, on which stand out the silhouettes of solitary women and men. In the name of what he sees, and finally comprehends, Munro expresses what, for Mann, could serve as a profession of faith: 'Death and honour are thought to be the same, but today I have learned that sometimes they are not.' If death is worth nothing in itself, survival constitutes, on the contrary, a supreme value and what found all heroic impulse. 'You survive!' Nathaniel implores Cora before leaving the cave where they took refuge. 'Stay alive, no matter what occurs!'

Technological defeat

If he occasionally takes some liberties with the accuracy of the facts, Mann follows rigorously the chronology of the life of Dillinger and the change of era[147] at the beginning of 1934. Dillinger and his gang were arrested in a hotel in Tucson on 25 January and were transferred to the prison of Crown Point, in Indiana, from which he escaped on 3 March. Hardly six weeks since his imprisonment, but the world he rediscovered had changed. The free man who, up until then, braved the frontiers between the States and chose his robberies was now a beleaguered man, forced to associate with gangsters who repelled him, beginning with Baby Face Nelson and Ed Shouse. The mirror-like construction of the story allowed Mann to show how much, between the first actions of Dillinger and those, the same, that he carries out after his escape from Crown Point, *everything is similar and everything is different.*

At the start of the film, Mann shows the first break-ins of Dillinger in the banks as so many spectacular stage entrances, almost too easy remakes of the gangster films of the time, shows regulated to the smallest millimetre and without real consequences which end with a general burst of laughter. For Dillinger and his kind, this is a golden age because they believe themselves to be elusive and speed is *objectively*

[147] When John Dillinger entered prison in 1924, there were no road networks and cinema was silent. When he got out nine years later, the road networks and talking pictures had been invented.

on their side. The immensity of the American territory belongs to them, like an open playing field, all the more so as no cross-frontier law allowing the State police forces to coordinate their responses yet exists – it is the era of the famous Tri-State Gang, also called the 'Dillinger of the East',[148] which until January 1935 ran rampant between Maryland, Virginia and Pennsylvania. The first part of *Public Enemies* thus aligns its tempo on the kinetic power of Dillinger. The camera embraces his elegance, magnifies his natural ease and his ability to move in a world which seems to have no physical grasp on him, like in the low angle shot which shows him launching himself in slow motion over a small wall at the moment of the attack on the bank in Racine, Wisconsin. Even the smooth face of Johnny Depp is part of this deceptive and seductive superficiality which characterizes this time of innocence. To journalists, he boasts about the record time in which he carries out his robberies ('1 min 40 chrono'), while the wide shot which closes the sequence of the inaugural heist offers a perfect distillation of the first Dillinger, almost a publicity image for posterity: under a gigantic wall clock, the man seems to pose for an instant, his back to a room of wide-open safes, arms stretched out and armed. Dillinger is then master of time.

When the gang arrives at the farm that will serve as their safehouse, the filming is organized exclusively around the movements of its leader and the multiple details he must settle: change their car for a more recent model, bring technical improvements to his weapons, bribe a Chicago policeman (Martin Zarkovich), gather useful information; so many micro actions that the camera shows with rapid panoramic shots, but without losing sight of Dillinger's body being the centre of gravity. As soon as he can, Mann articulates the competence of Dillinger to the superiority of his technical arsenal over that of law and enforcement: faster cars which enable him to easily outrun his pursuers (a Ford V8 that only gangsters possessed then), more powerful weapons (automatic machine guns versus one shot rifles) and a freedom of movement that bureaucracy does not authorize – when he appears for the first time at a Senate hearing, J. Edgar Hoover is refused the extra human and financial means which would allow him to modify the jurisdiction and improve the equipment of his men. One line of dialogue,

148 See *Highway 301* (Andrew Stone, 1950) and episode 9 of season 1 of *The Incorruptibles*, *The Tri-State Gang* (1959).

eventually omitted, even alluded to a letter that Dillinger, like Bonnie Parker, had written to Henry Ford congratulating him on designing this powerful car that allows him to escape the police.

During Dillinger's imprisonment, the Syndicate and the FBI accelerate their economic and technical revolution. The new scientific methods of intelligence gathering, already tested with the analysis of the suit Dillinger left on the back of the hostage Anna Patzke, now bear their fruit. On his side, Purvis announces to the agents of the Bureau that they will soon have powerful equipment, be it Thompson machine guns or Browning BARs, those powerful submachine guns which will be used during the assault on Little Bohemia Lodge in Manitowish Waters. With the character of Hoover and his enthusiasm for modern techniques of investigation, Mann describes here the beginnings of that network thinking which flows through all his films, from *Thief* right up to the digital exoskeleton of *Blackhat*.

'What prehistory does *Public Enemies* draw?' writes Hervé Aubron. 'That of a very old passion of Mann: the grid pattern (*Heat*, *Collateral*), the network that America invented in the twentieth century, that infinite horizontality of interconnections, of which Los Angeles seen from the sky has become the emblem.'[149] The interface becoming of the contemporary world, its obsession with total visibility, runs through all of Mann's cinema. At once the bearer of a new mysticism that has to be *revealed* in the photographic sense of the term, but also a project of espionage and global control, this 2.0 panopticon has nothing to do with that material reality described by its first theoretician, Jeremy Bentham, but it has mutated into new, unprecedented forms which haunt all of Mann's cinema. Is Michel Foucault's *Discipline and Punish* (1975) not one of the bedside books that Mann conspicuously frames in Nick Hathaway's cell in *Blackhat*? We will return to this.

On 3 March 1934, John Dillinger manages to evade the detection of his guards and escapes from Crown Point. But a red light stops his escape, an early sign of a space suddenly regulated by a technology that is increasing its power.[150] Immobilized for an instant outside the prison, Dillinger champs at the bit, 30 interminable seconds which make him run the risk of being recognized by a member of the

149 Hervé Aubron, 'Zone quadrillée', *Cahiers du cinéma*, 647, July–August 2009, p. 31.
150 And which is then developing across all the American territory.

National Guard. Then the light turns green and there he launches himself onto the road like a wild horse freed from its corral. He can at last make the V8 engine of his Ford roar and sing the refrain of *The Last Round-up* ('I'm headed for the last round-up…'), whilst understanding intuitively that this is undoubtedly one of his last cavalcades. Dillinger believes he can take up again the natural course of his activities and his criminal routine, but the world into which he is returning has transformed. As if Mann had made the same film twice, the first time from the point of view of Dillinger's technological advance, *the second from the point of view of his lateness.* For in the meantime, kinetic power has switched sides. To borrow a concept dear to Paul Virilio, the public enemy has lost on the terrain of dromology.[151] The film, and Dillinger with it, then enters, literally, its winter moment, and it is the attack on the bank in Sioux Falls, South Dakota, which seals the effect of rupture.

 The violence, the anxiety and the chaos which mark the sequence immediately contrast with the lightness and grace of Dillinger during his previous heists. *After the surfing, the drowning.* Dillinger finds himself caught up in speed, overwhelmed by the chaotic and bloody turn of the operation. Caught up in speed also by the forces of law and order which, this time, are *already* there, lying in ambush and ready to open fire; caught up in speed by Baby Face Nelson, whose murderous energy seems impossible to contain; caught up in speed, finally, by the circulation of information itself, since the money targeted has been withdrawn *in time* from the bank's safes. The outbreak of the gunfight starts to the rhythm of Nelson's machine gun, who stands up, belching on a counter, and initiated by Dillinger whose appearance, at the back of the shot, is symbolically delayed. Deprived of his centre of gravity, the disparate gang finds itself torn between Dillinger and Nelson, two irreconcilable dynamics which provoke a scattering of actions and points of view. The former tries to limit the victims and patch up the group so as to extricate it from the battlefield as fast as possible, while the latter only obeys his criminal urge. Dillinger has lost his touch as well as his ability to impose his tempo and rules of behaviour. The attack ends in

[151] Founder of dromology (the science of growing speed), Paul Virilio reread not only modernity, but also universal history in the light of a theory of acceleration, essentially in the technological domain. He identified the processes of acceleration as an 'engine for more rapid domination'. The struggle for power consisted, *in fine*, of the capacity to reach ever greater speeds. In his view, the Industrial Revolution was a dromological revolution.

debacle, blood everywhere, corpses and wounded. Tommy Carroll remains on the ground, hit in the head, Dillinger has received a bullet in the arm, a deathly silence reigns in the survivor's car which races along the road like a black coffin towards its terrible fate.

The safehouse, once a welcoming hive, has transformed into an inhospitable place, populated with menacing presences which forbid Dillinger from crossing the doorway. Survivor of an obsolete world that modernity must now crush, Dillinger notices the shrinking of his space and the new limits to his freedom of movement. From now on, a dark veil covers his era. Economically, the world has also brutally reconfigured itself, crime as business/business as crime, as has been described by so many American films noirs, from *Force of Evil* (Abraham Polonsky, 1948) to *Heat*. On Sport's advice, Dillinger and Red go to a cigar shop owned by a certain Gilbert Catena, the man, they are told, who will be able to give explanations about this new state of things. In reality, the shop hides a room swarming with bookmakers. 'Look around. What do you see?' Phil D'Andrea (John Ortiz) asks Dillinger, using again word for word the question Isabella asked Sonny in *Miami Vice*, before explaining to him the workings of a globalized traffic of which he does not yet appreciate the size. 'You see money. Last month, there were independent wire services letting bookies know who won the third race at Sportsman's Park, 300 of them nationwide. Now there's only one, ours. On October 23rd, you robbed a bank in Greencastle, Indiana. You got away with $74,802. You thought that was a big score. These phones make that everyday.' Dillinger has become a brake on, even an obstacle to, the capitalist transformation of mafia activity: 'You're bad for the business. So the Syndicate's got a new policy. All the guys like you, Karpis, Nelson, Campbell, we ain't laundering your money or bonds no more. You ain't holing up in our whorehouses anymore. No armorers, no doctors, no safe havens, no nothing. You get it?'

Let us remember that the month of December 1933, that is to say a few days before Dillinger's arrest, marked the end of Prohibition and, consequently, an important turning-point in the economic transformation of organized crime, since the amounts of money accumulated thanks to alcohol trafficking had led the Frank Nittis of the time to create apparently respectable enterprises or buy up banks (Meyer Lansky from 1927 onwards) in order to launder it. After the spectacular crimes of the Roaring Twenties, the return to normality, after the fame and front pages, anonymity and invisibility.

Little Bohemia Lodge

The night assault on Little Bohemia Lodge[152] constitutes the aesthetic acme of the film and the *technological coup de grace* administered by the FBI to Dillinger's gang. The gunfight breaks out in a fraction of a second and triggers an exchange of gunshots which transform the lodge and the surrounding majestic forest into a war zone. Mann dramatizes here the impact of these super-equipped agents who brutally invade and disfigure this wild landscape. Negative power of this State violence which riddles with bullets the bodies of men like it tears tree trunks to pieces. By changing in scale,[153] the violence *also changes in nature*, and Dillinger understands very quickly that he no longer has the technical means to resist the massive fire power of the assailants. Only Baby Face Nelson, with his psychotic *furia*, because it confers on him phantasmatic robustness, continues to believe that he can equal the FBI agents. With these machine guns crackling from all sides and puncturing the night with luminous bursts, these bits of weapons, of gleaming bodywork and hystericized faces which furtively aggregate, Mann composes a stroboscopic reality close to kinetic abstraction. The prepotent modernity wanted by Hoover can finally puff out its chest and show its dreamt-of face, that of a steamroller before which you can only capitulate, a blind machine which crushes and pulverizes. Pursued by agent Winstead and one of his acolytes, Red and Dillinger rush into the forest. Changing rhythm and mood, like a brutal return to a primitive space, after the din of futurism, the dawn of time and its elementary power. Mann reconfigures/denaturalizes this American nature with the help of motifs taken from Germanic mythology, and his passion for the films of Lang and Murnau. This hieratic forest, lit up by a strangely bright moon, reminds us as much of the cathedral forest of Teutberg (*The Nibelungen*) as of the grandiose ones drawn by Robert Longo.[154] The immaculate mist which floats around the two men, the stylized curtain of light

[152] In the film, the sequence of the massacre of Little Bohemia Lodge condenses three facts that are true but disconnected in time. In reality, that night, Baby Face Nelson escaped.
[153] In this regard, it is enough to compare the hunt for Pretty Boy Floyd by Melvin Purvis at the start of the film with the super equipped horde which here descends upon the lodge.
[154] Robert Longo is also the author of the famous series *Men in the Cities* drawn in the 1980s. His executives in black suits who contort themselves in all directions could have inspired the physical appearance and clothing of the gangsters in *Heat*.

formed by these tangles of monumental trees bestow on the place a magical aura, and on Dillinger's flight an almost fantastic dimension. As if, after crossing this forest, Dillinger, the only survivor of the massacre, had acquired a form of immortality, or rather of *virtuality*.

The episode of Little Bohemia Lodge and the inability of the authorities to get their hands on Dillinger increased his popularity with the general public: 'Already infamous for his crime spree through America's heartland, Dillinger became, after Little Bohemia, something of a national obsession. Even before the escape, newsreels about his exploits drew more applause and cheering from moviegoers than clips that featured President Roosevelt or Charles Lindbergh. The press, bemoaned one columnist, "has built a halo of maudlin adoration about Dillinger".'[155] Worried about the political fallout of this fiasco, Washington hardened its tone, ordering the police forces to put an end, at any cost, to the escape of the most wanted criminal in the United States. 'The Republicans coming out pretty strong now against the administration. Looks like if the Democrats don't get Dillinger, they may lose this Fall's election,' will even write Will Rogers at the time of the midterms in 1934.[156]

John Dillinger is a new Mannian figure of the hero viscerally attached to his independence who, in line with Frank (*Thief*), Nathaniel (*The Last of the Mohicans*), Lowell Bergman (*The Insider*) and Muhammad Ali, refuses to exchange his freedom, however precarious, for this cold modernity which possesses the dull face of Frank Nitti. In reality, like Frank in *Thief*, Dillinger only aspires to a normal and peaceful life, in the image of the sunny and ordinary dream he describes to Billie at the edge of Lake Michigan. In June 2009, Michael Mann declared in an interview with the *New York Times*: 'The Karpis project got me into the period trying to understand the history, imagining the tough existence of these guys being pressed on both sides by twin evolutionary forces – on the one hand, J. Edgar Hoover inventing the F.B.I., and on

[155] Alison Purvis, *The Vendetta. Special Agent Melvin Purvis, John Dillinger and Hoover's FBI in the Age of Gangsters, Public Affairs*, 2009.

[156] In the course of the months and the failures of the Bureau, the popularity of Dillinger never stopped growing until he becomes, just before his death, the model for several characters in the gangster films of the 1930s, be it Duke Mantee played by Humphrey Bogart in *The Petrified Forest* (Archie Mayo, 1936) or the bank robber Roy 'Mad Dog' Earle in *High Sierra* (Raoul Walsh, 1941).

the other, organized crime evolving rapidly into a kind of corporate capitalism that had no room for independent criminals either.' In the lobby of the Aragon Ballroom in Chicago, Dillinger comes across Gilbert Catena, a henchman who, at the start of the film, boasts to him about the merits of Nitti and his impressive network ('These guys are connected to everybody all over the country now'). But Dillinger remains a bandit of the nineteenth century, an outlaw whose models belong to a world on the brink of extinction and who does not intend to fold to the new rules of the Syndicate. To Alvin Karpis he proposes that he take part in the attack on a train planned for a few months later, Dillinger replies: 'Sounds like Jesse James.' Later, in the bedroom of Little Bohemia Lodge where Dillinger, Red and Nelson have found refuge after the Sioux Falls debacle, Mann emphasizes the presence of a painting hung above the bed and which represents a cowboy trying to tame a wild horse. The metaphor is crystal clear: Dillinger will have perpetuated a state of mind inherited from the old West, a certain type of relationship to honour, friendship and the wilderness.

Like most of Mann's films, *Public Enemies* is thus situated at a moment of historic transition, of a shift from one model to another, and Dillinger has the tragic experience of a *world which is becoming, but without him*. He is, to borrow Mann's words, 'an anachronism, an anomaly in a Darwinian world. The evolution of times and institutions has made him obsolete.' The glorious era of Dillinger is not yet that of organized crime and mafia syndicates which Hollywood, from *Underworld USA* to *The Godfather*, will film in abundance. In his review of *Public Enemies* in *Vanity Fair*, Scot Foundas rightly evokes the proletarian street theatre of the public enemies of the 1930s and contrasts it with the grand opera of the Cosa Nostra of Lucky Luciano, Frank Costello and Meyer Lansky. John Dillinger, Pretty Boy Floyd, Baby Face Nelson and Bonnie Parker are outsiders, often from the American lower classes – which explains, in part, Dillinger falling in love at first sight with Billie Frechette, a young woman of mixed race who wears '3 dollar' dresses and resembles him socially. Between them, there exists a form of class solidarity which leads them to exchange information, safehouses and services. Almost a form of natural mutual aid, in the image of the lawyer Louis Piquet, with whom they put each other in contact. These public enemies have also developed in felony (and sometimes crime) a form of specific competence, a professionalism which is not designed to serve outside interests. If they seek to enrich themselves individually, none of them wish to develop, or become part of, a criminal corporation. This manner

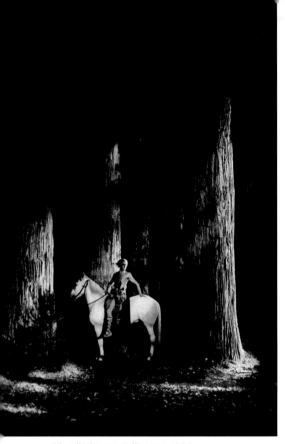

Die Nibelungen, Fritz Lang, 1924

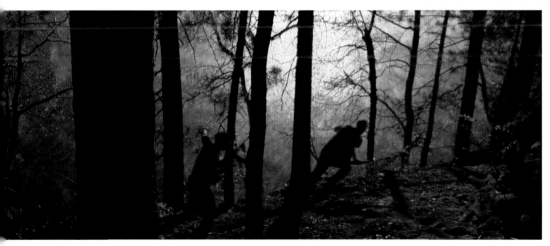

Public Enemies

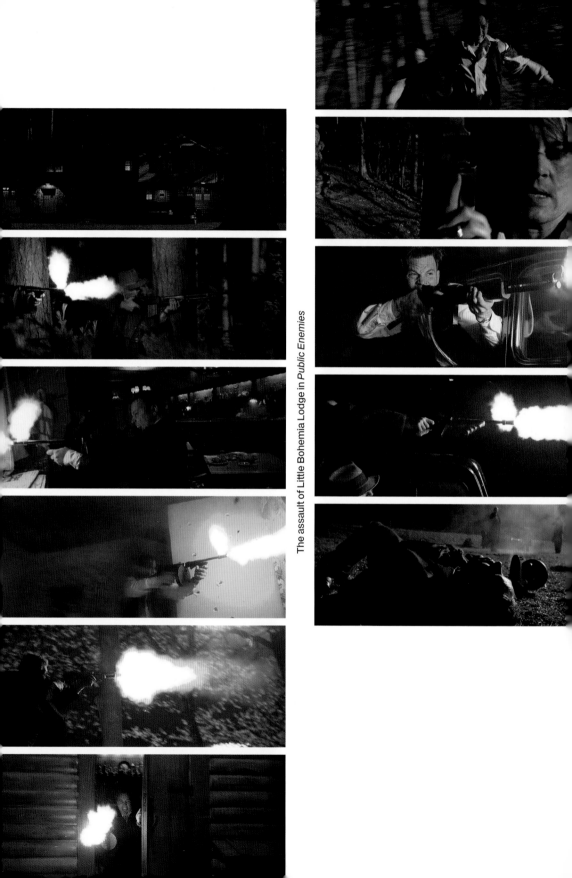

The assault of Little Bohemia Lodge in *Public Enemies*

of freedom, even of anarchy, in the face of the rigid and framed rituals of corporations of all kinds will be fatal to them. Dillinger and his ilk are thus missing links between the outlaws of the old West and the suited executives of contemporary crime, basically, the last representatives of a form of civil disobedience. To remain independent, free in your movements, your robberies and your friendships as well. It is, after Neil's credo in *Heat*, another golden rule which Red reminds Dillinger of after he has agreed to team up with Nelson and Shouse ('You don't work with people you don't know and you don't work when you're desperate, Walter Dietrich. Remember that?') and which he too has just contravened.

The manufacturing of his image

Public Enemies begins four years after the crisis of 1929 and takes place in the middle of the Dust Bowl, where dust storms sterilized the farmlands of the Midwest. For a large number of ordinary American people, Dillinger then embodied a sort of Robin Hood who robbed banks but not individuals,[157] a romantic figure of freedom and disobedience, as shown by that crowd of passersby who filled the pavements when he was transferred by car to Crown Point prison. He thus fulfills by proxy the revenge that this crowd ruminates against a banking system which caused its ruin and, sometimes, its exodus on the roads of the West.[158] A short scene suffices for Mann to suggest the context of the time and make us sense what some public enemies

[157] Like Neil who, at the moment of the heist sequence in *Heat*, asks a client to take back his money, or Nick Hathaway *(Blackhat)* who explains to Lien that he robs banks but not people.

[158] We remember that emblematic sequence in *Bonnie and Clyde* in which Clyde Barrow hands his pistol to an evicted peasant so he can fire on his own home. Let us remember here that the rural world, which hardly profited from the prosperity of the 1920s, was particularly affected by the crisis from the beginning of the 1930s onwards. To the fall in agricultural prices was added the problem of the restructuring of farm holdings, with mechanization of labour, an expansion of usable areas and a concentration of capital, which crushed and expelled small landowners. Finally, the exceptional droughts which marked the Southern States between 1933 and 1940 and the calamity of the Dust Bowl (described by Steinbeck in *The Grapes of Wrath*) ended up sterilizing the land, giving the banks an overwhelming argument for evictions. It is estimated that three million migrants were torn from their land because of the crisis.

could have represented then. At the moment when he prepares to leave his first safe house, Dillinger is approached by a haggard woman who asks him to take her with him so she can escape a visibly disastrous economic situation. Forced to say no, Dillinger walks away from this woman whom we now discover in a wide shot, holding the hand of a child in front of a derelict house. Mann takes care to keep in the same shot the face of Dillinger, who approaches the camera, and behind him, the image of this lonely woman standing there, which brings back the visual memory of all those photographs which, from Walker Evans to Dorothea Lange, documented the effects of the Great Depression on the American population. A world separates these two individuals, but the directing emphasizes rather what links them, since the composition of the shot literally lays on Dillinger's shoulders the symbolic load of all those have-nots, their despair and their anger of which, against his will, he is the custodian.

The media, then in rapid expansion, relate over and over again the exploits and existence of these gangsters who make the headlines. The public knows a lot about Dillinger's childhood, his life in Mooresville, Indiana, but also his first prison sentence. When he evokes Dillinger in the audio commentary of the DVD, Michael Mann insists upon the way in which the public enemy revolutionized the history of crime and of the police, but also analyses his trajectory as the product of a social determinism. That is to say the Marxist basis of Mann's cinema which explains, partly, the evident esteem that the film shows Dillinger. The heaviness of the sentence – nine years' imprisonment – which was inflicted on him in 1924 for having stolen $50 from a grocery store and his career as a young middle class man, ill-disciplined then a petty criminal, becoming a fearsome gangster through contact with a brutal prison environment no doubt strengthened the affective bond between the lower classes and Dillinger, creating, in fact, a natural sympathy among the former for a man who opposes elites of all kinds (the FBI, the institutions, the bank, but also the new crime bosses…). A bandit of honour hunted by raptors, a folk hero like the one Woody Guthrie celebrates in his song *Pretty Boy Floyd*.

Right from the start of the film, Mann establishes the chivalric image of Dillinger in a few details, be they the coat which he covers the shoulders of Anna Patzke, one of the two hostages in the Racine heist, or his reply to Alvin Karpis who proposes a robbery which supposes an abduction: 'The public don't like kidnapping.' 'Who gives a damn

what the public likes?' asks his interlocutor. 'I do. I hide among them. We gotta care what they think,' replies Dillinger. Like all the heroes in Mann's films, the latter has a code of honour and moral values which he does not want to compromise on. Violence is for him only a last resort, whilst for Baby Face Nelson it is a fuel. One is an old school professional who robs banks to live (better), whilst the other is a modern sociopath, an uncontrollable and violent amateur who acts in the name of a pathological will to power.

'Frank Nash, known as "The Gentleman Bandit", was a much better thief, who amassed nearly three million dollars, a considerable sum for a Depression-era outlaw', writes Paul Maccabee in *John Dillinger Slept Here* (1995). 'But Dillinger had style. During hold-ups, he liked to amuse bank customers with little and sarcastic jokes. He would jump over counters to show off his athleticism and sometimes shoot his

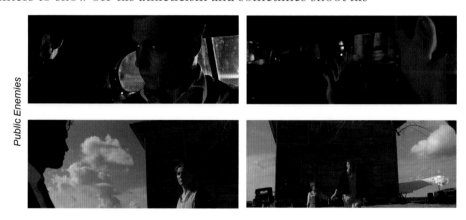

Public Enemies

Thompson submachine gun into the ceiling, but that was just to get people's attention. Some may have been stolen but they were worth their money's worth.'

Public Enemies describes a man concerned about his image, conscious of its effects, all the more so as he knows that his success, and especially his survival, depends largely on the useful goodwill that the public can feel towards him. Like a response, through the mastery of his own image, to the techniques of propaganda and control deployed by his adversaries – in Miami, he accepts the invitation to dine with Phil D'Andrea on condition that no photo of him will be taken. On arriving at Crown Prison, he poses in front of the photographers, flanked by the prosecutor Robert Estell and Lillian Holley, the director of the prison. Very quickly, he places his arm around the prosecutor's shoulder as if it was a reunion of two old friends, thus inverting the relationship of

domination and therefore the meaning of a photograph that all the newspapers will print.

But if Dillinger watches over the manufacturing of his image, he also constructs himself from those which surround him. Movie theaters were for him, as for many others (Baby Face Nelson imitating James Cagney just before the assault on Little Bohemia Lodge), places for apprenticeship of life which he frequents assiduously. For the dialogues in the film, Mann was greatly inspired by letters written by Dillinger, which were full of formulas and expressions borrowed from films of the time. Dillinger often speaks like a cinema gangster, cites the replies from films he likes and even uses the phrasing, concision and way with words of his favourite actors. 'I like baseball, movies, good clothes, fast cars, whiskey and you. What else do you need to know?' he says to Billie at the Steuben Club.

At the end of the film, he attends a screening of *Manhattan Melodrama*. Thanks to the juxtaposition of tight and reverse shots between the public enemy and the images of the film by Van Dyke, Mann actualizes the coincidence dreamed of by Dillinger between his life and that of the gangster played by Clark Gable, with whom he then fully identifies. And when Myrna Loy appears on the screen to say farewell to Gable, Dillinger can only see Billie Frechette.

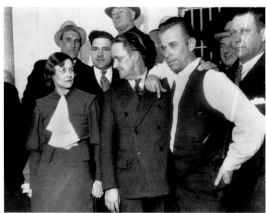

Famous picture of John Dillinger upon his arrival at Crown Point Prison, Indiana, in 1934, and its revival in *Public Enemies*

Virtual Dillinger

'I think you're a front. I think your prowess as a lawman is a myth created from the hoopla of headlines,' says Senator McKellar to Hoover, before a Senate commission which refuses him the appropriation of the additional means he is asking for. Furious, Hoover leaves the room and asks his team to organize a riposte to this 'Neanderthal man' who, in his view, is blocking the path of progress and of modern ideas. 'We will fight him on the front page!' he says to his assistants. The dialectical relationship between truth and reality shatters here to the advantage of a new power which knows how much control of information and the mass media, then in full expansion, is crucial. What is this new reality if not filmed and/or printed information which can be manipulated by a group or an institution? For the war which opposes the public enemy and the FBI has also become a war of images. Hoover and Dillinger both share an acute awareness of the impact of the media in a changing society where the means of communication are developing at full speed and shape, in large part, public opinion. Hoover never misses an opportunity to promote his image and that of his Bureau, be it Melvin Purvis, a modern recruit with an impeccable physique, whom he feeds to the journalists in the minutes following his appointment, or the award of decorations to a selection of exemplary young Americans staged for the cameras. It is also through interposed media that Hoover and Dillinger give each other news, test and sometimes taunt each other. On two occasions, the film highlights this virtual relationship: the first time, it is Hoover who, via the series *America's Most Wanted* which he thought up, throws at his adversary an intimidating message on the screen of a Chicago movie palace; a few weeks later, it is Dillinger's turn, after his escape from Crown Point, to send the Bureau chief a radio message in the form of a song (*The Last Roundup*) hummed by a prison guard. But by thus moving the struggle onto the terrain of the image, Hoover offers, unknowingly, a symbolic way out to Dillinger.

After finding refuge at Anna Sage's home, Dillinger decides, one day, to accompany Polly Hamilton, an adolescent whom Sage has taken under her wing, into a Chicago police station. But rather than keep his distance from the place, he chooses, out of defiance, to enter it as well, and goes up to the floor where there is based the 'Dillinger Squad', a police unit for which he is the main target. The place is almost deserted, with the exception of a few policemen grouped around a radio broadcasting a baseball game. Dillinger strolls alone in the midst of the desks and goes

along the walls on which he discovers a photo story of his life (press cuttings, portraits of his deceased companions, photos of crime scenes…). This brash visit echoes, of course, that sequence in *Ali* where the boxer falls, in a street of Kinshasa, upon a mural painting depicting his exploits in the manner of a children's drawing. Both are popular heroes whose life is connected with public opinion, Ali dreaming of himself as champion of the people, Dillinger as poor people's star. 'His audacity elevates him. It is triumph. With all their resources, modern technology and organization, they cannot lay a glove on him. He is better than they are. His gratification is internal. He leaves behind, as he exists, a wake of absurdity. He passed through and they didn't even know. History was made. Like a ghost, he's gone.'[159] In the course of his stroll, Dillinger understands that this man whose portrait he admires, this elegant gangster whose photo is pinned on a wall, *is another*. This is why his bluff, when he asks for the game's score from policemen who are supposed to be hunting him and they reply without recognizing him, appears incredibly risky from the point of view of the realist logic of the crime story – how can these men not see that they have, in front of their very eyes, the man that all of America and themselves are searching for? – but perfectly right from a symbolic point of view. Because between the opening of the film (Dillinger is very quickly recognized by a warden of the penitentiary in Michigan City) and this sequence, the perception of the public enemy has changed. Dillinger has understood that alongside him now moved a *virtual Dillinger*, a product of technology and mass media, a perfect analogue in whose shadow he could *exist* with impunity. Besides, Mann slips into the soundtrack an extract of *Dark Was the Night, Cold Was the Ground*, a famous song written in 1927 by the American gospel singer and evangelist Blind Willie Johnson, a sort of melancholy lament inspired by the crucifixion of Christ, his descent from the cross and the placing of his body on the ground. The metaphor is crystal clear: all the photos pinned to the wall carry the proof of the old Dillinger's death, and the one presently contemplating them is nothing other than his *resurrected* version.

In the second half of the film, which starts after his escape from Crown Point, Dillinger is certainly caught up by multiple physical contingencies – the wounds, the deaths, everything which, up until then, weighed nothing – but at the same time, he *spectralizes* himself. Two

159 Extract from the script of *Public Enemies*.

Dillingers now move side by side, the man and the icon, the model and its image, the unruly young man from Indiana and the folk hero of whom the radio waves, the newspapers and the screens show *ad libitum* the fantastic exploits. And this *iconic Dillinger is another* who, for the public and even the police, has ended up absorbing the original and erasing it. In reality, Dillinger knows, deep down, that he does not need to turn his head, like the other viewers, to not be identified in a movie theater; he knows that he can approach FBI agents at the moment of Billie's arrest in front of his building in Saint-Paul, Minnesota, without fear of being recognized; he knows finally that his image, by dint of haunting all of America, is going to make of him an invisible man. After all, the gods do not descend again from their Olympus nor do icons from their altar. No one would believe it. Not even agent Reinecke, who has nevertheless seen him with his own eyes. Dillinger belongs to the inaccessible world of fantasies, of aura, of myths, to that intangible planet that no system, however organized and oppressive it may be, will be able to capture. That is the intuition that, on entering the police station, he has come to verify: from now on, Dillinger belongs to the media, to the spirit of the times, a ghost among others in the vaporous world of the age of information and simulacra.

On the fateful evening of 22 July 1934, Purvis and his G-Men have posted themselves outside the Biograph Theater, a movie theater in which Dillinger has decided to spend the evening. Mann rapidly concentrates his camera on the agent Reinecke who taps nervously on his steering wheel, sweating, no doubt fearing the face-to-face with the man whose partner he has just beaten. But something else is at play here, an almost irrational fear, the intuition that the man who will soon come out of the cinema has become an individual out of the ordinary, all the more dangerous as he has ended up, by virtue of being elusive, not having a physical reality. Might he even be a supernatural phenomenon, all-powerful, gifted with secret qualities capable of petrifying him and mastering time? When he is finally on the pavement in front of the Biograph, Reinecke follows Dillinger, from behind, who moves away on the arm of Anna Sage and Polly Hamilton. Suddenly, the public enemy turns round to Reinecke and stares into his eyes. Struck down, the agent seems paralyzed, for a handful of seconds which prevent him from squeezing the trigger. A moment of petrification, a fragment of myth which materializes brutally on the sidewalk in the middle of ordinary mortals and dazzles you. The ineffable power of an image, the

ETECTIVE
BUREAU
DILLINGER
SQUAD

Dillinger: simulacra and the end (*Public Enemies*)

spell of an apparition. The man in flesh and blood may well die, but the Dillinger myth will have survived. Finally, did the irony of history not want Dillinger to be shot dead while leaving a cinema, like an image leaving its temple?

Off the map

'Nature is a prairie for outlaws,' wrote Thoreau in his journal,[160] but this nature that Mann, just after the escape from the Indiana penitentiary, films, through Dillinger's eyes, as a free desert space is on its way out. We think here of Nathaniel and Cora contemplating at the very end of *The Last of the Mohicans* the majesty of a landscape condemned, if not to disappear, then at least to be caged, privatized and normed. The filiation between the public enemy of 1933 and the ancestor of all the Mannian mavericks explains the numerous rhyming effects between *Public Enemies* and *The Last of the Mohicans*, as if Mann had envisaged a same problem (the domestication of space, the oppressive forces of modernity, the dehumanization linked to technological transformations) at two moments in its history: the first appearance of Melvin Purvis who hunts down and kills Pretty Boy Floyd in an apple orchard is reminiscent of that of Nathaniel hunting the stag in the opening sequence of *The Last of the Mohicans*; the disappearance of the Huron Magua in a cloud of dust echoes that of agent Winstead who, in the course of the gunfight at Little Bohemia Lodge, seems to vanish in the weapons' smoke and thus disappear from the sight of Red and Dillinger.

After having foiled the surveillance of the FBI and snatched Billie from her apartment, Dillinger pauses for the night in Indiana Dunes, at the edge of Lake Michigan. Sitting amidst the dunes, the couple stand out against a shimmering ebony surface. Cornered on all sides, Dillinger no longer has the latitude of his early years – 'I go where I want,' he said boldly to Billie on their first encounter – and now dreams of a place off the map, a typically Mannian imaginary place which reactivates the fantasy of a tangible frontier while simultaneously knowing its impossibility. No more limitless horizon, like at the start of the film, but a black hole, a projection screen open to all daydreams. 'What if we could get out of

160 *The Journal of Henry David Thoreau* (1837–61), NYRB Classics, first edition, 1960.

here altogether?' says Dillinger. 'Where? Like Cuba?' asks Billie. 'Maybe further. Alvin's got his job. It's a big job, a lot of dough. We could go away on it. We grab a Pan Am Clipper to Caracas, scoot on over to Rio for some fun in the sun. *Slide off the map.*' The camera slowly approaches the face of the young woman who listens to this fairy tale which she still wants to believe in, an enchanted parenthesis which, in reality, she knows full well, has no future. Even the expanse of water has been extinguished. A moment torn from the contingencies of space and time which reminds us of the Havana sequence in *Miami Vice* and that phrase of Sonny at the very end of the film: 'It was too good to last.' 'Yes, I want to take that ride with you,' Billie then replies to him, moved, while the song *Bye Bye Blackbird* is heard on the soundtrack. We then remember her violent reaction a few months earlier in the stands of the Miami racecourse, to Homer's joke ('Dead or dead') and the criticism she gives Dillinger for not understanding that he was racing straight towards death. But here, in front of Lake Michigan, at the dawn of the tragic end that she now knows is inevitable, Billie decides to enter Dillinger's dream rather than break it in the name of the reality principle. She chooses to follow the man she loves by embracing his *virtuality*. This enchanting trip that Dillinger proposes to her is a magnificent fantasy, a journey that is impossible except inside an imaginary space freed from technological domination, but it is above all an intimate utopia, a private place to which only they will have access. The sequence concludes with the song *Bye Bye Blackbird*, which we hear for the second time in the film, and whose words will return *in fine* in the mouth of agent Winstead, who has come to confide a secret to Billie in the women's prison of Milan in Michigan. This secret – a song that Dillinger hummed before dying – constitutes not only a man's last declaration to his sweetheart, but draws its strength from being, at this precise moment of the film, the metonymy of an imaginary space of which only Billie and Dillinger know the existence. By removing this information from the 'system', Winstead offers Billie (and Dillinger) a space of mental freedom, *off the map*, that the system will never possess. The film ends, in reality, on a closing door and the grey walls of a visiting room, but in Billie's mind, the secret is like an escape route.

Public Enemies

6.
FORMS OF LATE CAPITAL- ISM[161]

'This is the way the world ends.
Not with a bang but a whimper.'
T.S. Eliot, 'The Hollow Men'

[161] Term popularized by the Marxist intellectual Ernest Mandel at the start of the 1970s. It identifies a third age of capitalism characterized by the globalization of markets, the creation of multinational firms, mass consumption and culture, and capital flows on an international scale. Most of the sociologists and philosophers of the Frankfurt School (Adorno, Habermas and Herbert Marcuse) took this term on board from the late 1960s onwards. In 1991, Fredric Jameson published *Postmodernism or the Cultural Logic of Late Capitalism, op. cit.*

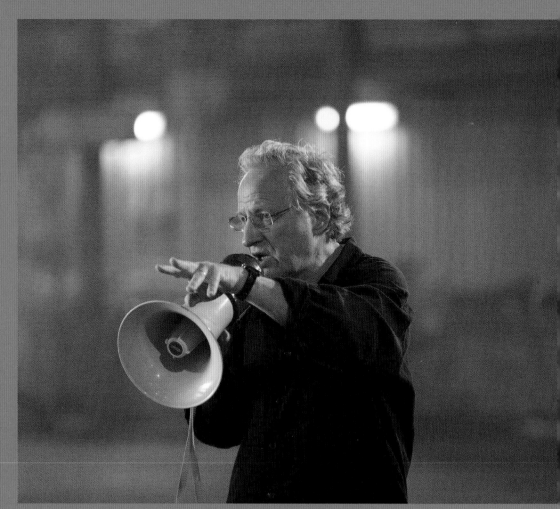

Michael Mann on the set of *Blackhat*, 2015

The decline of affect

> Sonny: It's part of the job description. I learned a long time ago that you can't let personal feelings get in the way. Trouble is, after a while, you can't feel anything at all Bianca. I think your problem is just the opposite. You feel too much.
>
> 'Freefall', *Miami Vice*, 1989.

Excerpt from the final episode of the fifth and final season of the series *Miami Vice*, this exchange between Sonny and the daughter of a Central American dictator he has just smuggled to Florida poses the terms of an anxiety which runs deep through Mann's films. That is to say, the question of affect as the site for a contemporary anguish. What place to occupy, between those who feel too much and those who do not feel enough, between a vital program (which has a tendency to repress it) and an existential program (which liberates it), between the automaton Vincent (*Collateral*) and, at the other end of the spectrum, the profiler Will Graham, whose hypersensitivity, and therefore excess of affect, is the basis for his sixth sense?

The new men of the Bureau as envisioned by J. Edgar Hoover undoubtedly resemble the hitman in *Collateral*, operational bodies programmed to hunt the adversary, obedient and unfeeling war machines – is it a coincidence that Vincent starts to break down, like an android, when Max throws down and smashes his computer from a Los Angeles bridge and deprives him of his criminal software? 'What'd he do to you?' Max asks about the man whose corpse has just crashed onto the roof of his taxi. 'Nothing. I only met him tonight,' replies Vincent. Throughout the film, Vincent displays a radical disinterest in humanity and a total absence of compassion. This assumed and even boasted-of misanthropy, which could make him the ideal hero of a Ridley Scott film, is part of the eschatological mood that envelops all of *Collateral*. For Vincent carries with him a splenetic atmosphere told by the treatment of Los Angeles, nocturnal, depopulated and mineral, which constitutes its echo chamber. As if his inability to inhabit the world and establish a sensitive connection with his fellow men had converted into an unformulated desire to precipitate it towards its end. The filming of *Collateral*, which evolves towards a greater abstraction, thus embraces Vincent's dehumanization, right up to the sequence which opposes him to Annie in the midst of the open spaces of a Federal building plunged

into darkness. Vincent thus embodies the terminal, and pathological, version of what Fredric Jameson has called 'the decline of affect in postmodern culture',[162] the recurrent symptom of that fear of dehumanization which, as much from a human point of view as an institutional one, infuses all of Mann's cinema. The ability to feel empathy for others, to feel alive, to make of one's affects and emotions a power rather than a handicap or a sign of submission traces, in all his films, a line of demarcation between two groups of individuals, be they Dillinger and Purvis vs Hoover and the FBI, Max vs Vincent, Ali vs the American government and The Nation of Islam, Nathaniel vs the British Crown, Sadak vs Hathaway (*Blackhat*) or within the individual himself, like Neil McCauley crossed throughout *Heat* by this tension. Always an intensity of life against a will to power, a thirst for freedom which opposes a desire for control. Far from the explosions, burn-outs and great Freudian repressions of modernism, in the postmodern world, writes Fredric Jameson, we witness 'the replacement of alienation by fragmentation'.[163] It is Melvin Purvis, victim of dissolution in the world of organizational bureaucracy (*Public Enemies*) or Jeffrey Wigand after his sacking by Brown & Williamson (*The Insider*). Let us note that his new sensibility also runs through the oeuvres of many postmodern artists, from David Hockney to Alex Colville, and translates anxiety at the possible end of civilization, a sort of apocalypse which, on the quiet, may have already started its work. In the 1970s, American cinema, and notably horror cinema, reacted to this possible end by producing spectacular monsters, baroque agents of chaos, and so many images made of flesh and blood. In the postmodern cinema of Mann, chaos is replaced by dislocation, the grotesque by indeterminacy, and baroque hyperreaction, even lavish, by the terror of a spectral becoming. The world will not disappear in one go, a spectacular explosion, but will die a slow death. A melancholy whisper rather than fury.

In *The Last of the Mohicans*, Michael Mann returns to the beginning of European colonization of America and what is called in the United States the 'French and Indian War'. But the film connects this big history, describing the way in which a new law is imposed on the native Indians to the small history of a woman from London, Cora, who during her forced journey across the wilderness falls in love with a scout, Nathaniel/

[162] Fredric Jameson, *Ibid.*
[163] *Ibid.*

Hawkeye, a white child and adopted son of an American Indian Sagamore. If Chingachgook is the 'last of the Mohicans' of the precolonial era and Nathaniel one of its last heroes, it is nevertheless the character of Cora who, throughout the story, fulfils that political awakening specific to Mann's films. At first corseted by the habits and customs of a blind and arrogant aristocracy, condemned to an arranged marriage to a man (Duncan) for whom she feels no love, Cora experiences, in contact with the Mohicans, the independence of her body and mind. She sheds the crushing weight of old Europe, gradually liberates her profound affects, at the same time as she opens herself to the pantheistic vision of the native Indians, from which she understands that it induces a certain moral and political relationship to others and to the environment. Thus, *The Last of the Mohicans* returns to the source of that moment when affect has begun to be controlled, limited, even stifled, as a repression inscribed at the very heart of the legalistic foundations of modern America and the colonizing saga of the European powers. Cora appears as an essential character in Mann's filmography, since in regard to Nathaniel, a free man *by nature*, she embodies the birth of a desire for independence that drives all the Mannian heroes. The amplitude of her psychological trajectory also proves how much this desire comes less from a political conviction or an ideological analysis of the balance of power than it is the natural consequence of an affect which she wants to liberate in the face of an essentially absolutist and hegemonic system which represses it. In Mann's work, affect, just as much as activity, is what marginalizes the individual: independence leads naturally to disobedience. But if affect, and its excess, often leads to the downfall of the characters in Mann's films, it is also what rehumanizes them, what lifts them up and gives meaning to their existence.

When she appears for the first time, her face framed in close-up and facing the camera, Cora is in the position of a woman who waits. We believe at first that the man approaching her in the background, Duncan, embodies the response to her state of vacancy, like a thought ready to be actualized. But very quickly, the polite joy she displays towards him and the following conversation prove that it is nothing of the sort. Sitting in a garden, facing one another, Cora and Duncan then reflect on their relationship. 'Respect and friendship. Isn't that a reasonable basis for a man and a woman to be married?' wonders Duncan, in the hope of putting an end to Cora's reticence to commit to him. 'I don't know what to say, Duncan. I truly wish they did but

my feelings don't go beyond friendship. Don't you see?' she replies. Visibly, the young woman dreams of something other than this planned marriage and the life that comes with it. Still indistinct in her mind, the mood of her desire expresses itself, however, in a detail which appears just behind her in the form of a white sheet undulating in the wind. This element which disturbs the impression of stiffness which emanates from the sequence (the incongruous placement of the two chairs in the middle of a field, the fixity of the characters, their language stilted by social conventions…) is the visual sign of her internal tumult. Cora wants to feel, stir, love for real, extricate herself from the corseted world of the English aristocracy, but her desire is still seeking its object. It is in contact with nature, and with Nathaniel who embodies, in reality, the same thing, that her small internal flame will become a raging fire. At the start of the film, she and her sister Alice take the road to Fort Henry, escorted by Duncan and a detachment of English soldiers. The group progresses slowly, on horseback, in the middle of a dense forest. Only Cora looks with curiosity and interest at the nature surrounding them, open to all that it can offer her, like that puma hidden behind the foliage which only she can *see*. Later, she gets angry at the indifference of Nathaniel who refuses to bury the bodies of the Camerons, before understanding that he is acting like this in their own interest. After Nathaniel, his eyes turned towards the celestial vault, has recounted to her an Indian belief, Cora confesses to him: 'We do not understand what is happening here. And it's not as I imagined it would be, thinking of it in Boston and London […]. It is more deeply stirring to my blood than any imagining could possibly have been.' The young woman then succumbs fully to the charm of the wild landscape and the profound change of scenery. She understands that this language which seemed foreign to her, as it is in the eyes of her compatriots, was in reality her own.

Mann uses the aquatic motif to mark out the stages of the affective unblocking of Cora: firstly, the still lake above which moves Duncan's detachment at the start of the film, then the water that streams along the rocks crossed by Cora and Nathaniel after the first Huron attack, and finally the raging waterfall behind which the small group of survivors takes refuge in order to escape Magua's men. It is the melodramatic, or vitalist, acme of the film, symbolized by an omnipresent curtain of water; that is to say, from Cora's point of view, a torrent of affect finally liberated which spreads throughout space in the form of a natural deluge and shows the *romantic sensibility* of Michael Mann's cinema.

From still waters to affected streams (*The Last of the Mohicans*)

The connection between the opening sequence, with these Mohicans running beneath a verdant canopy, and the arrival, in a horse-drawn carriage, of Major Duncan on a vaulted bridge in Albany, establishes from the outset a contrast between the movement of the native Indians and the stiffness of the English, which Mann's *mise en scène* will develop right until the massacre of Colonel Munro's troops by those of the Huron Magua. Nathaniel alone crystallizes the way in which the film sees the Indians, their way of being at one with nature, of moving in it, of capturing its signals. He is like Murphy in *The Jericho Mile*, a man who runs endlessly and who, through his freedom of movement, opens up the space of the film and therefore the action. His dynamism unblocks situations, makes events branch off and pushes the story forward – from his voluntary march to the middle of the Huron village to his final race along the cliff. Unlike this harmonious relationship with the wilderness, the English, officers and soldiers alike, resemble figurines placed in a natural space with which they will never be in harmony. Even the Crown's first messenger, come to order the colonists of the frontier to form militias in the service of His Majesty, remains perched on his horse, as if he was incapable of putting his feet on the ground. These people only seem at ease in closed, framed, restricted places, and lose their bearings as soon as they leave the enclosure. At the beginning of the film, Mann films the meeting between Duncan and General Webb in a dark and confined space which resembles a small shadow theatre, with its low ceilings and its motionless men, fixed in hieratic postures. The headquarters of the British army is supposed to be a high place of civilization, but it gives an impression of paralysis and dehumanization. It is only when we enter Cora's domain that the English frame finally opens up to the world and takes in its light, unless it is just a question of the vital strength of its occupier.

After having capitulated to the Marquis de Montcalm, Munro and his troops plunge into a meadow bordered by two lines of dense trees. Before the ambush organized by Magua, Mann films this army like a visual anomaly lost in a frame too vast for it, a compact column of fragile and heavy figurines whose fate can only be tragic. This opposition between the dynamism of the native Indians and the rigidity of the English of course reminds us of that which structures John Ford's *Fort Apache*, between Captain York (John Wayne) and Colonel Thursday (Henry Fonda). In Ford's work, the frozen group is condemned to disappearance or death: it is the last stand of exhausted and statue-like soldiers, defeated by the moral intransigence of their colonel and

engulfed by the Indian wave of Cochise, just as the defeated troops of Colonel Munro are, from the moment they leave Fort Henry, submerged by the wave of Hurons. Before the attack even takes place, we understand that the velocity of the Mohawks will prevail over the English tin soldiers. Thus, *The Last of the Mohicans* multiplies the lines of conflict which oppose immobility and speed, authenticity and calculation, the given word and contracts of all kinds, materialism and pantheism, ritual and protocol, freedom of conscience and the inflexible application of the law, Henry David Thoreau and John Locke. Evidently, the ghost of *Barry Lyndon* haunts certain shots in *The Last of the Mohicans* – the arrival on the bridge in Albany and the symmetrical construction of the shot around its reflection in a still lake, or the sententious face-to-face between Colonel Munro and the Marquis de Montcalm at the summit of a scorched hill – and the stiffness Mann associates with the English is also a way of anticipating the deliquescence of this very aristocracy that Kubrick's film described, 20 years later. But as a Hobbesian filmmaker, Kubrick is not interested much in the Rousseauist ideal that Nathaniel embodies at the start of *The Last of the Mohicans*. Under the fragile veneer of a sophisticated humanity, he hunts for signs of the essential violence of man, whilst Mann asks himself about the capacity for resistance of affects and individual passions in a modernity which works towards their suppression.

The Last of the Mohicans

The Insider: the moment of the world upside down

> 'When I was doing *The Insider*, trying to make a suspenseful
> drama from two hours and 45 minutes of people talking,
> the first thing I did was go look at Carl Dreyer's *The Passion
> of Joan of Arc*. Nobody shot the human head as adroitly
> and expressively as he did'
> Michael Mann

In a text published to mark the twentieth anniversary of the release of
The Insider in 1999, the critic Bilge Ebiri wrote: 'It's a movie about people
sitting in rooms and talking, and its climax involves everyone calmly
watching a television program.' The author pointed out, rightly, the anti-
spectacular dimension of the film at the same time as asking himself
what, over nearly two hours and 45 minutes, makes it so captivating. If
we were to trace a line which divides the oeuvre of Michael Mann, it
would undoubtedly pass through *The Insider*, so much does it mark, from
the double opening sequence (Lowell Bergman's journey in the streets
of Beirut/Jeffrey Wigand leaving the offices of his business), a break
with the style of *Heat* and lay the groundwork for all the films to come,
be they *Ali, Miami Vice* or *Public Enemies*.

In the history of American cinema of the 1990s, *Heat*
constitutes one of the sumptuous swan songs of Hollywood post-
classicism, next to *Dances With Wolves, Casino* and James Cameron's *Titanic*.
In Mann's trajectory, it marks the achievement of the goal aimed at since
Thief, which could only be surpassed by a stylistic *aggiornamento* of which
The Insider is the result. *The Insider* and *Ali* (1999 and 2001) thus belong
to a sort of aesthetic interval, a moment of searching during which
Michael Mann, who does not yet have at his disposal the new digital tools
and high-definition video, develops a more fragmented, more cut-up,
style which follows a more mobile camera whose movements seem
subject to a form of fragility.[164] Above all, he seeks to intensify what
Pierre Kauffmann as called 'the emotional experience of space',[165] which
supposes, in advance, a deconstruction of that of classical perception.
The filming of *The Insider*, at least in its first part, rather centred on the

[164] Dante Spinotti: 'So much of *The Insider* was handheld.' When the camera was on a tripod,
or a dolly, it was always on a shot bag, or a sand bag, 'so that the operator always had this
slight instability to the image.'; www.vulture.com/2019/10/the-story-behind-the-insider-
michael-manns-prophetic-film.html.
[165] Pierre Kauffmann, *L'expérience émotionnelle de l'espace*, Vrin, 1999.

character of Jeffrey Wigand, thus aims to make the world *unrecognizable*, to place the viewer in an uncomfortable position, of constant vigilance, and to deconstruct the space to the point of making it sometimes indecipherable at first sight. The characters, and in particular Jeffrey Wigand, seem badly connected to their environment, often unmoored, at odds, *in tension*, while everywhere emerge empty spaces which break the classical harmony with the settings. The film is full of big close-ups which seem to float around an invisible whole, bits of faces, of objects which, detached form their context, become enigmatic. But also, close-ups of necks, shoulders and napes, as if the camera was seeking to get into the head of the characters and transmit that 'strange invisible subjectivity' that Gilles Deleuze described about the films of Michelangelo Antonioni.[166] This dual position of inclusion and exclusion – seeing the world through a mind *which no longer recognizes it* – produces a feeling of disorientation which anticipates the psychological and political adventure of the two main characters of the film, who are forced to relearn, or not, the workings of the universe they believed to be familiar.

After *Heat*, Mann sought to develop a project around the arms dealers of Marbella, in collaboration with Lowell Bergman, producer of

The Insider, 1999

60 Minutes, one of the flagship programmes of CBS. In the course of the 1960s, Mann and Bergman frequented together the classrooms of the University of Wisconsin, but they only met up again later, at the summit of their respective careers. At the same time, Bergman was struggling with a situation which was poisoning CBS. He had just directed a documentary which, drawing on the testimony of Dr Jeffrey

[166] Gilles Deleuze, *Cinéma 2. L'image-temps, Minuit*, 1985, p. 16.

The Insider

Wigand, ex-director of research at Brown & Williamson, exposed the manipulations by American tobacco manufacturers in order to increase the absorption and effect of nicotine. To this explosive public health issue was added a scandal which mixed the ethical, the judicial and the economic, since the financial department of CBS decided to censor Wigand's revelations from the documentary on the tobacco industry, with the hidden motive that its broadcast could put in into peril the sale of the business to the Westinghouse group. 'They own the information he's [Wigand] disclosing. The truer it is, the greater the damage to them,' summarizes in a stinging way the lawyer for CBS in the middle of the film, in order to justify not broadcasting the documentary. Mann then changed tack and decided to devote his next film to this 'Tobaccogate'. Although far from the world of crime, the subject of *The Insider* offered Mann a new opportunity to address the questions which fascinated him: a couple of men that everything opposes but which, in reality, everything brings together; the cost of integrity for those who refuse to *collude*; the relations between law and capitalism, and the stranglehold of financial markets on the way of the world and the fates of individuals. In order to avoid any legal problem with CBS and above all Brown & Williamson, Mann bought the rights to an article by Marie Brenner, published on the subject in *Vanity Fair* in 1996: 'The Man Who Knew Too Much' paints the interwoven portraits of Jeffrey Wigand and Lowell Bergman, and contains most of the screenplay matter necessary for Mann and his co-writer Eric Roth.

 The film starts in 1993. Lowell Bergman (Al Pacino), producer of the programme *60 Minutes* on CBS, contacts Jeffrey Wigand (Russell Crowe), ex-director of research at Brown & Williamson, and proposes to him, for remuneration, that he translate a series of scientific reports and dossiers concerning Philip Morris which have been placed in front of him. But when they meet for the first time in a hotel in Louisville, Bergman has the intuition that Wigand knows a lot about the secret practices of the tobacco industry and sniffs the possibility of revealing a health scandal. Although having signed with his ex-employer a clause widening the domain of confidentiality, Wigand, at first unwilling, decides to speak to Bergman and inform him that Brown & Williamson, like most tobacco manufacturers, is increasing the quantity of ammoniac contained in the cigarettes in order to increase the level of nicotine and the effects of dependency. Helped by a team of lawyers from Mississippi, Wigand reveals before a State court that the director of Brown & Williamson, Thomas Sandefur, has committed perjury before the

Congress of the United States by declaring not to know about the addictive properties of nicotine. In the aftermath, he goes to New York and, in front of the cameras of CBS, replies to the questions of Mike Wallace (Christopher Plummer). Bergman, Wallace and his team are then summoned by the legal service of CBS which, due to a new legal argument ('tortious interference'), has decided to bury the *60 Minutes* documentary on the tobacco industry out of fear of legal action. Bergman opposes the truncated version they suggest be broadcast and leads his own investigation in order to understand what is behind this about-face.

The Insider

According to Michael Mann himself, Jeffrey Wigand's deposition before the State court of Pascagoula, Mississippi, constitutes the key sequence of the film since, by revealing publicly confidential information and legally ring-fencing it, Wigand sets out, with no way back, on a path which will change his entire life. 'I can't seem to find a criteria to decide,' Wigand confesses to Lowell Bergman and his lawyer Richard Scruggs. Long minutes of hesitation therefore, his face turned to the Gulf of Mexico, a moment of internal deliberation which, as always in Mann's work, is linked to an oceanic image. In the original screenplay, Mann and Roth describe this moment of suspension as a 'long pause on Jeffrey as he contemplates his future. And something just got resolved.' At this precise moment in the film, Wigand must make a choice between all sorts of criteria, but in reality these come down to the confrontation of two programs between which all Mannian characters must, sooner or later, decide. Like Frank in *Thief*, who decides to give up his house and his family life in order to keep his independence, or Neil McCauley abandoning in the parking lot his future with Eady in the name of personal revenge, Wigand chooses to sacrifice his vital program (material, social and family comfort) to his existential program – the ethics of a man who places scientific truth above financial interests and private contracts. 'Makes what you feel good? Putting what you know to use?' Bergman said to him a few days earlier, thus pointing out the internal and moral dilemma which has poisoned Wigand since he joined Brown & Williamson and which he must here resolve. Two reverse shots come to make explicit the

reason for, and the cost of, his testimony. On his way to the tribunal, Wigand, sitting in the back of a car, turns his eyes towards a cemetery and its hundreds of white crosses which pass by the window, as if they stand for all the deaths caused by the tobacco industry and the silence of those who work there. The cost: on the way back, in his new house in Louisville, Wigand looks again through the window and spots, in the middle of a dark night, a burning car which Mann insists upon for a long time. What is this about? The symbolic image of the sacrifice Wigand has just made,[167] echoing the sequence of *Thief* in which Frank burns down his own garage in order to settle accounts with Leo? After all, if property is a good, it is also a factor of alienation which must be destroyed by whoever wants to totally recover his freedom. Arriving home, Wigand notices that his wife Liane and his two daughters have left. Devastated, the man finds himself all alone, surrounded by bodyguards. In Mann's work, the family home is a fragile, unstable place, constantly besieged by forces that are external (Brown & Williamson) and internal (the illness of Wigand's daughter) and which threaten to destroy it. *The Insider* describes not only a man's fight against a powerful corporation which tries to silence him, isolation as a curse on all messengers of the truth,[168] but also the breakdown of an ordinary couple, *its moment of truth*, since Jeffrey and Liane Wigand do not resist in the same way to the 'extraordinary pressure' (Bergman) they are put under. Unlike her husband, Liane does not work and makes the quality of her vital

[167] Besides, for this sequence, Mann uses a song by Lisa Gerrard with an elegiac tone, *Sacrifice*.

[168] Solitude is the curse of the messenger. It is what illustrates the sequence in the hotel where Wigand stays. In his bedroom, a wide painting covers one of the walls. It represents a horseman galloping on a dirt track towards a distant city. Is this, as F.X. Feeney suggests, an allusion to Paul Revere and his famous 'Midnight Ride'? Let us remember that on the night of 18 April 1775, Revere went from the city of Boston to that of Lexington to warn the patriots of the American Revolution of the imminent movements of the British army. His ride was immortalized by Longfellow's poem *Paul Revere's Ride* and by the painting by Grant Wood, *The Midnight Ride of Paul Revere*. The painting in *The Insider* is reminiscent of Wood's – the surging movement of the horses is comparable, the two horsemen go in the same direction and an aquatic space appears on the two paintings. Could Wigand be that solitary horseman carrying a vital truth? Then the painting slowly comes to life – the camera makes a curved travelling along the wall – and dissolves until there appear Wigand's two girls playing in a garden. He tries to speak to them, but they don't hear him. It is the image of what he has momentarily lost. Let us note that in *The Last of the Mohicans*, the transmission of vital information (the despatch sent by Colonel Munro to General Webb) leads to the messenger's death.

program the *sine qua non* condition of her existential program: domestic comfort, her social status and the level of education of her children are part of a lifestyle which she turns out to be incapable of relativizing, and therefore surpassing. When Jeffrey announces to her, at the very start of the film, the news of his dismissal, she, devastated, has thoughts only for the financial situation of the household and immediately makes a list of the losses incurred. At the moment of abandoning the family property for a more modest house, Jeffrey tries to reassure her by placing himself outside the materialist field: 'We can make this work for us. Ok? It's just a smaller scale. Simpler, easier, more time. More time together. More time with the kids [...]. Can you imagine me coming home from some job feeling good at the end of the day? This is gonna be better,' he tells her. But in spite of his efforts, which are sincere, Liane will not manage to bear what she experiences as an intolerable downgrade. She has her reasons. From this point of view, the film paints less the cruel portrait of a woman alienated by the external signs of wealth and/or of celebrity (see her eyes light up when she addresses the television star Mike Wallace in the sequence in the New York restaurant) than it describes the way in which the existence of a man (and his family) depends entirely on the business that employs him, be it the level of his medical coverage, his lifestyle or his severance package. In reality, any Jeffrey Wigand belongs to Brown & Williamson, like Frank, in *Thief*, belongs to Leo and his small business. 'How could there still be private things, let alone private lives, in a situation where almost everything around us is inserted into all kinds of institutional frameworks, which nevertheless belong to someone?' writes Fredric Jameson in 'Totality as Conspiracy'. And it is by passing one day from a world that values research to another based on the culture of selling that Wigand has signed, without daring to admit it, his Faustian pact: 'The work I was supposed to do might have had some positive effect, I don't know,' he confesses to Bergman during their first conversation in the car. 'It could have been beneficial. Mostly, I got paid a lot. I took the money. My wife was happy. My kids had good medical, good schools, got a great house. I mean, what the hell is wrong with that?'

Pakula, golf and paranoia, *The Insider*

Mixing genres

The Insider does not belong to the crime genre, but it sometimes uses its codes and techniques: according to a converse movement to that of *Collateral*, in which the hitman Vincent pushes to its pathological limit, and therefore reveals the logic of capitalism, *The Insider* takes place in the world of legal financial empires but treats them, from the point of view of the filming as well as of the screen play, as if they were mafia corporations. 'Have you had a chance to play gold?' Thomas Sandefur, boss of Brown & Williamson, asks Jeffrey Wigand at the very start of an interview which aims to make his ex-employee sign a contractual amendment extending the domain of confidentiality of the business. This remark is not intended to immediately make sense for Wigand, but to feed, perhaps and retrospectively, the anxiety that takes hold of him when, during a nighttime driving range session, he believes he is being watched by a man posted at the other end of the range. The glacial setting in which this interview takes place, and Mann's directing, which works entirely on Wigand's anxiety, give the sequence a tension which expresses the extraordinary brutality of the business world and its ability to instil a silent terror. Right from his entrance into the office, Wigand appears as a blurred prey caught in the web of his predator (Sandefur's face, at the edge of the frame on the left). He sits down in front of him, but a wide shot, from behind, reveals on both sides of the frame the presence of two seated men whose faces we do not see. Visually, Wigand is thus destabilized, under surveillance, like a target placed at the centre of a triangle of hostile forces. At the start of their conversation, Sandefur addresses his ex-employee, but also these invisible men (lawyers? bodyguards?) whom he constantly calls to witness. Wigand thus becomes the object and the subject of the exchange. Although it is never explicit, the cold violence which emanates from Sandefur's words appear inversely proportional to his superficial friendliness.[169] Used to these kinds of relations, Wigand decodes very quickly the doublespeak of his interlocutor and the veiled threats which hide behind his flowery euphemisms. When he was a salesman, remembers Sandefur, he never

[169] In the dark and monochrome environment of Sandefur's office, a big painting hung on the wall represents a smiling peasant who holds in this hands a tobacco leaf in the middle of an orange field. This joyful postcard image, inspired by the advertising campaign for Lucky Strike in 1947, produces a striking contrast with the economic and psychological violence at play here.

The Parallax View, Alan J. Pakula, 1974

The Insider

The Insider

The Insider

The Insider

made a promise he could not keep. 'I knew that if I ever broke my promise, I'd suffer the consequence.' 'Is that a threat?' Wigand immediately replies. The camera, placed behind his back, then moves from the left to the right of the frame, achieving by the symmetrical effect obtained the reality of the double meaning of Sandefur's words. The latter then reminds him that work done for Brown & Williamson is confidential and just as secret as family affairs. Wigand grasps again the allusion – 'You're threatening my family now, too?' – while in the background, the appearance of the silhouette of one of the two men comes to embody Sandefur's implied threat. In the course of the story, Brown & Williamson becomes in the eyes of Wigand, and of the viewer, an entity with imprecise contours whose zone of influence seems limitless. After having discovered a revolver bullet in his mailbox, Wigand calls on the FBI. But the agents who arrive at his home turn the complaint into an accusation and behave like corrupt employees under the orders of the business. In this world where the hand of Brown & Williamson seems omnipresent, the most mundane events all take on a potential menace – it is while chasing a raccoon which is keeping him awake at night that Wigand discovers traces of an intrusion in his garden.

In the first part of the film, Mann reserves an aesthetic typical of political drama for the sequences with Lowell Bergman captured in the environ-ment of his work as a journalist-producer (newsrooms, multiple mee-tings, a feeling of intense activity, rather warm colours…), and shifts over to the thriller when it comes to describing the daily life of Jeffrey Wigand just after he has been fired. There, the colours are cold and bluish, the settings appear more geometric, abstract, closing up Wigand in grid-like, often empty, spaces and decors which, visually, put him at odds. The directing, which is much more fragmented, conveys the pul-sation of the postmodern world. It also conveys the dissolution of Wigand, ten years before that of Melvin Purvis (*Public Enemies*), in the universe of entrepreneurial and organizational bureaucracy. 'When I found myself confronted with this story', explained Mann at the time of the film's release in 1999, 'I asked myself how to make a thriller in an ordinary environment, to bring out emotion in the heart of banality, to give the very objects a psychological force that would act on the characters. I kept this question constantly in mind so that the audience could physically feel the anxiety that can emanate from the innocence of American residential spaces, as well as the degree of hostility that can arise from the setting where business is negotiated. For example,

the large hotel where Al Pacino and Russell Crowe meet is treated like a mausoleum, and I systematically sought to ensure that the shots convey the discomfort of individuals in this inflexible and formalized environment. From the moment he is dismissed, we no longer know whether the environment in which Wigand operates is distressing or whether he himself projects his uneasiness onto those around him. There is something inhuman in his living environment, and he orders his space in a methodical, almost compulsive way, as a defense against the schizophrenia that he sees on the horizon.'[170] Losing his job has made of Wigand a shaken, suspicious man, subject to fits of paranoia, as shown by the golf sequence which, beyond the possible homage to the cinema of Alan Pakula, constitutes one of the virtuoso moments of the film and the oeuvre of Michael Mann. The action is simple and *a priori* crystal clear – in the middle of the night, Wigand hits golf balls and becomes aware that another man is doing the same – but its interpretation is undecidable. Are we dealing here with an ordinary executive who has come to relax after a day's work or a henchman employed by Brown & Williamson to intimidate him? Is Wigand hallucinating about a threat which does not exist or do his paranoid tendencies make him, on the contrary, psychic? This undecidability is firstly due to the way in which Mann makes us enter the sequence via a series of details taken from a situation of which we do not know the global reality. Deprived of its context, the first shot – a dark flat surface dotted with blue – seems disconnected from any recognizable experience, all the more so as there then appears a spider-like vehicle with arms that retrieve the scattered golf balls. And then appears a close-up of Wigand's face floating against an indeterminate black background. The cutting thus creates an effect of worrying strangeness, even of bizarreness that almost flirts with the fantastic. What is going on? Where are we? On a foreign planet? In a nightmare? *The Insider* systematizes this way of keeping in reserve certain contextual images (here a general view of the golf course; in the opening sequence, the city of Beirut) so that their use has an emotional value and not simply a descriptive one. When the wide shot finally appears, we understand that this foreign planet is a simple golf course *reconfigured* by Wigand's anxiety. The scale shock finally produces a crushing effect on the character in a space that is too vast and dramatizes the presence of this other suited individual who, from afar, seems to spy on him.

[170] Laurent Rigoulet, interview with Michael Mann, *Libération*, 15 March 2000.

This feeling of paranoia, which infuses most of the sequences devoted to the daily life of Jeffrey Wigand before his deposition, is new in Mann's oeuvre and undoubtedly owes a lot to the work of Eric Roth, author of the screenplay of *The Nickel Ride* by Robert Mulligan (1975), one of the little-known jewels of the paranoid cinema of the 1970s.[171] Right from his first appearance, Jeffrey Wigand stands apart from his colleagues, in a laboratory which resembles an aquarium. While the latter, on the other side of a window, celebrate the retirement of one of them, Wigand packs up, silent, concentrated, with a sullen face. Mann emphasizes here the isolation of the character in a mineral and hygienic environment, surrounded by glass surfaces which express the theme of transparency and therefore of secrecy, central to *The Insider*: the confidentiality clause, thanks to which Brown & Williamson clouds its practices, the entire life of Wigand is scrutinized by his detractors or the hidden deal between CBS and Westinghouse which dictates the group's editorial choices. Mann then films Wigand's departure as if he was leaving a prison system – a high angle shot of his office-fishbowl reinforces the sensation of being crushed.[172] Wigand takes the elevator and walks towards the lobby, a dark and cold space, barred by the silhouette filmed in backlight of a security guard. A slight slow motion then dramatizes his departure; Wigand goes past the man and away into the background, towards the exit. The position of the camera, placed behind the character's neck, seems here to seek a point of equilibrium between an objective vision (of which we can, with him, notice the presence) and a form of subjectivity reinforced by a blurring effect and, especially, by the fragility of a frame fastened onto Wigand's body. The strange uncertainty of the character in space produces here a dual feeling of presence and absence which is reminiscent of the famous opening sequence of *Seconds*, in 1966, with the camera fixed to the shoulder of an unknown man who walks/wobbles in the middle of New York Grand Central Station. Even if its use is not as systematic and violent as in the film by John Frankenheimer, it is, from the point of view of the history of forms, one of its possible origins. Here, Mann reactivates this figure of alienation and of loss of bearings as an almost normalized, diffuse 'method' which

[171] In this film, Jason Miller plays Coop, known as the 'key-man', an influential man who works for the mafia by managing warehouses in the centre of Los Angeles. But the appointment of a new bodyguard, who is younger and behaves strangely, convinces him that his superiors want to get rid of him.

[172] A paradoxical feeling, because if the dismissal affects him negatively, it also opens the doors to his existential program.

Seconds, John Frankenheimer, 1966

no longer scandalizes to the point of jarring with the viewer's eye, *an uncomfortable way of being in the world* which, unlike the experimentations of *Seconds*, no longer needs a scriptwriting show of strength to impose itself. At the end of the sequence, Wigand leaves the building of Brown & Williamson by taking a revolving door which will become one of the film's leitmotifs – it is the same type of door which regulates the entries and exits to and from the headquarters of CBS, and the film ends with the image of Lowell Bergman going through it one last time. This motif of the revolving door serves as a metaphor of spaces and individuals, as if Mann was pointing out here the deep subject of his film, as much from an aesthetic point of view as from a political one (the circulation of capital and the interpenetration of zones of influence), that it to say a testing of the limit separating the inside from the outside, systems from their countervailing powers. A test of validity therefore, even one of relevance, for a concept which has structured a large part of the American imaginary and its cinema. In summary: what does it mean to be an *insider* if the *outside* has disappeared? What is the periphery when the centre extends to the horizon? How do you oppose? Finally, how do you live in an aquarium when you have marine desires? For Jeffrey Wigand, leaving Brown & Williamson brings about his economic and social demotion. Going through the door thus expresses a humiliation which echoes that suffered by the doorman in Murnau's *The Last Laugh* (1924), chucked out of the grand hotel in which he had spent all his career.

Alice in Wonderland
or the parallax effect

The Insider seems to return to the line of the conspiracy, as political structure and power, which makes its appearance in post-war American cinema and reaches its apogee in the mid-1970s. Big diffuse organizations, led by hardly identifiable individuals or groups, then become the epitome of a world in which everyone now has with his fellow man just relations of surveillance, domination and manipulation. Alan Pakula alone sums up the two tendencies of the genre since he created its two matrices: an optimistic vein, confident about the unshakable ability of the American system to correct its wrong-doings (*All the President's Men*, 1976), and a disenchanted vein, to which Mann's film belongs, which has shown how any totality becomes a conspiring power (*The Parallax View*, 1974). That

is to say, to borrow David Harvey's concept, two possible 'geographies of domination':[173] what could be *called a geography of the limit* (any system, however extended, has its outside) and a *geography of instability*, which is also that of capitalism, based on an intense circulation of individuals and capital, a permanent reversibility of positions and a confusion of antagonistic forces – adherence is then a modality of opposition. The screenplay of *The Insider* is constructed in two parts which correspond, each in their turn, to these two types of geography. In the first one, which ends with Wigand's deposition, Lowell Bergman leads his investigation in the manner of the Bob Woodward-Carl Bernstein tandem. What is at stake in the story seems clear and, with it, the outcome of the film is settled: convince Jeffrey Wigand to testify, then gather sufficient evidence against Brown & Williamson (and, with that, other tobacco manufacturers) in order to force its leaders to confess before the American justice system to their knowledge of the addictive effects of cigarettes as well as their deliberate intention to prevent any scientific research aiming to reduce their harmful ones. Bergman's work is thus reminiscent of that of the journalists of the *Washington Post* in Pakula's film, for whom the struggle can only be organized from a position outside the system, be it political, media or institutional. Here, the *Washington Post*, there, the programme *60 Minutes* which, for its producer, constitutes the natural place of responsibility. *The Insider* thus follows in the footsteps of *All the President's Men*, *Three Days of the Condor* and *Serpico*. In the last film mentioned, Al Pacino, already tried to expose from within a vast system of corruption undermining the New York police. If the field of responsibilities expanded endlessly – from a neighbourhood police station to the city hall – the limit remained active and the interface between outside and inside still operational. Frank Serpico ended up finding a place from which it was possible to purge the system. At the end of the film, Lumet pointed to the nomadic future of the whistle-blower (Pacino, alone with his dog, leaving for Switzerland), and his obligation to leave the country.

In Mann's work, however, this possibility of cutting yourself off from the system in order to fight it has disappeared. *The Insider* shifts when Lowell Bergman, Mike Wallace and Don Hewitt are summoned to Black Rock for a meeting with Helen Caperelli (Gina Gershon), the lawyer for the CBS group. At the centre of a meeting room, similar to a gigantic aquarium, the well-oiled discussion of the first part collapses when she

[173] David Harvey, *Géographie de la domination*, Les Prairies ordinaires, 2001.

The Insider

announces to them, in veiled terms, her decision not to broadcast the documentary, given the legal risk run by the business. 'We're all in this together. We're all CBS,' she says before leaving, thus turning the duality inside/outside (indispensable for any strategy of counterpower) into a mere vestige. In one sentence, Caperelli sounds the death knell of the political structure at work in the conspiracy cinema of the 1970s. What can then be done when the boat carries both the master and his slave, the leader and his opponent? How can you oppose when externality to the system is no more? Up until then an enthusiastic and rebellious activist, Lowell Bergman, *by not seeing the rift coming*, then experiences the Fitzgeraldian drama par excellence: 'The realization of having cracked was not simultaneous with a blow but with a reprieve,' wrote the author of *The Last Tycoon* in his final text.

Basically, the meeting between the journalists of CBS and Helen Caperelli plays an equivalent role to the famous monologue by Ned Beatty in front of the star anchorman played by Peter Finch in *Network* (1976). By summarizing the group's position in a falsely amiable way: 'We're all in this together. We're CBS,' Caperelli expresses in substance the same thing as the boss of the CCA conglomerate in Sidney Lumet's film: 'There is only one holistic system of systems. One vast and immense interwoven, interacting, multi-variate, multi-national dominion of dollars [...]. It is international system of currencies which determines the totality of life on this planet. That is the natural order of things today.' Twenty-five years later, Caperelli's words are softer, sharper too, since they cover up the order of things of that positivist doctrine specific to capitalism which aims at creating an ideological environment which neutralizes all forms of conflict. That is to say a raising of the curtain on the real other side of things, the brutal revelation of the hidden functioning of a world that the producer of *60 Minutes*, and with him the rebellious generation brought up in the 1960s, could not see, or refused to see. 'Is this *Alice in Wonderland*?' then asks Bergman as if the film had just, at that precise moment, passed through to the other side of the mirror. Mike Wallace tries to minimize the incident, but Bergman understands immediately the nature and the power of the systemic reversal which hides behind the legal fog manufactured by the business legal department of CBS. It is then, to borrow Céline's expression in *Journey to the End of the Night*, 'the moment the world turned upside down', its parallax effect, and for Bergman, a sort of negative epiphany which will lead to the evaporation of his political mirage and to his resignation from CBS. *The Insider*, it is '*all the president's men*' who

realize, halfway through, that they are in fact in *The Parallax View*. Bergman understands that this 'aesthetic distance' mentioned by Fredric Jameson – this 'possibility of the positioning of the cultural act outside the massive Being of capital, which then serves as an Archimedean point from which to assault this last'[174] – has disappeared – since when? – unless it has just been a lure created by liberal capitalism in order to feed the illusion of a counterpower.[175] It has disappeared because commodification has penetrated the entire social and human body, it innervates it from end to end, thus making obsolescent its software of political thought forged in the 1960s and 1970s. For him, and him alone, the film then seems to start again from zero, as victim of a *tabula rasa* which puts everything into question, the conditions of possibility of his work, his faith, his convictions (and what if he had been, like Howard Beale in *Network*, the useful idiot of the CBS empire?) and even his friendships. A few days later, a meeting at the CBS headquarters takes place between Bergman, Wallace, Hewitt and Eric Kluster. The sequence echoes the conversation between Wigand and Sandefur, and opens the line of symmetries between the two parts of the story with which the film abounds. Bergman finds himself, in turn, in the position of the whistleblower – in the meantime, he has discovered a series of documents proving the sale of CBS to Westinghouse and consequently, the real motive for the about-turn – and of the man who decodes the doublespeak of the business department of CBS, thus hoping to provoke a reaction by his colleagues.

> Lowell Bergman: Since when has the paragon of investigative journalism allowed lawyers to determine the news content on *60 Minutes*?
> Don Hewitt: It's an alternate version. So what if we have an alternate version? And I don't think her being cautious is so damned unreasonable.

Eric Kluster excuses himself, but must leave the meeting. Bergman asks him to wait a moment and takes out a thick report on the sale of CBS to the Westinghouse company. He begins by describing the main

174 Fredric Jameson, *Postmodernism, or, the Cultural Logic of Late Capitalism*, Duke University Press, 1991.
175 See Jean Baudrillard, *Simulacres et simulations*, Galilée, 1981.

beneficiaries of the merger of the two groups, who among them are Helen Caperelli, legal adviser to CBS, and Eric Kluster, its president.

> Hewitt: Are you suggesting that she and Eric are influenced by money?
>
> Bergman: Oh, no, of course they're not influenced by money. They work for free. And you are a Volunteer Executive Producer.
>
> Hewitt: CBS does not do that. And you're questioning our journalistic integrity?!
>
> Bergman: No, I'm questioning your hearing! You hear 'reasonable' and 'tortious interference'. I hear... 'Potential Brown & Williamson lawsuit jeopardizing the sale of CBS to Westinghouse.' I hear... 'Shut the segment down. Cut. Wigand loose. Obey orders. And fuck off...!' That's what I hear.
>
> Hewitt: You're exaggerating!
>
> Lowell: I am? You pay me to go get guys like Wigand, to draw him out. To get him to trust us, to get him to go on television. I do. I deliver him. He sits. He talks. He violates his own fucking confidentiality agreement. And he's only the key witness in the biggest public health reform issue, maybe the biggest, most-expensive corporate-malfeasance case in U.S. history. And Jeffrey Wigand, who's out on a limb, does he go on television and tell the truth? Yes. Is it newsworthy? Yes. Are we gonna air it? Of course not. Why? Because he's not telling the truth? No. Because he is telling the truth. That's why we're not going to air it. And the more truth he tells, the worse it gets!'
>
> Lewitt: You are a fanatic. An anarchist. You know that? If we can't have a whole show, then I want half a show rather than no show. But oh, no, not you. You won't be satisfied unless you're putting the company at risk!
>
> Bergman: What are you? And are you a businessman? Or are you a newsman?!

Whilst in Black Rock, Bergman still shared the frame with Wallace and Hewitt, Mann chooses here to isolate him in front of his three colleagues. 'I'm with Don on this,' finally says his friend Mike Wallace, stunning Bergman. Between them, the break up seems complete. But Mann, who

is always careful to expose the reasons of all his characters, does not abandon Wallace to what looks like a betrayal and gives him a scene, one of the finest in the film, which brings less redemption than explanation. On the morning of the publication of the explosive edition of the *New York Times*, Wallace goes to Bergman's hotel room for a moment of clarification. A sort of dejection, even exhaustion, envelops these two tired men – one is slumped on his bed, the other sitting in the shadows. Bergman begins by setting out his principles, and therefore the necessity of a form of radicality, whilst Wallace puts forward other considerations and moves the discussion onto an existential level emblematic of Mann's cinema, where it is a question of the passage of time, of old age, 'when you're nearer the end of your life than the beginning'. 'I've spent my lifetime building all that. But history only remembers most what you did last. And should that be fronting a segment that allowed a tobacco giant to crash this network?'

In the first part of *The Insider*, Jeffrey Wigand opposes a powerful corporation which tries to destroy him; in the second, Lowell Bergman struggles against a media empire. But, at this end of the twentieth century, his struggle is a lost cause, a last stand since 'What got broken here doesn't go back together again.'[176] By revealing to the *New York Times* the hidden goings on at CBS, Bergman knows that he is scorching the earth on which his entire career has been built and proceeds to make a sacrifice which echoes that of Jeffrey Wigand just after his deposition to the tribunal in Pascagoula.

Is it a wonderful life?

'But was the game worth the candle?' is the question hanging over the end of *The Insider*, so much does victory, as always in Mann's work, possess a strange taste of defeat. 'You go public, and 30 million people hear what you gotta say, nothing, I mean nothing will ever be the same again,' Bergman had promised at the start of the film to Wigand who, more sceptical, had replied: 'You believe that because you get information out to people, something happens?' Bergman finally gets the complete version of the documentary to be broadcast. The scene starts on a television in a bar, and continues via a cross cutting mixing the protagonists of the

[176] 'What do I tell a source on the next tough story? Hang in with us. You'll be fine...maybe?' Bergman tells Wallace.

affair with ordinary people, all viewers of the same programme in different parts of the country. The music of Lisa Gerrard (*Sacrifice*) and the chant that accompanies it[177] nevertheless gives the sequence a melancholy relayed by the exhausted face of Bergman sitting in a waiting room at the airport of Helena, Montana. For we are far from the Capraesque effusion which, in classic Hollywood cinema, accompanied the victory of the righteous over a system they managed to bring down: where are the hobos who acclaimed Gary Cooper at the end of *Mr Deeds Goes to Town*, when he had just beaten those who wanted to exploit him and refused to let his Rooseveltian plan be put into action? What has become of the hurrahs of the inhabitants of the neighbourhood of Wall Street when the patriarch of the Sycamore, in *You Can't Take It With You*, managed to preserve that house that so many bankers and real estate agents wanted to take from him? Or the outbursts of joy from the boy scouts after the verbal marathon of Jefferson Smith at the end of *Mr Smith Goes to Washington*? The 1970s had passed by there, disenchantment, repeated scandals, the end of utopias, the disintegration of the collective as well. This sequence, which could have constituted the euphoric acme of the story, is marked by a hangover, even an indifference to the scandal, which seems to have contaminated the entire social body. The sound of a whimper. Only Wigand, moved to see his daughters understand, perhaps, the decisions he took, appreciate the importance of the instant. It is not a question, like in the final sequence of *Three Days of the Condor*, of an unexpected doubt on the perimeter of the criminal system relaunching at the last moment the conspiracy hypothesis, but a deeper questioning of the objective effect of truth today. After all, the necessity of action does not prevent awareness of its weak influence, and if Mann celebrates the heroism of the last Mohicans of truth and the common interest, he also knows their anachronism in the contemporary world. How then do we find our rightful place between the jaded and the festive, between the resigned and the hollow men? What will have been the point of Wigand and Bergman's sacrifices? 'You won,' says Bergman's wife just after the broadcast of the programme. 'Yeah? What did I win?' he replies.

The films of Michael Mann are not political from the outset, in the sense where they might be filled with a content preexisting them via emblematic individuals or theses to defend, they become it along the way, since they

[177] Mann uses the same song as in the sequence of the burning car contemplated by Wigand on the night of his return from the tribunal at Pascagoula.

Opening sequence of *The Insider*

The disenchanted truth (*The Insider*)

make of the comprehension of events a dramatic issue. In other words, *the trajectory of the characters is always coupled, for them as for the viewer, with an existential and political adventure.* It is finding the point of harmony with themselves (Max in *Collateral*, Nathaniel in *The Last of the Mohicans*, Neil in *Heat*, Jeffrey Wigand in *The Insider* and Ali) that the Mannian heroes reach, in a single movement, a better political knowledge of the world and its stakes, of the power relations which determine it and of its workings. 'What do you see?' is, besides, a recurrent question in Mann's œuvre, which signifies the, sometimes forced, necessity of seeing more clearly before acting, in other words of improving your knowledge of things, of constantly updating it (*Miami Vice*, *Public Enemies* and *The Insider*). From this point of view, the opening sequence of *The Insider* constitutes a short cut that is particularly evocative of this question which occupies all of Mann's films, since it works around the sole motif of the partial and/or restricted vision of Lowell Bergman.

 The film opens on a burlap which firstly occupies all the screen before a wider shot reveals that it is a blindfold covering the face of Bergman, led to the safe house of a leader of Hezbollah in Beirut. On the way, Bergman tries to perceive, through the sounds and smells of the city, the atmosphere of the place and bits of the reality surrounding him, while a sustained, even martial, rhythm emphasizes his wilful character. In the house of the sheik, bodyguards take him to the centre of a dark room dominated by a big red hanging which masks the windows. There follows an exchange between the sheik and Bergman, who has come to convince him to give an interview for *60 Minutes*. But the exchange is asymmetrical since the CBS producer, his face still covered, cannot see his host, and when he takes off his blindfold, the latter has vanished like a chimera. Now that he can see, Bergman sees nothing. He then goes to the window and opens the curtain upon a sunlit panorama of the city. From a narrative point of view, this sequence aims to establish the determined personality of Bergman, his professionalism and, at this stage of the film, his sense of omnipotence. 'Welcome to the world,' he says to his technician before opening the curtain upon a world at his disposal. It also says the theatrical dimension of the geopolitical game – the curtain, the ritual of appearance and disappearance of the sheik and, later, the false quarrel triggered by Wallace to stimulate himself before the interview. But from a symbolic point of view, it recounts something completely different: a blocked vision to begin with (the blindfold), as if in this film, and on Mann's films in general, *you were entering the world a blind man* and you had to learn to (re)see this world as it is really, by freeing yourself from

your previous representations and all the pretences veiling it. It is a gesture at once ideological, intimate, existential and political, so much is the big curtain awaiting Bergman obviously not the one he has just drawn. For once, the French title of film, *Révélations*, rings true: Bergman believes he sees things correctly, but in reality, he sees nothing. For him, the *revelation* is to come.

At the end of the film, Lowell Bergman goes one last time into the offices of CBS and makes for central control room. Another news story is mobilizing the channel – the Unabomber affair – and the explosive interview with Wigand, broadcast the day before, is already history. A few technicians and journalists congratulate him on his documentary, but no one mentions the sale of CBS to Westinghouse – yet again, each has his or her reasons to forget the scandal which shook the business and move on to something else. Bergman takes Mike Wallace aside and reveals his decision to jump ship. Wallace understands his partner – a slight smile shows even the respect he feels for him – but, for reasons that he has expounded earlier, he chooses to remain in the system. One returns symbolically into the fishbowl, while the other, back turned, makes for the glass door of CBS. Outside the building Bergman then puts his overcoat back on his shoulders, goes away into the background, then slow motion breaks his movement. The ex-producer of *60 Minutes* then

Vanishing (*The Insider*)

resembles an opaque form, without clear shape, fixed on the window like an insect trapped in a crystal web. Bergman almost transforms into a ghost, before a lateral movement of the camera literally erases him from the frame: the outside is a zone for disappearance. This shot could have been a perfectly Fordian one – see that iconic one at the end of *The Searchers*, in which John Wayne, filmed from the doorframe, goes away into Monument Valley – but for Mann's outlaws there is no totemic future, no reification, no legendary inscription within one space in particular, but a spectral future indicated at the end of *Thief*, where James Caan vanished at the end of those countless rectilinear alleys which draw the topography of the American suburbs. From then on, the expulsion of the Mannian hero does not lead to an opening onto a new and desirable world, but marks his deep desire to take his leave of it after having confronted – in vain? – its beautiful mirages.

Miami Vice:
mirage of the sun, gravity of the flux

> 'The Real is nothing more than the asymptotic horizon of the Virtual.'
>> Jean Baudrillard,
>> *Le Pacte de lucidité ou l'Intelligence du Mal.*

In 2006, Mann directed his ninth film, *Miami Vice*, a dark epic devoted to the life of two undercover agents, which portrayed in detail and in violence the effects of the globalization of crime and the collusion between the political and the economic, even the absorption of one by the other. Mann was then at the summit of his artistic power and occupied in Hollywood a privileged position – both respected by the 'milieu' and a safe investment for the industry, he again demonstrated his ability to make the logic of the blockbuster (*Miami Vice* is oversold as such) fit into a personal universe, to the point that you sometimes have the impression of a large-scale misappropriation of funds – the film cost $150 million – to the advantage of a radical piece of work which makes no concession to the formal and stylistic ambitions of the filmmaker. So, nothing consensual in the approach, but rather an impressive ability to create an alliance between the demands of the filmmaker and those of an art which is powerful only on the condition of remaining popular (the genre film, basis of all his films).

At first sight, *Miami Vice* is halfway between the crime film and the spy film. Before it is blown up, the fiction begins with the suicide of an FBI agent who has infiltrated the drug scene, Alonzo Stevens, following the murder of his wife by the Aryan Brotherhood, a white supremacist group.

Miami Vice, 2006

In order to investigate the affair, two inspectors from the Miami drugs squad, Sonny Crockett and Ricardo Tubbs (Colin Farrell and Jamie Foxx), pass themselves off as hardened traffickers and make contact with the financial administration of the cartel, a vast organization of enormous means. In a few minutes, Mann jettisons the picturesque approach of the genre (colourful hoodlums, proletarian henchmen, posers dressed in bad taste) and composes a vague mafia web, a State within the State as at ease in the large scale transfer of funds as in the clinical execution of offenders.

A priori, *Miami Vice* returns to the vein of the political thriller of the 1970s and reuses its reversals of identity, its obsession with conspiracy (who, from the FBI, the CIA or the Miami-Dade is harbouring the traitor?) and its diffuse paranoia. But in reality, Mann films this story of high-level trafficking like a high-tech war film where it is above all a question of logistics, of exchange of information, of surveillance and technological mastery. Many times, the film emphasizes the collusion of police and military techniques: on the way to a place kept secret in Ciudad del Este where there awaits them Archangel de Jesus Montoya (Luis Tosar), the boss of the cartel, Sonny and Ricardo realize that the traffickers are using a system of electronic jamming identical to that used by the CIA in Baghdad. 'What's it doing on a dope deal?' Sonny then says in amazement. Finally, the film's big gunfight, as in *Heat*, does not invert the codes of a precise cinema genre (the western), but is directly inspired by the imagery of war reports: deafening and ultrarealistic weapon sounds, moments caught on the spot, discontinuity and partial unreadability of the action, proliferation of points of view and snipers lying in ambush.[178]

[178] Mann nicknamed the film plan for this sequence of *Heat* 'WWIII'. His technical adviser was Andy McNab, former member of a special unit responsible for sabotaging enemy materiel during the first Gulf War.

Fascinating, first of all, is the way in which Mann, totally against the grain of a classical treatment of the storyline which *Heat* had carried to its zenith, rejects off screen some key plot moments (a war tells itself in snatches) and chooses to make the big dramatic elements rest on details, whether it's a diamond watch which sheds light on the ambiguous relations between Isabella (Gong Li) and Archangel de Jesus Montoya or the discrete tear of Jose Yero (John Ortiz) in the face of Sonny-Isabella couple, through which we understand his deep motivations. The power of *Miami Vice* comes from this mixture of formal elegance and brutality, of extreme stylization and hyperrealism. Always the two at once, according to the great Mannian theorem: becoming the other in order to fight him at the risk, like the cop played by Colin Farrell, of losing your footing in an imprecise zone where nothing allows you to distinguish between reality and pretences. Very quickly, the reassuring foundation of the genre, with

Miami Vice

its archetypes, codes, values and denouement, collapses. The story then progresses by leaps and bounds, crushes most of the peaks of action (the robbery of the Haitian mafiosi settled in a few shots) and multiplies false starts, like the opening of the film, a misleading connection with the nightclub sequence in *Collateral*, which concentrates on the arrest of a pimp (Neptune) then, in a fraction of a second, changes direction after the panicked phone call from Alonzo to Sonny. Violence bursts into the shot, preceded by no ritual, breaks out without warning, and you enter the film (no explanatory sequence, no title)[179] like a war reporter thrown into the midst of an ongoing conflict. Without beginning or end. Just 132 minutes drawn from an uninterrupted flow of images and events.

 The first minutes thus impose a staccato and suffocating rhythm which the film, with the exception of the Sonny-Isabella couple's escapade, will not deviate from. Everything is already becoming mixed, inside and outside (Sonny passes from the nightclub to a roof in one continuous movement), public and private spheres (for Sonny, a short

[179] On the difference between the two versions, see p. 290.

sequence pulling a waitress then his immediate return to the mission): the stage entrance of Sonny and Ricardo appears the total opposite of those of De Niro and Pacino in *Heat*. If magnitude and expansion informed up until then the natural rhythm of Mann's films, *Miami Vice* places itself under the sign of compression, the fragment, speed and breathlessness. Immersed in the nightclubbers, already undercover, the two men emerge in the frame in a stroboscopic way. Between the bodies of the dancers, the movements of the crowd and the plasma screens, a few rapid shots show their intermediate presence while the soundtrack juxtaposes, without the slightest concern for smoothening, three mismatching tracks, linked solely by the hammering of a single repetitive pulsation. Ten minutes are enough for Michael Mann to set the tempo of *Miami Vice*: the event which takes place will always be less important than the one that follows, hence the strange feeling of a film in pursuit of itself, obsessed with what comes next. The filming with hand-held camera, started in *The Insider*, gives the sensation of a constant fragility of the shots and therefore of what they show. As if each shot *was thinking* of two things at a time – the event which takes place (a deal, an arrest) and the one to come (the same) – and that the best way of not collapsing rested on never fixing anything. In *Miami Vice*, however much we are physically there, here and now, mentally, we are always and already elsewhere. A film with short breath, always ejaculating prematurely (a joke by Ricardo to his partner Trudy which reveals, in fact, one of the driving principles of the story), *Miami Vice* possesses an immense but implosive energy which has nothing to do with the explosive one of Mann's previous crime films – from this point of view, the aborted sequence of the nightclub and its promise of resolution (the arrest of Neptune) opts for a treatment that is rigorously the opposite of that in *Collateral*, entirely organized around the murder (or the protection) of Peter Linn. The storyline, uneven and convulsive, unfolds less according to a classical logic of development of sequences (expansion, rise in power and explosion) than in frenzied compilation and short-circuits. The speed of the succession of actions, their extreme tightening, thus prevents the emergence of the feeling of a time which passes, of a duration that sets, to the advantage of a perpetual and monotone actuality beholden to the law of the 'here and now' – 'right now', endlessly repeat the characters throughout the film. 'The space of flux', writes Manuel Castells, 'dissolves time by overturning the order of sequences of events, by making them all simultaneous, placing society in an eternal ephemerality.'[180] We also

180 Manuel Castells, *La Société en réseaux. L'ère de l'information*, Fayard, 1996, p. 267.

think of that 'eternal omnipresent speed' that Marinetti called for in his *Manifesto of Futurism*. But actuality is the opposite of time and the excess (of actions, of characters, of ramifications, of story lines, of bifurcations, etc) becomes the mask for an existential lack which haunts the world through all its interstices. Lack of space, lack of the other, lack of time, especially: 'Time is luck,' Isabella repeats several times to Sonny, that is to say the tragic refrain and curse of all Mannian characters. 'Time is luck. I know the value of every single day,' already said Molly, Will Graham's wife, in *Manhunter*.

Surviving in the flux

Miami Vice is first of all a film of great acuity on the human condition at the time of flows, of globalized capitalism, of which it conveys the mood and illuminates the stakes. Everything progresses at top speed (the encounters, the love affairs, the twists and turns, the sports cars), but, fundamentally, nothing advances really. The general buzz of the flow absorbs any modification of the global system and relegates events and characters to simple disturbances of a sovereign background noise: a trail of blood on the tarmac (the suicide of Alonzo Stevens), an echo on the radar of a control tower or the sound of hands clapping,[181] but nothing more than an ephemeral imbalance of the global system. Hence the extraordinary (and paradoxical) feeling of exhaustion produced by a story so enamoured of rapidity, as much in the chain of sequences and of shots as in the execution of actions. Points of view overlap, shots fall like unchained links, but the general signal ends up triumphing over the events which constitute it. *It* travels, *it* shoots, *it* circulates: *Miami Vice* is the point of view of the flow against that of man. More precisely: the kinetic expression of the dynamics of capitalism, which, writes Hartmut Rosa, 'can neither pause nor rest, cannot stop the race and ensure its position, since it is condemned to rise or to fall. There is no point of equilibrium, for to stay still is equivalent to falling behind.'[182]

Even the men of the Miami-Dade seem to conform to programmes which pre-exist them, respond to electronic stimuli (a phone call, a reaction), and show themselves to be incapable of taking the reins

[181] 'That's the sound of air rapidly filling the vacuum created by your departed body,' says Rico to an intermediary to convince him to put him in contact with Jose Yero.

[182] Harmut Rosa, *Aliénation et accélération*, La Découverte, coll. 'Théorie critique', 2012, p. 42.

of a disarticulated story which occasionally reminds us of, but less playfully, the game 'Simon Says' imagined by Jeremy Irons in *Die Hard with a Vengeance* by John McTiernan. A shot is often enough to pass from Haiti to Miami, from Barranquilla to Venezuela or from Geneva to the falls of Iguazu, near which Montoya has *momentarily* settled, so much, in the world described by *Miami Vice*, has space *virtually* contracted through the speed of transport and means of communication, producing what Hermann Lubbe has called 'a compression of time'. The film thus conveys that instability specific to late modernity, or postmodernity, which characterizes our western societies, in opposition to the 'classic' modernity (1850–1970), to which still belonged *Thief* and *Heat*. The latter were, despite everything, guided by a form of telicity, a linguistic term which denotes the ability of a story to be brought to its end, via a series of actions and events which lead to it,[183] be it Frank's wish to start a family or Neil's desire to open a new line of life after the heist at the Los Angeles bank. In *Miami Vice*, Mann emphasizes, on the contrary, the atelic dimension of our postmodern societies, subjected to the infernal movement of a frenetic capitalism which dictates all its laws. Put end to end, the events of the film succeed one another at a mad speed, but from a dramatic point of view, they do not allow us to build a coherent causal chain, directed towards a strong and identifiable horizon. They seem to combine in a random or anecdotal way, deconstructed, almost haphazardly, as if disconnected from any form of progress or personal emancipation. Hence the feeling of polar inertia which runs through the entire film and, for the characters, that of a story, small or big, which leads nowhere, if not to reestablish a status quo which pre-exists it. In Mann's work, speed also proceeds from the denial of a world which we know does not advance. Or no longer. By ending the film on the disappearance of Montoya and Trudy's return to consciousness, Mann returns in reality to the story's point of departure and to the initial state of the system. Even classic heroism has paled: at the start of the film, Ricardo and Sonny prepare to help a young woman enslaved by a pimp, but an unforeseen phone call forces them to abandon their mission and thus deprives them of a heroic action. A few minutes later, they notice that they have not succeeded in preventing the murder of Alonzo's wife and witness, powerless, the man's suicide. From this point of view, Sonny, a pure

[183] A very relative telicity, since if it is respected in appearance (the story does reach an end), it is subject to a form of emptying, losing a bit of its substance and initial raison d'être.

postmodern a character, is the one who, faced with this structural immobility, has contracted a form of acedia, even boredom, and who finds in Isabella a possible vanishing point, perhaps a mirage of life, in any case the desired face of a finality that this contemporary world, emptied of all teleological principle, does not offer him.

Speedskating

The use of high definition allows Mann to create a dense, often opaque and viscous image which thickens all the backgrounds. Thus the characters gain in definition what they lose in sharpness, and therefore identity – visually, they stand out with difficulty from the background and seem constantly threatened with dissolution. This loss causes an increase in the weight of the bodies (which fall in the final gunfight), a constant vacillation of space and, for the viewer, the feeling of a hypnotic pitching and rolling of the shots. Heavy water is the mother substance of *Miami Vice*, a magmatic power which plays against the speed of the story and from which the individuals struggle, then fail, to free themselves. That world, our world, is in a bad way. It is racing towards extinction. In several nighttime sequences (Sonny's phone call to Alonzo on the roof of a nightclub, the meeting between the FBI officer and the team of the Miami-Dade…), Mann emphasizes the enormous presence of the Florida sky in the setting and captures, as soon as he can, its tempestuous, agitated mood, like an existential storm on the point of breaking, a sort of diffuse eschatology. In counterpoint, the filming multiplies the effects of surface (bay windows, villas by the sea) and of gliding (in a speed boat, in a plane, in a sports car). Impeccable images of a world where survival depends on your ability to stay on the surface and which consequently tolerates only two positions: drowning (Sonny, the most undercover of the two) or maintaining yourself at the heart of a centre which renders you spectral. On the release of the DVD of

Alternative opening sequence of *Miami Vice*

Miami Vice, Mann proposed a slightly re-edited ('unrated') version of the cinema release. Most of the modifications made are anecdotal, with the exception of the opening sequence (bursting into the nightclub), preceded here by a long powerboat race which ends in the harbour of Miami.[184] Against a black background appear the first names of the credits, then the film title, while an underwater noise gradually invades all the soundscape. The camera slowly moves back up to the surface of the ocean, plunges back down for a few seconds, then finally puts its head out of the water in front of the hull of a cigar boat which moves at lightning speed. In a few shots, Mann symbolically gathers together the existential motif – *a waterline that is difficult to hold* – and the kinetic law of the film to come. For *Miami Vice* is run through with a fear of stagnation, a constant obsession with being caught short by the event and the one after, and therefore, with being excluded at any moment from the big modern game. 'In skating over thin ice safety is in our speed,' wrote Emerson in *Prudence*. As Zygmunt Bauman, its outstanding theoretician, has shown, this 'liquid modernity', founded on instability, precarity and the fanatical circulation of men and capital defines in fact a new social and economic hierarchy whose mobility becomes a major criterium.[185] The film describes perfectly the antagonisms thus created: to the forced sedentariness of the declassed – from the poor neighbourhoods of Latin America to the shabby trailers of the American *lumpen proletariat* – is opposed the feverish nomadism of the elites who cross the world free from traditional territorial and physical constraints (Montoya); to stability and the long-time of desire replies the perpetual movement and infinite extension of the domain of consumption; all-out commodification weighs on everyone the threat of being demoted, at any moment, to the rank of waste (the ill young prostitute or Sonny and Rico's informer whose life hangs by a thread); finally, the compression of space, accelerated by the development of means of transport and technology, annihilates the imaginary of a localized utopia (Sonny and Isabella).

At the start of the film, Sonny and Ricardo catch up with the car of Alonzo, whose wife has just been kidnapped. A sequence of panic on the side of the highway: Alonzo confesses that he has talked and revealed the identity of certain undercover FBI agents. 'You don't need to go

[184] A sequence which echoes that which closes the episode *The Great McCarthy* in the series of *Miami Vice* (season 1, episode 9).

[185] Zygmunt Bauman, *La Vie liquide*, La Rouergue/Chambon, 2005.

Miami Vice

home,' says Ricardo who already knows it is too late. Shot on the devastated face of Alonzo ('They said they wouldn't hurt her...'), reverse shot on Ricardo's ('They lied'). Blurring of the cop's face and shifting the camera towards the flow of highway traffic. The man throws himself under a truck and leaves of himself just a scarlet spatter on the pavement, immediately erased by the passage of Sonny and Ricardo's car, as if perpetual movement was the only way to efface being. Integrating yourself into the flux is also disintegrating yourself. In *Miami Vice*, if you endlessly pass from one thing to another, it is because it is the best way of forgetting that, fundamentally, you never arrive anywhere.

The film ends as abruptly as it opened: Isabella escapes from the flow via the ocean (eternal aquatic utopia of Mann's characters since *Thief*), Sonny rejoins it, sinks into it again. And loses himself again. Suspended life on the one side, perpetual flow on the other. No dead time or respite: the system works at full tilt, but runs on empty, and has no finality other than its own perpetuation. To such a point that you could, like Isabella, spend your whole life there: 'The only thing I've known since I was 17,' she confesses to Sonny when the latter asks her about the possibility of an elsewhere, an alternative life. All that counts is the global equilibrium of the system and its ability to restore the immutable order of things (disappearance of Montoya/death of Jose Yero, disappearance of Isabella/Trudy's return to life...). Basically, between the beginning and the end of the film, nothing has really changed. Like James Caan at the end of *Thief* or Al Pacino in the last shot of *The Insider*, Sonny fades into the background, back turned, and disappears. In the world-flux that *Miami Vice* captures, the human is just an episode, an atom lost in the multitude similar to that which describes, resigned, the hitman in *Collateral*. It will be the arrogance and/or naivety of the Sonny-Isabella couple: to believe, or feign to believe, that the human can vanquish the flux.

Identity of the world and the network

The post urban (and posthuman) world of *Miami* Vice is a shattered, fragmented, gridded world, held together by nothing more than the financial flows crossing it and the electronic images (surveillance cameras, radars, computer screens) which reconstitute its simulacrum. No other logic than that of supply and demand, of all-round transit imposed by private economic interests. Regardless of whether the commodities be

licit or not, regardless also of the nature of the market, since the film notably treats capitalism as a war (Archangel de Jesus Montoya, the drug godfather, tuned into Bloomberg TV), with its exploitation of third world resources (here, Haiti, Paraguay and Uruguay), the pitiless elimination of competitors and its brutal and calculated violence. 'My intention was to characterize what a contemporary trafficking organization is like. In the post-modern world, what is trafficking? It's no longer one group of people in one location trafficking one product like cocaine. It's about networks that can move counterfeit pharmaceuticals, or pirated software out of

Miami Vice

China – you name it – all through the same extremely sophisticated channels.'[186] Impressive is the way in which the film draws the cartography of this world-flow, where we pass in a cut from one country to another, but also from the law to its reverse side, according to an intensive and vertiginous logic of permutation. The contemporary world as Mann describes it is characterized by the feeling of generalized communication, of an integral proximity of spaces and individuals permitted by an ultrasophisticated technological environment. A deceptive proximity because the solitude of beings (total in *Miami Vice*) amplifies as virtual exchanges develop. This *network thinking* is not new in Mann's cinema, but 10 years before *Blackhat*, it had never reached this point of coincidence with the world. Already in *Thief*, James Caan, independent burglar, knew how much his survival depended on his ability to act outside the mafia network of Chicago. Until he swallows his motto ('My money goes in my pocket') and agrees to make a pact, for this couple and the collage of his dreams, with the Faustian Leo. A fatal connection which ends in an immediate and devastating conflagration of the spaces he had been able to compartmentalize (the scores, his garage and his intimacy). Appearance of crooked cops, a house wiretapped and assault by home invaders. In *Heat*, the frontiers between outside and inside may well have trembled, but there remained the possibility of sheltering from the world. Friction between the public sphere and the private one was frequent, the impacts for both multiple, but precisely: the impacts suppose a crossing of and

186 Interview with Michael Mann, *The Daily Telegraph*, p. 64.

consequently the existence of limits that are still active. Besides, it was by organizing the alternation between one space and another, by exploiting this so Melvillean arrythmia, that the early Mann forged his style, characterized by long contemplative pauses inserted into hypercoded stories (crime fiction, adventure film, biopic, paranoid fiction, etc).

In *The Insider*, the power of the network went up a notch. Mann recorded the disappearance of the frontier separating the system (the tobacco manufacturers) and its counterpowers (CBS, in fact a simple link in a big global economic chain) and confronted an ageing journalist with an emerging reticular cartography in which he gradually lost his bearings. Where do you situate yourself when 'we're all in this together', to use again the CBS lawyer's reply in the middle of the film? Does there still exist a position outside the system? If not, how do you resist? With *Miami Vice*, this tension between outside and inside has been completely resolved to the advantage of a reticular world entirely beholden to the logic of networks and flows. Here, spaces of resistance are tiny, almost non-existent. Just Havana, a haven of peace, outside the flow and its exhausting actuality. A sublime sequence, 12 minutes of weightlessness, not one more, and already, for Sonny, it is time to return ashore (literally). The counter-space that Sonny and Isabella try to invent no longer holds. Back in the flow, it explodes. Only one possibility: to merge the two, abolish frontiers, bend to the rules of the network, like Ricardo and Trudy, lovers *and* work colleagues. *You don't need to go home.* And for good reason: in *Miami Vice*, the 'home' is no more. All that remains are an undifferentiated and homogenous zone, public and private, places without identity, history, or any relationship between them, be they derelict warehouses, sumptuous but soulless villas or abandoned houses.

The identity of the world and the network explains why what should have constituted, according to a classical approach to the genre (the undercover movie), of the principal things at stake in the film (How do you keep your false identity? How do you make people believe you are someone else?) is settled very quickly. In *Miami Vice*, identity, basically, is no longer an issue. What is the difference between being undercover and being up to your neck in it, Ricardo asks Sonny? The disconcerting ease with which the two cops assume the appearance of perfect traffickers says not only the indistinctness of the milieus, but also the absolute reversibility of positions. 'The fact that the priority is that of the network and not that of the individuals, implies the possibility of hiding in it, of disappearing in the intangible space of the Virtual,

and thus be trackable nowhere, which solves all the problems of identity, without counting the problems of alterity' (Jean Baudrillard, *Le Pacte de lucidité ou l'Intelligence du Mal*). A huge step forward is made here from *Heat* which, despite the resemblances between the cop Pacino and the gangster De Niro, safeguarded or kept intact a principle of alterity, a difference in nature vis-à-vis the law which prevented Mann from framing them together. *Heat* was a film on reflection, the mirror effect, the temptation of the other; *Miami Vice* is a film on confusion, indistinctiveness and the equivalence of opposites. The cop is no longer the inverted double of the trafficker, but his distant echo, his replica, even if at the end of the day ('So, fabricated identity and what's really up collapses into one frame. You ready for that on this one?' Ricardo asks his companion), Michael Mann opens slightly for one last time the door on to a world (*Heat*, a form of classicism, the law and its reverse side) on the brink of extinction. In *Miami Vice*, going undercover no longer constitutes a bending of the rules, but the general law of a globalized system which has resolved contradictions and amalgamated positions. In this indecipherable nebula deprived of limits, what you are, fundamentally (a cop, a crook), no longer matters. All that counts is the trace you leave in the system: back from Colombia where they have just completed their first mission as couriers for Jose Yero, Sonny and Ricardo pilot a plane full of drugs where they hide in the slipstream of an official plane. Two distinct signals then appear on the air control screen, two circles which overlap for a brief instant then merge. Two different planes, but for the radar, a single image. What is the difference between the law and its reverse side? None, 'Just a ghost,' says one of the controllers. Who cares about the differences when you end up with the same image, *the same simulacrum*. In *Miami Vice*, the image is not deduced from reality, but the opposite. It is through the image (parallel trajectories of two powerboats filmed at night) that Sonny and Ricardo identify Sal Maguda, the supplier who will enable them to enter the organization; it is also through it (two bodies entwined on a dance floor) that Montoya understands *truly* the relationship between Sonny and 'his Isabella'; it is finally it (the infrared image of Jose Yero's snipers and the leader of the Aryan Brotherhood hunted by lieutenant Castillo) which kicks off the final gunfight.

The conflict between classical and modern, which forms the spine of Mann's work, takes an unprecedented turn here. The question is no longer, as in *Manhunter* or *Heat*, one of evaluating what, between two

Miami Vice

worlds, is similar or different, since if the gap remains, it is negligible. From this point of view, classicism, with its big events (heists, gunfights, positions marked, etc), its simplification of stakes and its resolution of a given initial situation, is over: the leak from a government agency which launched the story will never be identified (it is the FBI, but who inside it?), the romance between Isabella and Sonny appears along the way and momentarily gains the upper hand, while at the end, Montoya vanishes into thin air. From modernity and the American cinema of the 1970s, *Miami Vice* has retained a problematic relationship to action, between deflation (how many sequences dispatched and how many denouements aborted?) and overheating. But also the feeling of a complex and unreadable world, upon which it has become impossible to act, except in a peripheral fashion (the liberation of Trudy from the claws of the Aryan Brotherhood, the elimination of the sidekick Yero…). The film is progressing (too) fast, but at a constant rhythm (that is to say the opposite of a classical temporality), as if nothing could race it or slow it down. Because of the network, the world of *Miami Vice* has lost its centre of gravity and seems condemned to a paradoxical movement: an illusion of speed (or rather haste), but an effect of standing still. *Heat* and *Collateral* were centred upon a dual relationship: two couples of characters (Al Pacino–Robert De Niro and Tom Cruise–Jamie Foxx) whose interweaving constituted the subject of the film, the point of equilibrium towards which it inexorably converged. Around what centre does *Miami Vice* turn despite everything? What is finally its anchor point?

Sonny and Isabella: the axis of desire

At the start of the film, in a villa that looks like an aquarium, a long discussion begins between the team from the Miami-Dade Police and Nicholas, a dealer linked to an international mafia. The aim: to put the two men in touch with members of the cartel and in particular one of them, Yero, considered at this stage of the investigation to be the keystone of a rather classical criminal pyramid, a vertically-functioning business which manufactures, produces and distributes its commodities. Standing near a bay window, Sonny leaves the conversation for a brief instant and turns towards the ocean. A moment of existential solitude characteristic of Mann's cinema (silence on the soundtrack, gaze lost in the horizon), which already points to the character's aspiration to extricate himself from the flow, *to reinvent a lost time*. Sonny is the desire

for an elsewhere, the perpetual will to disconnect from the world, as much mentally as physically, as shown by the escapade to Havana, a rapid and new trajectory on an ocean which seems untouched, and which arises perpendicular to a monotonous and deadly flow. After the ideal image of the American dream (*Thief*), the Fiji Islands (*Heat*) and the postcard of the Maldives (*Collateral*), Sonny in turn embodies the Mannian imaginary of a mental and geographical extension, a utopian elsewhere that the film will never actualize, but of which it will create the mirage, Havana, at the other end of the Gulf of Mexico. The two cops thus embody two divergent movements: Ricardo takes charge of the police fiction and ensures it is maintained, he is the man of stability (in love and professionally) and of the centre. Sonny, unpredictable and instinctive, carries within him a desire for rupture, deviation and *absenteeism*.

Ciudad del Este, at the frontier between Paraguay, Brazil and Argentina. The first test for Sonny and Ricardo, in the skin of veteran couriers. The trial of strength takes place in a dark warehouse, a classic space for the underworld and covert activities. Facing them, Jose Yero, Montoya's right-hand man and linchpin of the multinational. The confrontation between the three men dictates the cutting of the sequence (shots/ reverse shots and wide shots which underlines the presence of heavily armed guards), but the discussion turns nasty and risks meeting a dead end. Somewhere outside this little shadow theatre, an imperious and decisive voice then emerges off-camera, immediately relayed by a lateral camera movement which reveals the presence of a woman, already there, in the vicinity, but invisible up until then. Isabella's stage entry imposes a brutal displacement of the sequence, like a suddenly revealed centre of gravity which reminds us of the first appearance of the Huron Magua in *The Last of the Mohicans*. Thanks to a simple camera movement, Jose Yero passes from the status of boss to that of a cog in the machine, suddenly moved down the economic ladder of the multinational. Visibly, real power resides with this impeccably dressed woman. Like Sonny a few minutes earlier, Isabella stands apart, on the edge of the frame, and causes the movement of the shot towards its margins. From this point of view, the Havana sequence only concretizes what the filming has anticipated. Two identical desires to which correspond the same way of occupying the frame. The couple then takes a tangent in relation to a story that the film, for 12 minutes, leaves in suspense. Mann emphasizes for a long time their journey in a speedboat, from the coast of Florida

Sonny and Isabella: birth and end of a mirage (*Miami Vice*)

to that of Havana: time *un-winds*, distances widen space. Their escapade functions as an air pocket, an attempt at reconquering a space against the flow even if, as Olivier Mongin writes in *The Urban Condition*, 'places can only be the flip-side of the flows, make-believe, a simple existential haven, a cell destined to get its breath back, a retreat where the *vita activa* is banished'. An insular sequence. In reality, for modern and postmodern man, space if no longer a constraint or an obstacle for the accomplishment of a task. The development of means of transport has made it lose its primacy. From now on, *man struggles against a schedule*. Havana thus constituted for Sonny and Isabella less a utopia or an imaginary place, *off the map*, than a common heterotopia, in other words a geographically situated place. What Hartmut Rosa calls in his critical theory of modernity an 'oasis of deceleration'. Both then experience this slowing down as a factor of disembodiment and a way of reintroducing, against this myopic and perpetual present which characterizes the tempo of the flux, the passage of time. The future, the past, origins become again so many subjects for discussion which will then reinscribe their trajectories inside a long time. By disconnecting from the present (and from technology: there is not the slightest ring-tone), the film thus reconnects with history, with memories, and rediscovers something of the breath of Mann's previous opuses: Sonny recalls his trucker father, the Allman Brothers and the song *Free Bird* by Lynyrd Skynyrd, a magical moment which, as always in Mann's work, resembles the 1970s. As for Isabella, she reveals fragments of her childhood, speaks of her origins and shows Sonny a black and white photo of her mother taken a long time ago at a wedding. Mysterious, hieratic, this single woman who poses beside standard couples immediately serves as matrix or model for the character of Isabella, whose desire for independence is also accompanied by an existential solitude.

Fundamentally, it is only on the edges that you live truly, on the periphery of the world, *of this world*. The flow is technology, and technology is *also* death:[187] a literal equivalence posed via the explosion of the mobile home triggered by Yero's phone, and via all those phone calls bringing bad news which leads to death, from Alonzo's call at the start of the film to that from the Aryan Brotherhood which warns Sonny and Ricardo of Trudy being taken hostage. However, the Havana sequence ends on a deceptive exchange which again attaches the story

[187] A major achievement of the paranoid fictions of the 1970s: see the opening sequence of
Three Days of the Condor.

to that network thinking which haunts Mann's cinema. When Sonny inquires about their common future and askes Isabella what she plans to do *afterwards*, she brings him brutally back to the economic and political reality of a world which, basically, they have not left: 'What do you see around? Look around you. It's controlled by Archangel de Jesus Montoya.' No lasting escapade or elsewhere when the territory, whatever it is, covers the entire map.

How can man last in a world that is disembodied, so transparent yet fundamentally so opaque? The disappearance of the human, its dematerialization in an urban universe governed by technology, and therefore its capacity for resistance, constitutes one of the central themes of Mann's cinema and finds in *Miami Vice* (and *Blackhat*) one of its most successful extensions. Here, the only point of view capable of attenuating the flux is to be found in the Sonny-Isabella axis. When their eyes connect, the world immediately becomes peripheral, the flow lets go, becomes background noise. On the harbour of Barranquilla, in Colombia, the transfer of commodities fades into the background as soon as Isabella appears in the frame and looks for Sonny's eyes. In the same way, the final gunfight goes from foreground to background at the precise moment when Isabella discovers the badge (and identity) of Sonny. Without this woman, this man is nothing. Maybe all men. If he loses his anchor point, he falls (Alonzo's suicide, a return to the flux and to darkness for Sonny at the end of the film); if he retrieves it, he remains on the surface (Trudy comes out of the coma, Ricardo wakes up). But Isabella is not the only one to possess this power of aspiration and decentring. In *Miami Vice*, the women are those who possess the power to divert the story (the jealousy of Yero, who is secretly in love with Isabella), to calm it down (the love sequence between Ricardo and Trudy) or to hurry it up (Leonetta's death, Trudy being taken hostage). From the very first sequence, Mann makes the woman the pivot of all the twists and turns: silhouette of a dancer against the background of electronic images, Sonny's speed dating, deal between pimp and his client, and murder of the wife of an informer. The central tipping point of the film, its splitting, arises in a no man's land in the middle of which the two cops finally meet Archangel de Jesus Montoya. But Ricardo and Sonny do not see the sequence in the same way: the former concentrates on the drug baron, on his directives and the information he gives, while the latter only has eyes for Isabella and the relationship (two identical diamond watches) which, he believes links her *intimately* to Montoya. Ricardo

Miami Vice

remains riveted to the fiction of the genre, Sonny abandons it, sucked in by this iconic-looking woman. When she drives away and looks one last time through the window which she deliberately delays closing, Sonny can no longer take his eyes of her and finally finds the axis of his desire: the only luminous trace in the heart of this indecipherable night, a fascinating anchor point and a dazzling burst of light in a world that has become opaque, Isabella appears as the image of a possible elsewhere. But only the image, which is suggested by the frame within the frame (the rectangle formed by the window). Could Isabella be here the equivalent of Alice's rabbit, and the rectangular window the luminous rabbit hole down which Sonny is going to plunge?

In the last sequence of the film, Sonny leads Isabella to a house on the edge of the ocean, a deserted FBI safehouse where a boat awaits him. Of their story, there are now only two faces framed in close-up, turned towards a now-blocked horizon and a sad sky. 'This was too good to last,' says Sonny. 'A man named Frank is going to come in a boat. He will run you into Cayo Sotavento. And from there, you can find your way to Havana. Nobody will follow you. Including me.' Isabella sets sail, returning to her existential solitude, and looks to Sonny one last time. But the reverse shot does not come: Sonny, already in his car, drives away, and the optical axis they formed together breaks up brutally. It is time to return to the flow. To bend your back. The world rediscovers its equilibrium, but gradually loses its humanity.

There then returns to memory that reply by Sonny to Isabella: 'Probability is like gravity. You cannot negotiate with gravity.' In other words, you cannot do anything against the flow, if only to momentarily extricate yourself from it. You always end up rejoining it and dissolving in it (last shot of the film). Sonny: 'We have no future.' Here, no more sea algae to see sparkle for good (*Heat*), no more Maldives to breathe in with your eyes (*Collateral*), no more photographic dream to fulfil (*Thief*); in *Miami Vice*, the elsewhere is a lost cause. And melancholy is perhaps the only way to durably inhabit the world. It was scarcely the start of their story – Isabella and Sonny on the way to Havana – but it is already the end.

Advertising and death

Miami Vice opens on flashy images of a world of luxury where everything seems easy, *without gravity*, available, almost virtual, like a distant allusion to the opening credits of the television series of the same name. In front of a nightclub, we see a ballet of big cars from which get out women who look like fashion icons; inside, giant plasma screens, a crowd of silhouettes dancing, that is to say *Homo festivus* in all his splendour, that mediocre citizen of post history described by Philippe Muray in his book *After History*, the condensation of a hollow advertising world of which Mann is going to immediately reveal the morbid character. Sonny, Rico and their colleagues pretend to take part in the soiree, like ordinary clients, but they are on a mission. Their eyes soon concentrate on a man in a white suit, Neptune (Isaac de Bankolé), followed by the three women whom we spotted at the beginning. In reality, they are prostitutes. The client, who is an undercover agent, is worried about the behaviour of one of them towards the pimp and describes her as defective merchandise: 'What's with number three?' Nothing, 'She's sick, Man,' Neptune replies before sending the young woman a dark look which foreshadows a punishment. In a few minutes, the film thus shifts from a seductive universe to its seedy underside and reveals that violence which, in reality, underpins it. Just like the multinational of Archangel de Jesus Montoya which, behind the apparent respectability of its leader ('I extend my best wishes to your families,' he says to Sonny and Ricardo[188]) and its bank accounts opened in the four corners of the world, rewards, for doing his dirty work, a group of barbaric and dim-witted white trash, or the hacker in *Blackhat* who obtains the services of a mercenary from the Lebanese wars. Throughout the film, Mann never fails to articulate the superficiality of this world filled with proof of its human, economic and ecological cost – those unhealthy streets in Ciudad del Este, piled with garbage and

Advertising and its reverse side, the dump (*Miami Vice*)

188 In the unrated version, just after the meeting with Montoya, Tubbs phones Trudy to reassure her. She tells him she has just received some flowers.
189 We think of the character of the trader, Eric Packer, in the novel *Cosmopolis* by Don DeLillo, who crosses an apocalyptic New York overwhelmed with garbage.

plastic waste, that Montoya drives through in his blind limousine, as if it was a dumping ground among others for our hyperconsumer societies,[189] or those luxury villas, speedboats and sports cars that Mann contrasts with the derelict neighbourhoods of Haiti and the parks of filthy mobile homes situated outside Miami airport.

Anachronism and lost time

Born in 1943, Mann belongs to the second generation of the mavericks of American cinema of the 1970s – Martin Scorsese, Michael Cimino, Peter Fonda, Francis Ford Coppola, John Milius, Tobe Hooper, Paul Schrader and Brian De Palma. A generation with which Mann has probably shared the critical vision and totems, who has known the civil rights movements and the State scandals, the Vietnam war, the discredit cast on institutions and political activism including its most radical excesses. But while they reinvented, in part, American cinema during the 1970s, Mann was making rather confidential documentaries and wrote for television. It is only in 1980 that he directed his first film for cinema, at the precise moment when the Hollywood industry brutally closed the magical momentum of New Hollywood. *Thief* acknowledges, aesthetically and politically, this period of shock that seizes the opposition movements and force the movie brats of the previous decade if not to get back into line, at least to keep their heads down in the face of this America which is ready to do anything to regain its mythological and patriotic prestige. From this point of view, Michael Mann was from the outset an *anachronistic* filmmaker, who had come to cinema against the grain of his natural contemporaries. This delay, of historical and autobiographical origin, has become a diffuse but omnipresent haunting in his cinema, the matrix of an existential phase shift encoded everywhere, an idiosyncrasy common to most of his characters and, from his first film, a raw material inscribed in the screenplay.

For Frank, the burglar in *Thief*, the eleven years spent behind bars of Joliet signify an original delay to make up whatever it costs, which informs all his aspirations (to marry, have a child and fulfil his photographic collage as quickly as possible) at the same time as they echo, more intimately, Mann's trajectory and state of mind after a decade spent in Hollywood's backyard. This anachronism does not constitute just a typically Mannian 'being in the world' – this is almost the adventure of all his characters – or a way of looking at the contemporary while

always keeping a slight distance from the vantage point of a beacon that is anterior to it (the 1960s and 1970s), but also an ongoing process, the backlash from an untimely period which always outruns you. The tempo of *Miami Vice*. *To be is to always be late.* This is true of John Dillinger in *Public Enemies*, suddenly overtaken by a phenomenon of technological acceleration, of Lowell Bergman who becomes aware, in the course of *The Insider*, of how much the autocratic power of economic interests makes his conception of journalism old-fashioned, of Max in *Collateral*, prisoner of his own denial, or of Nathaniel in *The Last of the Mohicans*, custodian of a people and a vision that modernity will soon make obsolete. 'You're a glorified carder. A carder whose time is expired. Check your expiration date. Your shelf is over,' says the hacker of *Blackhat* to the young Nick Hathaway during their first phone conversation.

 In all of Mann's films, the present does not last; in reality, it does not exist, it is just an ephemeral mirage, elusive and silent like the clicking of fingers which announces the end, like the uncertain world which comes. Thus, if it is not already there, hidden in the lineaments of the story, the feeling of being late – regardless of whether it is imaginary or well-founded – is always close to the characters, like a spectre waiting to ambush and ready to provoke those changes of perspectives that Mann's films abound in. Only certain professionals (*Thief*, *Heat*, *Miami Vice*) believe it is possible to escape through action this curse of missing time, before understanding *in fine* that the lost time will never be made up. 'I don't know what I'm doing now,' Ned confesses to Eady (*Heat*), 'I know life is short. Every moment gained is a chance.' 'Time is luck.' To Vincent Hanna who asks him if he knows the meaning of the dream of drowning which nags at him, Neil replies with words that could apply to all the outlaws in Mann's films: 'Having enough time.' Even Lauren (Natalie Portman), the young daughter of Justine, panics at the idea of being late for the meeting with her father. Instead of being able to prolong the time available, the Mannian hero tries to increase its intensity, like Dillinger who, during his encounter with Billie, gets rid of the usual preliminaries so as to cut to the chase, or Frank who, in *Thief*, confesses to Jessie that he wants to experience *without waiting a second more* this love story that both of them desire. *Heat*: 'When you gonna get some furniture?' asks Chris, who has just spent the night in Neil's empty

[190] Vincent dies next to an advertising poster on which can be read: 'Life's too short for long names. Go Metro.'

apartment. 'When I get around to it.' 'Someday? Someday my dream will come? One night you'll wake up, and you'll discover it never happened. It's all turned around on you. It never will. Suddenly you are old. Didn't happen,' Vincent finally says to Max (*Collateral*) who, by procrastinating too much, risks missing Annie.[190] Even the tempo of Mann's films has accelerated since *Heat*, as if, in the light of his 60 years, his awareness of passing time had suddenly increased – from this point of view, we could say that *Public Enemies* is a hurried version of *Heat*, obsessed with the little time that remains: shorter shots, an almost ghostly soundtrack, a quickly-dispatched seduction sequence and the feeling of a world which goes so quickly that it becomes impossible to take a pause.

However, from this existential and biographical time gap, Mann has been able to draw new forms and a collection of questions which run throughout his oeuvre: how, when you have a head still full of the utopias of the 1960s, can you find your bearings within an era which has converted to liberal realism? What do you do after the orgy? What is the human, economic and intimate cost for those who try to adapt? Finally, how do you not give in to nostalgia, or to a form of chronic disillusionment, and remain open to beauty, seduction and especially comprehension of the world in front of your eyes? Michael Mann was 20 years old on the day of the assassination of JFK, 22 when Malcolm X was shot dead, 29 at the time of Watergate and 32 when the Vietnam war ended. The 1960s and 1970s belong *naturally* to his political and cultural DNA. It is in this particular period of the history of America that he forged his convictions, his tastes, and learned about the functioning of things. For him, as for most of the artists and intellectuals of his generation, the triumphant arrival of 1980s signified the death of a golden age which it would be necessary to learn to mourn. Or the romantic frontier. With the exception of *Ali*, of course, which takes the period face on, all Mann's films carry the traces or the memory of this prodigious time (the portrait of Malcolm X which hangs in Lowell Bergman's office in *The Insider*) and find, even implicitly, a way of dialoguing with. In *The Last of the Mohicans*, for example, Mann chose to give the roles of Chingachgook and Ongewasgone to Russell Means and Dennis Banks, both illustrious members of the American Indian Movement, as if to establish a link between the struggles of the Mohicans against the European settlers and those – the same? – of their descendants against the American government. Let us remember that Banks, who was one of the most active leaders and cofounder of

Russell Means, from the occupation of Wounded Knee (1973) to *The Last of the Mohicans*

the AIM branch in Minneapolis, took part in the occupation of Alcatraz prison in 1969, in that of Mount Rushmore in 1970, and three years later, in the siege of Wounded Knee, in the heart of an Indian reservation in South Dakota, in order to protest against the corruption of the Federal authorities responsible for the American Indian question.

The sequence takes place in a hotel bedroom in Louisville. Jeffrey Wigand, who still hesitates to testify against the tobacco industry, asks Lowell Bergman: 'How did a radical journalist from *Ramparts* magazine end up at CBS?' 'I still do the tough stories. *60 Minutes* reaches a lot of people'[191], replies Bergman. A former student of Herbert Marcuse, contemporary of a powerful political press, the journalist-producer of *The Insider* is undoubtedly the character biographically closest to Michael Mann, and his reply possesses, in this way, an obvious double meaning. In other words: 'How has a filmmaker originating in the 1970s and the milieux of the American left been able to navigate the studios and adapt to the totalitarian law of the market?' Is this capitulation or successful adaptation? Has there been fidelity or betrayal? This apparent contradiction pointed out by Jeffrey Wigand alludes to all those baby boomers who, in the course of the 1980s, turned the coat of their youth, and thus touches a raw nerve with his interlocutor. Bergman's reply, which is also the one that Mann could make himself, expresses two things: not only does he reassert his loyalty to the committed journalist he has been by producing a programme, *60 Minutes*, whose content accords with his convictions ('tough stories'), but he also says how much

[191] *Ramparts* was a satirical and political magazine published between 1962 and 1975, close to the American New Left.

the modalities of political commitment have changed. In his view, the effective opponents are today those who act *within* dominant and popular systems (the CBS machine, the Hollywood studios), that they use (hijack?) to the advantage of causes they believe to be just. One produces popular shows, the other directs personal films disguised as blockbusters, but both are insiders. Does the portrait of Cesar Chavez in Bergman's office not express, in his mind, a form of continuity between the civil and trade union struggles of the 1960s and 1970s and his work at CBS?

Blackhat: cartographical anxiety

'If I stop thinking about you, if I stop thinking about anything, it disappears. It vanishes. It ceases to exist.'
'It's my action that gave that code you wrote meaning.'
'What's it mean without bankroll?'

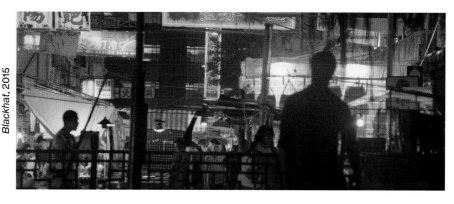

Blackhat, 2015

In the middle of *Heat*, Vincent Hanna gets into a police helicopter and flies over the grid of Los Angeles in search of his prey, Neil McCauley's car, reduced to a luminous point racing across a radar. To meet Neil, to finally face him, a moment of truth therefore, as if, to see more clearly and accurately, it was necessary to take to the skies, which, in Mann's work, means taking back control of the labyrinthine space of the modern mega-cities which, horizontally, are unreadable and indecipherable. In the same way as in *Collateral*, Michael Mann multiplies those aerial shots which will set a precedent where Los Angeles, framed from the sky and vertically, resembles a tangled web of rectilinear arteries with its luminous flows and blocks of buildings, that is to say a striking representation of

urban confinement which, seen from the ground or Max's taxi, resembles nevertheless an open space. In *Miami Vice*, we find the same series of shots called upon for a crucial sequence, when Lieutenant Castillo, from the Miami sky, tries to spot the mobile home where Trudy is imprisoned and literally serves as Sonny and Rico's eyes.

Seen from the sky, these tentacular urban networks produce a violent change of focus which expresses a geographical anxiety of which Los Angeles constitutes the emblematic city: 'Too sprawled out, disconnected,' Vincent admits during his first exchanges with Max (*Collateral*). Later, Vincent links this feeling of disorientation to a more existential anxiety: what are we? 'Nobody knows each other.' Unlike Max (the opening sequence), Vincent possesses neither the codes nor the keys which would allow him to find his bearings in the splintered and fragmented topography of Los Angeles. He is the victim and the contemporary expression of what Fredric Jameson calls 'postmodern hyperspace', that mutation of space which has managed to 'in transcending the capacities of the individual human body to locate itself, to organize its immediate surroundings perceptually, and cognitively to map its position in a mappable external world...'[192]

In Mann's work, the difficulty in navigating spatially, the absorption of anchor points by enormous agglomerations, the lost relationship to geographical totality and the feeling of confinement due to phenomena of technological and economic acceleration produce a feeling of cartographical anxiety which runs through all his oeuvre since *Heat* in 1995. This anxiety, linked to a global liberalism which affects all fields of modern societies, haunts *Public Enemies* as much as *Miami Vice* and makes of the world a closed, carceral, anxiety-inducing and immediately accessible space which feeds in some people a desire for an often oceanic elsewhere, a space *off the map* which might escape any form of network, a sort of new wilderness through which twenty-first-century man could reconnect with the founding mythology of American space.

Blackhat, which Mann directed in 2015, turns entirely around this cartographic anxiety, unfolds its mechanisms and consequences.

Everything begins in the air, and in silence, with a night view of Earth. From so high up, it resembles an icy gangue, veined with luminous filaments which draw, on its surface, an abstract diagram. That is to say

[192] Fredric Jameson, *Postmodernism, or, the Cultural Logic of Late Capitalism*, Duke University Press, 1991.

Opening sequence of *Blackhat*

a new image of the network and the grid pattern which adds to those, already multiple, which run through Mann's filmography. Then the camera approaches at top speed, penetrates the control centre of a Chinese nuclear power station and rushes to the heart of complex computer circuits right down to a tiny diode. Somewhere, a hand taps on a computer keyboard, the diode lights up and causes the surge of an army of pixels which are going to trigger the overheating of a turbine, then the explosion of a silo. A few minutes later, another cyberattack, with a similar *modus operandi*, provokes an extraordinary increase in the price of soybeans and throws the financial markets into a panic. Chen Dawai (Wang Leehom), a military expert in cyber-defence, convinces the Chinese and American authorities to cooperate, and release a gifted hacker, Nick Hathaway (Chris Hemsworth), so he can help them hunt a criminal they know nothing about, except that he uses a computer code co-written by Chen and Hathaway when they were students at MIT.[193] The idea for *Blackhat* came to Mann in 2011, after the Stuxnet affair – that computer virus created by the NSA, a year earlier, to disturb the Iranian nuclear programme by sabotaging the centrifuges of Natanz, that Tehran was then using to enrich its uranium. The question of technology – its evolution, its use and its impact on the economy and human societies – occupies an increasingly important place in Mann's cinema (*Miami Vice* and *Public Enemies*), to become the central subject of his twelfth film. Nevertheless, hacking, as a technique in itself, is of little interest to Mann, who sees it rather as the terminal manifestation of a spectral world that has become abstruse and transparent.

Scarcely released from prison, Hathaway joins up with Chen Dawai, Lien Chen (Tang Wei), his young sister, and a team from

[193] On 10 February 2016, Mann presented, at a retrospective of his work at the Brooklyn Academy of Music in New York, a new montage of *Blackhat*, a director's cut of 136 minutes which showed, with the cinema release version (133 minutes), some minor differences: certain dialogues had been shortened (the second part of the conversation between Hathaway and Chen Dawai in the helicopter no longer mentioned the happiness Lien felt in his relationship with Hathaway, the sequence of the prison in Canaan was reduced to the meeting with an FBI agent…), and Mann reintroduced a short sequence during which Hathaway, Barrett and Jessop shook off some pursuers by changing vehicles in the car park of a hotel in Hong Kong. The only notable modification concerned the shifting of the sequence of the explosion in the Chinese nuclear power station (which opened the first version) to the centre of the film. It seems that the studio was never satisfied with the original montage, considering that the most tragic event of the story arrived too early and that the flooding of the tin mines in Malaysia, which the rest of the film moved towards, lacked dramatic force.

the FBI (Viola Davis and Holt McCallany), and plunges into a mad, escapist adventure where you jump, with the help of one click, from Los Angeles to Hong Kong (China) and from Jakarta to the Perak Valley in Malaysia. The couple formed by the eyes of Hathaway and Lien Chen reminds us of the one uniting Sonny and Isabella in *Miami Vice*, but the story gives them no breathing space to flourish. What is at work in the film is situated elsewhere, in a fascinating and anxiety-inducing technology (pixels, programs, technical procedures and computer viruses) in the face of which humanity, in order not to become a ghost, must silence its doubts, its divisions, and move forward united. No time, then, for courtship or taking advantage of freedom – a few seconds of respite for Hathaway when he arrives on the Tarmac of the airport – no time either to familiarize yourself with each other's psychology. *Blackhat* thus accomplishes the *becoming trace* of the Mannian character as well as reaching the point of maximum sensory abstraction that Mann had aimed for since the 2000s. Which explains, in passing, how his films have been able to pass from expressive and embodied actors (James Caan, Daniel Day-Lewis, Al Pacino, Robert De Niro and even Tom Cruise) to receptacle-bodies without genuine stature, be they Colin Farrell, Johnny Depp or Chris Hemsworth. As if the actor, and his character, had to reflect the ever more vaporous form of the world and, himself, end up disintegrating in it – besides, 'Ghostman' is the pseudonym that Hathaway chooses for himself in his first virtual exchange with the cyberterrorist. This feeling of dissolution of individuals in a space that they cross without, however, inhabiting also affects their moments of intimacy: Mann thus films the love sequence between Hathaway and Lien *from the point of view of the absence of the characters to themselves*. To an atmospheric music by Atticus Rose, a series of shots-fragments, disconnected from one another, pass independently of any spatial and temporal continuity (shot of a pensive Hathaway curled up on the bed of a motel room, shot of the sleeping body of Lien, shot of Hathaway in his prison cell, shot of the two sitting next

Blackhat

to each other…), while in a voiceover, Hathaway reels off some snatches of autobiographical elements which seem to float around the couple: 'My dad was a steel worker… Single father… He raised us on his own… Came to visit… Twice… Then he got sick.' A mental and blue-tinted sequence where the time awake of one and the sleep of the other mixes, and then this sentence which Hathaway pronounces to the image – 'I used to replay memories so I could stay oriented for when I got out' – which immediately transforms into an inaudible rumour. What is this about? About memories which seem to no longer belong to those who have lived them, the unformulated sensation of a devitalization produced by the modern world, a memory, and therefore a singularity, hidden in the ever more distant layers of humanity. The sequence closes symbolically with a shot of those famous buildings constructed on the hills of Hong Kong, the emblematic and terrifying image of a mass urbanism and the terror of anonymity which infuses the entire film.

Detour via Asia

In line with *Miami Vice*, *Blackhat*'s tempo follows the speed of the flows and torrents of information (stock exchange values, accounting listings, lines of computer codes) and amplifies their dynamic. Never will space, and the notion of territory, have appeared so inconsequential, nebulous, so much do these men who travel across the surface of the globe seem condemned to perpetual movement, a sort of melancholy nomadism which affects their very identity. 'Sometimes I wake up in the morning and I don't even know who I am. Where I am. In what country. And you know me?' says the cyberterrorist to Hathaway. Because it strives to isolate certain details in the image (the curve of a neck, a hand brushing an arm, an undulating liquid surface or the fire of a street kitchen), the filming of *Blackhat* produces something immediately sensual. Mann prefers blurriness, the dissolution of the characters in urban backgrounds lit by sodium vapour, the ambient electronic music which comes and goes under the shots, and a camera often hand-held, in precarious suspension, which procures an effect of weightlessness and even of hypnotic undulation which, aesthetically, links *Blackhat* to a certain contemporary Asian cinema – *Millennium Mambo* and its opening sequence is the example which comes immediately to mind. Released in 2001, Hou Hsiao-hsien's film is undoubtedly

Thief

Collateral

Blackhat

Blackhat

Blackhat

Manhunter

Tapei Story

Taipei Story, Edward Yang, 1985

Millennium Mambo, Hou Hsiao-hsien, 2001

L'Éclisse, Michelangelo Antonioni, 1963

Taipei Story

Taipei Story

a masterpiece of virtual, muffled, *de-realized* cinema, perfectly fitting the volatility of the modern world. Besides, the sole scene of *Millennium Mambo* filmed in the United States takes place in a seedy motel, as if America now belonged to the Old World. Concerned to follow the curve of an ever more globalized time, Mann understood, no doubt after *Collateral*, that he had to widen geographically his field of action to Latin America (*Miami Vice*) then Asia (*Blackhat*).[194] The Asian tropism of Michael Mann, noticeable from the beginning of the 2000s to *Tokyo Vice* (2022), can undoubtedly be explained by his desire to turn towards the cinema the best connected to the contemporary, as much from an aesthetic point of view as an existential one, be it the films of Hou Hsiao-hsien, Wong Kar-wai, Tsui Hark – the ghost of *Time and Tide*, directed in 2000 and filmed in Hong Kong (China), uncontestably haunts *Blackhat* – or, more recently, Jia Zhang-ke (*Platform*, *Unknown Pleasures*, *The World*). But it is with the cinema of Edward Yang that Mann's films have the closest relations, in the manner of a possible Asian genealogy of his oeuvre.

In the course of the 1980s, Yang, who belongs to the same generation as Mann, directed films (*That Day on the Beach*, *The Terrorizers* and *Taipei Story*) which anticipated the majority of the issues that we would find, a few years later, in *Heat*, *Collateral* and *Miami Vice*: the spread of the capitalist model and its acceleration, the power of consumer society and its impact in the social field or the difficulty in finding your bearings in a constantly changing urban fabric. The one in Los Angeles and the other from Taipei are subtle observers of the end of the political utopias of the 1960s and 1970s, and of a dazzling mutation of society which, because it was not accompanied, produced a loss of meaning and a dislocation in human relations, even if for Michael Mann, the alienation produced by globalization and economic liberalism brought with it a form of seduction, and therefore of fascination, which was absent from Yang's cinema. Finally, both had, in order to describe this

[194] Michael Mann's desire to film in Asia oriented, according to him, a large part of the screenplay of *Blackhat*.

[195] In a lecture on Michelangelo Antonioni, Dominique Pain made the hypothesis that the oeuvre of the filmmaker from Ferrrare traced a trajectory which, by passing directly from classicism to the contemporary, might have jumped the stage of modernity. To deconstruction (of form, of the story) he opposed distortion; in the face of the radical break preached by the European new waves, he inscribed himself in a form of continuity. Rather than putting the world into pieces or making of it a tabula rasa, he chose to dislocate it (the finale of *The Eclipse* and its out of tune spaces).

evolution, integrated the same form of European 'modernity'[195] via the films of Michelangelo Antonioni, an influence acknowledged by Yang and underground in Mann's work: a same attention given to empty and abstract spaces as theatres for an internal vacuity, to places of modern nomadism (airports, transit stations, highway intersections, international hotels…), to industrial decomposition and flux-cities, to characters deprived of existential anchoring, to the difficulty of ancient feelings in surviving the transformations of society, but also the natural landscapes which, in the films of Antonioni like in those of Mann, constitute places of absolute detachment from the world at the same time as they dig out of the 'here and now' a diffuse absence. And then the death of time, that one filmed from the point of view of its *mineralization* and the other from the point of view of its compression and *acceleration*. Is it by chance that, in *Blackhat*, just before a cyberattack on the soy futures, a shot of the deserted Chicago stock exchange recalls that of the Rome stock exchange after a market collapse in *The Eclipse?*

Los Angeles is like Taipei, Lung roughly says, the main character of *Taipei Story*, after a trip to the United States. To see again *The Terrorizers* and *Taipei Story*, which Edward Yang directed in 1985, is to notice how much some of the motifs of the filmmaker were able to migrate towards Mann's films and vice versa – the way of isolating bodies in an urban space, the attention given to contemporary architecture and its deceptive transparency or the state of existential vacancy of the characters. The first scene between Al Pacino and Diane Venora in *Heat*, which underlines the difficulty the couple has in occupying the same frame, and therefore in communicating, echoes the opening sequence of *Taipei Story* with its two lovers separated by the walls of an empty apartment. At the end of the film, Lung dies from a stab wound, following a fight in a city park. The camera lingers for a long time on a spot of blood which

L'Éclisse,
M. Antonioni

spreads on the asphalt, thus reducing the death of the character to an anonymous trace absorbed by the flow of modernity. This visual idea is found again, almost identically, at the start of *Miami Vice*, when, after Alonzo's suicide under the wheels of a truck, Mann concentrates on the scarlet trail left by the informer's crushed body.

Volatility of critical space

With *Blackhat*, Mann seeks more to reflect a state of the world, to grasp its abstract beauty and enigma, the right noise, than to follow the path of a crime story, here reduced to its simplest and most coded bare bones, which calls in most of the big Mannian motifs. The first time Hathaway appears, in his prison in Canaan, Pennsylvania, he is reading a book by Michel Foucault, *Discipline and Punish*. On a small shelf, other books appear, like Jean Baudrillard's *The System of Objects*, Jean-Francois Lyotard's *The Postmodern Condition* and *The Animal That Therefore I Am*, a collection of lectures by Jacques Derrida published posthumously in 2006. At first sight, these references signify a sort of almost over-obvious ideological *coming out*, via which Mann might situate *intellectually Blackhat*, and all his work, in the wake of the French Theory of the 1970s and 1980s. The temptation is then great to take these clues for a series of keys indispensable for deciphering his film, like the Wachowski brothers, at the beginning of *The Matrix*, choosing *Simulacra and Simulation* as the great decoder of their virtual wonderland. This, always impoverished, way of seeking in films illustrations or classic examples of philosophical theses, and of placing in front of each other contents of which we verify, *in fine*, the coincidence, is of little interest for Mann, who here points rather to a possible archaeology of an idea which he tries to explore, *through cinema*, about the contemporary world. From then on, the film does not invite us to stick the analysis of the modern prison system of the early 1970s by Foucault onto that of an American prison in 2015, nor to make of Nick Hathaway a cultivated prisoner interrupted in the middle of a *meta training*, but to extend and experience its actuality.

Hathaway and his team of investigators follow blindly clues disconnected from any overall vision (What is the identity of the man they are pursuing? What does he want? In what aim? Why?), like a myopic hunt which, in order to find a hypothetical source, clings to snippets of sentences and signs to decipher: a bit of computer code, a file buried inside a damaged

Blackhat

hard drive, a receptor hidden in a thicket, or the images of a surveillance camera shown in the emptiness of a back room. In the first part of the film, the story thus turns around an elusive and unplaceable centre (Asia? Europe? America?) which is going to turn out to be deceptive or even pitiful.[196] For, with the exception of Elias Kassar, an old school mercenary who sells his services to the biggest bidder, the men they pursue resemble ectoplasms: in *Miami Vice*, a USB stick was passed from hand to hand in the streets of Jakarta, but ended its trajectory in those of a delimited first figure of crime, Jose Yero. Here, the criminal is reduced, during the first part of the film, to a trembling hand tapping nervously on a computer keyboard, some hair glimpsed in an indeterminate place. This big shot of the waters who wants to drown a valley in Malaysia in order to increase the price of tin constitutes a fragmented and tentacular figure of modern capitalism, a sort of Noah Cross 2.0[197] who embodies perfectly the volatility of this world of which Mann seeks to take the pulse since the middle of the 2000s. When he finally appears, Sadak (Yorickk Van Wageningen) has almost the effect of a burst balloon, being an ordinary man who could be another, here or elsewhere. The cyberterrorist of *Blackhat* is, in reality, just a metaphor, or the pathological symptom, of the virtuality of contemporary capitalism which uses the speculation, the manipulation of the financial markets and deregulation as a lethal weapon, and transforms the physical world into a play area whose fate leaves it indifferent – echoing the supremacists of *Miami Vice*, Elias Kassar and his gang of armed men do its dirty work.

The internet appears here as the modern version, with a power increased tenfold, of the videoscopic space of which Mann, in *Manhunter*, had made the critique. Since the 1980s, technology has evolved, but it is still a question of the same struggle against physical space, its frontiers, stability and laws. 'It's almost like there's an invisible kind of

[196] It is perhaps necessary, in the aftermath of 9/11, to grasp the allusion made, in the film, to the attacks on the World Trade Center. Does the hunt for the cyberterrorist in *Blackhat*, a big shot who is finally disappointing, echo that for Bin Laden who, as is shown at the very end of *Zero Dark Thirty* by Kathryn Bigelow, has created an existential void, as if his death had not (could not have) lived up to the fantasy he had fed?

[197] Let us remember that William Mulholland (who inspired the character of Noah Cross in *Chinatown* by Roman Polanski) is an engineer who, at the beginning of the twentieth century, built the first aqueduct in Los Angeles and diverted the water of the Owens Valley in order to irrigate what was then just desert. Does the cybercriminal of *Blackhat* replay in Malaysia one of the scandals of the foundation of the City of Angels?

exoskeleton above the layer in which we think our lives take place on planet Earth, that's made up of interconnectedness and data,' explained Mann at the time of the film's release. 'We're swimming around in it, and everything is totally porous, vulnerable and accessible. And if it hasn't been targeted, that's only because somebody hasn't bothered to yet.'[198] This critical space functions as the factory for an invisible new order, the digital world, which comes to double, cover over and sometimes direct the ancient and classical order of physical architecture: 'Today, it is even more than probable that most of what we persist in calling urbanism is composed/decomposed by these systems of transfer, transit and transmission, these networks of transport and transmigration whose immaterial configuration renews that of cadastral organization,'[199] Paul Virilio already wrote in *Critical Space*. Here too, power disappears behind a new prison architecture, an interweaving of various networks and communications systems, capable of watching and constraining without authority (capital, those in power) needing to show itself in flesh and blood. As if, following a completely Baudrillardian irony, the prison which opens the film served to mask that the whole world that has become a prison. Cyberspace as modern panopticon.[200]

　　　　One of Mann's aesthetic challenges consisted of treating this abstract, and by nature invisible, universe by escaping from the visual poverty of all those blockbusters of the 1990s which tried to put cyberspace into images (from *Johnny Mnemonic* to *The Lawnmower Man*). A figurative problem which he gets rid of via an astonishing opening sequence. The direction of *Blackhat* revolves, rather, around the principle of contamination of real space by its digital double and their interpenetration. Right from their arrival in Hong Kong, Hathaway, Chen and their team make contact with the local police. The latter are watching the movements of the three suspects, linked to their investigation, without managing to establish the proof of physical contact between them. Hathaway seizes the computer and notices that their trajectories coincide at a point situated in the district of Yau Ma Tei. On arriving there, they discover another police unit, undercover for a different case. It is the first appearance of Elias Kassar, in the form

[198]　www.nytimes.com/2014/12/28/movies/michael-mann-prepares-his-new-film-blackhat.html.

[199]　Paul Virilio, *L'espace critique*, Christian Bourgeois, 1984, p. 24.

[200]　'You continue to live as if you were still in prison,' Lien reproaches Nick. In fact, Nick passes from a real prison to a symbolic one, and the film develops the feeling of a world that is open but in reality enframed.

of a video image recorded by surveillance cameras. Sitting on a bench every morning, the man meets no one. He does nothing. He just sends texts, then leaves. Hathaway then borrows a policeman's phone and, while walking in the middle of the square, analyses the spectrum of Wi-Fi signals. He discovers, buried near a tree, a Bluetooth transmitter whose data now must be decrypted. Later, the FBI and the Hong Kong police fly to the district of Shek O to proceed with the arrest of Kassar. The man has disappeared but they spot, in an apparently ordinary apartment, a trapdoor which opens onto a spiralled underground passage, a sort of mined bunker through which Kassar and his men have fled. Finally, after analysing the accounts of Sadak, Lien notices that the man spends big sums to obtain satellite photos of the coasts of Malaysia. However, 'What's there?' asks Hathaway. 'Nothing much,' replies Lien. 'Why did he scan there?' Why localize a place where, apparently, there is nothing? Once there, in the Perak Valley, Hathaway and Lien discover a tin mine and, on the surface of this lunar landscape, another trapdoor which hides a vast underground complex filled with water pumps, the same used by the Chai Wan power plant and which were the targets of the first attack. Each time, the visible masks the existence of a hidden space, a secret cartography which doubles the real world. Emptiness hides fullness and the surface of things is just a mute tapestry filled with signs to decode. The square in Yau Ma Tei is, in reality, a place of intense exchanges between criminals, like the Perak Valley is not just that bed of stones visible on the photographs, but a space already occupied and mapped out. In *Blackhat*, the electronic systematically precedes the discovery of the world, *the virtual pre-exists the real* and becomes its condition of access. *What you see with your naked eye is not what is*. The film thus multiplies the rhyme effects between the tangible world and an imagery originating in the digital universe, like so many physical manifestations of an invisible order. The underground ramp that Kassar takes in order to escape from the police opens out onto the harbour of Repulse Bay. Just before the gunfight, Kassar's men take up position beside monoliths of concrete which resemble computer components rising up to the sky, like elements from cyberspace (here, a memory stick or hard drive slots) contaminating real space.

The technical competence of Hathaway resides in his ability to move from what hackers call the kinetic world – that is to say the physical world in which their operations must succeed – to cyberspace, that virtual exoskeleton which dictates its workings. Hence the close link

between the pirate of *Blackhat* and the profiler of *Manhunter*, since for both of them it is about connecting with the mind of the adversary and more widely, understanding the cartography of your virtual reality – cyberspace for Sadak, deadly fantasies for Dolarhyde. 'That's what you're doing, isn't it, son of a bitch,' says Hathaway, echoing a similar reply from Will Graham, at the moment when he understands Sadak's intention to flood the Perak Valley, its villages and inhabitants. The first phone conversation between the two men marks the tipping point of the story, since Sadak makes the old error of wanting to meet Hathaway and face him physically. Now, Sadak draws his power from not being visible and only acting by proxy, via Kassar, his armed wing in the real world and the computer tools at his disposal – from the Remote Access Tool, a software which allows him to remotely take control of a computer, to the panoptical system he directs. His strength resides in his virtuality. In this interconnected world, of which he is a malignant incarnation, Sadak shows a fantastic ubiquity, against physical space, whose constraints he does not know, and against classical geographical continuity, that he can break with a finger (a click here, an explosion there). His virtuoso use of digital space contrasts with the various burdens which hinder his pursuers, all forced, in order to circulate effectively, to settle problems of passports, authorization, extradition and frontier.[201] Thus, by descending into the physical world, to meet Hathaway, Sadak is a king who takes off his clothes. In the last part of the film, Hathaway inverts, to his advantage, the surveillance system – in an abandoned building in Jakarta where he has arranged to meet, Sadak finds himself, for the first time, caught in the gaze of his adversary. The final confrontation between the two men takes place in Papua Square, in Jakarta, in the middle of a traditional Balinese ceremony.[202] From a figurative point of view, this sequence consists of a reprise, but in the real world, of the opening sequence – exogenic elements (Hathaway, Sadak and his men/electronic particles who propagate in a network) come and disturb an ordered

[201] Let us note that if the cyberterrorist in *Blackhat* moves freely, the inhabitants of the Perak Valley, who are peasants and/or workers, have neither the financial means nor the technological ones to leave their territory. *Blackhat*, like *Miami Vice*, thus makes us see a *technological class struggle.*

[202] It is the Balinese ceremony of Nyepi, known as 'the Day of Silence'. The most important sacred festival of the year, it celebrates the New Year and the passage from animism to hinduism.

arrangement (the crowd of participants/the depths of a computer system). But here, it is Hathaway and Sadak who take the place of the virus.

Technique and spirituality

> 'To a dull mind all of nature is leaden. To the illumined mind the whole world burns and sparkles with light.'
> Ralph Waldo Emerson

In his introduction to the new edition of *Postmodernism*, initially published in 1984, year of the creation of *Miami Vice*, Fredric Jameson asks himself: 'Utopian representations experienced an extraordinary revival in the 1960s; if postmodernism is a substitute for the 1960s and a compensation for their political failure, then the question of utopia will undoubtedly be a crucial test of what remains of our capacity to imagine change.'[203] In the 1970s, the filmmakers of Michael Mann's generation produced, for the most part, virulently critical films about the consumer society and the political conservatism of the time (the current of dystopian fables, for example), but they also carried in them the belief, however tiny, in a real possibility of transforming the world. In 1980, Mann the filmmaker found himself the contemporary of what Mark Fisher has called 'capitalist realism', that is to say that 'the widespread sense that not only is capitalism the only viable political and economic system, but also that it is now impossible even to imagine a coherent alternative to it.'[204] In the last shot of *The Insider*, Lowell Bergman, who has lived through this political history in fast forward, not only leaves CBS, but seems to cut himself off from the world. What do you do when the catastrophe has already taken place and everything seems fixed once and for all? How do you dream when beliefs have collapsed 'all that is left is the consumer-spectator, trudging through the ruins and the relics'?[205] How do you survive in a world which has nothing left of the map, except as *hollow men*? In the shabby mobile home where the white supremacists have imprisoned Trudy (*Miami Vice*), a small television, that no one watches, is continually on. The atmosphere is oppressive, looks are stupefied and/or drugged, while an advertisement boasts of

[203] Fredric Jameson, *Postmodernism, or, the Cultural Logic of Late Capitalism*, Duke University Press, 1991.

[204] Mark Fisher, *Capitalist Realism: Is There No Alternative?*, *op. cit.*

[205] *Ibid.*

the merits of domestic comfort at the same time as it expresses one of the faces of the Mannian nightmare. 'What can we do to make our backyard a paradise? A vacation destination you can visit anytime, without the hassle of air travel, or even starting the car?' asks an advertisement that appears on a television behind Trudy.

The disappearance of utopias, the entire covering of the territory by the map and the colonization of imaginaries by consumer society have produced a metaphysical anguish which runs through all of Michael Mann's cinema. From this point of view, his quest for transcendence is the only antidote remaining in the face of a political state of the world which all his films have critiqued. If, for his characters, the vital program is situated, de facto, on the side of capitalist realism, the existential program works to create the possibility of a missing elsewhere, to reintroduce *spirituality* within a civilization ossified by materialism. What is often called in Mann's work, in a hasty manner, stylization, and even more his tendency towards abstraction, fully explodes at the time of *Heat* and consists firstly of a way of purifying the framework, to remove from it unnecessary elements, and completely *mastering* its content. By composing his shots from precise elements and by sometimes isolating certain details (the form of a car bodywork, an architectural detail, a luminous trace, a particular texture), Mann reinforces their presence on the screen and therefore the attention we pay to them, as if seeking to bring out from them a hidden virtuality. It is why this aesthetic asceticism is *also* part of a form of spirituality. And occasionally of fetishism, in so far as the way he looks at inanimate objects or machines renews the way he looks at the modern world. As the invisible man in the eponymous novel by Ralph Ellison reminds us in the prologue: 'I am invisible, understand, simply because people refuse to see me.' The incomparable elegance of Michael Mann's directing also comes from his way of filming, like others surf. Always in search of a state of weightlessness which seeks *to rise above* the exhausting flow of modernity, even if only for a few seconds – for example, in *Collateral*, the aerial shots filmed vertically above the streets of Los Angeles introduce a higher point of view on the action which transmits the enchanting power of the city as well as immediately poeticizing the trajectory of the two men.[206]

[206] Anecdotally, let us signal here that Michael Mann took care to scout locations for *Blackhat* from a helicopter and chose its places and its settings from an overhead point of view.

How can we find again the trace of the secret, of the oneiric, of utopia precisely, in a world obsessed with transparency, total openness and efficiency? Does there still exist a place for the experience of the sublime when everything seems won over by ugliness and/or mediocrity? Olivier Assayas rightly says: 'He [Mann] is, like the great filmmakers of the 1960s, Antonioni, Tati, in a simultaneous relationship of fascination and terror to the modern world. He wants to look in the most beautiful way at the highway intersections, the glass high-rises, the various urbanistic upheavals, and at the same time that petrifies him. It is magnificent, but it is the world of the dead.'[207] But that world is not only what it is, in the sense that you cannot accept it, Mann's films seem to say. It is occasionally enough to imperceptibly change focus, to raise your eyes to a tumultuous sky or reinvent a bit of lost time *against* a spirit of the times obsessed with speed for emotions you thought lost to reappear. *Blackhat*: the nighttime sequence takes place under a flyover in Quarry Bay, Hong Kong. The booby-trapped car in which Chen was driving has just exploded in front of the eyes of his sister and Hathaway. A gunfight follows with Kassar's men and two FBI agents who come racing to the scene. Scarcely out of her car, Carol Barrett receives a hail of bullets. Shot in the heart, she collapses. A few seconds later, the exchange of gunfire ceases, the bodies of the two agents lie on the ground. The place is now deserted, enveloped in a deathly silence. Mann then chooses to concentrate on Barrett's face, framed twice in close-up (sideways then front on), and especially to show us what she sees just before dying. The idea is magnificent: in a reverse shot then appears the upper part of a glass high-rise which goes up into a blue-tinted and vaporous night. A slight fade to black indicates to us that this is her last vision, the ultimate image seen by her wide-open eyes. Earlier, Barrett confided to her FBI colleague that she had lost her husband in one of the towers of the World Trade Center. This biographical detail here returns in the image and confers on it an unexpected depth, as if, via another glass tower, she was going to rejoin her deceased other half. Here is the last look of this woman which confers on the high-rise – of which so many exist in Hong Kong and the modern mega-cities – an almost religious, iconic aura, in the same way that at the beginning of *Thief*, Lake Michigan, *in the eyes* of Frank and his fisherman friend, took on a magical force. For

[207] Jean-Marc Lalanne, 'Olivier Assayas sur Collateral de Michael Mann', *Les Inrockuptibles*, 29 September 2004.

Blackhat

Mann, the modern world, once stripped of its superficial and garish strata, reveals itself to be filled with totems, ineffable forces, manifestations of the spiritual, and the directing – be it a look in particular, a way of placing the camera or of making a shot last – becomes a tool of revelation, in the mystical sense of the term, of its sacred dimension. Terror, perhaps, but also fascination with the contemporary, its objects, its architecture, its materials, its machines and its artificial lights. In Mann's films, these flashes of grace touch as much the fuselage of a plane cleaving a cloudy sky as the curve of a gleaming sports car setting off at top speed on a highway at night (*Miami Vice*), the movement of a palm tree bending beneath an orange sky (*Collateral*) as the sparkling grid of Los Angeles (*Heat*). These are perhaps mirages, but real mirages, since they bear witness to an invisible side of the world – a *hinterland*, to borrow Nietzsche's concept – of which cinema must prepare the epiphany. In the great tradition of American transcendentalism, but shorn of its Christian perspective, Mann's films console their characters for the *immanent* and pale reality in which they are plunged (late capitalism) by sublimating as much the grandiose (nature) as the ordinary – what we have under our eyes but do not see.

'When I observe the kind of cloudy skies you see in the Caribbean in summer, there is something so spectacular, exhilarating, that stimulates me and makes me want to transcribe the transcendental wonder that it produces to be alive and to witness such a spectacle', declared Mann in 2017. 'I react in this way, and I therefore immerse my characters and my spectators in the heart of this context.'[208] Ever since *Thief*, Mann has endlessly sought means of reproducing on the screen this wonderment, and it is the arrival, at the end of the 1990s, of high-definition video, of which he would become one of the precursors, which opened wide to him a field of aesthetic possibilities. In 2001, during the shooting of *Ali*, he discovered new digital cameras, easier to handle than 35mm ones, but especially much more sensitive to light. If most of the movie is shot on film, the immersive shots of the fight sequences and the panoramic shot around Ali who discovers, from the roof of a building, the nighttime unrest of Los Angeles at the moment of the riots in the black ghettos in 1968, are shot with this type of

[208] Interview with Julien Gester, *Libération*, op. cit.

camera. The result, which attains a form of hallucinatory ultrarealism, convinces Mann to continue along this path, as if he held there the technical tool which would allow him to reveal, in the photographic sense of the term, the mystical power of the contemporary. In 2004, *Collateral* was the first Hollywood film to be shot essentially in high-definition video and thus marked an important stage in the technical history of cinema. Mann continued to experiment with new cameras[209] and renewed completely the cinematographic vision of Los Angeles, starting with that famous apricot colour so characteristic of the city's atmosphere. The extraordinary density of the night, the diversity of the textures of the image and the coyotes' sequence (unthinkable on film without artificial lighting) are part of a constant visual delight. For example, the neighbourhood of Long Beach, south of Los Angeles, is no longer that dull zone for the petrochemical industry which we glimpsed in William Friedkin's *To Live and Die in L.A.*, but transforms into an entanglement of modern and multi-coloured cathedrals, topped by huge smoking chimneys thrusting into the sky. While some filmmakers have been dead against the digital image and have chosen to assert even more strongly their attachment to the film support – the 70mm syndrome brought up to date by Paul Thomas Anderson in *The Master* or by Quentin Tarantino in *The Hateful Eight* – Mann has, on the contrary, chosen to explore these technological developments thanks to which he has been able to invent a new feeling of the world and renew his first period style which, in 1995, had reached its zenith.

'Show yourselves, oh desired storms!' Mann could have said, paraphrasing Chateaubriand, when he started, in 2006, to shoot *Miami Vice*, so much do the blazing skies of Florida, captured in high definition by his director of photography Dion Beebe, seem to appear for the first time in cinema. *Miami Vice* then offers an unprecedented sensory experience. The grain of the image, the increased sensitivity to light which reveals, in the obscurest zones of the shots, an infinite variety of tones, those flashes of lightning which streak the Miami sky and confer on it an evocative power close to pictural romanticism, or that dense and incandescent night which permeates everything, gives the feeling of a sensualist, almost oneiric, film where man, nature and the urban environments stir with the same breath. Steven Rybin notes how much the great depth of

209 Thomson's Viper FilmStream and Sony's CineAlta.

Blackhat

Collateral

Collateral

Miami Vice

Miami Vice

field in some shots of *Miami Vice* 'make the world simply overwhelming, like an experience too strong to be felt in a single viewing of the film'. We find the same exacerbated cosmic feeling in *Collateral*, *Public Enemies* and *Blackhat*, a sort of *oversoul* which, in spite of the sadness of capitalism, the end of the frontier and its privatization, might continue to float in the ruins of our postmodernity and link the contemporary man to something greater than him. This is undoubtedly a diffuse and atheistic mysticism, halfway between a Christianity emancipated from institutions and a form of pantheism, which here reactivates a key element of the American unconscious. For this conviction that the sacred dwells everywhere and for all time, including in urban, technological or post-industrial environments, reconnects Mann's cinema with an Emersonian tradition. In *Heat*, Neil McCauley compares the glittering grid formed by the arteries of Los Angeles at night to the gleaming seaweed of the Fiji Islands, and the last shot of the film transforms the L.A. airport into a mythological place, out of time, which, to the music of Moby (*God Moving Over the Face of the Waters*), raises the destiny of Neil and Vincent to the level of the tragic sublime. Mann films in the same way the celestial vault that Nathaniel and Cora contemplate in *The Last of the Mohicans*, and the immense sky overhanging Hong Kong Bay and its myriad artificial lights in *Blackhat*. Two stellar monuments in which are then reunited all souls (the original great soul?), that of the Camerons after their massacre by the Hurons like that of Chen Dawai, killed in the explosion of his car.

In 2007, Mann directed for Nike an advertisement ('Leave nothing') which wove together the opposite trajectories of two NFL players, Steven Jackson and Shawne Merriman, on a football field. Photographed by Dante Spinotti, this one-minute film celebrates the pugnacity of these two sporting professionals who, whatever the weather and the strength of their opponents, pierce this hostile milieu in the same way as Nathaniel's arrow flies through the wilderness. The re-use of the theme song of *The Last of the Mohicans – Promontory* – reinforces the analogy between Cooper's hero and the two sportsmen. Above all, it wants to revive the mythological dimension of the wilderness at the very heart of a limited and civilized space which, *a priori*, constitutes its negation – a sports field, with which a majority of Americans have a quasi-religious relationship. The overlay of an industrial image and the idea on which was founded all of North American society can then be understood in two ways: either as the postmodern reactivation of an idea that has become a simple sign caught up in the advertising becoming

of all that is no more, or as the desire to reconnect the contemporary to an immemorial origin and to *transcend* it.

We remember the two coyotes in *Collateral*, two little bits of wilderness appearing in the heart of Los Angeles and provoking a sort of poetic short-circuit between modernity (of which the City of Angels is one of the paragons) and a wild power originating in a territory situated outside of civilization but in reality very close. *Blackhat* is, with *Miami Vice*, the film in which Michael Mann has confronted most evidently the extreme of the contemporary (hacking, the Dark Web, the virtual universe) with manifestations of archaism, be they Hathaway and Lien's car transversing the middle of a Malaysian valley scattered with rocky structures which seem to be there since the dawn of mankind, or the Balinese ancestral festival during which takes place the final fight. Granted, modern man no longer lives on the frontier, surrounded by imaginary beasts and sacred forests, but, in the midst of the highways, high-rises and neon lights, he continues to be at the heart of a Great Whole. For Mann, the visible world, whatever it may be, remains underpinned by an array of spiritual bonds that are always to be revealed.

Like Antonioni, Mann is convinced that a film must communicate through colour, landscapes and objects. He also knows how much the metamorphosis of appearances informs us about the world as much as, even more accurately, than political and/or ideological enterprises. He is a seer who perceives what is being born and captures at the surface of the contemporary the signs of profound mutations which he, moreover, can intuit. Mann thus uses digital technology as a revealer of new forms – and therefore of new political arrangements, to borrow Brecht's famous parallel. He approaches contemporary reality as if it were an aesthetic and metaphysical enigma and seeks by all filmic means possible to 'divert the mind from one level of consciousness to another, in other words […] to lead it from common, everyday experience […] towards a level where the givens of the perceptible world will now manifest themselves with so much force that the essential music can only declare itself there'.[210]

[210] Yves Bonnefoy, *La Stratégie de l'énigme*, Galilée, 2006, p. 34.

The oceanic shot or the littoralist drive

'In the final scene of *The Last of the Mohicans*, we gaze out into the wilderness. This nature is the frontier and the frontier moves like time. The frontier is the conflict between the past and the future. It is a moving area, which goes towards the west of the Americas. And that's where they look, towards the future. Their individual lives will continue, others will come after them, who will also have to fight, and who will live as we all do.'
Michael Mann

Just after escaping from an Indiana penitentiary, John Dillinger makes a stop at the side of the road. We see him alone contemplating, for a few seconds, a vast plain of the Midwest. The space is grandiose, the horizon as far as the eye can see, almost infinite, as if, at this precise moment, Dillinger felt that no technology or turn of history could ever frame entirely this immensity. The eternal frontier, the always renewed promise of a better future, a dream of space which always ends up becoming reality, America as it is, mythological, free and sovereign. A religious song – *Guide Me, O Thou Great Jehovah*, composed at the end of the eighteenth century[211] – accompanies the sequence and comes to emphasize the dual nature, spiritual and romantic, of his vision. Like Nathaniel at the start (and the very end) of *The Last of the Mohicans*, Dillinger here contemplates his own future – or rather, he questions it – and the use of the biblical song makes his trajectory close to a mystical journey: 'Guide me o thou great redeemer/Pilgrim through this barren land.' This shot is at the exact interface of a fervent lyricism that is close to that of Emerson – an inclination for solitary and silent contemplation of the beauties of nature – and an elegiac lyricism completely contained in that shot of a majestic landscape which closes, as it opened, *The Last of the Mohicans*.[212] From one shot to the other, eyes gaze on those misty mountains of North Carolina, those of Nathaniel, Cora and Chingachgook, the last of his line, which is accompanied, like Cooper's

211 'Guide me o thou great redeemer/Pilgrim through this barren land/I am weak but thou art mighty/Hold me with thy powerful hand/Bread of heaven/Feed me now and evermore.'
212 This elegiac feeling, which runs through Michael Mann's cinema, is reinforced by the frequent use of requiems, arias and other liturgical music which populate the soundtrack of this films.

novel, by a form of nostalgic meditation on the disappearance of the American Indians and their wild space. Civilization will make its way and this reverse shot, at once desirable and available, will never take place again. It is the materialization of a mirage which haunts, inconsolably, all Michael Mann's films. A promise of a future as well, if we are to believe its author. But will we know how to experience the same wonderment at the spectacle of the coming world?

Is it then by chance that the shot that has become emblematic of Michael Mann's cinema, which had been prepared by the sequence of Lake Michigan in *Thief* and the final shot of *Manhunter*, appears constituted for the first time in his following film, *Heat*, like the beginning of a long litany? That is to say, as a reminder, the blue image of Neil McCauley looking out at the Pacific Ocean behind the bay window of his apartment. This implicit link between *The Last of the Mohicans* and *Heat* is notably made by Eady who, in front of the grandiose panorama of Los Angeles, reveals to Neil that she comes from a Scottish-Irish family who 'emigrated to Appalachia in the late 1700s'. This urban expanse on which they both gaze with dazzled eyes returns us, at two centuries distance, to the grandiose panorama placed at the two extremities of *The Last of the Mohicans. In a same movement* are manifested here the catastrophe of a lost utopia (the wilderness) and aesthetic fascination for the contemporary – that urban landscape of which all Mann's films hunt the secret side.

The shot of a man from behind contemplating an oceanic (or terrestrial: *Public Enemies* and *Blackhat*) horizon has almost become a signature around which Mann's films briefly hypostasize. And its recurrence shows that it holds a (the?) truth of his cinema. It is Jeffrey Wigand (*The Insider*) and Sonny Crockett (*Miami Vice*) in front of the Gulf of Mexico, John Dillinger facing an endless plain in the Midwest, Nick Hathaway walking on the Tarmac of Los Angeles Airport as if it was *terra incognita* and even Max, in *Collateral*, who regularly returns to his postcard of a coast in the Maldives. One of the sources, or premises, of this shot could be found in the famous painting by Caspar David Friedrich, *Wanderer above the Sea of Fog* (1818), a masterpiece of pictural romanticism which expresses as much a desire to be engulfed as a dream of a journey without return: 'Haunted by nostalgia for origins [...], Friedrich establishes the coastline as a stage for metaphysical anguish,'[213]

[213] Alain Corbin, *Le Territoire du vide*, Flammarion, 2018, p. 191.

Thief

The Insider

The Insider

Miami Vice

Blackhat

Caspar David Friedrich, *Wanderer above the Sea of Fog*, 1818

writes Alain Corbin. At the extremity of the world, external and internal space pair in one dream of pantheistic fusion. On the other side, the territory of passions, of pure affects and of freedom; on this side, the territory of existential emptiness, of anonymous trajectories and late capitalism.

Moments of mental escape, of introspection and deliberation, the temptation of withdrawal echoing Thoreau's *Walden*, the melancholy tendency to dream about an object lost forever, these shots ask: Does there still exist *an edge to this world*, like at the end of *La Dolce Vita*? What secret is held by this oceanic infinity which grabs these solitary men and frees them from the flux for a brief instant that Mann films as if it was an eternity? Finally, what mirages do they see that we do not? The enormous but invisible projection of a wild imaginary, the place of an untamed utopia opposed to the continent of the real, a space of transcendence which gives relief from a contemporary completely covered by capitalism, speed and globalization. But that place, none of the Mannian characters since *The Last of the Mohicans* has succeeded in reaching it, or finding it again, perhaps with the exception of Sonny in *Miami Vice*, during his romantic retreat to Havana, before a remark by Isabella ('It's controlled by Archangel de Jesus Montoya'), draws a disappointing curtain on his little island paradise.[214] In Mann's films, there no longer exists any elsewhere in our world. No heterotopia which is not already colonized,[215] mapped, consumed. Dillinger's 'off the map' was beautiful as a dream. But the totality is a prison. For Mann, the wilderness cannot be reduced to wild nature, it is like the frontier, a paradigm which restores a certain relationship to time, justice, independence, space, human relations and the cosmos. It is a representation of a world in decay (America, from the Mohicans to John Dillinger), as eternal Italy was in Antonioni's films. The *littoralist drive* which rouses all Mannian heroes objectifies their spiritual need to return to the shore in order to feel the distant call of that ancient world and to verify, one more time, its vanishing. In Mann's work, water, to borrow the expression of Huysmans, is a *melancholizing* element. It carries far away those who contemplate it at the same time as it becomes for them the object of a dissolved disenchantment.

The wilderness has disappeared, but for he who can *see*, it is still there, lurking in the glacial geography of the skyscrapers and (artificial) lights of the city. And at night, occasionally, some coyotes continue even to prowl there.

214 In *Miami Vice*, Mann 'gifts', for the first and only time in his filmography, an oceanic shot
 to a minor character: gazing at the sea, Jose Yero contemplates Sonny and Isabella sailing
 away into the Gulf of Mexico. This shot thus sheds light on Yero's existential program,
 which is summed up entirely in the image of this woman, an object of desire who joins
 here the inaccessible horizon of Mannian mirages.
215 Heterotopia in the sense that Michel Foucault gave it in a lecture in 1967: a concrete
 space which harbours the imaginary, a physical localization of utopia. In relation to the
 other spaces of society, Foucault reminds us, heterotopias are spaces for perfection and/
 or illusion.

Afterword: *Ferrari*

Ferrari began with a vision: in 1967, Mann came face-to-face with a Ferrari – model 275 GTB – and instantly fell under the charm of this elegant and wild race car. According to Mann, it was on this very day that the idea of developing a film about Enzo Ferrari was born. In 1991, the publication of Brock Yates' book – *Enzo Ferrari: The Man and the Machine* – reignited his desire and provided him with the historical and human material. But Mann would have to wait until 2022, with the new popularity of Formula 1, and eight films later, to finally make his *Ferrari* a reality.

 Ferrari is an old school melodrama set in Modena in 1957, a crucial year in which all the lines of conflict that ran through the life of the Commendatore converged – on the domestic and economic levels as much as the sporting one. It would be the final occasion of La Mille Miglia, the legendary 1,000-mile race across Italy which ended, that year, in a human drama outside the village of Guidizzolo (11 dead, over 20 injured). From a stylistic point of view, Mann opts for a kind of operatic classicism. Moreover, the lyrical dimension of the story is signified from the start of the film by the simultaneous arrival in Modena of a driver and an opera company, and later by a major sequence which takes place at the opera when, to the tune of Verdi's 'Parigi, o cara', buried memories rise to the surface of the different protagonists.

The wall

A sequence takes place in a small private room in the Cavallino, a former canteen of the Ferrari factories in Maranello turned into a trattoria by the Ferrari couple in 1950. The entire team is gathered around the table, silent, pitiful, when Enzo Ferrari (Adam Driver) launches into a lecture which intermingles technical and existential considerations: he contrasts the state of mind which electrifies the Maserati team ('Men with a brutal determination to win') with that of his own ('Aristocrats straight from *Almanach de Gotha*. Gentlemen sportsmen'), then delivers a lesson in tactics which for him, we then understand, extends well beyond the field of sport:

> On the straight into the tight corner at Nouveau Monde? There's only one line through it. Behra pulls up next to you, challenging. You're even. But two objects cannot occupy the

same point in space at the same moment in time. Behra
doesn't lift. The corner races at you. You have, perhaps, a
crisis of identity. Am I a sportsman or a competitor? […]
You lift. He passes. He won. You lost. At the same moment
Behra thought: fuck it, we both die.

On the professional level, this analysis by Ferrari returns to the reasons
why de Portago lost the duel with Jean Behra, the star driver of Maserati.
But this impossibility of *two objects occupying the same point in space at the same
moment in time* also functions as the perfect metaphor for the dilemma
which poisons Ferrari's domestic situation, the spine around which Michael
Mann and his screenwriter Troy Kennedy Martin structured the story.
The film quickly reveals the double life of Ferrari, and the two households
between which he navigates daily. First, rays of sunlight on the
Emilia-Romagna countryside: Enzo Ferrari, with greying hair and wearing
an impeccable suit, leaves the house in Castelvetro where Lina Lardi
(Shailene Woodley) and their young son Piero live, gets into his Peugeot
403 then returns Modena, where he lives with his wife Laura (Penélope
Cruz) and mother, Adalgisa.

 During the whole film, Ferrari tries to maintain this status
quo which, apparently, suits him perfectly – a family in Modena, the
remains of another in Castelvetro – and the watertightness of the frontier
separating them. In spatial terms, this double life supposes the existence
of two parallel lines which never cross. Here is a man who wants to make
the world bend to his desires and configure it completely, be it the
mechanical performances of his cars, his daily life regulated like clockwork,
his relations with the press, his public image and, of course, his domestic
situation. For Ferrari, as for most Mannian heroes, *to live is to control.*

 Now, if Ferrari is a true Mannian character – the taste for
independence (personal and economic), excellence at work and especially
the compartmentalization of the intimate worlds of which he is composed
– he evolves in a space (a small 1950s Italian city) organized according to
contrary laws. As pointed out to him by Lina, all of Modena knows about
the existence of Enzo Ferrari's hidden son and his parallel life in Castelvetro.
The city may well be the administrative centre of Emilia-Romagna; but it
remains a village where information circulates everywhere, spreading into
all the interstices of society.

 Mann emphasizes the existence of this Modenese collective
which follows the same rituals, frequents the same places and shares the
same stories and concerns. In Modena, *everything that happens elsewhere also*

happens here and everything takes place in a *compressed space* – the arrival of Behra in Modena is immediately known by Ferrari. The Modena of the 1950s is characterized by an extreme connection of individuals to each other – the exact opposite of the Los Angeles felt by Vincent in *Collateral* – who all belong to the same time-space continuum and possess a shared memory. Here, anonymity is impossible, since what touches a section of the community necessary affects all others. Therefore Ferrari's will to ring-fence, his obsession with compartmentalization, goes against a natural environment desiring to combine opposite modalities. Especially since he is one of the keystones of the Modenese community, one of the most exposed, respected and feared public figures, here as in the rest of Italy.

Emotions

Just after the new record set by Maserati's driver, Ferrari summons his driver Eugenio Castellotti and his team to the racetrack at Modena. But the test run turns to tragedy. Castellotti leaves the track and dies instantly. Then, Ferrari turns to Alfonso de Portago, a young driver who dreams of joining the Scuderia: 'Call my office on Monday,' he tells him. Unfazed, as if what had just happened was a simple turn of events to move on from immediately, Ferrari gives away no emotion, showing an apparent insensitivity that the press violently reproaches him for, calling him an 'industrial Saturn' capable of sending his drivers to death to satisfy his professional hubris. However, this Ferrari contrasts violently with the one we saw at the start of the film, praying at his son's sepulchre and tearfully remembering the death of his two friends, Campari and Borzacchini, 24 years earlier on the circuit at Monza. Set against each other, these two sequences determine the two modalities of Enzo Ferrari's character and, above all, his ability to pass rapidly from one to another. The first one, of the public space, shows the impenetrable, dignified and authoritarian face. This Ferrari controls not only his domestic situation, his business affairs, his team, but also completely masters his image. The tinted glasses are part of Ferrari's visual identity, his *persona*, serving as both screen and façade. Sometimes, Mann underlines the importance of putting on (or taking off) the glasses through a slight slow motion which dramatizes the gesture, as if there is something more at play here than mere coquetry. It's about maintaining the mystique. As Ferrari confides to Lina, the brutal deaths of Campari and Borzacchini mark the origin of this internal wall which he has erected between the two facets of himself; the sensitive soul

and his public self. For Ferrari, compartmentalization is not only a mental discipline which he applies to himself but also the condition for a professionalism he demands from all his collaborators.

Resolution?

In 1957, all Modena knows about Ferrari's double life, except his wife Laura, and for him this alone justifies things being so. 'Ferrari needs continuity to stay Ferrari,' declares Sergio Scaglietti to Enzo in the Scuderia's workshop, when the latter reveals to him that Laura has just learned about Lina and Piero. For unlike Lina, Eady (*Heat*), Jessie (*Thief*) or Billie Frechette (*Public Enemies*), Laura also belongs to her husband's professional universe. It was with her that Enzo founded the Scuderia Ferrari. She is physically marked by grief (her son Dino died in 1956), which she is still to come to terms with and which she partly blames on her husband. With her pale complexion and the deep lines under her eyes, Laura sometimes looks like a living dead person, who has chosen to live as a recluse in the dark spaces of the family apartment, as if this proximity to darkness brings her a little closer to her deceased son. Apart from her daily visit to the cemetery of San Cataldo, only coercion makes her leave her apartment. Laura also lives in a tomb, going over the past, doubtless thinking that after her son's death, life is forbidden to her. Mann mentioned the influence of the paintings of Caravaggio and of the Italian Renaissance on the artistic direction of the film and, in particular, some indoor sequences (darkened backgrounds, rather tight frames, a strong side light). For his part, Enzo navigates between his Modenese apartment and the house of Lina and Piero; in other words, between the past and the present. For him, mourning does not prevent the desire for life. Besides, the films plays a lot on the opposition between the dark interiors associated with Laura and the pastoral side of Castelvetro, its flower garden and softened lights.

Terrible joy

One evening, his head plunged in his engine plans, Enzo explains to his young son Piero how much 'when the thing works better, it's most beautiful to your eyes'. At a high technological level, the car is less about technical competence than sensibility. Inherited from the Italian Renaissance, this ideal of beauty which associates perfection, and therefore the excellence

of the professional, with the purity of forms could serve as a guide for the entire Mannian aesthetic. It also appears, and particularly in *Ferrari*, as a prolongation of the Futurist adventure and its passion for mechanical myths. 'The beautiful machine', Marinetti wrote in his *Futurist Manifesto* of 1909, 'is the beautiful modern subject'. In *Ferrari*, Mann films car races as a mechanical *ballet*, which alternates almost fetishistic close-ups (bits of chromed cockpits, dials, gearsticks, smoking tyres…) and wide shots where the screaming racing cars slice through the Italian landscape like fireballs from another time. For the sake of authenticity, Mann scrupulously respected La Mille Miglia's route and design, as well as the colours of the cars of the time. Thus, in the same way, the 'rossa corsa', that bright red so characteristic of the visual identity of Ferrari cars, is scarcely different from the aniline red of the Maseratis. And when the cars are framed together, caught up in a frenzied race, only certain details allow the viewer to distinguish them from each other, be it the 'M' of Maserati on the front of the car or, on the right side of the Ferraris, the famous 'cavallino rampante'. This interweaving of almost identical cars confronting each other on the asphalt then produces a both gracious and brutal *pas de deux* which combines the race cars of the opposing teams to create a roaring kinetic symphony. Within an ace of victory, Alfonso de Portago speeds down a straight country road and reaches, at that very instant, an unprecedented feeling of plenitude, as if Mann was filming here a new relationship to the world, a new aesthetic sensitivity which modifies notions of time and space, something which is underlined by the combined use of a compensated tracking shot and music which then reaches its lyrical climax. Here Mann materializes two profound characteristics of car racing and the irresistible addiction it produces in all its actors: on the one hand, the driver's extreme concentration on one object in particular (the narrowing of the field of vision to a single line) and on the other, the feeling of euphoria which seizes him. But this moment of intense vitality has its downside, since death is always prowling nearby: a fraction of a second later, the front tyre of the Ferrari 335 S driven by de Portago blows. He and his co-driver are killed instantly, while the race car mows down part of the crowd of spectators massed on the roadside. 'Terrible joy,' says Ferrari of the passion for cars. This violent juxtaposition of a moment of exaltation with another which immediately reveals its cost can be found throughout Mann's filmography, from *Thief* (the celebration of the burglary in California, immediately followed by the murder of Barry) to *Heat* (Chris's smile when he leaves the bank of downtown L.A. with bags full of dollars, wiped away in one go by the arrival of the forces of the LAPD).

To the light

Ferrari opens (almost) and closes on the cemetery of San Cataldo, where the vault of the Ferrari dynasty can be found. At the very end of the film, we find Piero who is waiting for his father, in the early hours of the morning, seated on a bench in the middle of the cemetery. Enzo arrives and jokes with his son. 'Come on, I'll introduce you to your brother,' he tells him, before taking his hand to walk him the considerable distance to Dino's tomb. The mood of this sequence, which functions as a sort of bucolic epilogue, contrasts radically with the rest of the film, of which it constitutes the sunny and peaceful reverse side. As if in spite of the many deaths which have haunted the story, the tragedy of the Mille Miglia and the deterioration of relations between Enzo and Laura, Mann and Troy Kennedy Martin chose to impose, *in fine*, a reverse movement: from death towards life, from the darkness of the grave to the rising sun which radiates the last shot of the film, from Enzo's tears in front of the photo of his deceased son to his final burst of laughter alongside Piero. 'It occurred to me', Michael Mann declared to *Vulture*, 'to make Piero the end of the story and then have the story ultimately be about his fate. Once I made that decision, I reverse-engineered his presence into the film and used it as a value system to decide how all the scenes should play.' This reversal of perspective, which makes Piero the secret engine of the story and, consequently, dictates its narrative arc, explains the feeling of irresolution which marks the end of the film. 'She knows he's my son. But nothing has been resolved,' Enzo tells Lina, who inquires about Laura's reaction after she discovered Piero's existence. At the end of *Ferrari*, therefore, nothing seems to have been decided. Still the same status quo, the same indecision, the same conflicts. This is, precisely, the modern and realistic dimension of the film: 'How do these oppositions end in most of our lives?', Mann asks. 'We sit around in a Barcalounger, or watching daytime TV, and then we die – they don't get resolved.' And yet, if nothing is really resolved, something unravels in Enzo's mind, once we consider Piero's fate as the film's underground compass. What then happens in the final sequence? The film opened on the black and white photo of Dino and closes on the young Piero's body, full of life. So from one son to another, as if the baton has finally been passed. At the end of 1957, the time has finally come for the future to definitively prevail over the past, the resentments and the regrets.

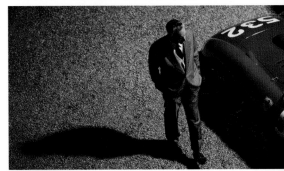

© 1992. Morgan Creek Entertainement, Twentieth Century Fox (all rights reserved) / Blu-ray: ESC Editions (France 2019): 36, 110, 114, 224, 226, 247, 255, 257; © 1995. Warner Bros., New Regency Productions (USA), Forward Pass, Art Linson Productions, Monarchy Enterprises B.V (all rights reserved) / Blu-ray: Warner Home Video (France, 2012)): 36, 37, 100, 105, 146, 148, 152, 156, 163, 165, 172, 173, 199, 313; © 2009. Universal Studios in association with Relativity Media, Tribeca Productions and Appian Way, Forward Pass, Misher Films (all rights reserved) / DVD Universal Pictures (France, 2009): 209, 211, 212, 217, 221, 235, 236, 239, 240, 244, 245, 247, 248; © 2004. Paramount Pictures, Dreamworks Pictures, Parkes/McDonald Image Productions, Edge City (all rights reserved) / Blu-ray: TM & © 2010 Paramount Pictures Corporation and DW Studios LLC (France, 2010): 66, 148, 176, 183, 191, 195, 196, 199, 313, 316, 333; © 2006. Universal Pictures in association with Motion Picture ETA Produktionsgesellshaft, Forward Pass, Focus Arte Digital, Metropolis Films and Michael Mann Production (all rights reserved) / Blu-ray: Universal Studios (France, 2008): 36, 65, 66, 284, 285, 289, 291, 293, 296, 299, 302, 304, 313, 333, 338; © 2015. Forward Pass, Legendary Entertainment (all rights reserved) / Blu-ray: Universal Studios (France, 2015): 36, 309, 311, 313, 314, 316, 321, 329, 330, 333, 339; © 2001. Columbia PIctures, Forward Pass Productions, Initial Entertainment Group, Moonlighting Films, Overbrook Entertainment, Peters Entertainment, Picture Entertainment (all rights reserved) / Blu-ray: 2009 Studio Canal Video (France 2009): 112, 124, 129, 130, 135, 136, 141; © 1981 Metro Goldwyn Mayer Studios Inc., Mann/ Caan Productions (all rights reserved) / Blu-ray: Wild Side (France, 2015): 10, 25, 29, 31, 36, 42, 44, 316, 338; © 1986 De Laurentiis Entertainement Group, Red Dragon Productions S.A (all rights reserved) / Blu-ray: ESC Editions (France, 2018): 36, 71, 81, 82, 85, 87, 89, 91, 93, 96, 100, 316; © 1999 Touchstone Pictures, Forward Pass, Mann/Roth Productions (all rights reserved) / Blu-ray: Buena Vista Home Entertainment (USA, 2013): 37, 259, 260, 262, 265, 267, 271, 274, 280, 282, 338; © 1983 Paramount Pictures, Associated Capital, Capital Equipment Leasing (all rights reserved) / Laserdisc: Paramount Home Video (NBC) (USA, 1995): 50, 53, 57; Eros Hoagland: 348; Lorenzo Sisti: 348.

Filmography

1979
The Jericho Mile
Sentenced to life imprisonment for murdering his father, Larry Murphy does his time Folsom prison. Every day, he trains at running. The quality of his performances gives his trainer and social adviser the idea of organizing an official competition in the prison.

1981
Thief
Chicago. Frank is a seasoned and independent jewellery thief who, one day, makes a deal with a local mafia boss in the hope of fulfilling his dream: to hang up his gloves and start a family.

1983
The Keep
During the Second World War, a detachment of Nazi soldiers is sent into the Carpathians to guard a col. On arriving, they discover a mysterious fortress. When evening comes, one of them frees, involuntarily, an evil force.

1986
Manhunter
Withdrawn to Florida, following the wounds inflicted on him by Hannibal Lecktor, the ex-profiler Will Graham returns to active duty when his friend Jack Crawford, a former colleague in the FBI, asks him to help him apprehend a serial killer calling himself the 'Red Dragon'.

1992
The Last of the Mohicans
1757, State of New York. On their way to Fort Henry, where they must rejoin their father, Cora and Alice fall into an ambush set by Magua, a Huron warrior. In extremis, they are saved by Nathaniel, Chingachgook and Uncas, three Mohicans who are going to help them to reach their destination

while, around them, the war of conquest between the English and the French is raging.

1995
Heat
After the bloody attack on an armoured car in the heart of Los Angeles, lieutenant Vincent Hann goes on the trail of Neil McCauley and his high-flying gang.

1999
The Insider
Investigative journalist and producer of the programme *60 minutes*, Lowell Bergman one day receives a pile of documents describing certain dubious practices in the tobacco industry. In order to decipher this data, he calls on Jeffrey Wigand, former director of research at Brown & Williamson. The latter has just been fired and a confidentiality contract prevents him from saying what he really knows.

2001
Ali
The rise of Cassius Clay, soon renamed Muhammad Ali, his victories in the ring, his title of world heavyweight champion won in 1964, his run-ins with the military administration, his meetings with Malcolm X, his turbulent private life, right up until his fight with George Foreman in Kinshasa in 1974.

2004
Collateral
One evening Max, a cab driver in Los Angeles, takes Vincent, a yuppy in a grey suit who proposes to hire his services until dawn in order to fulfil a series of commercial contracts. But in reality, Vincent is a hitman. Despite himself, Max is embarked on a crime spree.

2006
Miami Vice
Two Miami cops, Sonny Crockett and Ricardo Tubbs, infiltrate an

international criminal organization specialized in drug trafficking. Sonny rapidly falls under the charm of Isabella, its financial director.

2009
Public Enemies
1930s. The last two years of John Dillinger, famous bank robber decreed 'public enemy number one' by the founder of the FBI, J. Edgar Hoover. The latter launches Melvin Purvis, one of his most brilliant Federal agents, on his heels.

2015
Blackhat
Following the pirating of a nuclear plant in Chai Wan, China, captain Chen Dawai manages to convince his hierarchy and the American authorities to release Nick Hathaway, a genius hacker with whom he did computer studies. Together they are going to try and track down the cybercriminal.

2023
Ferrari
Modena, 1957. Enzo Ferrari, founder and boss of the most famous Italian car brand, must face an intimate and professional crisis. Since the death of his son Dino the year before, he maintains a conflictual relationship with his wife Laura and lives a hidden double life alongside Lina Lardi, with whom he has a son, Piero. On a sporting level, Ferrari is preparing its team for the famous Mille Miglia race. A victory would allow him to save his business.

In 2022, Michael Mann published *Heat 2*, a novel co-written with Meg Gardiner that is both a prequel and a sequel to *Heat*.

Michael Mann has co-written all the screenplays of his films, with the exception of those of *Collateral* and *Blackhat*.
In 1978, he collaborated (without being credited) on the screenplay of Ulu Grosbard's *Straight Time*.
Michael Mann was the coproducer of *The Aviator* (Martin Scorsese, 2004), *The Kingdom* (Peter Berg, 2007), *Hancock* (Peter Berg, 2008, in which he appears as an actor) and *Texas Killing Fields* (Ami Canaan Mann, 2011).
He was executive producer of *Bob Dylan: Band of the Hand* (Paul Michael Glaser, 1986), *How to Get the Man's Foot Outta Your Ass* (Mario Van Peebles, 2003) and *Le Mans '66* (James Mangold, 2019).

Television

As director

1977: he directed episode 6 (*The Buttercup Killer*) of season 4 of the series *Police Woman*.

1978-1981: *Vega$* (68 episodes), series of which he was also the creator.

1979: *The Jericho Mile*, film of which he was the director and co-scriptwriter.

1987: *Crime Story*, series created by Chuck Adamson and Gustave Reininger (43 episodes). He directed the episode *Top of the World*.

1989: *L.A. Takedown*, film of which he was the director, screenwriter and executive producer.

2011: *Luck*, series created by David Milch (10 episodes). He directed the pilot episode and was executive producer of the series.

2022: he directed the pilot episode of the series *Tokyo Vice*.

As executive producer

1984-1990: *Miami Vice*

1986-1988: *Crime Story*

1990: *Drug Wars: The Camarena Story*, miniseries of 3 episodes. He wrote the story of the first episode.

2002-2003: *Robbery Homicide Division* (13 episodes), series created by Barry Schindel.

2012: *Witness*, documentary miniseries of 4 episodes.

As screenwriter

For television, Michael Mann wrote 2 episodes of the series *Bronk* (*Death with Honor and Jackson Blue* in 1976), an episode of the series Gibbsville (*All the Young Girls* in 1976), 4 episodes of the series S*tarsky and Hutch* (between 1975 and 1977: *The Psychic, Jojo, Lady Blue* and *Texas Longhorn*) and 4 episodes of the series *Police Story* (between 1976 and 1978: *River of Promises, Trial Board, Thanksgiving and Eamon Kinsella Royce*). He also wrote an episode of the series *Vegas$* (High Roller in 1978). In 1980, he cowrote the TV movie *Swan Song* by Jerry London. In 2002, he wrote an episode of the series *Robbery Homicide Division* (*Life is Dust*).

Select bibliography

Vincent M. Gaine, *Existentialism and Social Engagement in the Films of Michael Mann*, Palgrave Macmillan, 2011

Steven Sanders, Aeon J. Skoble and R. Barton Palmer (editors), *The Philosophy of Michael Mann*, edited by, The University Press of Kentucky, 2014

Steven Rybin, *The Cinema of Michael Mann*, Lexington Books, 2007

Alston Purvis, Alex Tresniowski, *The Vendetta: Special Agent Melvin Purvis, John Dillinger, and Hoover's FBI in the Age of Gangsters*, Public Affairs, 2009

Mark E. Wildermuth, *Blood in the Moonlight. Michael Mann and Information Age Cinema*. McFarland & Company, 2005

Quarto

First published in 2024 by White Lion Publishing, an imprint of The Quarto Group.
One Triptych Place
London, SE1 9SH,
United Kingdom
T (0)20 7700 6700
www.Quarto.com

Originally published in French under the title: *Michael Mann: Mirages du contemporain*
© Flammarion, Paris 2021
© English language translation Quarto Publishing 2024
Text Copyright © 2023 Jean-Baptiste Thoret

Jean-Baptiste Thoret has asserted his moral right to be identified as the Author of this Work in accordance with the Copyright Designs and Patents Act 1988.

All rights reserved. No part of this book may be reproduced or utilised in any form or by any means, electronic or mechanical, including photocopying, recording or by any information storage and retrieval system, without permission in writing from White Lion Publishing. Every effort has been made to trace the copyright holders of material quoted in this book. If application is made in writing to the publisher, any omissions will be included in future editions.

A catalogue record for this book is available from the British Library.

ISBN 978-0-7112-9412-7
French edition ISBN: 978-2-0802-3689-0

10 9 8 7 6 5 4 3 2 1

Text by Jean-Baptiste Thoret
Translation by Gavin Bowd
Designed (English edition) by Ben Ruocco

Flammarion:
Editorial director: Julie Rouart
Assisted by: Dorine Morgado
Head of editorial administration: Delphine Montagne
Proofreader: Clémentine Bougrat

Quarto:
Publisher: Jessica Axe
Senior Editor: Laura Bulbeck
Assistant Editor: Katerina Menhennet
Senior Designer: Renata Latipova
Production Controller: Rohana Yusof

Printed in China

MIX
Paper | Supporting
responsible forestry
FSC® C016973
FSC
www.fsc.org